Made with passion

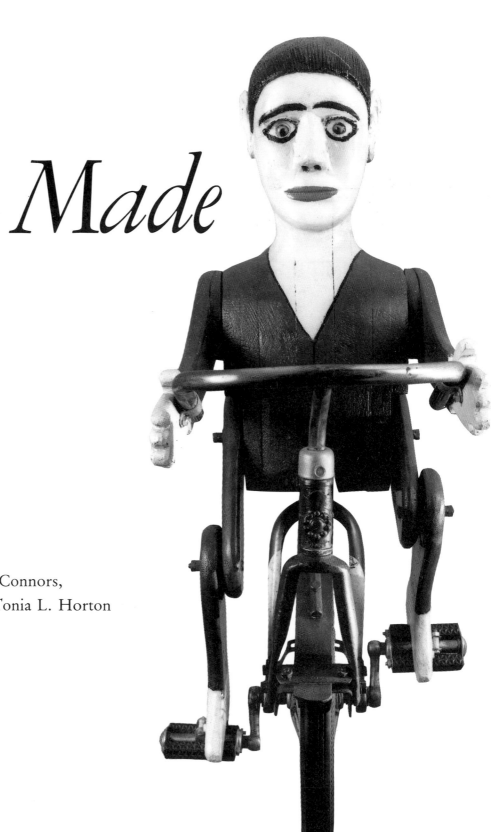

Made

with contributions by Andrew L. Connors,
Elizabeth Tisdel Holmstead, and Tonia L. Horton

with passion

Lynda Roscoe Hartigan

Published for the National Museum of American Art
by the Smithsonian Institution Press
Washington and London

Published for the exhibition
MADE WITH PASSION: THE HEMPHILL FOLK ART COLLECTION
in the National Museum of American Art

National Museum of American Art
Smithsonian Institution, Washington, D.C.
22 September 1990–21 January 1991

Made with Passion: The Hemphill Folk Art Collection in the National Museum of American Art has been made possible by grants from the Smithsonian Institution's Special Exhibition Fund

Editor: Richard Carter
Designer: Janice Wheeler

Library of Congress Cataloging-in-Publication Data
National Museum of American Art (U.S.)
 Made with passion: the Hemphill Folk Art Collection in the National Museum of American Art/Lynda Roscoe Hartigan, with contributions by Andrew L. Connors, Elizabeth Tisdel Holmstead, and Tonia L. Horton.
 p. cm.
 National Museum of American Art, Smithsonian Institution, Washington, D.C., 22 September 1990–21 January 1991—Verso t.p.
 Includes bibliographical references.
 ISSB 0-87474-293-5 (alk. paper). — ISBN 0-87474-289-7 (pbk.: alk. paper)
 1. Folk art—United States—Exhibitions. 2. Hemphill, Herbert Waide—Art collections—Exhibitions. 3. Folk art—Private collections—Washington (D.C.)—Exhibitions. 4. National Museum of American Art (U.S.)—Exhibitions. I. Hartigan, Lynda Roscoe. II. Title.
NK805.N35 1990 745′.9073′074753—dc20 90-9622
 CIP

The paper used in this publication meets the requirements of the American National Standard for Permanence of Paper for Printed Library Materials Z39.48.1984

Front cover: Irving Dominick, detail of *Marla*, 1982, cat. 13, photograph by Edward Owen, Washington, D.C.
Title page: Louis Simon, *Bicycle Shop Sign*, early 1930s, cat. 8.
Dedication page: Unidentified artist, *Policeman Smoking Toy*, twentieth century, cat. 65, photograph by Edward Owen, Washington, D.C.
Contents page: Unidentified artist, *Airplane*, ca. 1933–35, cat. 62
Page viii: Selection of objects from the Hemphill collection, photograph by Edward Owen, Washington, D.C.
Page xvi: Herbert Waide Hemphill, Jr., at home, New York City, Fall 1989
Back cover: Unidentified artist, *Bottlecap Giraffe*, completed after 1966, cat. 69, photograph by Edward Owen, Washington, D.C.

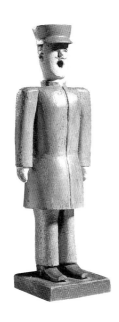

This book is dedicated to three people. Martha M. Meek, my maternal grandmother, introduced me to the dignity and ambition of the self-taught artist as she shared with our family the drawings, quilts, and memory vessels that she made from the early 1900s to the 1960s. Harry Lowe, co-savior of *The Throne of the Third Heaven*, encouraged my research on James Hampton's visionary environment. As assistant director of the National Museum of American Art until 1981, Lowe staunchly supported adding the works of self-taught artists to the museum's collection. Walter Hopps, the museum's curator of twentieth-century art from 1973 to 1979, provided my opportunities to research the work of Hampton and Joseph Cornell, two very different artists nonetheless related by their self-taught origins. These three people have helped me realize that understanding the alternative is not only possible but necessary.

On a personal note, I would like to thank my family—Roger, Pierce, and Kirsten, as well as Céline Grasset. Their unfailing patience and support made my writing possible.

LRH

Contents

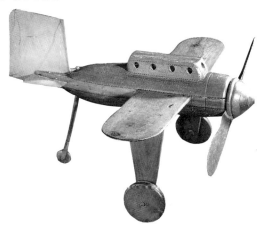

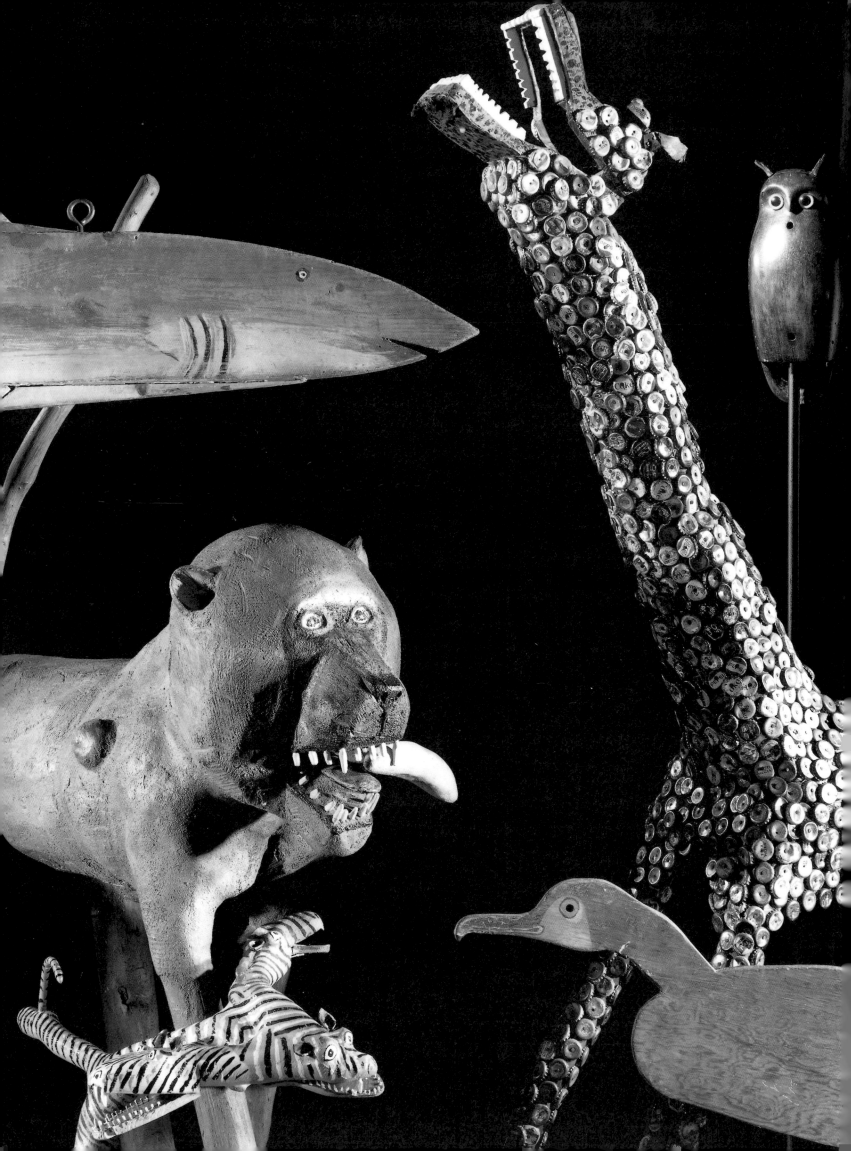

Foreword

In 1986, the National Museum of American Art acquired through gift and purchase a major collection from Herbert Waide Hemphill, Jr., the man dubbed "Mr. American Folk Art" by *Connoisseur*. The Museum already owned almost two hundred folk pieces, of which James Hampton's magnificent *Throne of the Third Heaven*—a glittering liturgical ensemble made of castoff furniture wrapped in cheap foils—was by far the most curious and imposing. Although the *Throne* was widely circulated to museums in America, folk art remained a modest part of the Museum's program. A few folk objects were tucked into a small corridor gallery, where visitors encountered them as a parenthetical aside to the featured collections of traditional painting, sculpture, and graphics.

The acquisition of the Hemphill Collection (now numbering more than 427 pieces and growing) meant more than simply trebling the size of the folk art collection. As curator Lynda Roscoe Hartigan explains in her essay in this book, the time was ripe for a new understanding of folk art, with the post-Pop Art aesthetic, decline of modernism, rise of cultural anthropology, and broadening of the art market all playing a role. Instead of appearing marginal, folk art began to seem an essential part of our visual arts, helping to fill in the delicate lacework created by the first historians of American art, who wove intricate but incomplete traceries of great men linked by stylistic influences and academic training. Over the past decade or two, folk art, decorative arts, crafts, and art made by ethnic and racial minorities and women emerged as essential components of the whole. With the acquisition of the Hemphill Collection, introduced to our audience through this book and the accompanying exhibition, the National Museum of American Art has embarked on a major collecting, research, and public program in folk art.

What does it mean when folk art moves into a museum founded long ago as a traditional painting and sculpture gallery? For those who championed its cause through decades of official neglect, finding folk art in museum galleries next to Hudson River School landscapes and Abstract Expressionist canvases is a long-awaited legitimization, affirming the collector's independent judgment and giving

overdue recognition to artists who worked without formal training, critical acclaim, or financial reward. But the implications go far beyond this simple endorsement of previously ignored work and taste. Many find that accepting folk art as an aesthetic expression equal to other cultural forms is disorienting. Assumptions about art fall quickly by the wayside, replaced by perplexing questions of technique, form, function, quality, and intention.

Many scholars reject the word art altogether, preferring to speak of artifacts and material culture. If the people who made these objects were not trained as artists, and most did not call themselves artists or exhibit and sell work in galleries, are we then entitled to reclassify the makers and their creations to suit a market- and museum-driven idea? Why not also designate appealing toys, tools, trains, advertisements, and doodles as art? If anything and everything can be anointed, without taking into account the intentions of the maker, then surely the word has lost all meaning.

On one level this argument is easily discounted—neither cave painters nor glass stainers would fit such a narrow description, yet Lascaux and Chartres have been firmly enshrined in our canon during the past century. Only the most rigid modernists would claim formalist intention as the sole defining principle of art. But on another level the argument cannot be dismissed, for art is less a category than an honorific. Often this sign of esteem is cast like a veil over the object, obscuring what can really be known about it and substituting a vague transcendent idea that says less about the work than the speaker.

Folk art seems especially susceptible to this phenomenon. Although it relies on tradition and repetition (repeated patterns, subjects, formats, conventions) and derives some of its appeal from this easy accessibility, folk art is prized for its "originality." While usually linked closely to a specific time and place of origin, it is praised for "universal" human qualities. Ironically, even the unself-conscious, or "artless" aspects of these pieces contribute to our estimation of their aesthetic merit.

The language of art sometimes gets in the way of understanding these fascinating works, and the museum setting may seem to channel them into categories invented for other purposes—all of which is alarming to those who value these objects precisely for their differences. Yet just as Bert Hemphill avoided the patterns of earlier folk art collectors to find those who Howard Finster calls the "lone and forgotten," art museum curators can escape their own confining precepts and, together with those from other disciplines, begin to develop a vocabulary of ideas specific to these objects. This collection is in the National Museum of American Art because it represents an essential part of the American visual heritage; the work of stretching our understanding to encompass these multifaceted objects is just beginning. The challenge is not to fold them into a canon of art based on established formalist precepts, but to open our eyes and minds to all that they say about our lives and experience.

Bert Hemphill's astonishing ability to see what was invisible to so many others left him free to roam in uncharted territories of art. Like an explorer, he came back from his collecting trips with exotic items that fit no established order, selected for the special appeal they held for him. Remarkably, these private passions hold the same appeal for a broad public, perhaps because they so forcefully engage life's fundamental aspects—family, politics, sexuality, work,

nature, religion. The present exhibition opens exactly two decades after his groundbreaking, controversial show in New York, "Twentieth-Century Folk Art and Artists," when "the Hemphill thing" first went public, to the mingled shock and delight of audiences.

The proposal to acquire this landmark collection for the National Museum of American Art began in 1986 with talks among Lynda Hartigan, Michael Hall, and Bert Hemphill. At the Smithsonian, former NMAA Director Charles C. Eldredge, Assistant Secretary Tom L. Freudenheim, and the late Carlisle Humelsine, Smithsonian Regent, enthusiastically endorsed the plan, which was approved by the NMAA Board of Commissioners. Elaine Johnston, Charles Robertson, Ann Leven, and George Meyer completed the legal and financial arrangements for the combined gift and purchase. Richard Ahlborn, curator at the National Museum of American History, and Richard Murray, then director of the Archives of American Art, lent crucial support to the early discussions. Grants from the Smithsonian's Research Opportunities Fund and Special Exhibitions Fund provided for research and conservation of the collection.

In planning the exhibition, numerous colleagues and scholars offered essential advice and assistance, including the project advisors: Ramona Austin of the Art Institute of Chicago, Alicia Gonzalez of the Smithsonian Quincentennary Project, Michael Hall of the Cranbrook Academy of Art, Alan Jabbour of the Library of Congress Folklife Center, Richard Kurin of the Smithsonian's Folklife Program, and Eugene Metcalf of Miami University's School of Interdisciplinary Studies. To these and to the many others who contributed to this exhibition and book, I am deeply grateful.

Elizabeth Broun
Director, National Museum of American Art

Acknowledgments

In the summer of 1974, the National Museum of American Art was preparing James Hampton's *Throne of the Third Heaven of the Nations Millenium General Assembly* for its loan to the Walker Art Center's exhibition, "Naives and Visionaries." Estelle Friedman, a new friend, called to ask if a folk art collector named Bert Hemphill could visit our conservation lab where the *Throne* was being treated and packed. She explained that he would like to see the monument he planned to reproduce in a book, and that he was someone I should meet as part of my initiation into the twentieth-century folk art field. Shortly thereafter, a dapper, soft-spoken gentleman arrived and carefully listened as the conservator explained the work's construction, and I described my research on Hampton. As a token of appreciation, our visitor gave me a catalogue for the Heritage Plantation's exhibition of his collection. Later, I discovered that he had inscribed it, "Thanks for giving me a glimpse of Heaven, Yours, Bert Hemphill." Little did he or I know then that our meeting would lead to the museum's acquisition of his collection in 1986. Bert Hemphill joins me in thanking Estelle Friedman for her auspicious good deed.

Words can often return to haunt us, but I hope that Bert will not mind some rephrasing as I thank him on behalf of the National Museum of American Art for giving us and the nation his version of a folk art heaven. In this extraordinary collection, the museum has embraced folk art as an equal partner in America's visual history and will build on its energizing effect. From the day the museum began negotiations to the day we opened the exhibition, Bert has cooperated to the fullest measure possible, welcoming our staff into his apartment, his library and papers, introducing us to his network of friends and associates, and most of all, sharing his memories. I am sure that he has felt like a piece of Atlantic City salt water taffy, tugged and pulled, as we tried to digest the enormous tasks of preparing the collection for publication and exhibition. Throughout it all, his characteristic sense of responsibility to folk art never waned and provided an example for our efforts.

At the museum an exceptionally hard-working army has marshaled its forces.

I am particularly grateful to Elizabeth Broun, director of the National Museum of American Art, whose wholehearted conversion to folk art and commitment to this complex project assured its success. During their respective tenures as the museum's chief curator, Richard Murray and Virginia Mecklenburg greatly supported the necessarily extensive research as well as a generous maternity leave in its midst.

The publication is the harvest of concerted efforts. Andrew Connors, Elizabeth Holmstead, and Tonia Horton have been energetic and resourceful members of a research team whose explorations took them well beyond their previous expertise. I commend them for translating their hard-earned information into so many well-written, illuminating catalogue entries. I would also like to thank Elizabeth for her timely, good-humored efforts that assisted my research and the preparation of the bibliography. Acting chief of our publications office, Terence Winch, was devoted to the detailed negotiations and arrangements with the publisher. Editors Richard Carter and Joan Harris Lautman took exquisite care in shaping a complex manuscript. Staff photographers Mildred Baldwin, Michael Fischer, and Eugene Young, as well as Washington free-lance photographer Edward Owen, produced a sensitive array of photographs under the capable direction of Robert Johnston, Alexandra Nicolescu, and Emily Bernard.

Few objects in a collection have received as much specialized scrutiny and judiciously loving treatment as have these from the Hemphill collection. Marjorie Zapruder catalogued the works and researched the textiles with zest and pain-staking care. Our painting conservators Anne Creager and Stefano Scafetta, paper conservators Fern Bleckner and Kate Maynard, objects conservator Helen Ingalls, and former conservation assistant Eileen Werner-Blankenbaker, admirably treated objects with diverse, time-consuming, and often unusual conditions. Helen Ingalls was also responsible for coordinating the specialized assistance provided by Mary Ballard, Robert Behr, Greg Cullen, Jim Howard, Lighten Up Neon, Michael Palmer, Virginia Pledger, and William Westervelt. In the registrar's office, Marc Palombo and Maria Marks, as well as graphic arts specialists Abbie Terrones, Lynn Putney, and Charles Booth, all did yeoman's work to help catalogue, treat, and photograph the works.

During an odyssey of research, those involved with this project and I have called upon expertise nationwide. Collectively, we would like to thank all of the artists and their families, independent researchers and curators, museum and library staff, private collectors, dealers, and conservators who shared information with good will, and whose suggestions or viewpoints have expanded our understanding of the material. We especially wish to thank Julia Weissman for sharing her extensive research files from which the entire project has benefited.

The assistance of four institutions was crucial to this exhibition and publication. In Washington, the Smithsonian's Archives of American Art has undertaken ambitious documentation of American folk art under the leadership of Liza Kirwin, who has unfailingly made its growing resources available. The Museum of International Folk Art in Santa Fe, New Mexico, greatly contributed to our perception of the field's cataloguing, storage, and conservation challenges, and to its director Charlene Cerny and its conservator Claire Munsingrider go our thanks for frank, informative discussions. At the Museum of American Folk Art in New York, director Robert Bishop, assistant director Gerald Wertkin, director

of exhibitions Michael McManus, director of publications Didi Barrett, curator Elizabeth Warren, librarian Edith C. Wise, archivist Alice Hoffman, and photographic services staff Janey Fire and Julia Arliss graciously shared their impressive resources. Equally helpful were director Caroline Weekley, curators Barbara Luck and Richard Miller, and registrar and librarian Anne E. Watkins at the Abby Aldrich Rockefeller Folk Art Center in Williamsburg, Virginia. The National Museum of American Art looks forward to perpetuating this spirit of cooperation among our institutions.

Preparing my essay distilled years of observation as well as recent research. To Bert Hemphill, I extend my heartfelt gratitude for guiding me through the collection and for answering any and every question he hoped I would never ask. Lengthy discussions with Michael and Julie Hall and Eugene Metcalf have been both dynamic and enlightening. Alphabetically in all fairness, I would like to thank the following people whose generosity in sharing their collections, inventories, research, memories, and photographs over time have most directly contributed to the essay or my entries: William Bengston, Mary Black, Jane and Jeffrey Camp, Shari Cavin and Randall Morris, Varick Chittenden, the Center for the Study of North Country Folklife; Martha Cooper, David Davies, LeRoy Davis, Elizabeth Ehrhardt and Dorothy Westcoat, the Atlantic County Historical Society; Kenneth Fadeley, Caroline Farquhar, Fred Fossel and Scott Coulter, the Columbus Museum of Art, Columbus, Georgia; Gene Epstein, Frederick Fried, Richard Gaspari, Elias Getz, M. J. Gladstone, Baron and Elin Gordon, Carl Hammer, Marshall and Sara Hemphill, Tim Hill, Sandra Hoffacker, the Solebury School; Walter Hopps, Elinor Horwitz, Deborah Iannarelli, Barbara Johnson, Harvey Kahn, Phyllis Kind, Donald Kloster, the National Museum of American History; John Lassiter, the W. C. Bradley Memorial Library, Columbus, Georgia; Martha Little, the Lawrenceville School; Patricia Lorenz, Harry Lowe, Roger Manley, Frank Maresca, Heidi Monza, John Ollman, Neal Prince, Neil Printz, Dorothy and Leo Rabkin, Deborah Reid, Roger Ricco, Seymour Rosen, Chuck and Jan Rosenak, Beatrix Rumford, Sterling Strauser, Diane Tepfer, Nancy Karlins Thoman, Don Walters, Annys Wilson, Bard College; and Brent Zerger.

Andrew Connors, Elizabeth Holmstead, Tonia Horton, and Marjorie Zapruder wish to thank those who contributed to their research. Affiliated individuals include Richard Ahlborn, Hope Connors, Scott Ellsworth, Anne Golovin, Rayna Green, Paul Johnston, Larry Jones, Harold Langley, Susan Myers, Rodris Roth, Gary Sturm, and Robert Vogel of the National Museum of American History; Gloria Seaman Allen, the Daughters of the American Revolution Museum; Lewis Alquist, Arizona State University; Robin Bolton-Smith, Martina Norelli, and William Truettner of the National Museum of American Art; Cinda Baldwin and Catherine Wilson Horne, the McKissick Museum, University of South Carolina; Sue Buckner, Dorothy Kendrick, and Terry Smith of the Fulton State Hospital, St. Louis, Missouri; Philip Budlong and Benjamin Fuller, Mystic Seaport; Robert Davis and Norman Gleason, the Improved Order of the Red Men; C. Kurt Dewhurst, the Museum, Michigan State University; Leonidas N. Economides, the Saint Sophia Greek Orthodox Cathedral; Barbara Franco and Barbara Oaks, the Museum of Our National Heritage; Stuart Frank and Ellen Hazen, the Kendall Whaling Museum; Ellwood Green, the Native American

Center for the Living Arts; Vernon Gunnion, the Landis Valley Historical Society; Howard Hendricks, the Museum of the Confederacy; Bill Henry and Richard Malley, the Mariner's Museum; Martha Katz Hyman, the Abby Aldrich Rockefeller Folk Art Center; Suzi Jones, the National Endowment for the Arts; Jean King, the Thomas Gilcrease Institute of American History; Lee King, chief of social work, Cleveland, Ohio; Greg Kimball and Colleen Callahan, the Valentine Museum; Richard Kugler, the New Bedford Whaling Museum; Allie Light and Irving Saraf of Light-Saraf Films; Millard Lomakewa, Hopi Arts and Crafts Guild; Ellen Miles, Wendy Wick Reaves, and William Stapp of the National Portrait Gallery; Winnie Owens-Hart, Howard University; Robert Pelton, the P. T. Barnum Museum; Samuel Pennington, *Maine Antique Digest*; John Platt, Masonic Temple, Philadelphia; Betty Prisch, the Rochester Museum and Science Center, Rochester, New York; Bernard Reilly, the Library of Congress; Judy Siegrist and Caroline Wenger, the Mennonite Historical Society; Martha Simms, the Seneca-Iroquois National Museum; Nick Spitzer, the Smithsonian Office of Folklife Programs; Robert Ferris Thompson, Yale University; John Vlach, the George Washington University; Robert Van der Linder, the National Air and Space Museum; and Sibylle Zemitis, California State Library.

Private individuals deserving the team's thanks are Mary Adams, Beth Almanza, Aarne Anton, Gina Parks Badami, Mark Boultinghouse, Lillian Codina, Paul Conner, Bud Corwin, James Cottle, Asie Crump, Irving Dominick, Sam Dyke, Charlotte Easley, Albina Felski, Helaine Fendelman, Marshall Fleming, Harold Garrison, Robert S. Gerard, Dr. Norman Goldstein, Bonnie Grossman, Virginia Gunn, Ron Hall, Trish Herr, Betty Jo Hieck, Anne Hopkins, Faith Jackson, Michael Kabotie, Myrna Kaye, Art Kimball, Greg La Chapelle, Karen Lenox, James Leonard, Mr. and Mrs. George Lopez, Bates Lowry, Marc Montefusco, James Mauzy, Ruth McDonald, Reverend Franklin McGuire, Debbie McKinley, Penny McMorris, Nancy Mead, Kate Morgan, Richard Navenma, Delbert Nevayaktewa, Sabanita Lopez Ortiz, Mr. and Mrs. Henry J. Perates, Mr. and Mrs. Rod Rosebrook, Jennifer Resch, Leisa Rundquist, Mary Colclough Ruth, Alexander Sackton, Jack Savitsky, Mahlon Schuyler, Holly Schaper Scott, Jon Serl, Charles Shannon, Julie Silber, Albert Simon, Q. J. Stephenson, Jane Tebbs, Elizabeth C. Tisdel, Robert Toll, Caroline Welch, and Malcah Zeldis.

Each and every person who lent his or her commitment, knowledge, and enthusiasm to this project has immeasurably enriched the National Museum of American Art.

Lynda Roscoe Hartigan

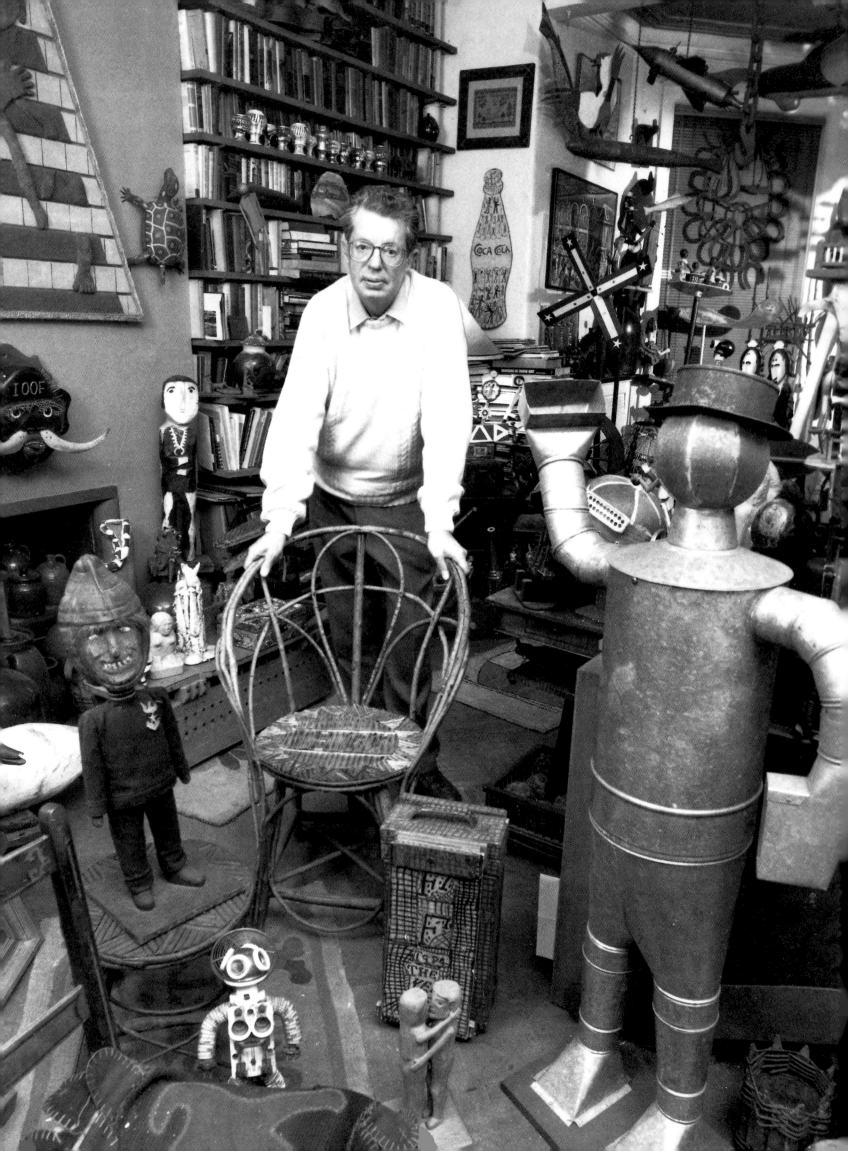

If a man tells us that he sees differently than we, or that he finds beautiful what we find ugly, we may have to leave the room, from fatigue or trouble; but that is our weakness and our default. *J. Robert Oppenheimer*[1]

Collecting the Lone and Forgotten

INTRODUCTION

In the winter of 1949, Herbert Waide Hemphill, Jr., then a well-to-do twenty-year old, settled in Manhattan. Over the next four decades he assembled a collection that quietly yet irrevocably altered the perception of American art. To some, including the collector himself, that estimation might come as a surprise. Hemphill's shy yet generous personality embraces a sharp preference for the different, but he is by no means a self-anointed revolutionary. His chosen territory is American folk art, and his catalytic efforts as a collector, curator, and author have been recognized in that arena since the mid 1970s. Hemphill makes no claims beyond his specialty, and his collection's significance has gone unnoticed in some segments of the American art world. Nonetheless, his influence—reflecting the impact of the objects he has gathered—spreads into the so-called mainstream, bringing with it a body of work that simultaneously questions and establishes the very nature of art.

From the outset Hemphill did not attempt to define folk art, nor has he debated the validity of adjectives—primitive, naive, self-taught, outsider—associated historically or recently with the field.[2] He has had no substitutes to suggest, although he now believes that applying only the word "art" to many of these objects would be a therapeutic release from endless efforts to assign just the right qualifier or modifier. In the past Hemphill has preferred the term folk art, largely because of the timing and character of his first serious efforts to collect in the 1950s. That term will appear here as a matter of convenience as well as a reminder of his evolution.

Of greater interest is Hemphill's role as a taste maker in the twentieth century. Has his background or postwar American culture helped form his approach to collecting? How did earlier events and figures in the folk art world influence him? How did he interact with, stimulate, or alter that sphere during his generation of collectors and those following? And finally, do the patterns within the Hemphill collection refer only to the collector, or do they bear meaning for

Herbert Waide Hemphill, Jr., at home, New York City, fall 1989. Photograph by Martha Cooper, New York.

I

our contemporary understanding of American art? Sweeping questions all, they guide the thoughts that follow about what has become known as the "Hemphill thing."[3]

FROM ATLANTIC CITY TO NEW YORK CITY, 1929–49

Hemphill's childhood coincided with the Depression and the first heyday of collecting and popularizing American folk art.[4] He was born on January 21, 1929, into the prosperous family of Emma Bryan Bradley and Herbert Waide Hemphill, Sr., of Atlantic City (fig. 1). His mother had been born on family land in Lumpkin Township, Georgia (fig. 2), but had been raised in nearby Columbus by an entrepreneurial uncle, William Clark Bradley, who had made his fortune in steamships, cotton mills, agriculture, and banking. As chairman of the Coca-Cola Company for twenty-two years, Bradley catapulted the soft drink to its international fame.[5] On her mother's side, Emma was said to be related to William Jennings Bryan, the famous orator and presidential aspirant.[6] After two failed marriages, she asserted her independence and went to Atlantic City as the chaperone for Florida's entry in the Miss America pageant around 1924. There she met Herbert Waide Hemphill, Sr., whom she married in 1926. Emma's third husband was a native of New Jersey whose family favored the ministry and medicine as professions (fig. 3). He owned one of three controlling interests in the Shill Rolling Chair Company, acquired in 1907 during a previous marriage to the daughter of the company's founder.[7] Herbert, Jr., would not aspire to join the firm that his father and much older half-brother Harry ran until the late 1950s.

During the Depression, the family lived comfortably in Atlantic City's upper-class neighborhood of Chelsea. Though the senior Hemphill's business suffered, as did the various area financial institutions for which he was a prominent officer, his wife's resources allowed them to maintain their standard of living, which the younger Hemphill perceived even then as privileged. His memories of their Tiffany studio house, complete with a large stained-glass window of Romeo and Juliet, ornate Italian wallpaper, and a stuffed elk's head, are very strong. Winters in Florida, golfing at Pinehurst, and a new Cadillac for his father every year were family traditions.

Hemphill's mother was more interested in culture than his father, and it was she who introduced her son to nearby Philadelphia's resources—concerts, historical sites, the Philadelphia Museum of Art, the Franklin Institute's scientific paraphernalia, and Wanamaker's department store. Emma also loved to shop, an activity that proved infectious for her son. Together they frequented the wide range of stores along the boardwalk and elsewhere on the New Jersey shore— auction houses and shops that handled antiques and collectibles (including one whose international inventory, shrunken heads and all, greatly impressed young Hemphill at the time). His mother collected Dresden china, ormolu, and paperweights, an assortment that Hemphill recalls was expensive, though modest in number, and tastefully displayed at home. He now characterizes her pursuit as "Southern belle" or "gentlewoman's" collecting.

Encouraged to shop during their outings, Hemphill began buying objects around 1936.[8] Most of his early finds reflected his schoolboy's love of American

history, such as a Maryland canvasback duck decoy, acquired for about fifty cents (fig. 4), a centennial Boston beanpot, an 1882 pencil drawing of the Charles R. Dodge minstrel show, and tin candle molds. Mr. and Mrs. Len Alger, friends of his parents, introduced him to decorative glass objects made in southern New Jersey, especially the Glassboro area, and gave him several bottles shaped like buildings, animals, or human figures in 1939. To them Hemphill added fancy glass canes, also from Glassboro. More typically youthful treasures were baseball cards, marbles, sea shells, stamps, coins, and international dolls (including southern walnut and apple heads). Although his energetically acquisitive nature did not mature until the 1950s, these childhood forays introduced him to the pleasure of locating, owning, and organizing objects, the essence of collecting.

The Depression dramatically reduced Atlantic City's audience, but Hemphill's childhood impression of the resort was one of fun and fashion, nonetheless. The Shill Company's fleet of 2,200 elaborate wicker rolling chairs supported the time-honored custom of promenading the boardwalk, for which, Hemphill recalls, men wore coats and ties, and women white gloves and hats (fig. 5). Regularly he explored the attractions along the boardwalk and on the piers: the last of the minstrel shows, big jazz and dance bands, puppet shows, mechanical amusements, movies, the "Diving Horse," and curiosities galore. He especially enjoyed the Steel Pier, to which he had free access because of his father's standing in the business community (fig. 6). Continuing a tradition popular since the turn of the century, "sand" artists still made ephemeral monumental sculptures or traced color-enhanced drawings on the beach, which Hemphill, like many visitors and residents, found to be fascinating (fig. 7). In a similarly quixotic vein was "Lucy," the sixty-five-foot building shaped like an elephant, erected in nearby Margate in 1879 (fig. 8). No self-respecting curiosity seeker, the young Hemphill included, bypassed this larger-than-life tribute to fanciful architecture and roadside advertising. He also frequented the exhibitions of trade and professional associations held at the resort's convention center; the medical and book displays were his favorites. During one visit to the center, he and his father met Admiral Richard Byrd, the famed Antarctic explorer, who treated young Hemphill to an indoor ride on his dog sled.

Fig. 3 Herbert Waide Hemphill, Sr., Atlantic City, New Jersey, ca. 1929. Courtesy Herbert Waide Hemphill, Jr.

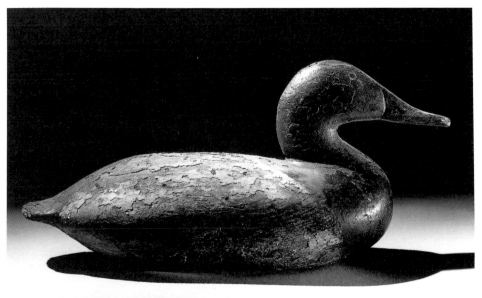

Fig. 4 *Maryland canvasback duck decoy*, acquired by Hemphill, ca. 1936. National Museum of American Art, Washington, D.C.; gift of Herbert Waide Hemphill, Jr., 1988.74.18.

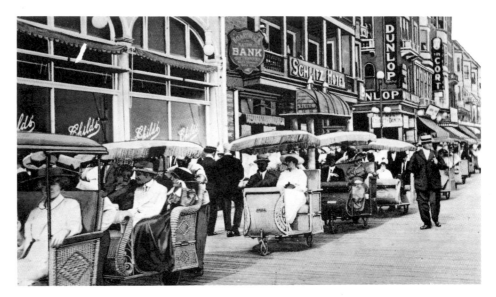

Fig. 5 Shill Company rolling chairs on the Boardwalk, Atlantic City, New Jersey, 1927. Courtesy Atlantic County Historical Society, Somers Point, New Jersey.

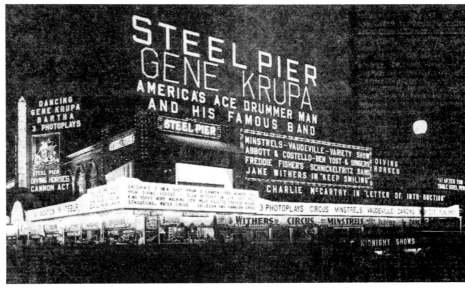

Fig. 6 Steel Pier's marquee at night, Atlantic City, New Jersey, 1930s. Courtesy Atlantic County Historical Society, Somers Point, New Jersey.

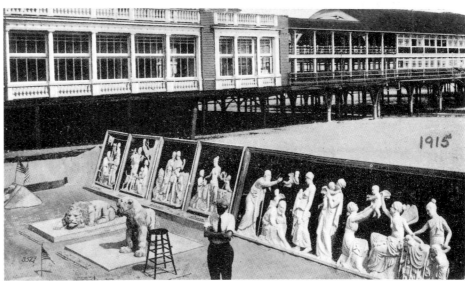

Fig. 7 Unidentified artist and his sand sculptures, near Steel Pier, Atlantic City, New Jersey, 1915. Courtesy Atlantic County Historical Society, Somers Point, New Jersey.

In its current incarnation as Las Vegas East, Atlantic City is a mere shadow of its comparatively elegant past. Since its founding in the 1850s, however, the resort has depended on the aspirations and tastes of the lower middle classes. Its promotion well into the twentieth century has included claims to a distinguished national patronage, designed to attract those who wished to emulate an upper-class lifestyle. One historian has characterized the city during its turn-of-the-century heyday as the "Newport of the Nouveaux Bourgeois."[9] Extravagant fashion, garish architecture, abundant merchandise, large crowds, cavernous hotels, spectacular entertainment—all dominated by the boardwalk's insistent advertising—this has been Atlantic City's true menu for families and pleasure seekers throughout most of its history. The senior Hemphill's business concerns clearly contributed to the resort's ambience, while his son's exposure to its offerings unwittingly laid the foundation for the young man's openness to the popular and the eccentric.

At the age of ten, Hemphill's world changed abruptly when his mother unexpectedly died. As her only child and frequent companion, he felt her loss deeply. Shortly thereafter, his father sent him to live with Margaret Dykes, his late wife's sister, in Columbus, Georgia, for approximately two years. During a Christmas visit around 1941, Hemphill's father met and eloped with Pearl Dykes, his sister-in-law's niece. Hemphill returned to the family home in Atlantic City, but his relationship with his father had already started to decline. He resumed collecting Americana on a modest scale, this time with help from the Algers, family friends, who had introduced him to New Jersey's decorative glass. (Today, examples of his early glass collection decorate a French bottle-drying rack, wired as a chandelier, in his apartment.) Strongly influenced by the resort's musical offerings, Hemphill also collected recordings that established his lifelong taste for show tunes and the jazz of New Orleans and Chicago. As a teenager, he saw many theatrical productions that came to Atlantic City on the Broadway-bound circuit, and he credits his preference for the popular theater to this steady exposure.

After completing one year at a public high school in Atlantic City, Hemphill spent three years at prestigious private schools. From 1944 to 1946 he attended the Lawrenceville School in Lawrenceville, New Jersey, and in 1947 he graduated from the Solebury School in New Hope, Pennsylvania.[10] Both schools had strong visual and performing arts programs in which Hemphill pursued classes in painting and drawing—interests developed by private art lessons that began at the age of six. At Lawrenceville, he was an associate editor of the school's literary magazine, for which he also wrote poetry and designed covers. While at Solebury, he exhibited his paintings in a local soda shop, typical of informal displays in New Hope (still an artist's colony but well past its prime as the center of a regional landscape style inspired by French Impressionism). New Hope's small town atmosphere made it easy for Hemphill to meet artists, especially at the Delaware Bookshop where he worked, and occasionally he purchased paintings and drawings by area artists.[11]

Hemphill's higher education was conducted in fragmentary fashion. After briefly attending the University of Virginia in the fall of 1947, he went to Europe, thinking that he would enroll in a Swiss university. Entrance requirements proved too stringent, however, and he traveled instead throughout Switzerland, France,

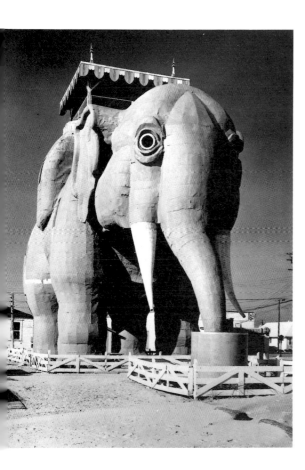

Fig. 8 *Lucy*, monumental trade sign erected for a summer home development, Margate, New Jersey, in 1881. Courtesy Atlantic County Historical Society, Somers Point, New Jersey.

and Italy for about eight months. He spent most of his time in Berne and Paris, visiting museums and historic sites with other students and young artists, many of whom were the children of wealthy Europeans who had moved their families to Switzerland during the war. Through these contacts he also visited several private Swiss art collections, including one devoted to the work of Paul Klee.[12] That opportunity and his introduction to the work of Gustav Klimt were among his strongest impressions of his first trip to Europe.

Upon his return to the United States, Hemphill enrolled in Bard College in Annandale-on-the-Hudson, New York, during the fall of 1948. Founded in 1860 as an Episcopal men's college with a strong classical curriculum, Bard was a small, progressive, coeducational institution by the late 1940s.[13] During the previous decade, the hallmarks of its philosophy had been established. It stressed independent study, modeled after Oxford's tutorial system, in hopes of encouraging a lifelong appreciation for self-education. It also emphasized the fine and performing arts in a liberal arts program. The latter feature was unique in American education at that time and was intended to foster understanding of artistic achievements within a cultural context. During the 1940s the school's faculty included the precisionist painter Stefan Hirsch who was head of its fine arts program.

When Hemphill entered Bard, he was interested primarily in art and literature but was unsure of his goals. As a painting student under Hirsch, he tried to develop an individual style. At Lawrenceville he had experimented with a meticulous Surrealism. At Solebury his efforts had leaned toward the primitive, the term then used to express the art world's understanding of non-Western art, filtered primarily through the work of Picasso as well as Robert Goldwater's landmark publication of 1938, *Primitivism in Modern Painting*. Since the early 1920s the term had also appeared regularly in the literature on American craftspeople and self-taught artists and had figured in two influential books published in 1942: Sidney Janis's *They Taught Themselves: American Primitive Painters of the 20th Century*, and Jean Lipman's *American Primitive Painting*. The extent to which Janis's and Lipman's books influenced Hemphill would not become evident until later, however, and his passing artistic experimentation with the primitive instead reflected Cubism's impact. While at Bard, Hemphill's efforts included forays into the expressionistic and what he called the "faux naive" as well as stylized abstractions. Rather than resolving his search for an individual style, he decided to abandon painting, believing that he lacked the necessary dedication and that his talents favored the "chic and mannered."

Today, it is difficult for Hemphill to explain what he means by "faux naive." It is equally difficult to assess the influence exerted by his teacher, Stefan Hirsch. During the late teens Hirsch was among the artists who had summered at the artists' colony of Hamilton Easter Field in Ogunquit, Maine, and had subsequently caught Field's enthusiasm for collecting early American objects and paintings. After 1926 Hirsch exhibited at Edith Halpert's Downtown Gallery, the first important commercial crossroad for America's modern and folk art. He was also among the lenders to Holger Cahill's landmark "American Primitives: An Exhibition of Nineteenth-Century Folk Artists," organized for the Newark Museum in 1931. Although Hemphill saw some of Hirsch's collection at Bard, his teacher's impact remains unclear.[14]

Because Bard's program of independent study required fieldwork, Hemphill spent a month working in the slide library of the Philadelphia Museum of Art during the winter of 1948–49 and again during the summer of 1949. Access to the museum's resources was an education itself. Staff members introduced him to private collections in the area, most notably Jean Lee's exceptional Oriental holdings and Titus C. Geesey's collection of Pennsylvania German material, subsequently donated to the Philadelphia Museum in 1953.[15] He did not visit Dr. Albert Barnes's hermetic collection of modern art in nearby Merion, but eavesdropped on an impromptu lecture delivered by Barnes in one of the Philadelphia Museum's galleries. He also visited the gallery of Robert Carlen, since 1939 the principal source for the paintings of Horace Pippin, a self-taught African-American artist from nearby West Chester, who had been discovered in 1937. Hemphill recalls seeing Pippin's work at Carlen's gallery and home, but at the time Hemphill was collecting visual information more than anything else while also acquiring his first taste of working in a museum.

Although his stay at Bard was short-lived, it provided Hemphill's first contact with New York's art scene. He visited the city as often as he could with his art teachers, especially the sculpture instructor Glen Chamberlain, and friends like the wealthy, fledgling writer James Merrill, who introduced him to Greenwich Village. The hub of the country's cultural rebellion since the teens, the Village still gathered artists, writers, and performers in studios, restaurants, and bars. Once exposed to this atmosphere, Hemphill quickly lost interest in college. He left Bard during the winter of 1949 and moved into an apartment on New York's lower East Side.

THE COLLECTOR EMERGES, 1950–61

Free of financial concerns when he arrived in Manhattan, Hemphill began establishing a coterie of friends, exploring shops, galleries, and museums, and attending the theater and clubs. He also began building the nucleus of an art collection, and by 1961 he owned more than two hundred works, distributed among modern European and American art, non-Western art (especially African), American folk art, miscellaneous jewelry and accessories by Fabergé, theatrical designs, and some contemporary efforts by friends.[16] The range of his acquisitions is deceptive, however, since at least half of the collection was devoted to American folk art. By 1961 his reputation as a collector of folk art earned him an invitation to help establish the Museum of Early American Folk Arts in New York. After eleven years Hemphill had not only found the focus for his acquisitiveness, but he had also joined the inner ranks of those involved with promoting and collecting folk art. He arrived at that point intuitively, rather than deliberately, during a period that produced an influential generation of American collectors.

By his own description, Hemphill was a "reactionary." Favoring the past when he started decorating his new apartment, Hemphill's perception of the past was modern nonetheless, for he began collecting late nineteenth- and early twentieth-century modern art by both Europeans and Americans. Though his financial resources freed him from working, they did not provide an extravagant budget for acquisitions, and so he purchased modestly priced works on paper by noted figures.

Fig. 9 George Luks, *Celebrating Completion of the Third Avenue El*, ca. 1905, watercolor and ink on paper, 19¼ x 31¼ in. The Columbus Museum, Columbus, Georgia; gift of Herbert Waide Hemphill, Jr., 68.250.

Among the European efforts were an undated pencil drawing of a woman by Sir Edward Burne-Jones; an undated watercolor of a mother, child, and boat by Maurice Denis; a 1914 cubistic ink drawing of a head by Albert Gleizes; a 1919 watercolor of a landscape with a house and figures by Ernst Kirchner; and a 1922 charcoal portrait of Baudelaire by Jacques Villon. Later examples were a 1948 collage in blue, white, beige, and black by Jean Arp; and a 1948 watercolor of a nymph and fauns done by Picasso in Antibes. Among his sources for European works was the Curt Valentin Gallery. This key gallery of the period offered a large and excellent stock that reflected its owner's breadth of taste: Picasso, Juan Gris, Henry Moore, Paul Klee, Alexander Calder, and the German Expressionists.

American works in the early collection included a group of undated examples: an oil of two female nudes in a landscape by Louis Eilshemius; a watercolor of a man in a top hat by Elie Nadelman; a pastel of a nude by Arthur B. Davies; a blue crayon drawing of a male head by Joseph Stella, and the watercolor, *Celebrating Completion of the Third Avenue El,* by George Luks (fig. 9). He also owned a pencil drawing, circa 1910, of Molly Pitcher by Everett Shinn; a pencil drawing of a seated girl in high-buttoned shoes by John Sloan, also dated about 1910; a 1917 watercolor of a man in a William Morris chair by Stuart Davis; and a 1921 pencil-and-wash drawing of a nude by Childe Hassam.

Hemphill found many of the American works with the help of an emerging generation of young art dealers who offered a potpourri before later moving on to a more specialized inventory. One of his regular sources was LeRoy Davis, who opened the Davis Gallery on East Sixtieth Street in 1953.[17] There, Davis promoted contemporary realist painters such as David Levine, contemporary pottery, bits and pieces of antiques, and late nineteenth- and early twentieth-century American fine art. Hemphill also used the gallery's framing services, provided by Robert Kulick, one of Davis's schoolmates from the Tyler School of Art, who was then developing his reputation as a frame designer in New York.

By 1954 Hemphill was also acquiring intimately scaled sculptural artifacts from other cultures. During his student days in Paris, he had purchased minor

antiquities such as a Greek terra-cotta head. To them he now added a small group of African figurative carvings, relief sculptures, masks and amulets; Eskimo carvings (fig. 10); several Nayarit figurines in clay and faïence; Mexican (sometimes Mayan) stone carvings and masks; and Peruvian clay vessels. Miscellaneous acquisitions included a fertility figure from New Guinea; a Luristan (Persian) bronze, circa 600 B.C.; a terra-cotta Egyptian mask of the Eighteenth Dynasty; and a Coptic tapestry fragment. Looking for such objects led Hemphill to the small, crowded Third Avenue shop of Julius Carlebach, then a widely respected dealer in museum-quality antique jewelry and international ethnographic material, especially from Africa.[18]

Contemporary American art did not figure into Hemphill's varied international inventory. This, more than any other factor, is the reason he called himself a reactionary. By 1950, when he began exploring the city in earnest, New York had established itself as the center of the international art world. European artists, fleeing Hitler, brought to New York tremendous energy and ideas that had formerly made Paris the artistic Mecca. Marcel Duchamp, Max Ernst, Piet Mondrian, and Arshile Gorky, among these expatriates, stimulated a generation of young American painters and sculptors eager to move beyond the Regionalist and Social Realist styles that had dominated American painting during the 1930s. Migrating to New York from all parts of the country, painters such as Jackson Pollock and Franz Kline began charting the bold new vision of Abstract Expressionism.

Conversant with modern art and attuned to the city, Hemphill might have been expected to number among the early fans of this avant-garde development. His curiosity drew him, like others, to Dorothy Miller's groundbreaking exhibitions of the New York School at the Museum of Modern Art. And he visited the key contemporary art dealers uptown—Charles Egan, Eleanor Ward, Betty Parsons, Virginia Zabriskie, and Leo Castelli, for example. But collecting works by Jackson Pollock or David Smith, or those of emerging figures such as Robert Rauschenberg, simply did not appeal to him.

On one level, his response to the new art around 1950 is a barometer of his time. Since the turn of the century, the American public had been skeptical of daring artistic experiments and was essentially uninterested in the nation's efforts to develop an individualistic art. Moreover, an active community of American collectors, whatever their stylistic preference, simply did not exist in 1950 despite the ambitiously sustained example of the Rockefeller family or "the little man in a big hurry," Joseph Hirshhorn.[19] Although the American art world would revolve around the imperative of abstraction well into the 1970s, few collectors during the early fifties followed the lead of the handful of dealers, curators, and critics who recognized the avant-garde efforts of the New York School as an emerging force in American culture.

Clearly, Hemphill's taste ran instead to stylized yet essentially figurative variations of a modern art already validated by dealers and collectors active after 1900 and well into the 1920s. One need only call to mind the pioneering efforts of Alfred Stieglitz, Charles Daniel, Joseph Brummer, and the young Edith Gregor Halpert as dealers in New York. John Quinn, Gertrude Vanderbilt Whitney, and Walter Arensberg all in New York; Duncan Phillips in Washington, D.C.; Dr. Albert C. Barnes in Merion, Pennsylvania; and the sisters Etta and

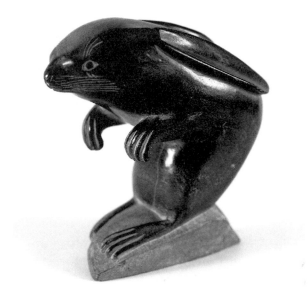

Fig. 10 Unidentified Artist (Canadian, Eskimo), *Rabbit*, date unknown, carved steatite, 6 x 6½ x 3¼ in. The Columbus Museum, Columbus, Georgia; gift of Herbert Waide Hemphill, Jr., 71.69.

Claribel Cone in Baltimore were among the period's adventuresome collectors. Through their efforts, as well as that of the revolutionary Armory Show in 1913, European artists as diverse as Redon, Cézanne, Matisse, Picasso, Duchamp, and Brancusi, and Americans such as Walter Kuhn, Georgia O'Keeffe, Charles Demuth, and Arthur Dove enjoyed their initial patronage in this country.

Just a year later, in 1914, Alfred Stieglitz became the first American to place African art in an aesthetic setting at his Fifth Avenue gallery, 291. By mingling non-Western and modern works from the collection of the Mexican caricaturist and collector Marius de Zayas, Stieglitz introduced the trend of looking at African and Oceanic masks that Picasso, Matisse, Maurice de Vlaminck, and André Derain had already instigated in Paris in 1906.[20] De Zayas subsequently exhibited African art at his gallery on Fifth Avenue in November 1919. Later he coupled Picasso paintings from 1919 to 1923 with African masks at the Whitney Studio Club on Eighth Street in May 1923. By December of the same year the Brooklyn Museum presented the first major exhibition of African art in an American art museum. Collectors and dealers involved with modern art have regularly followed suit, especially since the mid 1930s when Nelson Rockefeller made collecting the modern and the tribal fashionable.

Hemphill's first acquisitions also reflect an inherently tumultuous dichotomy among early twentieth-century American artists. Some, like John Marin and Charles Sheeler, began exploring the power of abstraction, stimulated by the example of European innovations. Others, like John Sloan and George Luks, took a narrative, image-oriented approach to shaping an American art, in much the same manner that their literary contemporaries—poets Ezra Pound, T. S. Eliot, and H. D. (Hilda Doolittle), who were dubbed "Imagists,"—favored clear yet subjective language. Hemphill tapped into both strains, perhaps because of his own fluctuations between them as he tried to develop a personal style as a painter. He did not juxtapose realism and abstraction deliberately as he began collecting, and today he has no retrospective explanation for this clear dichotomy in his collection. He only observes that he bought what he could afford. While that is true, his artistic sensibility influenced even his early choices. One wonders, for example, if his decision to stop painting—just as Abstract Expressionism hit its stride publicly—checked any attraction to the avant-garde and instead reinforced his interest in styles he had explored as a student.

Moreover, Hemphill's coterie of new and old friends did not focus on the contemporary art scene and its impassioned intellectual currents. For the first time since the 1920s, New York witnessed a free-wheeling avant-garde intent upon staking out a unique, indigenous American culture. At the Eighth Street Club and Cedar Bar, in Village studios and apartments, and in other artists' haunts from East Hampton to Provincetown, the often volatile discussions about art and culture took place well into the mid 1950s. Hemphill met some of the emerging figures central to this debate—young poets like Frank O'Hara—through the writer James Merrill, his old friend from Bard, and attended parties given by artists such as the gregarious painter and jazz musician Larry Rivers. But the issues of New York's emerging avant-garde were not Hemphill's, and his observation that "we all knew one another vaguely" captures his involvement with the period's principals.

By 1952 his social circuit instead included a wide range of contacts in the

theatrical, decorating, publishing, and fashion worlds. With his friend Neal Prince, Hemphill regularly attended Broadway productions and the era's chic cabarets and clubs such as the Copa Cabana, Upstairs at the Downstairs, and Basin Street until the late 1960s. Prince had come to New York from Corsicana, Texas, during the late 1940s, in hopes of becoming a playwright and director, and was active at Lee Strasberg's Actor's Studio for approximately five years. He supported himself as an architect, and by 1960 he was the vice-president of interior and graphic design for Intercontinental Hotels. Between 1950 and 1952, Hemphill and Prince shared a brownstone on East Sixty-fifth Street with Katherine Anne Porter, who was then slowly writing *Ship of Fools*. Hemphill and Prince enjoyed rubbing elbows with the likes of Noel Coward who gathered in the garden to listen to Porter read aloud from her work. The two men proved to be formidable party-goers and givers themselves, and at their salon-style gatherings on Saturday nights one could have met Paul Lynde, Eartha Kitt, Paul Newman, Leonard Sillman the Broadway producer, Jerome Robbins, or Carrie Donovan, then an editor for *Vogue*.[21]

Decorating his living space had reawakened Hemphill's youthful interest in collecting. He describes his tiny apartment on lower Second Avenue as "very moderne"—sparsely appointed with his first cubist works and a few good pieces of streamlined contemporary wood furniture by Charles Eames. After 1950, however, he lived in uptown brownstone apartments where older furniture styles seemed more appropriate. He readily found an eclectic mix of what he liked and could afford—a late Victorian horned chair, Thonet bentwood chairs, a dining room set from a Mississippi riverboat, a Windsor bench—during his forays along Second and Third avenues, where he discovered a wealth of resources not unlike those he had explored as a child in Atlantic City and Philadelphia.

New York's varied neighborhoods have traditionally been defined by ethnic communities and commercial concerns. Since the 1930s, for example, anyone interested in "things" regularly toured the shops handling antiques, accessories, and secondhand goods as well as some small print and picture galleries that scatter the length of Second and Third avenues and the numbered streets between them (fig. 11). In Hemphill's first years in New York, most of these businesses were concentrated between East Fiftieth and Seventieth streets, although similar enterprises also clustered in the upper "80s" and in Greenwich Village. The contents of households, lost during the Depression, often found their way into stores that sprang up to accommodate such merchandise, while the economic prosperity of the postwar years had kindled a new wave of consumerism. Photographers and artists in search of props and raw materials, interior decorators, and economy-minded collectors were the principal clientele of this small, intimate marketplace, then still in the shadow of the Third Avenue El.

Where would a typical rummaging through the area have taken someone like Hemphill during the 1950s, and what could he have seen or acquired? A brief survey suggests that the area's staggering resources are well worth study as an influential cultural smorgasbord.[22]

On Third Avenue near East Fifty-fifth Street, Helena Penrose maintained a two-story shop considered to be without peer as a source for Americana.[23] In her cavernous basement, trade signs, carousel figures, cigar store Indians, decoys, weathervanes, antique toys, and country furniture fought for the browser's

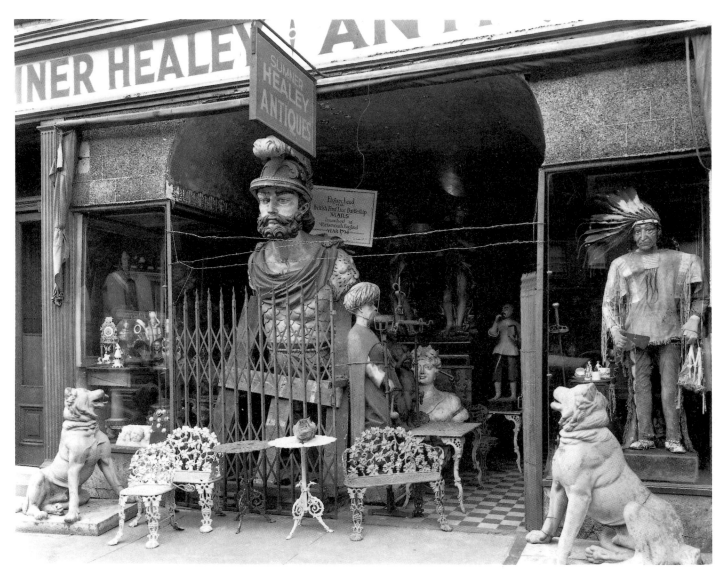

Fig. 11 Sumner Healey Antiques, Third Avenue, New York, 1936. Photograph by Berenice Abbott. Courtesy Museum of the City of New York.

attention. The shop also included several small rooms paneled in various woods and arranged as domestic period settings for even more Americana. Penrose presided over her establishment in chiffon gowns or daringly short skirts under a monkey-fur cape—a colorful figure to her customers and the country "pickers" who supplied her merchandise. Hemphill visited Penrose regularly but seems not to have acquired anything from her shop until he bought a late eighteenth-century portrait included in the auction of her inventory at Parke-Bernet in 1960.[23]

Although folk art collectors, including Hemphill, spent more time browsing at Harry Shaw Newman's Old Print Shop on East Thirtieth Street, Rodman's Prints on Third Avenue became a mecca for those interested in works on paper, especially a generation of enterprising print curators building collections for American museums.

At his gallery on East Sixtieth Street between Second and Third avenues, LeRoy Davis began helping New Yorker Joan Patterson assemble a collection of paintings by the American Impressionists John Twachtman and J. Alden Weir, and by the Ash Can School painters, John Sloan, William Glackens, and Maurice Prendergast, all unappreciated and undervalued during the late 1950s. In addition

to works from the Ash Can School, Hemphill bought from Davis a painted wood footstool shaped like a turtle for twenty-five dollars (fig. 12), small American figurative carvings, and one of his first examples of mid nineteenth-century calligraphic drawings.

Just across the street from Davis's gallery was the shop of Frederick-Thomas Associates, patronized by many decorators in search of provincial European and American furniture and objects, as well as early American paintings as accessories for their clients. An anonymous painted carving of a Dalmatian, a wood chair assembled, stained, and inlaid to resemble a banjo (cat. 25), and some of Hemphill's first wooden weathervanes were among his finds there.

Many at the time considered George M. Juergens's small store, on Third Avenue between East Sixty-fourth and Sixty-fifth streets, a private museum of sorts. Here, Hemphill found such things as a boot-shaped Iroquois beaded whimsy (cat. 118), a Masonic paper cutout of Faith, Hope, and Charity in an elaborately carved frame (cat. 135), a miniature model of a mine complete with coal, and a kangaroo thighbone incised with scrimshaw and rumored to be the powder horn of an American sailor.

Nearby was George Gary's shop that stocked, among other things, European and American furniture as well as stacks of inexpensively priced paintings by then forgotten nineteenth-century American artists such as Martin Johnson Heade, Jasper Cropsey, and William Merritt Chase. It was here, for example, that Hemphill's friend Lee Anderson began collecting Belter and American Gothic furniture and nineteenth-century American painting, especially Hudson River landscapes, on a school teacher's salary during the early 1950s.

On Second Avenue near East Fifty-second Street, Martin Grossman offered nineteenth-century French bentwood furniture and Americana, a combination greatly admired by his patron and collector Walter P. Chrysler, Jr. Grossman was brother-in-law to the modern art dealer Sidney Janis who also championed twentieth-century self-taught artists such as Morris Hirshfield. From Grossman came many of Hemphill's early finds—mourning pictures, theorems, portraits, Frakturs, New Mexican *retablos*, Victorian architectural renderings, and the exceptional painting, *Stag at Echo Rock* (cat. 72 and cat. 167).

Coleman's Auctioneers on East Fifty-ninth Street between Second and Third avenues handled everything from the kitsch to the precious, as did a string of thrift shops, lesser antique stores, and junk stores located on Second Avenue,

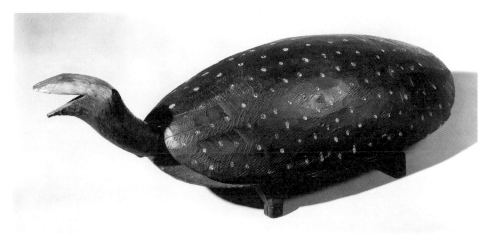

Fig. 12 Unidentified Artist, *Turtle*, carved and painted wood, nineteenth century, 7¼ x 20⅜ x 7⅝ in. Museum of American Folk Art, New York; gift of Herbert Waide Hemphill, Jr., in the name of Neil Adair Prince, 1964.1.2.

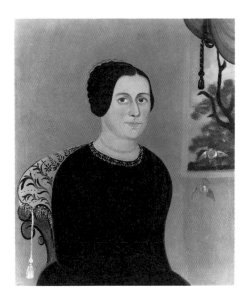
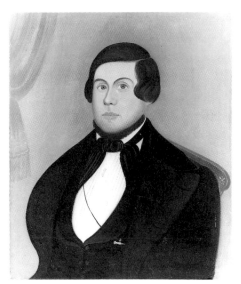

Fig. 13 Attributed to Prior-Hamblen School, *Portrait of a Woman*, ca. 1850, oil on canvas, 27¼ x 22¼ in. National Museum of American Art, Washington, D.C.; gift of Herbert Waide Hemphill, Jr., and museum purchase made possible by Ralph Cross Johnson, 1986.65.134.

Fig. 14 Attributed to Prior-Hamblen School, *Portrait of a Man*, ca. 1850, oil on canvas, 27¼ x 22¼ in. National Museum of American Art, Washington, D.C.; gift of Herbert Waide Hemphill, Jr., and museum purchase made possible by Ralph Cross Johnson, 1986.65.133.

where rents were much cheaper. The solemn painted commentary, *King Capital forbits the rising tight [of the poor]*, surfaced in a "funky junk and antique store" (cat. 85). From similar anonymous sources on Second Avenue came Hemphill's model of an airplane (cat. 62), a pair of portraits later attributed to the Prior Hamblen School, (figs. 13 and 14) and a carved tableau of a Catholic funeral procession (fig. 15).

In this milieu of antiques, inexpensive curios, and forgotten treasures, Hemphill rediscovered his childhood interest in Americana. By the mid 1950s his acquisitions fluctuated between the modern and the folk, but by 1961 the patterns and inclinations that still determine his approach to collecting folk art had clearly emerged.

Hemphill's self-imposed description of himself as a "reactionary" comes to mind again when one realizes that his first inclination was to buy nineteenth-century examples that reflected the standards of an earlier generation of folk art promoters and collectors. Although not yet widely read in the field, he had discovered Jean Lipman's books, *American Primitive Painting* (1942) and *American Folk Art in Wood, Metal and Stone* (1948), shortly after their publication.[24] Together, they codified a conservative evaluation of folk art objects as sensitive, highly aesthetic expressions produced by early Americans who fell into two

Fig. 15 Unidentified Artist, *Catholic Funeral Procession*, possibly Vermont, ca. 1910, carved wood, leather, metal, and bone. Abby Aldrich Rockefeller Folk Art Center, Williamsburg, Va., 80.701.3. Formerly part of the collection of Herbert Waide Hemphill, Jr.

camps: anonymous men and women working in and for their communities, and craftspeople or amateurs whose documented names or idiosyncratic examples marked them as individuals.

Lipman's two books also provided rich visual surveys of genres and exemplars of folk art from the eighteenth and nineteenth centuries. Leafing through them quickly establishes the criteria used by Lipman, a collector of both folk art and contemporary sculpture since the 1930s. She was drawn to folk objects that emphasized simplified stylization, surface pattern and design, multiple perspectives, and bold, flat areas of color. These characteristics had attracted twentieth-century artists and collectors before her. Charles Sheeler, for example, responded to the hard-edged precision of Shaker furniture, although it is difficult to claim a direct stylistic influence on his work. And by 1931, Abby Aldrich Rockefeller was collecting folk art, in part because of its formal parallels with the modern art she acquired privately and for the Museum of Modern Art.

What Lipman set in print was the culmination of a generation's perception of folk art, and Hemphill easily recognized the connection between its aesthetic and his approach to collecting modern and non-Western art. He has repeatedly credited Lipman's publications as one of his earliest influences, but even Hemphill perhaps does not realize that Lipman's books also provided him with a subliminal, if not intentional, checklist of desirable acquisitions. Thus, when portraits such as *Man in a Yellow Chair* (cat. 70), or Elizabeth Capron's theorem on velvet (cat. 129) came to his attention, Hemphill quickly bought them because they matched Lipman's aesthetic standards.

In 1956, something else, however, was afoot when Hemphill purchased a pair of robust carved wood figures at Parke-Bernet's auction of Rudolf Haffenreffer's collection of cigar store Indians and other American trade signs (figs. 16 and 17).[25] Already a regular visitor to New York's auction houses, he had spotted the sculpture described as a "primitive Warrior with Spear" in the catalogue for part one of the auction. Its monochromatic appearance and rough-hewn shapes

Fig. 16 Hemphill and Susan Reed, antique dealer and folk musician, with *Indian Trapper* outside Parke-Bernet Galleries, New York, 11 April 1956, the day Hemphill purchased the figure at the Haffenreffer auction. Photograph © by Ken Heyman, New York.

differed considerably from the garish coloration and conventionalized forms of trade-sign figures then in vogue among collectors and dealers. Far less expensive as a result, the male Indian figure suited his budgetary constraints while allowing him to add the first large trade-store figure to his collection. He acquired a female Indian figure believed to be by the same hand at the second auction of the Haffenreffer collection later that year. Together, they formed an exotic approximation of, and yet a curious departure from, the trade-sign tradition. Ironically, the pair had been offered to Edith Gregor Halpert by A. Starnworth of the Boston Antique Shop in Massachusetts for $250.00 in 1933, but whether the ordinarily sharp-eyed Halpert availed herself of the opportunity is unknown (fig. 18).[26] The figures' powerful statement went unappreciated publicly until the 1970s; in the meantime, they initiated Hemphill's reputation for being interested in offbeat nineteenth-century objects overlooked by others.

One other work acquired by 1961—the painting, *Stag at Echo Rock*—confirmed that Hemphill was developing an independent approach to the folk art of the previous century (cat. 167). Martin Grossman had offered the work to the Abby Aldrich Rockefeller Folk Art Center in Williamsburg shortly after it opened in 1957. The Center's acquisition committee ultimately decided that the painting was probably executed after 1850 and, therefore, too late an example for their collection. The Rockefeller Center's concern with dating reflects a belief introduced in the 1880s and entrenched since the early 1920s. "Genuine" folk art had to be a product of the frontier mentality or of an idyllically quaint domesticity that could not exist once industralization and mass production became established. Hemphill did not care about the dating of *Stag at Echo Rock*. Its complex composition, centered around the animal's iconic silhouette, fascinated him, and in one stroke he boldly sailed past any sense of time constraints. For Hemphill, great folk art was not necessarily "antique." Today, the Center's former director,

Fig. 17 Cigar store Indians and other trade signs from the Haffenreffer collection at Parke-Bernet Galleries, New York, before their auction on 10 October 1956. *Indian Squaw* at far left. Photograph by Taylor and Dull, New York.

Fig. 18 *Indian Trapper* and *Indian Squaw* in photograph sent by A. Starnforth, Boston, to Edith Gregor Halpert, New York, 1933. Courtesy Downtown Gallery Papers, Archives of American Art, Smithsonian Institution, Washington, D.C.

Mary Black, and subsequent staff acknowledge that the painting was "a fish that got away."[27]

Moving into the twentieth century—forbidden territory for folk art collectors well into the 1960s—was a natural progression for Hemphill. No doubt it occurred unintentionally as he encountered offbeat objects that appealed to his eye or fed his growing, acquisitive appetites. Some of his first twentieth-century additions, found in the shops along Second and Third avenues, recall genres or the look of the previous century. The compact carving of a woman with a tambourine, made by Ed Davis in 1931 (fig. 19), resembles the earlier carving tradition, to the extent that its shapes uncannily echo those assimilated by the modernist emigré sculptor Elie Nadelman from his collection of American folk carvings acquired since the 1920s.

Hemphill, however, also began finding early twentieth-century paintings and sculptures that expanded his penchant for the different or problematic. Probably the two best examples are an anonymous carving apocryphally known as the *Baron Samedi* and E. Stearns' 1931 painting *King Capital forbits the rising tight [of the poor.]*

No longer confortably called *Baron Samedi,* the standing articulated figure came to Hemphill from Charles (Elmo) Avet, an antique dealer with shops in New Orleans and on Third Avenue in New York (cat. 97). The piece has a romantic and still questionable history that revolves around being found in an African-American's barber shop in the French Quarter during the 1950s. Then said to show traces of blood and chicken feathers, the figure was considered a 1920s ritualistic representation of the voodoo god of the graveyard, Baron Samedi. The carving's intent, dating, and ethnic connection may never be resolved, although recent scientific analysis has at least confirmed its geographic origin in the United States.[28] The point, however, is that Hemphill embraced this riveting,

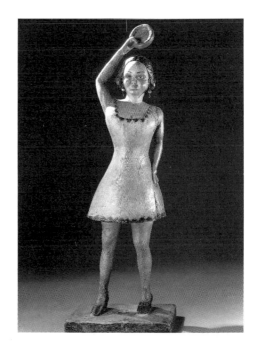

Fig. 19 Ed Davis, *Woman with Tambourine*, 1935, carved and painted wood, 17 x 5⅞ x 3⅜ in. National Museum of American Art, Washington, D.C.; gift of Herbert Waide Hemphill, Jr., and museum purchase made possible by Ralph Cross Johnson, 1986.65.240.

articulated figure not only because of its exoticism, but because its presence resembled that of the non-Western objects he had always admired.

The dark social commentary of Stearns' Depression-era painting is another matter (cat. 85). One wonders, for example, to what extent Hemphill's teenage reading of Sidney Janis's 1942 book, *They Taught Themselves,* influenced his receptivity to the work.[29] Janis had featured thirty American men and women actively painting after 1900, but mostly during the 1930s. Until Hemphill's publication on twentieth-century American self-taught artists appeared in 1974, Janis's book was the principal reference for such paintings executed before 1945. Although the dealer's publication was not the first indication that contemporary efforts existed, it was Hemphill's comprehensive introduction to them. Hemphill did not yet know about the pioneering efforts of Max Weber, who arranged for the first American showing of the magical canvases of his French friend Henri Rousseau at Alfred Stieglitz's gallery 291 in 1910. Rousseau had already been toasted by Gauguin, Picasso, Brancusi, and Guillaume Apollinaire in Paris while they were synthesizing the forms, if not the values, of tribal art. Nor was Hemphill yet aware of Holger Cahill's exhibition and publication, *Masters of Popular Painting: Modern Primitives of Europe and America,* presented by the Museum of Modern Art in 1938. Alive and well, albeit different, was the thrust of Cahill's perception of works by the contemporary "common man."[30]

Artists, dealers, collectors, and some curators in the modern art world, both European and American, had little difficulty in attaching aesthetic quality to the works of early twentieth-century self-taught artists. Few, however, considered it folk art. Although Hemphill has spent little time arguing the cultural underpinnings of what is and is not folk art, he effectively muddied the waters when twentieth-century examples began filtering into his collection.

Coming across Stearns' painting, *King Capital forbits the rising tight [of the poor],* Hemphill may have felt that he had discovered another artist in the spirit of Janis's roster without having to pay the mounting prices already accruing to works by Horace Pippin, John Kane, or Morris Hirshfield, which he could not afford. Unknown beyond this single example, Stearns could have been a trained artist employed by the federal arts projects and then relegated to the anonymity that plagued many participants whose works were subsequently scattered or lost. One could also speculate that Stearns was among the small company of untrained artists helped by these projects; sculptor William Edmondson, painter Lawrence Lebduska, and illustrator Perkins Harnly come to mind. Who Stearns was, and whether he was self-taught or not, did not concern Hemphill; he acquired the painting in the spirit of open-mindedness fostered in part by the example of Janis.

Two other aspects of Hemphill's early collection bear mention, although they did not fully flower until the 1970s. Occasionally, Hemphill added examples that once again tampered with this neatly packaged field. From several different sources in New York he acquired objects such as a Mickey Mouse kachina (cat. 120), a beaded Iroquois whimsy (cat. 118), a New Mexican *santo* of the Virgin Mary, and "grotesque" jugs (possibly face jugs from the South or Ohio).[31] Their character and low prices may have attracted him, but it is also possible that their ethnographic or craft origins once again struck a chord because of his non-Western holdings. Whatever Hemphill's reason, these works did not figure into

the mentality of those collecting in the accepted genres of folk art such as early portraits.

Hemphill's willingness to escape the East Coast as the principal territory for nineteenth-century folk art also distinguishes his collecting habits even during the 1950s. The jewel-like portrait, *Sun River, Montana* (bought for a "song" at Knoedler's), or the gilded carving of an eagle, once believed to have been made in Texas before its independence from Mexico (cat. 80 and cat. 82), indicates that his search was taking him into mostly uncharted territory.

At the time, these patterns were not evident to Hemphill or to others in the small, amorphous folk art world. What was noticed, however, was his rapidly growing collection and his willingness to experiment, and those qualities facilitated his access to dealers and merchants. In the shops along Second and Third avenues or on Greenwich Street in the Village, objects were set aside for his consideration, although sometimes because "only Bert would buy this crazy or offbeat thing."[32] Not yet openly articulated, the concept of a "Hemphill thing" or a "Bert thing" was in the air.

Quickly, his rounds grew to include not only auctions of odd lots at Parke-Bernet and the antique shows regularly held at New York's armories since the 1940s, but also occasional trips to antique stores and flea markets in New York, Connecticut, New Jersey, and Pennsylvania. Since the early part of the century, collectors and dealers had picked their way through the Northeast looking for folk art, and Hemphill now joined that lineage. One of the key routes after 1940 was north of the George Washington Bridge along highway 9W, where almost a dozen antique stores clustered near the auction house Yonder Hill Dwellers in Palisades, New York. In the minds of some, its auctioneer Tippi O'Neil has helped furnish the Metropolitan Museum's American wing through his sales of Hudson River Valley material to New York dealers and collectors.[33]

The annual antique shows at the Thirty-fourth Street Armory and, after 1954, the prestigious Winter Antiques Show at the Seventh Regiment Armory attracted a wide range of out-of-town dealers, especially from New England.[34] John Bihler and Henry Coger, then among the most prominent dealers in the East, regularly brought selections from their inventory in Ashley Falls, Massachusetts. From Tolland, Massachusetts, came the firm of Good and Hutchinson; from Boston, Marika; from Connecticut, Russell Carrell; from Pennsylvania, Herb Schiffer; and from upstate New York, Celeste and Ed Koster, specialists in Shaker materials. These highly regarded dealers offered an excellent range of Americana and folk art, two terms then used almost interchangeably to encompass paintings—especially early portraits—furniture, textiles, three-dimensional objects such as whirligigs and weathervanes, glass, and pottery embellished with *intaglio*. Looking back on the period in which he was a young dealer in Greenwich Village, Robert Bishop has observed that "although there were just a handful of people here in New York City, the antique shows inevitably brought major dealers with good folk art. So there was a market place here even though it was transitory."[35]

The provenance of Hemphill's acquisitions before 1961 includes several of these out-of-town dealers, especially Bihler and Coger, and Good and Hutchinson. Ironically, he did very little business with Edith Gregor Halpert, the *grand dame* who began showing early American folk art at her Greenwich Village gallery in 1929. Although he regularly visited Halpert's later gallery on East Fifty-first

Street to browse and talk, Hemphill could not afford her prices.[36] His most fruitful associations with folk art dealers of the period were forged instead with Mary Allis, based in Fairfield, Connecticut, and Adele Earnest and Cordelia Hamilton, partners in Stony Point, New York.

A tireless dealer since the late 1920s, Allis negotiated Stephen C. Clark's two influential folk art acquisitions for the New York State Historical Association's Fenimore House in Cooperstown—Howard and Jean Lipman's collection, especially strong in wood carvings, in 1950; and 175 works, primarily portraits, from Mrs. William J. Gunn's six hundred nineteenth-century paintings, in 1958.[37] Allis also helped to found the American Museum in Bath, England. She was probably the first to spread the word that Hemphill was an up-and-coming collector, eager to learn, acquire, and share. It was she, for example, who urged her protégé Mary Black, at the Rockefeller Folk Art Center, to see Hemphill's already legendary collection in 1958.[38] By 1961, Hemphill was a regular visitor to Allis's Connecticut home, and she began introducing him to other collectors and resources.

Around 1927, Adele Earnest and her husband Joel started collecting folk art while living in Pennsylvania.[39] Their early preference was the Pennsylvania German material of their ancestry; Adele's lifelong passion became sculptural objects, especially weathervanes, decoys, and carvings found throughout New England. Relocating to rural Stony Point, New York, by 1942, she and her neighbor Cordelia Hamilton opened a folk art gallery in a barn on Earnest's property (fig. 20). From antique shows, and their exhibitions at Marian Willard's modern art gallery in New York, the two women developed a far-ranging clientele whose legacy has been felt most directly at the Museum of American Folk Art in New York. Like other dealers, Earnest and Hamilton also recognized the potential of Hemphill's youthful energy and adventuresome inclinations, qualities

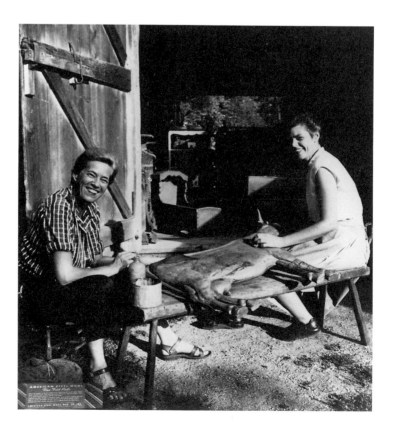

Fig. 20 Cordelia Hamilton (left) and Adele Earnest (right), Stony Point, New York, after 1943. Courtesy Adele Earnest, Stony Point, New York.

that prompted them in 1961 to invite him to help establish a folk art museum in Manhattan.

It is significant that Hemphill joined this effort through his contacts with dealers, since his association with other folk art collectors was still quite limited at this point. By the time he became involved with American folk art, major private collections had been growing since 1911 when Eliza Greene Metcalf Radeke began acquiring Pennsylvania German pottery, and key private holdings became publicly accessible after 1924 when sculptor Elie Nadelman built a museum for his collection on his estate in Riverdale-on-Hudson, New York.[40] Electra Havemeyer Webb in Shelburne, Vermont; Maxim and Martha Karolik in Boston; Bertram and Nina Fletcher Little in Essex County, Massachusetts; Edgar William and Bernice Chrysler Garbisch near Cambridge, Maryland; Howard and Jean Lipman in Cannondale, Connecticut—all crucial members of the first and second generations of folk art collectors—were active during the 1950s. One by one, most of these collectors founded museums for their holdings or provided for major expansions in the permanent holdings of already existing museums. Hemphill's path, however, did not cross theirs, and their geographically distant activities were known to him primarily through coverage in the period's publications, especially *Antiques* magazine.[41]

Abby Aldrich Rockefeller's collection was the only major private effort from the first wave of collectors that Hemphill learned from firsthand. By 1939, Rockefeller had given her folk art holdings to Colonial Williamsburg and essentially eased away from collecting prior to her death in 1948. Shortly after meeting the Rockefeller Folk Art Center's director, Mary Black, in New York around 1958, Hemphill began visiting the Center in Williamsburg where he found ample demonstration of the collecting aesthetic he had first encountered in Jean Lipman's publications.[42] Some of his acquisitions before 1961 reflect Mrs. Rockefeller's influence, since he began adding works that he recognized as efforts by similar hands or schools as those in her collection (figs. 21 and 22). That knowledge continued to affect his choice of nineteenth-century works well into the 1970s.

Fig. 21 Susan Whitcomb, *The Residence of Gen. Washington Mt. Vernon Vir.*, 1842, watercolor and pencil on heavy wove paper, 18 x 21⅞ in. Abby Aldrich Rockefeller Folk Art Center, Williamsburg, Va., 31.3023.1.

Fig. 22 Unidentified Artist, *The Residence of General Washington at Mount Vernon*, ca. 1840, watercolor and pencil on wove paper, National Museum of American Art, Washington, D.C.; gift of Herbert Waide Hemphill, Jr., and museum purchase made possible by Ralph Cross Johnson, 1986.65.211.

The genealogy of who collected what and when in the folk art field, especially after 1950, has not been carefully traced and analyzed yet. For Hemphill's part during the 1950s, one must consider his youth, but more importantly his relative isolation from historical models. Although attentive to Lipman's and Rockefeller's example, Hemphill emerged essentially as an individual. He was quite separate from, and in many respects unconcerned with, the rhetoric and issues attached to earlier collecting efforts. Folk art's part in nostalgically reconstructing the country's past, or in justifying modern art in America, was often weighted politically; in both roles, folk art became a lobbyist rather than an actual phenomenon as art in and of itself. Although personally conservative, Hemphill is apolitical and emotional, and the field's political or intellectual underpinnings did not dictate his approach. Quite simply, he embraced the material because he believed it was art and because his personal tastes (and budget) preferred the different.

Although it is tempting to maintain that Hemphill's penchant was singular during the 1950s, two other figures—Frederick Fried and Andy Warhol—also began altering the equation at that time. Together, the three form an intriguing triumvirate, since all were trained as artists. Their training took them in different directions, but an artist's sense of experimentation and alert, aggressive intelligence guided their individual connoisseurship.

A Brooklyn native born in 1908, Fried was the art director for Bonwit Teller between 1955 and 1962; since then he has free-lanced to make time for his many avocations: collecting, researching, writing, curating, and carving, to name a few. Around 1953 he began acquiring architectural ornaments in New York, an activity well ahead of the past decade's craze for such material. Coin-operated machines, nickelodeons, music boxes, alarm clocks, and a twenty-seven-ton, intact carousel from Coney Island became passions by 1957. Carousel figures had not yet become popular among folk art collectors, and his other gadget-oriented objects never would because of their popular and mass-produced origins. Typical nineteenth-century genres have held little interest for Fried, and he knew that his taste during the 1950s was considered "screwball," in his own words.[43] Nonetheless, he has produced influential exhibitions and publications: *A Pictorial History of the Carousel* in both book and exhibition form (1964); *Artists in Wood* (1970) and its companion show "Carving for Commerce" cocurated with Hemphill at the Museum of American Folk Art; and *America's Forgotten Folk Arts* (1978), most notably. Unknown to each other until the 1960s, the two men have become closely identified with the offbeat and overlooked (albeit found in different quarters), and their acquisitiveness has led them to salvage thousands of objects. One of their principal points of departure is the archeological (rather than aesthetic) approach Fried has taken in documenting and interpreting the objects that interest him.

Hemphill shares his birth year with Andy Warhol, who was Frederick Fried's "shoe artist" at Bonwit Teller. As usual, disagreement exists about what Warhol did when and why, but it does appear that American folk art was one of his first collecting interests after coming to New York from Pittsburgh during the 1950s (fig. 23). Fried believes that his holdings exerted some influence since Warhol gleaned architectural ornaments, carousel carvings, nickelodeons and pinball

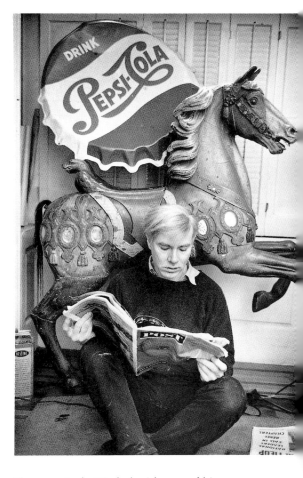

Fig. 23 Andy Warhol with two of his early Americana acquisitions, New York, after 1957. Photograph © by Ken Heyman, New York.

machines during the artist's famous sweeps along Second Avenue.[44] Walter Hopps has suggested that Warhol, as a commercial art student in Pittsburgh during the late 1940s, responded to the emblematic portraits and signage in the photographs of Walker Evans, who also collected contemporary vernacular objects such as hand-done signs.[45] Evans's interest in the folk crafting of practical things and the people who made them is evident in his photographs of the rural environment in the South, New York, and Pennsylvania during the 1930s.

Whatever its impetus, Warhol's compulsiveness quickly spread beyond cigar store Indians, weathervanes, whirligigs, decoys, and other folk art genres. When Sotheby's auctioned his vast collection of three thousand or so items in 1988, the full range of his appetite—from junk mail to now almost priceless decorative arts and furniture—became publicly evident for the first time.

Warhol and Hemphill had known each other in passing since the early 1950s, but neither seems to have affected the other. Obviously, they shared a compulsion to buy, a love of a bargain, and a hunter's instinct honed along Second Avenue. Warhol, however, was essentially an encyclopaedic hoarder whose collection was seldom seen publicly during his lifetime. The Museum of American Folk Art's 1977 exhibition and catalogue *Andy Warhol's Folk and Funk* was the notable exception. The size of Hemphill's collection rivals that of Warhol's; both men could be chided for a certain lack of discrimination nurtured by their obsessiveness. Hemphill's universe, however, revolves around a specific interest as opposed to Warhol's "I like everything" approach. Moreover, although crowded into a much smaller space, Hemphill's holdings have always been accessible in their domestic setting or in exhibitions and publications.

As much as the three men's tastes may have seemed eccentric then, their drive to collect was very much in tune with a generation of Americans who began collecting in earnest by the late 1950s. A key curator of the time, Walter Hopps dates this phenomenon to the contemporary art world's 1957 fall season (on the heels of Jackson Pollock's death in August 1956), when Hopps and others like Sam Hunter and Dore Ashton detected the difference in the private, public, and critical response to contemporary art.[46]

Around the country a group of committed collectors gained momentum. In New York, Ben and Judy Heller, George and Eleanor Poindexter, Philip Johnson, and Armand and Celeste Bartos became conspicuous patrons of the New York School, as did Burton and Emily Tremaine from Connecticut. In Chicago, a similarly active group was forming around Morton G. Neumann, Joseph Shapiro, Edwin and Lindy Bergman, Muriel Kallis Newman, and Leonard and Ruth Horwich, whose interests included the artists Picasso, Max Ernst, Alexander Calder, Jean Dubuffet, Jackson Pollock, Joseph Cornell, and Robert Rauschenberg, and non-Western art. John and Dominique de Menil, active after their arrival from France in 1941, were unique as collectors in the Southwest; their discerning liberality drew them to antiquities, Byzantine art, the tribal arts, and twentieth-century art, especially Surrealism. Frederick and Marcia Weisman, Stanley and Betty Freeman, and Gifford and Joanne Phillips initiated the community of collectors that would grow in Los Angeles. Having worked for Sidney Janis in New York, Virginia Bagley Wright in Seattle began the first major private collection of modern and contemporary art in the Pacific Northwest

during this period. By 1965, it was evident that a national explosion of ambitious collectors, best exemplified by Ethel and Robert Scull in New York, were staking out their territories.

At the risk of reducing a phenomenon to its bare bones, one could attribute this explosion of collecting to a constellation of factors. Since World War II the country had enjoyed an absolute sense of itself as a world power as well as unprecedented economic prosperity. Confident Americans made up for wartime austerity measures by becoming conspicuous consumers. Buying everything from refrigerators to art, they displayed a decided preference for American-made goods. By the mid 1950s another generation of Americans began to reap the benefits of public colleges and state universities. The liberal arts curriculum broadened after the war to include the visual arts, aided by the GI Bill which opened the doors of higher learning to more Americans than ever before in the nation's history. Although many Americans were skeptical of the different, ironically, the end of McCarthyism brought a high level of curiosity about what was new, offbeat, and even taboo. This was the era of Russia's Sputnik and Jack Kerouac's Beat generation. America's curiosity was nowhere better satisfied than in the printed media. *Life* and *Look* magazines in vivid color pictures diffused cultural information rapidly as well as dynamically. The mass media popularized the new generation of artists and collectors devoted to the avant-garde, and slowly the lag between artistic invention and public acceptance began to shrink.[47]

Nevertheless, nineteenth- and early twentieth-century American art would not gain status among the country's collectors until the early 1970s. The fact, however, that Fried, Warhol, and especially Hemphill, represented a new breed of folk art collector by the late 1950s should not be forgotten. In their own way they were defining an avant-garde approach to the field at a time when acquisitiveness, openness to the new, and preference for the American were givens in our national culture. Enlisted by members of the folk art world's old guard, Hemphill would become the lightning rod for a new generation's perceptions and activities.

NEW FORUMS FOR FOLK ART, 1961–74

An elegant, private man, Hemphill did not foresee that his founding role in the Museum of Early American Folk Arts in 1961 would lead to subversive adventures in the public domain or that his apartment would become a crossroads for radical discoveries. In 1968 his introduction to carvings by Kentuckian Edgar Tolson, then sixty-four years old, dramatically altered his perception of folk art's possibilities, while his first encounter with Michael and Julie Hall the same year inspired a dialogue that spread throughout a national community of artists, dealers, and collectors receptive to change. By 1974, when Hemphill and Julia Weissman co-authored *Twentieth-Century Folk Art and Artists,* a revolution within the field was well underway. This important development cannot be understated, and its coincidence at a time of political and artistic tumult should not be overlooked.

Three dealers—Adele Earnest, Cordelia Hamilton, and Marian Willard, and three collectors—Joseph (Burt) Martinson, Arthur Bullowa, and Hemphill— joined forces in 1961 to establish a museum devoted to American folk art in New York City.[48] The instigating trio of Martinson, Earnest, and Hamilton believed that New York needed such a specialized institution. No doubt they knew that

by the late 1950s fifteen major public collections of folk art had been established in other Eastern cities and towns.[49] The three were also responsible for including the word "early" in the new museum's title; doing so, of course, reflected the field's historical bias toward the Revolutionary period. In 1966, an expanded board of trustees dropped "early" in anticipation of broadening the museum's scope. Despite a liberal history of exhibitions and programs, until recently the museum's orientation has been identified with nineteenth-century material.

Organized without an endowment, a permanent collection, or a building, the fledgling museum needed to establish its profile quickly. The founding group decided to stage a major loan exhibition at the Time and Life Exhibit Center under the auspices of *Life* magazine. Mary Allis and Hemphill were recruited as the show's curators.[50] Together, they visited the extensive network known to Allis, Earnest, and Hamilton, providing Hemphill with a comprehensive introduction to private and public collections primarily throughout New York and Connecticut. Opening on October 5, 1962, the exhibition included 106 works drawn from fifty-one private collections and fourteen public institutions.

Too lengthy to annotate here, this impressive roster indicates that a healthy group of private collectors attracted to folk art existed. The gamut ran from the Garbischs and Stewart Gregory, who focused on eighteenth- and nineteenth-century American material, to David Rockefeller and John and Dominique de Menil who included folk art in more broadly based collections. In the middle was a group not commonly known as folk art collectors but who nevertheless contributed to the field.[51]

The material selected for the show reflected the genres then considered standard among collectors, while the generally high quality of the objects chosen indicated the discerning taste of the lenders and curators. The exhibition included, for example, a *Peaceable Kingdom* by Edward Hicks, the now famous *Angel Gabriel* weathervane, and Hemphill's *Indian Trapper* and *Indian Squaw*. The show was an auspicious beginning, attracting fifty thousand visitors over six weeks and garnering a review in *Time* magazine that noted, "If there was one fault with the show, it was this: it would be hard to beat."[52]

Highlighting the exhibition's content was a wooden gate constructed and painted to resemble a nineteenth-century American flag (fig. 24). The gate,

Fig. 24 Unidentified Artist, *Flag Gate*, ca. 1876, painted wood and iron brass, 39½ x 57 x 3¾ in. Museum of American Folk Art, New York; gift of Herbert Waide Hemphill, Jr., 1962.1.1.

originally made for the Darling Farm in Jefferson County, New York, had been spotted by Hemphill in a Parke-Bernet auction of garden furniture. In 1961 he donated the patriotic construction to establish the museum's permanent collection and to stimulate similar philanthropy. Over the years he has continued to seed its holdings and those of other public institutions in this fashion.[53]

When Mary Black became the Museum of Early American Folk Arts's second director in 1964, she brought considerable knowledge and a well-developed network from the Abby Aldrich Rockefeller Folk Art Center, where she had served consecutively as registrar, curator, and director since 1957 (fig. 25). Born in Pittsfield, Massachusetts, in 1922, Black came to her interest in folk art through her family's four ancestral portraits by Erastus Salisbury Field, exposure to the Shakers' Berkshire communities, and a decade of research for Colonial Williamsburg after 1947. When Black appointed Hemphill as the museum's first official curator, he resigned from the museum's board of trustees, ordinarily a more prestigious and powerful venue. Ultimately, however, he exerted far more influence as curator until 1973.[54]

Initially, Hemphill's tenure was devoted to helping with exhibitions conceived by Black or guest curators. Between 1964 and 1966, Black reintroduced New York audiences to *santos* from New Mexico, and the decorative and fine arts of the Shakers, material not seen in the city's museums or galleries since the 1930s and 1940s. By 1970, she organized the first full-scale exhibitions of portraitist Ammi Phillips and portrait and narrative painter Erastus Salisbury Field. Some thematic shows also dealt with Black's specialty, early American paintings. She also seems to have been drawn to less conventional genres such as tools, early military equipment, and ephemeral folk figures including scarecrows. Under her direction, guest curators presented a wide range of material, usually derived from their private collections or inventories. Such exhibitions as "The Art of the Decoy," by Adele Earnest, "The Art of the Carousel," by Frederick Fried, both presented in 1966, and "The Hunt for the Whale" done in 1968 by Barbara Johnson, the country's most active collector of whaling material, were highlights of these early years.

Exposure to these varied projects was Hemphill's on-the-job-training. As a result, his knowledge of the folk art field and its resources increased dramatically. The timing of this education is significant because it coincided with the period

Fig. 25 Hemphill and Mary Black with *Stag at Echo Rock*, at opening of "What Is American in American Art," M. Knoedler and Co., Inc., New York, 1971. Photograph by Katrina Thomas, New York.

in which folk art's exhibition history began changing. In 1924, the Whitney Studio Club's show, "Early American Art," initiated this history, dominated until the early 1960s by general surveys prepared by a handful of major urban institutions such as the Museum of Modern Art and the National Gallery of Art.[55] Presenting large groups of related works, usually organized by date, artist, medium, or subject, the art survey is a time-honored format for exhibitions, especially when introducing a broad idea or style. Folk art's debut as a recently discovered national expression greatly benefited from this approach.

By the early 1960s, however, resources and research were sufficient enough to sustain more specialized efforts, and the Museum of American Folk Art became the principal arena for regularly staging one-person, thematic, and genre-specific exhibitions. To be sure, its budget and space—limited to a shoestring and two small rooms in a brownstone walk-up—restricted its efforts and its audience. But, in retrospect, its exhibition program during the 1960s signaled a major change in the field.

In this context, Hemphill began organizing shows with Mary Black in 1967. By 1969 he mounted his first independent show; within five years he had prepared twenty exhibitions almost evenly divided between the roles of curator and cocurator.[56] Although documentation of his efforts is scattered, Hemphill's topics and installations became known for the sense of challenge they offered. That impression, more than anything else, still lingers among those who saw the exhibitions he mounted.[57]

Consider, for example, "Folk Artists in the City/Painters and Carvers of Greater New York" or "The Plenty of Pennsylvania," cocurated in 1967 and 1968 with Mary Black, who credits Hemphill with proposing and selecting both exhibitions. Twenty years later, such projects seem obvious, given the bicentennial-inspired trend to examine the folk art of regions or states.[58] In 1968, however, assembling the richly varied contributions of a particular area was a novel curatorial ambition.[59] Four years later, the Museum of American Folk Art adopted the approach for its bicentennial project, a series of five exhibitions devoted to the arts and crafts of New York state. Held annually until 1976, each show traced a particular medium—fabric, metal, ceramics, wood, and paper—from the eighteenth century to the present. Hemphill prepared the first two installments in the series—"Fabric of the State" in 1972, and "Metal of the State" in 1973.

An artistic rather than scholarly curator, Hemphill was at his best when suggesting aesthetic relationships among things extracted from different environments and different times. An exhibition of fabrics made in New York could have been restricted to the familiar nineteenth-century textiles such as quilts, rag rugs, table runners, and garments (fig. 26). The catalogue for "Fabric of the State," however, reveals that Hemphill took a much broader view of fabric's potential as a medium. His selections dated from 1757 to 1972. Embroidered samplers and mourning pictures, Masonic ceremonial aprons, historical handkerchiefs, stitched banknotes and postcards, political banners, centennial badges, flags, wall hangings, Torah wrappers, and Iroquois souvenir beadwork were added to the standard items. In the museum's two small galleries, 212 works, as well as beds, looms, and yarn winders, literally produced a layered installation, evocative rather than documentary, thorough, yet unstudied.

Since the 1930s, most presentations of folk art have reflected the environment

Fig. 26 Hemphill's installation for "Fabric of the State," at Museum of American Folk Art, New York, 1972. Courtesy Museum of American Folk Art, New York.

in which it was collected. For whatever reason, historical societies have traditionally opted for the cluttered look of grandmother's attic. Outdoor village museums have equated folk art with antiques in pointedly nostalgic attempts to suggest some sense of historical context; in these settings, folk art is a quilt draped on a chest to convey a utilitarian but cozy past. Art museums have presented folk art in their share of period rooms, but have also isolated the material in neutral environments characterized by white walls, pedestals, and spotlights. The latter approach, developed for modern art, had become well entrenched by the late 1960s. Marcel Breuer's streamlined installation for the Whitney Museum's 1974 exhibition, "The Flowering of American Folk Art (1776–1876)," was the apotheosis of applying this design philosophy to folk art exhibitions.

Hemphill avoided these traditional formats. He was, however, influenced by the collecting "environment," and his exhibitions often distilled the baroque sensibility at work in his apartment. To be sure, one could fondly compare his stacks, clusters, and islands of objects to those in the Paris apartment of Gertrude and Leo Stein or in the Baltimore apartment of the Cone sisters (figs. 27 and 28). The variety and density of Hemphill's collection have prompted impressions ranging from "pack rat" to the American equivalent of entering King Tut's tomb. A visitor perplexed by the apartment's contents once asked Hemphill, "Do you own all of this or do you rent it?"[60] A subtle yet dynamic logic—in the midst of seeming chaos—has always existed in the collection. This logic is the result of making do in a limited space, accenting walls, floors, and furniture with color and texture, and, most of all, orchestrating disparate objects in close proximity to stimulate Hemphill and his visitors.

Ideas for exhibitions and the objects gathered for them evolved from Hemphill's peripatetic curiosity. The wider net he cast in projects such as "Fabric of the State," however, was tame and instinctual compared to the deliberately provocative

goals of four other exhibitions: "Twentieth-Century Folk Art and Artists" (1970), "MACRAME" (1971), "TATTOO" (1971), and "OCCULT" (1973). These shows, now historically identified with Hemphill, literally rocked the folk art world.

The question of time has dogged the field from its very inception. What were the country's earliest folk expressions, and who were its first practitioners? When was something made? How do the effects of time influence our perception and care of an object? What is the accurate chronology of folk art's discovery and promotion? Finally, perhaps the most debated question focuses on whether folk art existed after the advent of industralization and the mass media. In 1970 the possibility of genuine contemporary expression was of negligible interest to the overwhelmingly conservative folk art world. The fact that artists Charles Sheeler and Robert Laurent had discovered that a new hooked rug could be as good as, or better than, an older example was long forgotten.[61] The early twentieth-century folk artists identified by curator Holger Cahill and the dealers Sidney Janis, Robert Carlen, and Otto Kallir in exhibitions and publications after 1938 had been forgotten and largely dismissed in 1970 by those still intent upon romantic nationalism or provocative parallels with modern art.

Hemphill's proposal to explore the twentieth century met with mixed if not volatile reactions from the Museum of American Folk Art's board of trustees, many of whom subscribed to the field's conservative interpretation. Nonetheless,

Fig. 27 Sampling of Hemphill's collection in his New York apartment, before 1964. Courtesy Herbert Waide Hemphill, Jr.

Fig. 28 Sampling of Hemphill's collection in his New York apartment, 1986. Photograph by staff of National Museum of American Art, Washington, D.C.

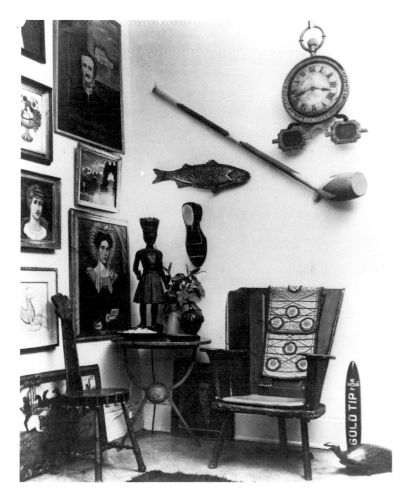

Fig. 29 Morris Hirshfield, *The Artist and His Model*, 1945, oil on canvas, 43½ x 33¼ in. Collection of David Davies, New York. Photograph courtesy Sidney Janis Gallery, New York.

the show moved forward, essentially ignored by a board hoping to divorce itself from controversy.[62] The fact that the museum had recently established a junior membership group called the "Inheritors" to attract a new audience is an irony of timing.

With only a draft of the checklist, a few press notices, fragmentary recollections, and no photographic documentation, the anatomy of Hemphill's landmark "Twentieth-Century Folk Art and Artists" can only be sketched.[63]

The historical underpinnings of the show were a key feature. Of the almost fifty identified artists included, one third were drawn from the group discovered by Cahill, Janis, and Kallir. The two New York dealers lent generously to the show.[64] From Janis's gallery, for example, came Morris Hirshfield's 1945 *Artist and His Model* (fig. 29) and Patrick Sullivan's 1939 *Haunts in the Totalitarian Woods;* from Kallir's Galerie St. Etienne came Grandma Moses's 1946 *Out for a Christmas Tree* and Joseph Pickett's 1910 *Lehigh Canal Sunset, New Hope, Pennsylvania.*

To this roster, dominated by painters, Hemphill (among others) reintroduced stone carvings by William Edmondson, discovered in Nashville, Tennessee, during the 1930s. In 1937, Cahill's wife, Dorothy Miller, had organized Edmondson's first one-person exhibition at the Museum of Modern Art where she was a curator. Hemphill first saw Edmondson's carvings at the Marian Willard Gallery in 1964 when Adele Earnest organized a one-person exhibition that revived New York's interest in his work. No doubt at Earnest's urging, Mary Black subsequently featured Edmondson at the Museum of American Folk Art in 1966.

Acknowledging this century's early folk art figures and their supporters was

obviously important to Hemphill, who characteristically worked his way forward from an historical touchstone to more recent developments. In 1938 Cahill, in *Masters of Popular Painting*, and in 1942 Janis, in *They Taught Themselves*, had argued that aesthetically significant works by twentieth-century self-taught painters continued an honorable lineage established by anonymous limners in seventeenth-century New England. When Hemphill began organizing the show, Janis still held the body of Morris Hirshfield's paintings, but his focus as one of the country's most discriminating dealers was now modern and contemporary art. At his Galerie St. Etienne, founded in New York in 1939, the Austrian emigre Otto Kallir and his granddaughter Jane represented Grandma Moses, around whom they built a stable of American and European self-taught artists. Any proselytizing on Kallir's part, however, revolved around the career of Moses. Hemphill essentially focused attention on a discussion that had lapsed in New York. Embracing Cahill's and Janis's perception of an aesthetic continuum, Hemphill then built upon it, gathering for his show an assortment of more recently discovered artists as well as anonymous efforts.

The exhibition's selection was eclectic and certainly not comprehensive, since Hemphill had not yet embarked on a systematic, nationwide search for twentieth-century artists. Among the approximately thirty new players was a baker's dozen whose names would be quickly recognized today: Eddie Arning (cat. 164), Vestie Davis, Minnie Evans, Victor Joseph Gatto, Theora Hamblett, Clementine Hunter, J. C. Huntington (cat. 159), Justin McCarthy (cat. 89), Sister Gertrude Morgan, Jack Savitsky (cat. 173), Dana Smith (cat. 170), Edgar Tolson, and Joseph Yoakum (cat. 163). The balance were artists whose efforts have since been forgotten.[65]

The anonymous material included Appalachian broom dolls, an articulated doll impersonating Bing Crosby (fig. 30), a Mickey Mouse kachina (cat. 120), duck decoys, New Mexican *bultos*, and a neon fish trade sign from the 1930s. Exploring this sort of material had never once occurred to the likes of Cahill or Janis. Moreover, although Hemphill considered objects such as neon trade signs as a logical updating of an earlier tradition, such objects certainly ignored the boundaries between craft, art, and popular culture.

These diverse selections—apparently 162 paintings, drawings, sculptures, and "things"—were presented in an installation "just wild with color," recalls Michael Hall.[66] Walls, platforms, and pedestals painted strong reds and blues created a brightly upbeat setting that complemented the sense of currency and freshness in the works themselves.

Was there a message in this diversity? Hemphill's agenda, when stated now, differs little from what he originally proposed for this 1970 exhibition. His intent was demonstrative rather than definitional. It was summed up by the opening statement of the exhibition's press release: "Folk art is flourishing in the U.S.A. today." To that assertion, Hemphill added that the work had historical roots, legitimate aesthetic merit in a variety of media besides painting, and diverse geographic and occupational origins.

Presenting three-dimensional objects took Hemphill's project well beyond the efforts of Cahill and Janis as well as those of three people who had much more recently organized exhibitions of twentieth-century, self-taught painters. In 1966 and 1967, the Museum of Modern Art circulated "Seventeen Naive Painters" to

Fig. 30 Unidentified Artist. *Articulated Figure of Bing Crosby*, ca. 1950s, Minute Maid orange juice can, carved and painted wood, and turned iron, 10½ x 3½ x 2¾ in. National Museum of American Art, Washington, D.C.; gift of Herbert Waide Hemphill, Jr., and museum purchase made possible by Ralph Cross Johnson, 1986.65.277.

seven American cities; the show did not appear in New York. George Montgomery, coincidentally the first director of the Museum of American Folk Art (from 1961 to 1964), organized the show, which included standard figures such as Morris Hirshfield and newcomers such as Justin McCarthy.[67] In 1969, Virginia Zabriskie presented "American Naive Painting: Twentieth Century" at her New York gallery. Again, artists such as John Kane and Patrick Sullivan were shown with more recently found painters such as Jack Savitsky and Justin McCarthy.[68] Overlapping with Hemphill's show in 1970 was "Symbols and Images: Contemporary Primitive Artists," circulated nationally outside of New York by the American Federation of Arts. Featuring twenty-nine painters, it was organized by Gregg N. Blasdel, a young painter in New York who had been documenting outdoor environments by self-taught artists since 1960. Unintentionally, Blasdel's show complemented Hemphill's effort because it brought together artists like Andrea Badami, "St. Eom," J. R. Adkins, and Nounouphar Boghosian for the first time and duplicated choices such as Sister Gertrude Morgan, Minnie Evans, and Clementine Hunter.[69]

These three exhibitions indicate that interest in twentieth-century artists was in the air even as Hemphill was preparing his show. Montgomery, Zabriskie, and Blasdel, however, did not break the mold of focusing on painting, while Hemphill clearly took a far more panoramic approach. Only his longtime friend Adele Earnest had shown an interest in showing twentieth-century sculptors, featuring Edmondson and the recently discovered Clark Coe and John Scholl in one-person exhibitions at the Marian Willard Gallery between 1964 and 1967.

In presenting his show, Hemphill did not define twentieth-century folk art; he simply asserted that it existed and began exploring the kinds of objects he thought demonstrated that existence. Some may see the exhibition's absence of parameters or criteria as a failing, but to do so assumes that Hemphill set out to analyze the material systematically. That approach is antithetical to his visceral processing of art as information and emotion. Others interpret his apparent catholicism as an ability to see artistic potential in anything, a characterization

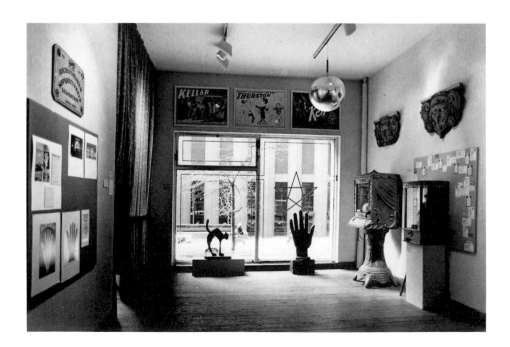

Fig. 31 Hemphill's installation for "OCCULT," Museum of American Folk Art, New York, 1973. Courtesy Museum of American Folk Art, New York.

that verges on overstatement. In 1970 neither view was accurate. Hemphill's perception of what folk art was and what he would collect was changing rapidly and dramatically. In many respects the show is best understood as an individual's attempt to visualize and share a personally felt challenge.

Between 1971 and 1973 the Museum of American Folk Art presented "MAC-RAME," "TATTOO," and "OCCULT." This series of exhibitions was funded by the National Endowment for the Arts under the theme, "Rediscovery of Grass Roots America."[70] When Hemphill and M. J. Gladstone, the museum's director from 1970 to 1971, proposed the series, they hoped that its provocative topics would attract a younger audience. Their goal once again suggests internal dissatisfaction with the museum's constituency.

These exhibitions coincided with the most troubled period in the museum's history. Serious financial difficulties resulted in a public auction of its collection, which the New York State Attorney General investigated in 1974.[71] Unintentionally, the three shows became a symbol of the museum's problems. Each was extended because of popular demand; more than twelve thousand people visited "OCCULT," a figure well beyond the museum's usual attendance for its shows. Press coverage included lengthy articles in *Newsweek* and Rita Reif's prestigious antiques column in the *New York Times*, but it was clear that professionals and collectors were sorely divided in their opinions. The shows were either damned as controversial or praised as innovative. In an article in the *New York Times*, critic Grace Glueck quoted an anonymous member of the museum who lamented the "faddishness" of the three exhibitions and noted that they did not "represent American folk art qualitatively enough to be staged by a museum."[72] In the same article, Dr. Louis Jones, a new museum trustee and the highly respected director of the New York State Historical Association, defended the "grass roots" series: "As for the shows on the occult . . . a museum of folk art should break down barriers and get some fresh ideas. Museums can get very stuffy and when they cause people to sit back and rethink some of their assumptions, that's fine."[73]

The three exhibitions did just that.[74] Although the museum had presented

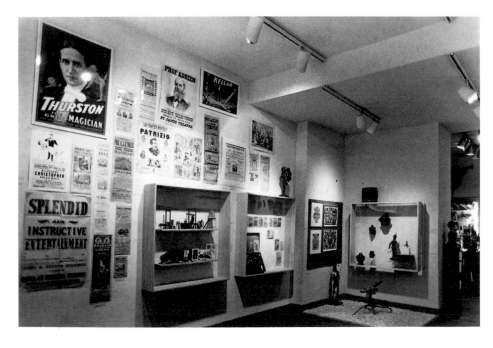

Fig. 32 Hemphill's installation for "OCCULT," Museum of American Folk Art, New York. Courtesy Museum of American Folk Art, New York.

Swiss folk art in 1969, "MACRAME" and "TATTOO" were its first broadly based international efforts including historical and contemporary material. Hemphill capitalized on macramé's national popularity during the 1960s and gathered current expressions—belts, bracelets, plant hangers, hammocks, and sculptures. To them he added knotted fringes made in seventeenth- and eighteenth-century Europe, knotted Peruvian headpieces, pre-Columbian and African efforts, and knotwork by nineteenth-century American sailors. These far-flung examples were intended to establish the technique's time-honored and ethnically diverse origins. Demonstrations of creative and traditional knotting supplemented the show.

"TATTOO," cocurated by Hemphill and Frederick Fried, also took its cue from the counterculture of the 1960s, acknowledging that the psychedelic era had spawned a rebirth of tattooing in America. From public and private collections, the two men assembled more than one hundred objects to demonstrate the technique as a craft practiced since ancient times. A photograph of tattooed figures in an Egyptian tomb painting from 1330 B.C., historical Japanese tattoo sketches, photomurals of twentieth-century tattooists, tattooing equipment (cat. 155), as well as tattoo designs and advertisements (cat. 156 and cat. 157) were among the offerings. The most radical touch was the reconstructed early twentieth-century tattoo parlor, complete with needles, pigment jars, and sterilizer. The word "TATTOO," painted on the museum's window overlooking West Fifty-third Street, was done so realistically that it attracted the attention of the police, concerned that an illegal tattoo parlor had opened near the Museum of Modern Art.[75]

Dealing with decorative aspects of supernatural practices in America, "OCCULT" attracted a very curious public, especially after eleven members of Brooklyn's benevolent Coven of Welsh Traditionalist Witches blessed the show during an invocation rite at its opening (figs. 31 and 32). A wildly eclectic group of 110 objects entranced visitors: Pennsylvania German hex signs, magicians' posters, palmreaders' trade signs, Zoltan (an electric fortune-telling machine), devilish face jugs from the South, and phrenological heads. Also included were sculptures of root monsters and devils by Miles Carpenter (cat. 180), so-called voodoo carvings (cat. 97), canes from an Appalachian rattlesnake cult, fraternal initiation certificates, and an astrological sundial. One area was set aside for five altars, created to suggest the practices and equipment of witches and some cults. In another area, members of New York's School of Innervision lectured, did psychic readings, and also read visitors' palms and tarot cards. Hemphill acknowledges that the show's contents did not support his premise. Extracting objects from different contexts to flesh out a point had not worked, largely because genuine occult material was scarce or difficult to separate from owners unwilling to be identified with the supernatural. Nonetheless, the exhibition fulfilled its outreach goal, for it "gave a whole new image to the museum; that it wasn't just about old fusty stuff from grandma's attic."[76]

These four exhibitions all sought the new, the young, and the different. Although increasingly offbeat, Hemphill's collection during the 1960s was still geared to the nineteenth century. By 1970, however, something had galvanized him, turning him to the contemporary.

While visiting New York during the early summer of 1968, Michael and Julie Hall were enroute to the Museum of Modern Art when they noticed some objects

in the window of a brownstone on West Fifty-third Street.[77] Their curiosity drew the Halls into the Museum of American Folk Art's exhibition, "Permanent Collection and Promised Gifts Part III," cocurated by Hemphill and Black. Whirligigs, decoys, weathervanes, panoramic landscapes, and Hemphill's powerful pair of Indians were among the objects they encountered. Their response resembled a religious conversion, as Michael Hall recalls:

Wham! It just came out of the sky. Knocked Julie and me out—for reasons that I can't really explain, except that we were open to it that day. It spoke and we listened. . . .[78]

The recognition that this was primitive art of a domestic sort was all that came to us, but that was enough. We had a base to understand the primitive but not a base to understand the domestic primitive. The material in that particular exhibition was enough to carry the day for us. We could understand the form, we could understand the surfaces. It was just that we lacked any background. Here was this wonderful patinated, time-worn stuff. Primitive it was, and seductive it was. Ready we were.[79]

Hemphill followed the Halls' agitated conversation in the otherwise empty galleries for almost an hour, though the two visitors took little notice of him. Finally overcome with curiosity, he approached the couple and shyly asked, "Do you like these things?" and, when the Halls displayed their enthusiasm, "Would you like to see some more?" In the midst of their first visit to the Museum of American Folk Art, the Halls did not realize that Hemphill was the museum's curator and an ardent collector. And Hemphill did not bother to explain as he closed the museum for the day and hailed a cab. The three struck out for his apartment literally as strangers. Looking back at what he describes as an adventure, Michael Hall observes:

I think that he was as amazed to find that there were people who never had heard of American folk art just as we were amazed to find that there was such a thing as American folk art. It was a double amazement because in the circles that he ran in, everybody knew about American folk art. It showed how cloistered or closed off the folk art world was at that time, and perhaps remains to this day. Ours was a naive response, and he was curious enough to want to know what it was that interested us. He was interested in that outside kind of view.

Responding to the folk material that day, Michael and Julie Hall distilled years of complementary experiences (fig. 33). Born in 1941 in Upland, California, Michael Hall was then a sculpture professor at the University of Kentucky in Lexington. In 1960 his undergraduate study at Mexico City College included anthropological fieldwork. As an art major at the University of North Carolina during the early 1960s, Hall also studied ethnomusicology and made field recordings of Appalachian folk and country singers such as Doc Watson. He also studied folk tales and folklore with Arthur Palmer Hudson. A trained guitarist, Hall supported himself through college as a folk singer performing in cabarets and coffee houses before devoting himself to making sculpture and teaching. His well-stocked "song bag" held a repertoire ranging from traditional ballads and folk songs to pop tunes. In Nashville, Tennessee, where she was born in 1943, Julie Hall grew up surrounded by her mother's collection of

Fig. 33 Michael and Julie Hall at home
with their folk art collection, the
Cranbrook Academy of Art, Bloomfield
Hills, Michigan, 1977. Photograph by
Taro Yamasaki. Courtesy Detroit Free
Press and Michael Hall.

African masks and carvings, acquired in part at Julius Carlebach's gallery in New
York during the 1940s and 1950s. Her mother, Estelle Friedman, also owned
stone carvings by Nashville's William Edmondson, who had been discovered and
patronized as a native son by a number of the area's new collectors. Influenced
by her mother's aesthetic interests, Julie majored in art history in college. She
also studied ceramics with Hall at the University of Colorado where he taught
in 1965 and 1966. After they married, the couple moved to Lexington in 1966.
They decorated their first home with some ceramic objects and wood carvings
that readily formed the beginnings of a primitive art collection.

While exploring Hemphill's apartment, Michael Hall told his host that some
of the collector's sculptures reminded him of figures made by a man he and Julie
had met recently in Kentucky. To prove his point, Hall returned the next day
to show his recently taken photographs of Edgar Tolson and his starkly direct
carvings of Adam and Eve to Hemphill. The collector's skepticism promptly
vanished.

During the 1960s southern craft fairs were the principal outlet for government-
promoted cooperatives, created intermittently since the late 1920s to help improve
regional economies, especially in Appalachia.[80] The craft fairs themselves had a
much longer though sporadic history, dating back to 1896 when Dr. William
Goodell Frost initiated fairs offering hand-woven articles at Berea College in
Berea, Kentucky. Thus it was that in May 1967 the Halls visited Berea's now
annual craft fair, newly organized that very year by the Kentucky Guild of
Artists and Craftsmen.[81] In the midst of what she recalls as "too many applehead
dolls, pots, quilts and macrame plant hangers," Julie Hall stumbled across a
large, red poplar carving of a woman at the booth of the Grassroots Craftsmen,
a cooperative from Jackson, Kentucky. With its wavy hair and A-lined skirt, the
"strange doll"—as Julie described it then—was markedly different from the
handicrafts she had become interested in since moving to Kentucky. Over the
next year the Halls encountered similar carvings and began trying to locate the

maker, a quest shared by a fellow art professor, the painter James Suzuki.[82] The cooperative in Jackson identified the carver as one Edgar Tolson of the mountainous vicinity around Campton, Kentucky, and one weekend in June 1968 the Halls and James Suzuki, and his wife Emi Ozaki, drove to the small isolated town. Inquiries at the local pool hall eventually led them to Tolson, who showed them the rented shack where he carved (fig. 34). Tolson also took them to a friend who sold the Halls one of the artist's small carved dolls for eight dollars since Tolson did not have any finished works that day.

In 1967, VISTA volunteers documented Tolson's carvings. The following summer, he demonstrated his skills at the Smithsonian Institution's Folklife Festival in Washington. Although the Halls did not discover Tolson, they charted his path into the art world. By 1984, when Tolson died, they were the most ardent collectors of his carvings and the most astute commentators on his life and work. In 1968, however, when they met both Tolson and Hemphill within a very short time, the Halls were not art collectors.[83] Unaware of American visual folk expressions, they equated the term "folk" with music, craft with pottery, and primitive with African, Oceanic, and pre-Columbian art. At the time, even Edmondson's work was simply "sculpture in the family."

Confronted with the photographs of Tolson's carvings, Hemphill immediately expressed interest in acquiring one. Michael Hall agreed to serve as the middle man, an offer that initiated his activities as Tolson's representative for the next ten years.[84] In early 1969, Hemphill purchased his first Adam and Eve for fifty dollars. In the early spring of 1970 Hemphill came to Kentucky, in the company of the Halls, to visit Tolson. It was an event that Michael Hall, quite rightly, has described as an "American episode." The well-dressed, urbane Hemphill was initially nonplussed by the encounter in Tolson's rundown house, where both the visitor from New York and his Appalachian host sat on overturned five-gallon lard buckets. Although eager to know more about Tolson and his work, Hemphill did not easily understand the carver's mountain dialect. Acting as a translator of sorts, Hall fielded questions and answers between the collector and the artist. Once acclimated, Hemphill found Tolson to be "as charming and witty as he could be," according to Hall.[85]

As Hemphill and the Halls drove down from Campton's mountains, Hemphill said that meeting Tolson was the equivalent of meeting the artists, all dead and often nameless, who had made the works in his collection. Hemphill had never encountered a living folk artist and, unbelievably, had not contemplated the possibility. Talking to Tolson where he worked had literally made his collection come alive and initiated the direction that it subsequently took. At the time, the Halls did not understand Hemphill's fervor as he expressed his gratitude, but they were soon its beneficiaries. Hemphill struck a bargain, offering to educate them about "the old folk art," in return for their access to "this other folk art." An outgrowth of their "double amazement," the trio became reciprocal mentors.[86]

For Hemphill's part, he arranged folk art expeditions whenever the Halls came to New York during the late 1960s and early 1970s. Their itineraries usually included visits to collectors, dealers, historical societies, and country antique shops.

One foray into New Jersey took Hemphill and the Halls to Millburn where they visited the eighteenth-century "Hessian House" of Harvey and Isobel Kahn.

Fig. 34 Edgar Tolson at work, Campton, Kentucky, 1983. Photograph by Michael Hall, Bloomfield Hills, Michigan.

Moving from Manhattan into their rustic farmhouse around 1951, the newly married Kahns

would save a few hundred dollars and load a station wagon with furniture and some folk art. Painted furniture was to be had. There was very little competition. If you zeroed in on something, you could have it. My first love was sculpture—but not the so-called classic weathervanes and cigar store Indians—and it was easier to find because the dealers did not really understand other types of sculpture back then.[87]

By the early 1960s, the Kahns began filling their house with early portraits, shop and trade signs, and stoneware, but especially the painted furniture, whirligigs, and articulated figures that distinguish the couple's efforts. Although they unearthed many of their finds while traveling through New England and Pennsylvania, they also acquired works from the auctioned inventory of the dealer Helena Penrose and from the estates of Elie Nadelman and Stewart Gregory. Set in a historic house, the Kahns' collection emphasizes the eighteenth and nineteenth centuries, but their friendship with Hemphill also led them into the twentieth century. They purchased, for example, a Tolson *Adam and Eve* from the Halls immediately after Hemphill began buying his. Paying tribute to Hemphill's knowledge and contacts, Kahn recalls that "you were very fortunate to know Bert. He was very willing to share everything with you. There is absolutely no ego as to competitiveness with Bert. He'd just go out and find it, you know, and then he'd tell you the dealers or the shops or the artists he found."[88]

Another trip to New Jersey took Hemphill and the Halls to Princeton, where they saw the collections of Barbara Johnson and Bernard and Edith Barenholtz. A Swiss-born lawyer, Johnson was then president of the Museum of American Folk Art's board of trustees. Any and every kind of object associated with America's whaling history—especially scrimshaw and illustrated sailing journals—was the focus of her passionate collecting since the early 1960s. American hooked rugs were her other fast-growing specialty. When Hemphill and the Halls visited the home of toy manufacturer Bernard Barenholtz and his wife, Edith, the couple had recently added a multistory gallery for their growing collection that featured nineteenth-century weathervanes and trade signs as well as antique tin and cast iron toys.

Hemphill also shared with the Halls his familiarity with the resources of Pennsylvania and New York. Shops and dealers in and around New Hope, Pennsylvania, where he returned regularly since his days at Solebury, were the focus of one trip. On another outing the three explored Pennsylvania's rich ironwork and furniture traditions as they visited the historical societies of Berks and Montgomery counties. Mary Black and Adele Earnest were among the well-established New York curators or dealers whom the Halls met through Hemphill. He also introduced them to a new generation of Manhattan-based contacts such as the dealers Allan Daniel, Gerald Kornblau, and George Schoellkopf as well as the collector and sometime dealer Dr. William Greenspon. By the late 1960s, Daniel, Kornblau, Schoellkopf, and Greenspon were excellent resources for early, often elegant objects. They also proved open to offbeat twentieth-century

examples, especially when they realized that Hemphill and emerging collectors like the Halls were interested in more recent material.

By 1969 Hemphill had amassed an extensive folk art library. Having learned from books and catalogues, as well as directly from objects, he urged Michael and Julie Hall to read as much as they could, advice he has regularly given to others. Over time his recommended reading list included many standards then increasingly difficult to find: *American Folk Sculpture: The Work of 18th- and 19th-Century Craftsmen*, the 1931 catalogue for Cahill's first exhibition at the Newark Museum, and Janis's *They Taught Themselves*. More recent publications were Erwin Christensen's 1950 publication on the Index of American Design, the National Gallery's two catalogues of the Garbisch collection (1954 and 1957), Nina Fletcher Little's 1957 publication on the Abby Aldrich Rockefeller Folk Art Center's collection, and *American Folk Painting* by Mary Black and Jean Lipman in 1966. Seemingly out of character was *Art and Argyrol*, William Schack's 1960 unauthorized biography of Dr. Albert C. Barnes, perhaps suggested because Barnes was a single-minded and adventuresome collector, albeit a thoroughly irascible one.[89]

Learning how to hunt for objects was the most important legacy that Hemphill gave to the Halls:

Bert doesn't drive but he'd get out the maps and plan all our routes and we'd do the driving. He knew where all the good shops were, where the pickers were, where all the good outdoor flea markets were. We took all the back roads and stopped at every store that had that horrible sign that says "Antiques" or "Junque" hanging out. Bert would invariably find something great and then he'd teach us about it en route to the next shop. We'd always come back with a carload of stuff.

The best times were the times we would literally sprint from the car into a shop and Bert would go right and we'd go left and we divided up the turf. If we both scored it was a great visit. It was a friendly but real competition where he was our guide and our teacher and he taught us a lot that way. We "picked" dozens of flea markets and visited hundreds of antique stores in Pennsylvania, New York and New Jersey on our junkets with Bert.

He's in his rarest form working his way through a flea market (fig. 35). His pace is unhurried and his inspection of every booth is methodical and thorough. He probes under tables, in drawers and on tops of cupboards—the quintessential hunter. And then he scores. He pulls a terrific little carving out from under a pile of quilts and smiles triumphantly. We, of course, had already been through that booth.[90]

Fig. 35 Hemphill at the Sixth Avenue flea market, New York, fall 1989. Photograph by Martha Cooper, New York.

Though Hemphill believed in networks, neither he nor the Halls had any idea that their universe of opportunities was about to expand exponentially during what can now be seen as the second great wave of folk art explorers and their discoveries. In the early years of the century, artists had spearheaded the first folk art rush, followed in the twenties and thirties by pickers, dealers, collectors, and a few museum professionals eager to join the almost archeological pursuit of eighteenth- and nineteenth-century material. Artists were the generators of the second wave that began building momentum during the late 1960s, bringing newly discovered self-taught artists and their objects to dealers, collectors, and curators. In both phases, folk art was a beacon for artists committed to change,

Fig. 36 Sterling Strauser (left) and Victor Joseph Gatto (right) at Stroudsburg Outdoor Art Show, Stroudsburg, Pennsylvania, 1955. Photograph by Jesse Weiss, courtesy Sterling Strauser, East Stroudsburg, Pennsylvania.

ironically, for very different reasons. Based in New York, the first group had championed modernism as they struggled to develop a nationalistic art and cited early American folk art as an indigenous precedent. Spread throughout the country, the second group rebelled against modernism's formalist legacy and embraced contemporary folk art because it reinforced the latter's search for individuality.

Interestingly enough, the second period's pioneers, Sterling and Dorothy Strauser of East Stroudsburg, Pennsylvania, had participated in folk art's first heyday.[91] Married in 1928, the couple had been trained in elementary art education at Bloomsburg State College. To help make ends meet, Strauser was a picker between 1928 and 1930 for Jack Chamberlain, a rural mailman in East Stroudsburg who enjoyed collecting antiques. Together, the two men kept abreast of the mounting interest in folk art, based on articles they read in art magazines, where they learned that artists like Alexander Brooke and Elie Nadelman were involved with the material. Traveling throughout the area, Strauser looked for what Chamberlain was most interested in at the time—furniture, especially wing chairs, paintings, Pennsylvania German birth certificates, flintlock rifles, and decorated slipware. Sometimes, the enterprising mailman then sold his picker's finds; Dr. Albert C. Barnes, Edith Halpert, and Colonel Garbisch were among his clients. Gradually, Strauser developed his own network, trading with the sculptor Chaim Gross, for example, decorated slipware pieplates for sketches; according to Strauser, Gross was known by the 1930s as "someone who collected everything."

In 1928, Strauser came across a group of carvings by Wilhelm Schimmel in a Mt. Pocono antique store. Too crude for Strauser's eye at that time, the Schimmels were left behind, a decision he has since regretted. By 1935, however, "the scales were removed from my eyes about folk art," when he saw the John Law Robertson American folk art collection at the Everhart Museum in Scranton.[92] In 1942, Strauser noticed a photograph of a painter in a New York newspaper and wrote to him in hopes of purchasing some works.[93] So began his lifelong friendship with Victor Joseph Gatto, who shortly thereafter turned up on the Strausers' doorstep and became a regular visitor (fig. 36). A former boxer who had served time in prison, the feisty Gatto had started painting after 1938 and

Fig. 37 Justin McCarthy at work, Weatherly, Pennsylvania, 1972. Photograph by Leonard Ross, Bethlehem, Pennsylvania, courtesy Sterling Strauser, East Stroudsburg, Pennsylvania.

gained his first public recognition just as Sidney Janis was preparing his book on folk art in 1942. Although Janis mentioned him among other self-taught painters too numerous to appear in his book, the dealer later noted that "I probably would have included him if he hadn't come into my gallery and told me how lousy all my artists were and how great he was."[94] Despite their friend's cantankerous nature, the Strausers were deeply influenced by Gatto, who "taught us that naive, primitive art can be profound. . . . He busted all the rules . . . he had this 'uninhibited perception,' and he had this drive, this compulsion. He had twice as much energy as an average man. I don't think I'd have been ready for Justin without Gatto, and [without] learning from him that twentieth-century primitive/folk/naive art has validity."[95]

The "Justin" mentioned by Strauser was Justin McCarthy, whose highly expressionistic paintings caught the eye of Dorothy Strauser in 1960 at Strouds-burg's Annual Outdoor Art Fair, where both she and her husband exhibited their own works (fig. 37). A year later the couple began buying McCarthy's paintings and drawings, done since around 1920 at his home in Weatherly when he was not on the road selling produce. At the same fair, during the early 1960s, the Strausers also discovered the boldly patterned paintings of McCarthy's friend Jack Savitsky, a disabled coal miner who had just started painting and drawing at his home in Lansford, Pennsylvania.

Today, the eighty-two year old Strauser still calls himself a "self-taught" painter because his curriculum had not included studio courses. In painters like Gatto, McCarthy, and Savitsky, Strauser found abundant evidence to defend "the self-taught man" as the equal of the academically trained. The Strausers became zealous patrons, providing moral and financial support for Gatto, McCarthy, and Savitsky as well as other self-taught artists in and around Pennsylvania's Carbon County—most notably "Old Ironsides" Pry and Charles Dieter.[96] Their generosity also extended to their well-made connections in the art world, where they have especially promoted the works of McCarthy and Savitsky. Through their efforts, both men quickly began exhibiting in galleries and museums in Pennsylvania as well as in New York City. McCarthy's breakthrough came when the Museum of Modern Art included his paintings in "Seventeen Naive Painters," circulated in 1966 and 1967. And in 1969, Strauser persuaded Virginia Zabriskie to include both McCarthy and Savitsky in her gallery's show, "American Naive Painting: Twentieth Century." It was here that Hemphill first saw McCarthy's and Savitsky's work.[97] Subsequently, he presented them in his 1970 twentieth-century exhibition. Shortly thereafter, he began visiting the couple in East Stroudsburg and acquired more paintings and drawings by McCarthy and Savitsky. He also met the two men and by 1972 brought others like Michael and Julie Hall, the Chicago-based dealer Phyllis Kind, and others for their first visits with the Strausers and the artists (fig. 38).

Similar stories abound for more than two hundred self-taught artists discovered around the country between 1960 and 1974; even more have come to light subsequently. The quality and ambition of their efforts fluctuate widely, from saccharine memory paintings to compulsively complex visionary environments. Everyone from discerning employees at senior citizens' centers to trained artists traveling back country roads have aided in their discovery. A survey of the numbers indicates that at least a dozen self-taught artists, now considered senior

Fig. 38 Sterling Strauser, Jack Savitsky, and Bert Hemphill (left to right), at Strauser's home, East Stroudsburg, Pennsylvania, 1975. Photograph by Paul Dressel, courtesy Sterling Strauser, East Stroudsburg, Pennsylvania.

Fig. 39 Steve Ashby, Delaplane, Virginia, 1973. Photograph by Kenneth A. Fadeley, Ortonville, Michigan.

figures in the folk art world, emerged during this period. In addition to Tolson, McCarthy, and Savitsky, this group included Eddie Arning, Steve Ashby, Andrea Badami, David Butler, Miles B. Carpenter, Clark Coe, Henry Darger, Minnie Evans, Sister Gertrude Morgan, John Perates, Elijah Pierce, Martin Ramírez, Inez Nathaniel Walker, and Joseph Yoakum. Charting when they started working and exhibiting against who discovered them when and how is a much-needed analytical exercise too lengthy to conduct here. Briefly taking stock, however, suggests the dynamics of the phenomenon and its players.

Michael Hall often held his sculpture classes in the midst of his growing collection of folk art at the University of Kentucky after 1968 and at the Cranbrook Academy after 1970. For Hall, the folk artist's affirmation of self, often in the face of adversity, was a paradigm of survival. At any time this is particularly true for an artist, but especially for those who diverge from paths circumscribed by the art world, and Hall hoped to convey this lesson to students. He did not intend, however, to make them avid folk art collectors, but many began to collect after being inspired by Hall's articulate discussions and examples. Spreading out around the country after 1970, a key group of Hall's proteges began to discover both self-taught artists and anonymous twentieth-century objects. Some, like Kenneth Fadeley, realized that they had already encountered figures such as Steve Ashby back home in Virginia and began documenting, collecting, and disseminating their respective works (fig. 39). Others, like sculptors Mike Sweeney and Lewis Alquist, and the potter Bennett Bean, alerted Hall when they came across the carver Elijah Pierce in Columbus, Ohio, the visionary draftsman Peter Minchell in Florida, and the painter James Crane in Maine. From those contacts came opportunities to collect the works of these artists, which the Halls generously shared with Hemphill.

A chain of events in 1972 spurred the discovery of Miles B. Carpenter. Originally from Pennsylvania's Mennonite country, Carpenter began carving small animals around 1941 while his Waverly, Virginia, lumber business languished during the war years. After 1960 he resumed carving, this time making objects—

Fig. 40 Miles B. Carpenter and his truck filled with carvings, Waverly, Virginia, 1973. Photograph by Jeffrey Camp, Richmond, Virginia.

like an oversized watermelon and a pair of Indians (cat. 11)—used to attract customers to his roadside icehouse and vegetable stand which he had opened after his retirement in 1955 (fig. 40). Trade signs in effect, the objects caught the eyes of those more interested in the carvings than soda pop and produce. By 1972, a group of people began spreading the word about Carpenter's work. Barry Lubman and Christopher Sublett, art students at Virginia Commonwealth University in Richmond, told their professor, Lester Van Winkle, about seeing Carpenter's roadside store and its carvings. Van Winkle notified Michael Hall, with whom he had studied at the University of Kentucky. Hall began buying and selling Carpenter's carvings, including the first two major pieces acquired by Hemphill in 1972 and 1973 (cat. 11 and cat. 180). By the summer of 1972, Jeffrey Camp, the proprietor of the newly opened American Folk Art Company in Richmond, also heard about Carpenter from Virginia folklorist and collector J. Roderick Moore and promptly began buying his works. The following summer, Camp became Carpenter's exclusive representative, placing his carvings in exhibitions and collections ever since. Soon, Hemphill became a regular client for Carpenter's works. Don Walters, then associate curator of the Abby Aldrich Rockefeller Folk Art Center, noticed Carpenter's giant carved watermelon while driving through Waverly in the fall of 1972 and immediately arranged to exhibit it at the museum. A year later the Center purchased the sculpture as part of its newfound willingness to venture past the late nineteenth century. That same year Hemphill included Carpenter's carving of a devil roasting a man on a pitchfork over an open fire in his exhibition, "OCCULT."[98]

Fig. 41 Joseph Yoakum, Chicago, Illinois, 1960s. Courtesy Phyllis Kind Gallery, Chicago.

Around 1962 in a storefront on Chicago's South Side, seventy-six-year-old Joseph Yoakum began drawing radiant organic landscapes under "the force of a dream" (fig. 41). First shown in a church-sponsored coffeehouse, his drawings inspired an article in the *Chicago Daily News* in November 1967.[99] By the spring of 1968, Edward Sherbeyn's gallery and frame shop exhibited more than fifty of Yoakum's works, attracting the attention of Chicago's art community. That same year, Whitney Halstead, a critic and teacher at the Art Institute of Chicago, and artists such as Jim Nutt began collecting Yoakum's work. Although Hemphill does not recall how he learned of Yoakum's drawings, his exhibition of twentieth-century folk art included examples that he bought in 1970 (cat. 163) as well as loans from the Sherbeyn Gallery. In the early 1970s Phyllis Kind, the adventuresome dealer for many of the city's iconoclastic artists, began handling Yoakum's drawings, recalling: "This is a story on myself, but it's true. Roger Brown had a walk-through railroad flat apartment, and the hallway was all full of Joseph Yoakums and it was like triple hung on both sides. I think for at least a year after I started showing Roger I walked past those Yoakums and then one day I just went, 'Oh, my God!' Now, Joseph Yoakum didn't change, I did. Suddenly, I saw those things and realized what they were."[100]

Chicago artists also proved instrumental in bringing the powerfully structured drawings of Mexican immigrant Martin Ramírez into the art world (fig. 42). Hospitalized as a diagnosed schizophrenic near Sacramento from 1930 to 1960, Ramírez began drawing around 1948. Six years later Dr. Tarmo Pasto, an artist and psychologist teaching at Sacramento State College, discovered and began studying Ramírez's efforts. Offering encouragement to the artist, Pasto also collected his drawings, preserving what otherwise would have been destroyed

Fig. 42 Martin Ramírez, DeWitt State Hospital, Auburn, California, 1950s? Courtesy Phyllis Kind Gallery, Chicago.

because of hospital regulations. In the fall of 1968 Jim Nutt stumbled across some of the drawings stored at Sacramento State College, where he had come from Chicago to teach and run the art gallery. After seeing all of the Ramirez drawings saved by Pasto, Nutt arranged a one-man show at the college in 1969. Two years later the doctor sold almost three hundred drawings by Ramírez to Nutt and his dealer Phyllis Kind, who began exhibiting and selling them in 1973.[101] Buying three drawings (cat. 100 and cat. 101) at that time, Hemphill was one of her first clients.

Artists again were in the forefront of preservation, on-site documentation, and the debate surrounding another area of folk art—that of monumental, outdoor constructions. In the September/October 1968 issue of *Art in America*, Gregg N. Blasdel published "The Grass-Roots Artist."[102] A photographic essay, it featured fifteen men who had built architecturally scaled environments on rural sites scattered around the country since the turn of the century. Originally from Kansas, Blasdel was a painter trained at the University of Kansas and Cornell University during the 1960s. One of the first environments that Blasdel saw around 1960 was S. P. Dinsmoor's *Garden of Eden*, built outside Lucas, Kansas, during this century's first quarter (fig. 43). Constructed in concrete, the *Garden of Eden* still occupies its half-acre lot. Dinsmoor combined figurative sculpture and homemade architecture to convey his moralistic understanding of the Bible as well as his allegorical commentary on American life at that time. His curiosity aroused, Blasdel hit the Midwestern roads, discovering and documenting similarly ambitious projects. After moving East, he continued his efforts. Funded in part by the National Endowment for the Arts and the Whitney Museum of American Art, his research was first introduced to a national art audience in his article for *Art in America*.

Blasdel's essay focused attention on these monumental visionary sites in ways that earlier articles had not. In 1946, Walker Evans photographed a massive carved stone ensemble of figures and animals in the Maplewood Cemetery of Mayfield, Kentucky (fig. 44). Colonel Henry G. Wooldridge had commissioned William Lydon, a local self-taught stonecutter to create a family monument during the 1890s.[103] Drawn to sophisticated and vernacular architecture in New England and the South, Walker Evans took numerous pictures from different views of the powerful albeit eccentric memorial, an unusual approach for the photographer who normally shot only one definitive view of a subject. In

Fig. 43 S. P. Dinsmoor, *Garden of Eden*, 1905–1920s, Lucas, Kansas. Photograph by Eric Sutherland, Minneapolis, Minnesota.

Fig. 44 *Wooldridge Family Monument*, Mayfield, Kentucky, 1890s. Photograph by Walker Evans, ca. 1946, courtesy The Menil Collection, Houston, FO83–13.05MF.

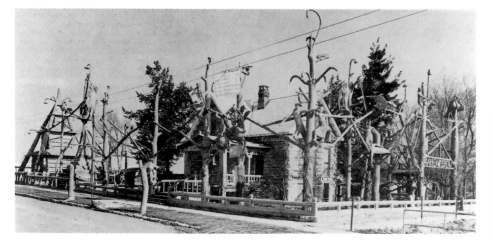 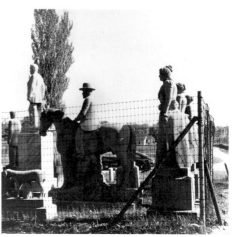

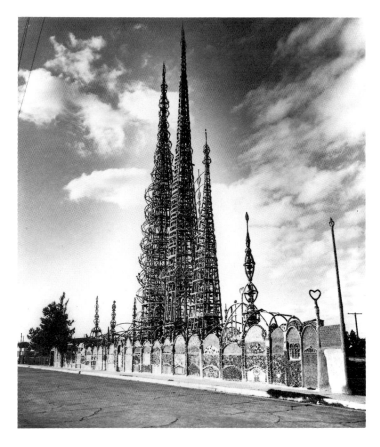

Fig. 45 Simon Rodia, *Watts Towers*,
1921–1945, Los Angeles.
Photograph by Seymour Rosen, Los
Angeles.

December 1954, *Harper's Bazaar* published one of the photographs in tandem with "Sepulture South: Gaslight," an autobiographical short story written by William Faulkner after seeing Evans's photographs of the gravemarker.[104] Although the magazine was widely read in New York, the monument was no doubt perceived as an isolated oddity and went unnoticed until Edward Bryant and William Bayer published a photographic essay, "Rediscovery: The Mayfield Monuments," in the July/August 1968 issue of *Art in America*. Formerly a curator at the Whitney Museum of American Art and a director of the University of Kentucky Art Gallery in Lexington, Bryant published his article one month before Blasdel's appeared in the same magazine.

To a certain extent, Simon Rodia's *Watts Towers* in Los Angeles were also considered an isolated phenomenon at this time (fig. 45). Between 1921 and 1954 Rodia, a diminutive immigrant from Italy, built a walled complex of looming towers and cagelike structures, using steel rods, concrete, and a glittering miscellany of broken glass and pottery. Rodia abandoned his all-consuming effort before completing it. Critic Jules Langsner's photographic essay of the *Watts Towers* in *Art and Architecture* in 1951 attracted some national attention, as did Calvin Trillin's 1965 *New Yorker* essay, which documented efforts to preserve the *Towers* and raised the issue of defining the work.[105] Artists from both southern and northern California, however, were visiting the site before it became fashionable. Edward Kienholz, Bruce Conner, George Herms, and Wallace Berman, all centrally involved with assembling and transforming found objects on the West Coast, were among them.[106] Others, like the painter Mae Babitz and the photographer Seymour Rosen, have actively worked to save the *Towers* throughout its troubled existence since the 1950s. From Rosen's involvement with the *Towers* would grow his extensive photographic documentation of other

environments in California as well as his organization Spaces Inc., formed in 1978 to document and help preserve such projects across the country.

When Gregg Blasdel's article appeared in 1968, no one knew that works similar to the *Watts Tower* have existed nationwide since the late nineteenth century.[107] Forced to classify what he had discovered, Blasdel chose the term "grass roots" to suggest their intimate relationship with the landscape in which they were made and the humble origins of their makers. The creators of these works were not trained as artists and did not call themselves artists. Many, however, have expanded upon experience related to their vocations, a fact that coincidentally connects them to other self-taught artists. Semantically and conceptually, the environments still challenge folk art circles and the larger art world, both unsure of how to evaluate the motivation or bravura of these projects. Hemphill, who began to broaden his perceptions of folk art even more during the early 1970s, was among the first to embrace the larger-than-life projects in his 1974 book on twentieth-century folk art.

These various scenarios reflect the vigorous spirit of the country's second folk art rush. It rolled on the cultural energy of the 1960s and early 1970s, a period marked by tumult, political as well as artistic. Starting with the assassination of President Kennedy in 1963, and ending with Nixon's ignominious resignation, it was a turbulent time, and the overwhelming media coverage made it difficult to escape a sense of constant social upheaval.

Less obvious to the general public, but similarly significant within the American art world, was the discontent spreading among artists across the country. Two exhibitions that opened in 1969 reflect that discontent.

Henry Geldzahler's "New York Painting and Sculpture, 1940–1970" was a major event for the art establishment. A source of endless parochial squabbles in and out of the press, the show linked three generations of abstract artists, codifying at once the abstract as the country's modern art as well as its avant-garde. With the exception of Joseph Cornell's symbolically laden constructions, Geldzahler excluded art with any figurative references or intent. His choices underscored the dichotomy between abstraction and imagism that has haunted American artists struggling to create a dynamic art since the second decade of the century.

Nowhere was the struggle's renewal more evident than in the exhibition, "Human Concern/Personal Torment: The Grotesque in American Art," organized by Robert Doty at the Whitney Museum of American Art in 1969. Geldzahler's show received the art establishment's accolades and notoriety. Doty's received its silent treatment. The show's two role models were similarly received: "New Images of Man" at the Museum of Modern Art in 1959 and "Funk" at Berkeley's University Art Museum in 1967, both organized by another experimental curator, Peter Selz.

By the early 1960s the expressive or illusionistic imagery of artists such as Red Grooms, Larry Rivers, Marisol, and George Segal were favorably recognized challenges to abstract art. So, too, were the innovations celebrated by the landmark exhibition, "The Art of Assemblage," organized by William Seitz at the Museum of Modern Art in 1961. Exposing the underbelly of contemporary figurative art in his show, "Human Concern/Personal Torment," Robert Doty raised the specter of the "alternative," a prospect shunned by New York's avant-

garde. He featured painters and sculptors whose imagery of "estrangement and the intensity of common experience" was a frontal assault on New York's canons of abstract, minimalist, and conceptual art.[108] Dark assemblages by southern California's Edward Kienholz, acerbic ceramics by northern California's Robert Arneson, sensually baroque fiberglass figures by New Mexico's Luis Jimenez, finely crafted enigmatic constructions by H. C. Westermann of Chicago and Connecticut, and high-strung figuration drawn by Chicago's Jim Nutt all suggested that independently minded artists were working around the country.[109]

California became one breeding ground for the new and the maverick; the state spawned artists searching for alternatives during the 1950s and 1960s. This was especially true of those in the San Francisco Bay area during the heyday of the counterculture movement. Artists as diverse as ceramic sculptors Peter Voulkos and Robert Arneson, Fluxux agitator George Maciunas, and painters Joan Brown and Wayne Thiebaud were among the artists involved. A self-conscious eccentricity, a concerted denial of traditional materials, a reinvention of Dada formulas and agendas, and a forceful, "do it" attitude were all part of the artistic climate. Comics, advertisements, movies, and kitsch became important sources of inspiration, as did the work of other cultures and self-taught American artists. The outdoor visionary environments found throughout California were another particularly influential resource for California's experimental artists who sought to make metaphorical statements with found materials.[110] During the late 1950s and into the 1960s, many of California's artists produced a gritty, sensual, tactile, and wacky body of work that can best be described as "Funk."

Since the 1930s Chicago has nurtured a highly personal figurative art. H. C. Westermann, whose constructions and drawings from the 1950s played with appearances and content, opened a path for the city's younger artists whose interest in making powerful statements did not accommodate mainstream styles. During the 1960s artists such as Jim Nutt, Gladys Nilsson, Ray Yoshida, Karl Wirsum, Roger Brown, and Ed Paschke began harvesting Westermann's lesson as they developed a figurative art that still startles as much for its humor as its hysteria in sharply colored, flawlessly drafted images.

Loosely associated under the rubric "The Hairy Who," or "Chicago Imagists," these artists have mined the so-called high arts as they looked at the city's resources in Surrealism, Expressionism, and Oriental art. Equally productive was their familiarity with enthnographic material and the comics, indoor and outdoor advertising, and the various broadcast media (fig. 46). "Trash treasures" from tattoo parlors, amusement parks, burlesques, and dime stores were other vernacular resources.[111] The search for unpretentious, genuine expression also led these experimental Chicago artists to the work of twentieth-century self-taught artists, particularly Joseph Yoakum and Martin Ramírez. Jim Nutt neatly summarized the group's affinity for their work: "Yoakum's work for me is fantastic, true fantasy, and I came to learn that I had a right to my own when I realized I was willing to accept his. When you see someone like Ramírez or Rodia or Yoakum striding out on their own, it makes you feel more comfortable with doing that yourself."[112] The efforts of anonymous figures, however, were equally prized. H. C. Westermann had collected rustic or ephemeral examples during a cross-country car trip in 1964, and most of the Chicago artists and critics involved with imagism earnestly collected ethnographic and folk art as

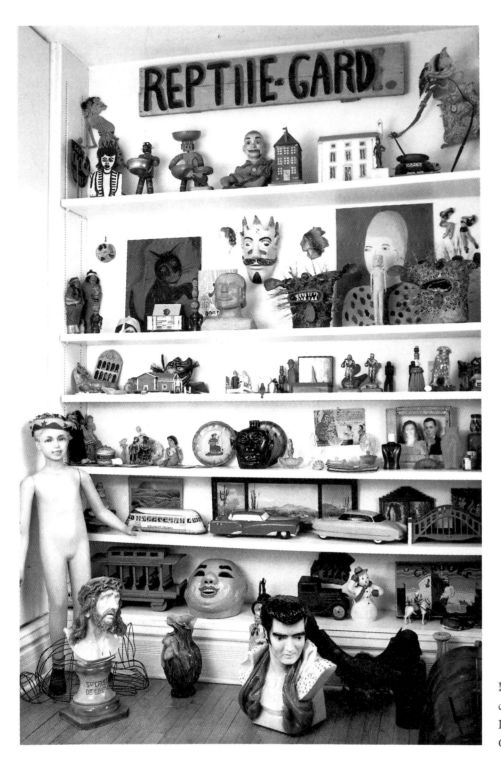

Fig. 46 Sampling of Roger Brown's collection, Chicago, Illinois, 1987. Photograph by William H. Bengston, Chicago.

well as cheap, offcast "things." Their collections reveal the profound, although seldom direct, influence of these materials on the character of Chicago's contemporary art.

Nationwide, independently minded artists found alternatives to New York modernism that were reinforced as they discovered and collected American folk art. Although New York's avant-garde ignored Robert Doty's exhibition, it attracted many of these young artists in search of sympathetic eyes. Doty began traveling throughout the South and Midwest in search of artists for the Whitney's biennials. From the West, the Midwest, and the South especially, artists also began making pilgrimages to New York during the late 1960s. Artists brought

their slides to Doty and to Ivan Karp, director of the O. K. Harris Gallery. A self-proclaimed maverick, Karp opened his space in 1969 after cutting his teeth at the gallery of Leo Castelli, for whom he had identified fresh young talents such as Roy Lichtenstein. To his new enterprise Karp brought his reputation for being willing to show almost anything. "I like to see everything," he said, and news of that willingness spread to artists as Karp juried exhibitions across the country.[113]

Slides of their work were not the only things many of these artists carried with them. Those involved with folk art, whether as artists only or as collectors, pickers and dealers, often brought their finds to New York. At that time one person alone was folk art's equivalent of Robert Doty and Ivan Karp. Bert Hemphill became the hub of a taste-making phenomenon, a benign father figure who galvanized and focused the energies and ambitions of a younger generation of rebels.

Timing was obviously an important factor. Presented less than one year after Doty's and Geldzahler's shows, Hemphill's exhibition of twentieth-century American folk art alerted artists to someone receptive to the material they were finding. Young artists, Michael Hall's students among them, perceived Hemphill's subsequent macramé, tattoo, and occult shows as ratifications of an alternative aesthetic or viewpoint not unlike their own. Hemphill's efforts in a New York-based public forum suggested that what was happening in New York was happening culturally. Clearly, something was on the horizon, putting down roots in New York, and making it tangible for artists.

Although the Museum of American Folk Art contributed to the education of these young artists, the museum clearly preferred collecting older, more conservative folk art, despite Hemphill's efforts. Artists eager to see more or to share their finds gravitated instead to his small duplex apartment on East Thirtieth Street, a private forum where a constant dialogue took place. As he had with the Halls, Hemphill laid open his collection, library, and contacts. In many respects, he conducted a casual if not haphazard salon where "everybody came, everybody went through things, and everybody ran into somebody they didn't know before."[114] Artists came away with a dramatic picture of the significance, diversity, and ongoing nature of objects made, used, and valued by people. As Julie Hall has observed, "The fact is, Bert let the world intrude in the melée, the cacophany of objects that's there. In all of its splendor and confusion his mixture of things stimulates you to think about what else is out there."[115]

For Hemphill, the interest artists took in alternative expressions provided access to a national network of newly discovered self-taught artists and anonymous material. And, the objects artists brought to his attention became a moveable feast for someone so acquisitive as Hemphill. As a result of this cross fertilization with artists and their ideas, Hemphill began purchasing works at an accelerated pace. Showcased in his apartment, the mounting numbers of twentieth-century folk objects demonstrated Hemphill's vote of confidence in the material and, in effect, ratified its exploration by artists. Moreover, Hemphill's advocacy as a collector actually created contemporary folk art's market, for which he was the principal client during the early 1970s. Not until Hemphill's book, *Twentieth-Century Folk Art and Artists*, appeared in 1974 was it clear, however, that contemporary folk art had found its home in New York's art world and its

marketplace. Sterling Strauser summarized the situation when he observed, "The hard thing, the important thing about naive artists is to get them into strong hands. Bert is strong hands; somebody whose collection makes other people wish they had it."[116]

BABY, LOOK AT YOU NOW: 1974–86

Never having married, Hemphill's collection has become, in a way, his family, providing the companionship of objects as well as friends and colleagues. For a younger generation his activities as a seasoned and pioneering collector have taken on parental connotations. Uncomfortably cast in that role, Hemphill has nonetheless recognized his responsibilities to the values and issues of the folk art field. Both publicly and privately he has mused "What's happening to the baby?", when referring to his collection or to the field itself.[117] His question reflects fatherly concern and a parent's sense of nurturing, but it also registers surprise in reaction to the field's dramatic changes between 1974, when he and Julia Weissman published *Twentieth-Century Folk Art and Artists,* and 1986, when the National Museum of American Art acquired the core of his collection.

Nineteen seventy-four was a benchmark year for folk art. Two exhibitions and four publications defined the field's parameters at that time. In February, the Whitney Museum of American Art opened its nationally touring exhibition, "The Flowering of American Folk Art (1776–1876)" in New York. Organized by Jean Lipman and Alice Winchester, the mammoth survey codified the appreciation of early folk art as an aesthetic statement, not only for those intimately involved with the field but for the larger art world and the general public as well. Indeed, the dramatic increase in the popular audience for folk art stems from this exhibition.

Winchester, longtime editor of *Antiques* magazine, and Lipman, then editor of *Art in America,* asserted that folk art was "a central contribution to the mainstream of American culture in the formative years of our democracy."[118] Both organizers juggled a tricky contradiction. They emphasized "art" rather than "folk" to establish the aesthetic merit of the objects presented. They insisted, however, that originality and craftsmanship were virtually the only criteria for evaluating that merit since other standards usually applied to art were not relevant.

Indeed the first to survey the entire range of early American folk art, the exhibition and publication brought the field full circle into New York's perception of American art. Exactly fifty years earlier the Whitney's predecessor, the Whitney Studio Club, had presented the country's first public exhibition of folk art. By 1950, however, the Whitney museum had sold the folk art collection of Juliana Force, the curator of that first effort and one of its early directors. Until the Museum of Modern Art circulated its show of contemporary folk painters in 1966, it too had abandoned the field that had been advanced through the pioneering exhibitions of its curator, Holger Cahill, in the 1930s. Although the Museum of American Folk Art conducted an active exhibit and education program after 1961, the struggling institution could not compete with the cachet or resources of a major museum. In many respects, the Whitney accomplished in one fell swoop what the much smaller museum had aspired to over a period of

years. Ultimately, the Museum of American Folk Art, under the direction of Robert Bishop after 1976, would reap the benefits of the Whitney's popular exhibition and its accompanying publication.

The art world's critical response to the "Flowering of American Folk Art" took folk art well beyond its parochial consideration in antiques columns. *Newsweek*'s Douglas Davis claimed that the exhibition "heralds much more than a shift in taste or a surge in prices for old paintings and weathervanes hidden in dusty attics. It implies nothing less than the rewriting of American cultural history" and that its contents were "the sum of an alternative culture that is almost lost."[119] Hilton Kramer, critic for the *New York Times*, interpreted the effort as "the recovery of the American imagination as it has expressed itself in visual terms" during a turbulent period that, to his mind, paralleled the Depression era's attempt to locate our national identity.[120]

Two other critics, however, departed from this archeological tone. At *Time*, Robert Hughes reminded readers that folk art was then "an industry with scholarly spinoffs" and that "It is mildly ironic that such unpretentious objects, conceived and made without much more than a fleeting reference to the canons of eighteenth- and nineteenth-century mainstream art, should now have lost their practical use and migrated to the museums."[121] Thomas B. Hess delivered the most cogent and timely evaluation in *New York Magazine* when he noted that the methodologies of cultural anthropology indicate that

folk art does not operate in opposition to savant art, as had been thought, but rather in an intimate, polar relationship, the latter continually feeding and amplifying the folk repertory. And, logically, it becomes evident that the genius of the folk artist does not lie in his creation of new forms from some ideal, uncontaminated source of inspiration, but in how he changes the savant prototype, how he adapts it, simplifying and accentuating its elements to fit new requirements.[122]

Hess called for placing folk art in a social and historical context and criticized the show's organizers for clinging to sentimental nostalgia and "marveling" at folk art's presumed forecasting of modern art.

Another landmark show of the mid 1970s opened in Minneapolis in March 1974 at the Walker Art Center, a museum well known for its experimental spirit. Called "Naives and Visionaries," the show was accompanied by a publication of the same title. Inspired by Gregg Blasdel's research, the Center's director, Martin Friedman, mounted the first full-scale attempt to examine a group of environments in a museum context. The installation relied heavily on photographic documentation since all but one of the nine environments selected were immovable. The physical centerpiece of the exhibition, however, was James Hampton's *Throne of the Third Heaven of the Nations Millenium General Assembly*. Dedicated to the Second Coming of Christ, this shimmering complex of 177 foil-wrapped objects is the only major environment capable of being installed in settings other than the garage where it was built in Washington, D.C. (figs. 47 and 48). Overlapping with "The Flowering of American Folk Art," Friedman's project provided a radically different view of how far the folk art umbrella could be stretched. Characterizing the site-specific projects as "bizarre," "chaotic," "unique,"

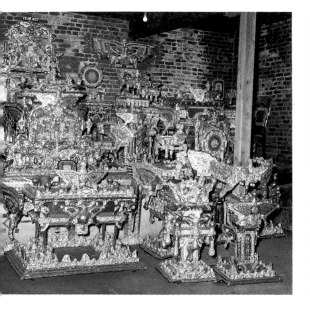

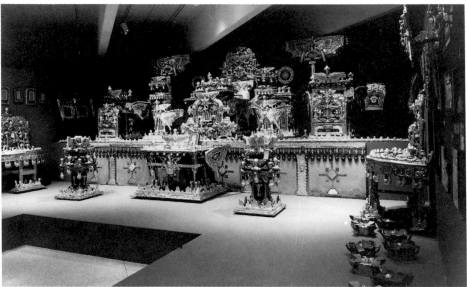

Fig. 47 Detail of James Hampton's *Throne of the Third Heaven of the Nations Millenium General Assembly*, ca. 1950–64, installed in its original site of construction, a garage in Washington, D.C., 1965. Courtesy National Museum of American Art, Washington, D.C.

Fig. 48 James Hampton's *Throne of the Third Heaven of the Nations Millenium General Assembly*, ca. 1950–1964, installed in "Naives and Visionaries," at Walker Art Center, Minneapolis, Minnesota, 1974. Courtesy Walker Art Center.

and "isolated," Friedman, however, forestalled their consideration as cohesive, deliberate expressions of individuals more attuned to cultural traditions, national life, or local settings than they were perceived as being at that time.

Also published in 1974 was Robert Bishop's *American Folk Sculpture,* a comprehensive pictorial anthology of material that had long been overshadowed by the field's early preference for the two-dimensional. Although Jean Lipman had published the substantial *Folk Art in Wood, Metal and Stone* in 1948, Bishop's book embraced a much wider range of three-dimensional objects, updated the universe of known examples, and mingled sculpture from the eighteenth to twentieth centuries in his diverse categories.

Bishop culled his material from years of traveling. He was a very young dealer in New York from the late 1950s to 1966, when he moved to Ingster, Michigan.[123] There, he earned a Ph.D. in American culture at the University of Michigan, while serving as the curator of American Decorative Arts, and then museum editor for the Greenfield Village and Henry Ford Museum until 1976. He also continued his activities as a private dealer, holding informal but influential folk art showings in his home. His early preference was formal and fine country furniture. During the 1960s and 1970s, however, Bishop discovered works by twentieth-century figures such as painter Dana Smith (cat. 170), environmental sculptor Clark Coe (cat. 184), iconic carver John Perates (cat. 99), and expressionistic painter Mose Tolliver. These experiences disposed him toward incorporating twentieth-century examples into his survey of American folk sculpture. And it was Bishop's estimation of Hemphill's *Indian Trapper* and *Squaw* that signaled the turnaround in appreciation of yet another collector's eye for offbeat early objects: "These masterpieces of American folk sculpture, unique both in the monumentality of their conception and in their fascinating details, make almost all other cigar store figures look slick by comparison."[124]

Co-authored with Julia Weissman, Hemphill's *Twentieth-Century Folk Art and Artists* was long in the making before its publication in 1974. A transplanted Texan, Weissman was an editorial assistant in New York where she regularly visited museums and galleries (fig. 49). Her interest in primitive art led her to

the Museum of American Folk Art during the late 1960s, and in 1970 she saw Hemphill's twentieth-century exhibition.[125] From this revelatory experience grew her interest in preparing a book, and her search for a coauthor naturally led to Hemphill. Initially, he declined the collaboration since he believed writing was not his forte. To her credit, Weissman persisted until Hemphill agreed, and the pair launched a massive campaign to identify candidates for the book, which was to go well beyond the scope of the original exhibition.

Weissman corresponded with museums, galleries, and community centers around the country, while Hemphill tapped into his network of contacts. Together, they compiled copious files. Excerpts from Weissman's letters suggest their intent. To Gustave Klumpp, an elderly painter in Brooklyn, she explained the perception of folk art she shared with Hemphill: "By folk art, we mean work by untaught artists, people like yourself who have never studied art and are not professional artists."[126] In a note to Robert Tessmer, director of the Red Hook Senior Center where Klumpp had started painting, Weissman added an illuminating "P.S.: Incidentally, our criteria for folk art are not limited to the standard media of painting and sculpture, so if something rare turns up—unusual material, unusual construction, assemblage, or collage—and you think it interesting, get in touch."[127]

Their inquiries unearthed more than Weissman and Hemphill could ever have imagined. Making sense of material ranging from faces painted on pebbles to the "stop the presses" discovery of "Uncle Jack" Dey's schematic painting of Adam and Eve (cat. 111) became the challenge. The coauthors turned to Robert Bishop, the Halls, and Cyril I. Nelson, the book's editor and a folk art collector in his own right, for help in winnowing and shaping the selection.

In its final form, *Twentieth-Century Folk Art and Artists* includes the work of 145 identified and fifty-nine anonymous artists. Opening with a colorplate of Morris Hirshfield's 1945 painting, *The Artist and His Model,* the book remains true to Hemphill's desire to demonstrate a continuum. Its contents are arranged chronologically as a "broad survey of the wealth and variety of American folk art produced since 1900."[128] The eclecticism that marked Hemphill's exhibition is also very evident in the book's mélange of paintings, drawings, sculptures, constructions, collages, decoys, neon trade signs, whirligigs, textiles, ceramics, and site-specific environments. The quality of the works included also varies widely, from crafty felt cutouts to the eerie animated carved dolls in Calvin and Ruby Black's *Possum Trot and Fantasy Doll Show* (cat. 187). Finally, Hemphill stipulated that the book represent a broad spectrum of artists of all ages, occupations, ethnic groups, and geographical locations.

Julia Weissman primarily wrote the book's introduction. To reflect upon the individuality of folk art and artists, she relied heavily on the theories of art historian Herbert Read and painter and art educator Henry Schaefer-Simmern. Weissman observed that "the vision of the folk artist is a private one, a personal universe, a world of his own making," while Hemphill, sounding a democratic tone, added that "the products of the folk art world are truly the art of the people, by the people and for the people."[129] Somewhere between the isolationist and patriotic overtones of their statements is the deeper truth they intended to convey: art can be made by anyone whose sensibility seeks no other alternative but visual expression. Subliminally, the introduction is a tribute to Edgar Tolson's impact on Hemphill's perception of contemporary efforts, since its ten illustrations

Fig. 49 Julia Weissman, 1981.
Photograph by Michael Hall, Bloomfield Hills, Michigan.

are solely those of the carver and his works. These people-oriented statements and photographs set the tone for the rest of the book, a compendium of captioned illustrations. Hemphill and Weissman did not inject their opinions about the works. Instead, the captions emphasize biographical information and whenever possible include statements from the artists.

Unlike the publication for *The Flowering of American Folk Art*, Hemphill's and Weissman's book received little notice in the press beyond one review in the *Wall Street Journal*. The *Journal's* reviewer noted that it was the first book about modern folk artists in over thirty years and then waxed poetic about the "folks" as "rare individuals whose visions have stayed pure in the face of mass education, mass media and mass macrame."[130] Despite its lack of public attention, the book has persisted in its influence, especially among collectors and dealers, and can still be described as the major pictorial anthology of twentieth-century folk art. Sterling Strauser appears to have coined its designation as contemporary folk art's "bible," a term he feels describes its universality as a reference book and its power to convert readers to the art it champions.[131]

Understandably enough, the person most affected by the book was Hemphill himself. By 1974, anyone familiar with his collection over time could tell that it was undergoing tremendous changes. Gone was the modern and primitive art. Hemphill divested himself of it around 1967 for personal reasons as well as to finance other acquisitions. Unable to afford the mounting prices for nineteenth-century folk art, Hemphill retreated from that arena, adding early examples intermittently at best. While organizing his various shows for the Museum of American Folk Art, he often collected in tandem with their topics, a pattern most evident after his twentieth-century exhibition in 1970, and certainly reinforced by preparations for the book. His introduction to contemporary folk art during the late 1960s was fortuitous. Stimulated by his interaction with those finding the material, Hemphill also created his own opportunities to collect as he traveled throughout the country. His trips between 1970 and 1974 gleaned material for the book and unleashed his acquisitive appetites. His expeditions after the book's publication fed his commitment to finding twentieth-century

Fig. 50 Hemphill with objects gathered during a southern trip, 1978. Photograph by Jeffrey Camp, Richmond, Virginia.

material, evidenced by the more than fifteen hundred objects added to the collection during the 1970s and 1980s.

By his own admission, Hemphill is a folk art "addict."

One does really need the "fix." You find yourself lethargic or depressed. It's like some people needing to buy a new hat or suit. . . . The drive to do it makes me vulnerable. It sometimes causes distortions in my perspective but I am a survivor. I can expend love on objects without a fear of loss or rejection. . . . I would also not discount boredom. It drives you to continually revitalize yourself. . . . I can't imagine that anyone who could sit in front of the same four pictures for a lifetime could have a very intelligent or inquiring mind. . . . Anyway, I need new things to look at and I go looking for them.[132]

Hemphill's search for new things has developed a farflung circuit (fig. 50). Since the early 1970s, trips to Chicago have found him not only at Phyllis Kind's gallery but also in the homes and studios of Roger Brown and Whitney Halstead, as well as the tiny clapboard house of Albina Felski (fig. 51). A painter discovered by Kind, Albina Felski was included in "Contemporary American 'Naive' Works," the first effort to exhibit newly found self-taught artists at Kind's gallery in March 1972.[133] On the heels of Hemphill's exhibition at the Museum of American Folk Art, Kind was the first dealer to showcase this recent material. Road trips with Kind have taken the pair in different directions: to the Strausers in Pennsylvania, to Miles Carpenter in Virginia, or to Fred Smith's outdoor environment, *Concrete Park,* in Phillips, Wisconsin.

Fig. 51 Albina Felski, with her painting, *Indian Village,* at the Art Institute of Chicago, 1972. Courtesy Albina Felski, Chicago.

Fig. 52 George López at the National Folk Festival, Wolf Trap Farm, Vienna, Virginia, 1974. Photograph by Joshua Horwitz, courtesy Elinor Horwitz, Chevy Chase, Maryland.

In his desire to widen the geographic scope of both the book and his collection, Hemphill made at least three tours through the Southwest before and after 1974. The collector remembered a visit with the carver George Lopez (fig. 52) during a trip in 1972: "He would make souvenir things which he sold in his front room. In the back room were the more elaborate big things. He'd let me in there, and I knew the whole family. That's where I bought the devil under the foot of St. Michael (cat. 126). At that time I saw his father's house, where I saw the screen door that I've just bought (cat. 3)."[134] On several later occasions Hemphill went to see one of his favorite carvers, Felipe Archuleta, with Davis Mather, the artist's representative in Santa Fe. Michael Hall vividly recalls the fruits of a southwestern trip when Hemphill set out to find the "inheritors of the *santero* tradition."[135] En route from Arizona and New Mexico around 1972, Hemphill and his friend James Spies drove up to Hall's house at the Cranbrook Academy in a "car that was absolutely bristling with stuff picked up along the way, everything from matchstick crucifixes, Lopez carvings, no Archuletas—he didn't have any at the time—but that extraordinary carved complete skeleton, a couple of average *bultos*, souvenir shop stuff, Navajo pictorials—and Jim Spies and Bert Hemphill barely able to wedge themselves in. . . ."

Fig. 53 S. L. Jones, Hinton, West Virginia, 1981. Photograph by Jeffrey Camp, Richmond, Virginia.

Hemphill also explored the Southeast, a territory familiar to him since childhood when he regularly visited his mother's family in Columbus, Georgia, or accompanied his parents as they drove between Atlantic City and Florida during the winter. In 1972, as James Spies and Hemphill drove through West Virginia, they stopped at Charleston's historical society where Hemphill spotted a display of carvings by Shields Landon Jones (fig. 53). With the help of Tom Scriven, editor of *Golden Seal Magazine*, they found Jones's house in Hinton, and Hemphill bought his first carvings by Jones—a group of stark, trophylike heads—from the artist's wife. He returned to visit the couple several times. Although Jones showed his work at local fairs, it was not until Hemphill brought the artist's carvings and drawings to the attention of Phyllis Kind and Jeffrey Camp that Jones enjoyed the attention of the folk art world. If the person who acts after finding someone's work can be described as having discovered it, then Hemphill should be credited with discovering S. L. Jones.

Concentrated between 1972 and 1977, Hemphill's southeastern travels inspired significant additions to the collection. As early as 1966 he had acquired his first

Fig. 54 Lanier Meaders at work, Mossy Creek, Georgia, ca. 1972–73. Photograph by Jeffrey Camp, Richmond, Virginia.

piece of Georgia's "oatmeal" pottery while visiting Columbus. Actually, "I swore I'd never collect pottery, but I suddenly flipped," he said, and he began buying southern pottery in bulk in 1974, while traveling through Kentucky, Alabama, Georgia, and the two Carolinas.[136] On that one trip alone he bought at least seventy-five pots, pitchers, churns, vases, and face vessels (cat. 38 and cat. 40). Bob Bishop recalls that "the first time I ever saw southern pottery . . . was on the floor in his [Hemphill's] apartment, and we all went by and absolutely marveled at it, but still didn't pay any attention to it because it was just not—well, it just wasn't New England."[137] The seventies was the decade of serious fieldwork on southern pottery by folklorists Ralph Rinzler, Charles Zug, and John Burrison, as well as the beginning of renewed interest in collecting American crafts. New York's folk art world, however, was not ready for Hemphill's newfound interest. For his part, Hemphill greatly appreciated the time that Lanier Meaders took to demonstrate the firing and glazing techniques for both his functional pottery and face vessels during his first visit with the White County, Georgia, potter in 1974 (fig. 54).

Hemphill's most productive southern forays, however, have revolved around Jeffrey Camp. Twenty-eight years old in 1972, Camp left the public relations business and established the American Folk Art Company in Richmond, Virginia (fig. 55). After closing the shop in 1976, Camp and his wife Jane continued their efforts privately in Tappahannock and Richmond. Growing up in what he describes as a "light blue collar family," he had little exposure to art when he opened a business devoted to "things made by hand in America."[138] An expansive personality, Camp has taken an open-minded yet clearly focused approach to having "the folk experience under one roof." At any given time his tiny shop offered a freewheeling inventory: steel knives made from saw blades, new or old quilts, baskets and pots, country canning, cookbooks, re-recordings of early Leadbelly records, rural furniture, and whirligigs. The carvings, paintings, and constructions by contemporary southern self-taught artists that he began finding were right at home in this company and provided his entrée into the folk art world in 1973.

Camp's search for material took him on marathon trips throughout the South. "The minute I got something I liked, I was fueled and ready to roar from then on. Because really it was bang bang bang here there and everywhere, whether it

Fig. 55 Jeffrey Camp's American Folk Art Company, Richmond, Virginia, 1974. Photograph by Jeffrey Camp, Richmond, Virginia.

Fig. 56 Harold Garrison with a *Watergate Gun*, Mars Hill craft cooperative, Mars Hill, North Carolina, 1974. Photograph by Jeffrey Camp, Richmond, Virginia.

was a front porch or an antique shop or an artist's house. In about two days I could fill a Maxivan chockful even in the drawers of things; there wasn't an inch of space left." Camp's circuit included mountain craft cooperatives in North Carolina where he found the carvers Harold Garrison (fig. 56) and Russell Gillespie, the pottery districts of Georgia and South Carolina, back country roads in Virginia where he spotted Patsy Billups's paintings tacked on her house, daybreak openings of flea markets for the pick of quilts or hooked rugs or pie safes, and Richmond's blue-collar neighborhoods where the paintings of retired policeman "Uncle Jack" Dey cropped up. Camp's most ambitious efforts, however, were devoted to promoting the carvings of Miles Carpenter and the multimedia works of the Reverend Howard Finster near Summerville, Georgia.

In July 1974, the *Wall Street Journal* featured Camp in an article, "Folk Art Finders," based on the writer's efforts to keep up with the dealer on one of his buying trips.[139] The article mentions Hemphill, whom Camp had met only months before with the help of the Connecticut collector Gary Stass. Camp and Hemphill immediately became friends. Hemphill had met an enthusiastic newcomer with a sharp eye, addictive acquisitiveness like his own, and territory rich in resources. The younger found the openness and encouragement of an informal mentor as well as an eager client. From three lengthy trips together and fairly regular contact, Camp helped Hemphill acquire a substantial body of southern work, from pottery, canes, and whirligigs made with muffler parts, to major paintings by Howard Finster and "Uncle Jack" Dey and carvings by Carpenter and Harold Garrison (cat. 111 and cat. 91). Today, Hemphill recalls that some of his warmest visits with a folk artist were those spent having barbecue with Miles Carpenter and Camp's family in Waverly, Virginia.

The Hemphill collection contains items from nearly all the fifty states. Although his open-door policy has introduced more than three thousand objects to those who have come to his apartment, the works themselves have also attracted a public forum. Approximately twenty-four museums across the country have hosted exhibitions devoted to his collection between 1973 and 1988. In 1976, the American Bicentennial Commission selected his collection for a goodwill tour throughout Japan (fig. 57).[140] Often, collectors do not welcome such widespread exposure. Hemphill, however, has said, "I don't feel that I own the collection. I don't believe that in theory any individual can or should own art. We as collectors are curators and conservators. Art belongs to history. This may sound

Fig. 57 Installation of "American Folk Art from H. W. Hemphill, Jr., Collection," circulated to Japan by the American Bicentennial Commission, 1976. Courtesy Herbert Waide Hemphill, Jr.

Fig. 58 Installation of "The Herbert Waide Hemphill, Jr., Collection of 18th, 19th, and 20th Century American Folk Art," at the Heritage Plantation of Sandwich, Sandwich, Massachusetts, 1974. Courtesy Herbert Waide Hemphill, Jr.

pretentious, but it is how I think, and it is the reason why my collection has always been available to those who wanted to see it and why I have loaned so many of my things to exhibitions."[141]

In 1974 the Heritage Plantation of Sandwich, Massachusetts, organized "The Herbert Waide Hemphill, Jr., Collection of 18th, 19th, and 20th Century American Folk Art." Including 270 works, the exhibition was the public debut of Hemphill's twenty-year career as a full-time collector. After selecting the works, the museum gave Hemphill free rein for the installation, which featured sympathetic groupings of objects on the side walls and a central island of sculpture (fig. 58). Although staged outside of New York, the show was reviewed by the *New York Times*'s Rita Reif. She wrote ". . . this is a highly personal, provocative and controversial collection," noting that it embraced exceptionally crafted as well as crude objects made over such a wide span of time.[142]

The national tour circulated by the Milwuakee Art Museum between 1981 and 1984 also produced the first major publication on the collection. Michael Hall's probing interview with Hemphill, curator Russell Bowman's essay on the significance of folk art's variety, and critic Donald Kuspit's consideration of contemporary folk art and the modernity of toys provided three very different but complementary perspectives. The show itself focused on 105 works considered the collection's "crown jewels." At the time, Hemphill stated

I get strong feelings about certain objects in the collection but my feelings alone cannot elevate anything to that designation. Simply stated, the crown jewels are the things that are chosen for exhibitions and books. They are the things that constantly epitomize what everybody thinks great folk art is. These things are crowned over time by a process of consensus which continually ratifies them from the outside. *Black Hawk, Stag at Echo Rock* etc.—these things have a life in a wider consciousness.[143]

Hemphill's sense of wider consciousness has always included dealers. Phyllis Kind and Jeffrey Camp were involved in the field as *Twentieth-Century Folk Art and Artists* went to press in 1974. Once the book appeared, however, it visualized the material's possibilities for a generation of young dealers.

From Michael Hall to Robert Bishop, many agree that James Kronen was New York's first dealer committed to twentieth-century folk art objects.[144] Although trained as a painter, Kronen was a jack-of-all-trades until the early 1970s. His career had a meteoric rise—from junk shop owner on Second Avenue to gallery dealer on upper Madison Avenue—until his premature death during the early 1980s. Among the first to discover Kronen's Second Avenue store were Hemphill and Hall, and it was clear to them both that Kronen favored unusual, anonymous objects, more often twentieth-century than not. At that time, it was easy to buy such objects along the avenue and elsewhere as curiosities and conversation pieces. Kronen quickly escalated his business activities, largely by recognizing two factors: the effects of Hemphill's activities in New York, and the importance of the Midwest as a territory that the East had not yet tapped for folk art. Though Kronen had a discriminating eye, he also developed a network of "folk art finders" that included Michael Hall, Jack Adamson, and Tim Hill, the latter just then entering the business as a country furniture and antiques dealer outside of Detroit.[145]

The term "picker" is used widely in the folk art business, although its origins are unclear. No doubt it became popular by the 1920s when rummaging for weathervanes and the like became a business; Sterling Strauser, for example, clearly recalls that Jack Chamberlain called him a picker during the late 1920s.[146] Tagged to the obvious connotations of plucking and gathering has probably been a less flattering characterization coined in 1884 when Cassell's *Family Magazine* mentioned "pickers" who scavenged rags in the streets. In 1893, in a story about people subsisting on pickings from household rubbish, a newspaper article noted that "There are pickers and pickers . . . aristocrats and plebians in this profession as in every other."[147] Locating something that someone doesn't want but that can be sold to someone who does, striking a bargain, dealing in volume in hopes of finding one good thing—these are the staple activities of pickers. Often, they have initiated the upward movement of folk art and antiques through an economic pyramid internally well defined and culminating in sales to prestigious dealers, collectors, and museums.

From these origins, Kronen developed an inventory impressive enough to take uptown when he decided to feature folk sculpture and contemporary art in a posh gallery near the Whitney Museum of American Art. His eye for exciting material matched his ability to promote it, and he developed an important clientele that included a private collector who has built the exceptional Marvill Collection, as well as Elizabeth Johnson, who later sponsored another folk art gallery.

Kronen's activities attracted the attention of the Brooklyn Museum, where Michael Kan, curator of African, Oceanic, and New World Cultures, responded to Kronen's proposal of a contemporary folk sculpture exhibition as its bicentennial project. Enlisted as the organizer, Hemphill altered the concept to include key historical pieces and selected the contents of "Folk Sculpture USA" by committee with the Halls and Kan. Although several important works were snared instead by the Whitney for the folk art segment in its blockbuster "Two Hundred Years of American Sculpture," the two shows ultimately complemented one another when they opened in 1976. With the notable exception of James Hampton's *Throne of the Third Heaven*, the Whitney featured folk objects that substantiated the time-honored modernist perception. At the Brooklyn Museum a different brand of folk sculpture was evident—more often quirky than classic, rough-

edged than elegant. The show's catalogue also signaled a different perspective in Hall's discussion of collecting folk sculpture as a contemporary sculptor, Daniel Robbins' forceful argument against the existence of the "folk," and Michael Kan's exploration of the material's ethnic sources.

Kronen's activities also stimulated other dealers. During the late 1960s, Roger Ricco (originally from Milwaukee) abandoned his career as a young artist in New York and opened a lower East Side business devoted to restoring and mounting ethnographic objects. Discovered by Hemphill and Kronen at about the same time during the mid 1970s, Ricco began expanding his business to include American folk art. "Floored by material that he never knew existed in our culture," he recognized that something was growing as folk art image in New York. Inspired by Kronen and Hemphill, Ricco was buying and selling "raw things" that he calls "pre-art" by the late 1970s.[148]

Around 1979, Ricco met native New Yorker Frank Maresca. Maresca's love of objects with "wonder, fantasy and mystery" began as a child when he explored the Museum of Natural History's storerooms where an uncle was a curator.[149] A still-life and fashion photographer in the city since 1970, Maresca began collecting American antiques and accessories for his apartment. After seeing Hemphill's streamlined owl decoy (cat. 15) in the collector's 1974 book, Maresca became a decoy collector. By 1977 Maresca was dealing in American antiques, largely at shows throughout New England.

Two years later Maresca learned of Ricco's restoration business and the two discovered they had much in common. From very different directions they were both gravitating to the "rough raw primal edge" championed by Hemphill and Kronen, and Maresca especially acknowledges the influence exerted by the exhibition "Folk Sculpture USA." For three and a half years during the early 1980s, Ricco and the collector Elizabeth Johnson operated the Ricco-Johnson Gallery in Soho, where they specialized in the work of contemporary American primitive artists, identified as well as anonymous. Maresca developed a successful American furniture business in the meantime. The two men joined forces around 1986, and now operate a gallery in New York.

Around 1975, the Philadelphia dealer Janet Fleisher discovered Hemphill's book. In the art business since 1952, Fleisher had been handling ethnographic art since 1970 and occasionally offered nineteenth-century portraits or paintings by Horace Pippin, the contemporary "naive" son of West Chester, Pennsylvania. In 1975, the gallery presented its first major venture into the contemporary folk art arena, "Twentieth-Century Folk Art and Artists," named after Hemphill's book.

The gallery's director John Ollman organized the show. During the 1960s he was a sculpture student at Indiana University where artists-to-be questioned the relevance of art in contemporary society. About the same time, friends in the school's pioneering folklore department introduced Ollman to "folk art" as art that had a function.[150] In 1975, Ollman gathered almost eight hundred works from dealers and collectors Jay Johnson, Jeff Camp, Phyllis Kind, the Halls, New Yorker Jeffrey Wolf, and Hemphill himself for the exhibition. Densely installed on red walls, the ensemble of Finsters, Carpenters, Elijah Pierces, Inez Nathaniel Walkers, Sister Gertrude Morgans, and others, reflected the impact of Ollman's first visit to Hemphill's apartment. Initially, Philadelphia artists were the Fleisher Gallery's principal clients for the self-taught material. Many were

already aware of the work, having been in touch with Chicago's Imagist artists since 1969. That year Stephen S. Prokopoff featured the Chicago Imagists in "The Spirit of the Comics" at the University of Pennsylvania's Institute of Contemporary Art, while sculptor Italo Scanga, who taught at the Tyler School of Art, presented Joseph Yoakum's first one-person museum exhibition at Pennsylvania State University's art gallery.[151] Since 1975, Ollman has been instrumental in organizing exhibitions while building a national clientele, Hemphill among them, for the works of Finster, Ramírez, Yoakum, and Henry Darger, especially.

In 1981, when they first encountered it, Randall Morris and Shari Cavin felt that Hemphill's book transfixed them both. Morris and Cavin said the book opened new doors on folk art as it proclaimed "Look, there is something viable, fascinating, spiritually active here."[152] The young New York couple were collecting and dealing in ethnographic material, particularly Haitian paintings and Mexican masks. Interested in the dynamics of cultures as they clash or blend, Morris and Cavin considered twentieth-century art by Third World peoples as ethnographic rather than eccentric offshoots of traditional arts. Hemphill's book led them to the discovery of what they perceived as America's contemporary ethnographic art. A year later with the help of Jeffrey Camp, Morris and Cavin visited Hemphill's apartment for the first time. They realized that "if we had the wherewithal and the knowledge, we could collect like that. That changed as time went on, but at that point that's what it was. We felt very much at home, not in the chaos but in the fact that there was this world that could be collected. There were so many worlds in one room. It was a world eye." Morris expanded his familiarity with the American variations while working at the Ricco-Johnson Gallery. In 1981, Cavin and Morris created their own version of a world eye, mingling Haitian, Mexican, African, and American self-taught works in their loft-based Ethnographic Arts, Inc. They have continued the practice since 1987 at their Tribeca gallery Cavin-Morris Inc., where they have introduced a growing roster of newly found or rediscovered figures such as Louis Monza (fig. 59), Jon Serl (cat. 172), Bessie Harvey, and Andrea Badami. Today, Cavin and Morris acknowledge that "Bert strengthened us and then let us go our own way."

New dealers have benefited greatly from participating in New York's invitational Fall Antiques Show. The entrepreneur Sanford Smith first organized the now

Fig. 59 Louis Monza, Redondo Beach, California, 1982. Photograph by Ron Miller, courtesy Heidi Monza, Sequim, Washington.

annual event in 1978 to feature American material, something not done in the trade's other prestigious antique shows. Ricco, Maresca, Aarne Anton from New York, the late Larry Whitely from California, Carl Hammer from Chicago, Tim Hill from Birmingham, Michigan, among other young dealers nationwide, have featured objects rather than furniture and the usual accessories at the annual show. Their material has frequently favored the offbeat and the contemporary. Staged on the Pier, Sanford Smith's event has become known as the "American folk art show."[153] Whether visiting their galleries or their booths, Hemphill is acknowledged by this generation of dealers as their first and steadfast supporter, and his collection has expanded with their offerings.

By contrast, Hemphill's personal interaction with the academic folklore community has been limited, yet the collection has played a part in their reconsideration of folk material since the 1970s as well. No doubt he realizes that his activities as a collector represent the very attitudes and ideas that have sparked lively debate between two equally assertive groups engaged in the interpretation of folk art. On the one hand, connoisseurs of folk art (collectors, dealers, and curators) have invariably asked the objects of their delight to follow form more than origin, meaning, and function. On the other, scholars of folklore and material culture have assigned significance to both context and artifact in their evaluations of the macro and micro. Two conferences—one at the Henry Francis du Pont Winterthur Museum in Delaware in 1977, the other at the Library of Congress in Washington, D.C., in 1983—clearly delineated this dichotomy for the fields of folk art, folklife, and material culture. Hemphill attended both meetings in an effort to keep abreast of developments, but in fairly deliberate fashion he shied away, as he always has, from the philosophical debates that these two historic conferences stimulated. Ironically, he has provided sand for folklore's oyster, despite his discomfort with polemics and controversy. His predilection for the offbeat and his expansive embrace, more than his unabashedly aesthetic criteria, have stamped his collection as a potentially rich resource for the folklore community. His holdings represent a process of sorting that suggest the personal and cultural decisions involved in determining what to keep and to discard, what to order and to value. Offering his objects as their own best advocate (or irritant), Hemphill has been a passive yet effective agitator for those involved with the concepts of community, innovation within tradition, group taste, and contemporary rather than historical expression.

In 1983, Alan Jabbour's opening remarks for the Washington meeting on folk art included a cautionary observation: "Those who praise folk art, must be careful—to echo Shakespeare's sonnet—that folk art is not, at our instigation, 'consum'd by that which it was nourish'd by.' "[154] In his more eloquent fashion Jabbour has rephrased Hemphill's own concern about the effect of his efforts. Like many in its originally small and open community, Hemphill looks askance at today's competitive folk art field:

To give advice, guidance and inspiration is as rewarding to the teacher as to the pupil. If I have any regrets it is with the proliferation of dealers and collectors who have confused the material, either intentionally or through lack of knowledge. . . . It is different collecting now. There was a different freedom when we were just a small group and when speculation about twentieth-century material wasn't so profit-oriented.[155]

Having simply done what he thought he could do, Hemphill's collection has inadvertently become central and historical rather than peripheral and faddish. In 1986, the National Museum of American Art's acquisition of his collection's crown jewels and study pieces alike confirmed that status.

EXCAVATING A COLLECTION: SOUP OR ART?

In 1986, Lily Tomlin and Jane Wagner created *The Search for Signs of Intelligent Life in the Universe,* a series of dramatic vignettes commenting on contemporary times. Throughout the one-woman play, its narrator—Trudy the bag woman—discusses life on earth with invisible aliens. She removes an imaginary can of Campbell's soup from her imaginary shopping cart, and asks both her extraterrestrial guests and her audience, "Soup, Art?", "Art, Soup?" The questions appear to be a thinly disguised reference to Andy Warhol and contemporary art's blurred boundaries.[156] Barely veiled also is Tomlin's celebration of uncommon insights.

In its mass and complexity, Hemphill's collection has inspired derision as well as praise over the years. Excavation of its patterns benefits from the question, is it soup or art? Do its patterns reflect only the uncommon collector, or do they

Fig. 60 Collection installed on upper floor of Hemphill's apartment, before 1964. Courtesy Herbert Waide Hemphill, Jr.

nourish a larger community's understanding? How does one value a different viewpoint?

The excavation of Hemphill's collection begins in the brownstone apartment, where since 1956, he has arranged his many finds into an indoor version of the monumental environments he has admired. Though Hemphill decided not to become a painter many years ago, his understanding of what art is and his grasp of the artmaking process have defined the collection both in its choices and its assembly. Building the collection and arranging its contents have fulfilled Hemphill's creative sensibility for most of his adult life. In short, the all-encompassing effort to personalize his environment has literally absorbed and transformed that environment, becoming one with its maker.

The word arrangement suggests order and design, qualities expected in a museum or gallery's installation or in a private collector's domestic setting. This definition, however, seems foreign to the topsy-turvy ambience of Hemphill's apartment. For the collection's first press coverage in the 1960s, photographs presented an orderly view, with folk art, furniture, and accessories placed in careful counterpoint (fig. 60). Nevertheless, few visitors recall the apartment in the studied manner conveyed by these photographs. Over the years, however, the sheer volume of the objects Hemphill has acquired and his generous open-door loan policy have disrupted any attempt to sustain an installation in its traditional sense.

The casual visitor to Hemphill's apartment is not likely to discern much beyond abundance and variety. Only from extended familiarity do seeming coincidences of placement or repetition begin to take on meaning. Later, it becomes clear that regions exist in the apartment and have been staked out according to their role or contents.

Just inside the front door, a central island of predominantly large objects surrounds a few pieces of furniture, say a bench and a chest. The furniture is lost amidst objects densely packed about the room from floor level to midair, where whirligigs or weathervanes are often suspended on poles (fig. 61). This profusion of objects signals the need to look everywhere. Hemphill, as if to announce their arrival, often places new acquisitions of any meaningful size in this area.

Two narrow paths encircle this island. To the left are shelves laden with books that run the length of the wall except for a centered vertical space above a modest fireplace, which is often reserved for a favorite large or important work. This clearing hosted the *Mexican Eagle* (cat. 82) until 1979 when Howard Finster's ambitious portrait of Hemphill arrived (cat. 75). Flanking the fireplace are two reading chairs, each with a side table and lamp. Hemphill prefers the chair in the corner nearest the entrance (fig. 62). Here, he can survey the entire room and contemplate newly acquired objects.

To the right of the island, a bulky wood chair and table guard works stacked on the floor in the corner; they have not yet found a place in the collection or have just returned from an exhibition. A potpourri of mostly nineteenth-century paintings and works on paper blanket the long right wall. Nearby, Felipe Archuleta's only known large figurative sculpture—*Christ Child in the Manger*—has usually been prominent, as has the large carved snake installed on the bannister, itself extracted from an old New Orleans house.

A visitor can bear left toward the library area or inch forward into a tiny, three-sided alcove. Here, a menagerie of carvings is suspended from the high ceiling. Here too is the French bottle rack transformed into a chandelier that displays Hemphill's childhood antique glass collection. Ceramics, decoys, and sculptures all crowd the floor around a divan buried under miscellaneous objects. Drawings and paintings vie for attention on precious wall space. On the alcove's large windows, venetian blinds remain permanently closed to provide a backdrop for hanging works. Occasionally, a large figurative sculpture or two find room in the alcove, the legacy of displaying his *Indian Trapper* and *Indian Squaw* in the window bays during the 1950s and 1960s.

To the visitor, the sheer wealth and number of objects on walls, suspended from the ceiling, resting on tables, or on the floor, makes the mind reel with the notion of having overlooked something.

Yet, there is still more . . . as a wall of paintings and drawings leads the visitor down the stairs. Here, much lower ceilings telescope the space. To the right of the stairway landing is another three-sided alcove packed with three-dimensional objects from floor to ceiling. Southwestern carvings, native American objects, and a large family of memory vessels usually find their home in this area.

To the left of the stairway landing is a corridor, narrowed even more by two large chests that display an army of small and medium-sized objects, over which

Fig. 61　Central island of objects on upper floor of Hemphill's apartment, 1986.

Fig. 62　Hemphill's favorite corner on upper floor of his apartment, 1986.

Fig. 63　Corridor and rear section of lower floor of Hemphill's apartment, 1986.
Photographs for figs. 61–63 by staff of National Museum of American Art, Washington, D.C.

still more paintings and drawings hang on the walls (fig. 63). Eight footsteps navigate the corridor that leads into a shallow room where Hemphill spends much of his time. Dominated by a couch, the room has hosted a combination of familiar works and new acquisitions over the years, gathered together as companions as well as touchstones for discussions. Among book shelves and a television set, modestly scaled paintings, drawings, and sculptures abound. More objects are always underfoot or hanging from the ceiling. Canes especially are placed in different nooks, as they are upstairs, often standing in large southern pots like umbrellas.

Sometimes, several examples of works by the same artist cluster together. More often than not, however, works by artists represented in depth are scattered throughout the apartment, testing powers of memory and comparison while accommodating space constraints. Certain kinds of objects—pots, decoys (fish or fowl), and canes—tend to gather in groups, but more often, works varying in scale, medium, subject, and period mingle, sometimes by design, sometimes by chance. A glittering 1980s assemblage by Simon Sparrow, delicate figurative watercolors, chunky memory vessels, and a swordfish bill decorated with miniature vignettes may hang together. The relationships between the object-encrusted surfaces of Sparrow's panel and a memory vessel, or between the careful rendering of topical events and symbols in the watercolors or swordfish

bill, may escape the casual observer's notice. Nevertheless, relationships do exist.

Since 1970, this has been the nature of the collection's environment at any given moment. Set in a small space, the dynamic contrasts and extravagant (some might say bizarre) array of almost three thousand objects give the collection a baroque flavor. For most, a few particular works register vividly during an initial visit, but it is the sense of profusion that dominates residual impressions. Designer, collector, and friend Kenneth Fadeley has described the collection's dense variety as testimony to Hemphill's "360-degree eye."[157]

What has that remarkable eye taken in? Readily discernible even in the setting of the apartment is an encyclopaedia of categories, ranging from traditional—portraits, weathervanes, mourning pictures, and trade signs—to the unexpected—objects used by fraternal organizations, carnivals, and tattoo parlors.

Cumulatively, the variety of the Hemphill collection is double-edged. On the one hand, it honestly reflects Hemphill's belief that more is more. On the other, the heterogeneity of the collection has proceeded without regard for hierarchy or conventions of taste. Certainly, it runs the gamut from the masterpiece to the mundane. Observers have subsequently characterized its contents as "crown jewels" and "study pieces," a division often repeated by Hemphill. Left to his own curiosity, over the years Hemphill has sought out objects made as art, artifact, or as something in between, gathering them almost like specimens of the popular and vernacular rather than the elegant and erudite. To him, the inherent beauty of the *Black Hawk Horse Weathervane Pattern* (cat. 1) is not better than the deliberate grotesquerie of *Herein Lies What Remains of Muchabongo*, (cat. 154): the value in these two objects lies precisely in their difference. Admitting and understanding these differences without assigning higher or lower values has been one of Hemphill's strengths as a collector.

In this way, visual and conceptual patterns have emerged in the collection organically rather than purposely. Hemphill has clearly gravitated toward the manipulation of surface, texture, and materials most often expressed in three-dimensional form, but also evident in many of the paintings and drawings he has collected. The strokes of Edgar Tolson's Tree Brand Boker pocket knife, for example, mark the surfaces of local poplar and ash selected for his allegorical carvings. Animals, made from hundreds of castoff bottlecaps, suggest intense piecing and covering (cat. 68 and cat. 69). An unidentified artist applied sand to add texture to the paint used in his storm-tossed view of the ill-fated schooner, the *Thomas W. Lawson* (cat. 148).

Closely related to this is Hemphill's preference for works that reflect the artist's reinventing from scratch with experience and materials often appropriated from the maker's immediate environment. Most of the artists in the collection display self-confident flair and common sense first and foremost; facility is not important. Building a complex pugilistic crank toy, for instance, involved the labor-intensive wrapping of countless layers of textile remnants (cat. 66). Sheet-metal workers in need of trade signs assembled their own from an inventory of spare parts (cat. 10 and cat. 13). Max Reyher, an optometrist and naturalist, formulated and ground his own paints even though he could afford to buy them (fig. 64).

The urge to invent leads to a subtheme in the collection that one might call the American "carny" mentality. Reflecting the carnival sideshow spirit of

Fig. 64 Max Reyher at home, Belmar, New Jersey, 1943. Courtesy the artist's granddaughter, Mrs. Faith Jackson, Washington, D.C.

Fig. 65 Calvin and Ruby Black, *Possum Trot*, Yermo, California, 1960s. Photographer unknown, courtesy Light-Saraf Films, San Francisco, California.

hawking and entertaining, ball toss heads, freak show displays, and tattoo banners are obvious manifestations (cat. 153, cat. 154, and cat. 157). Less evident examples also exist, such as Miles Carpenter's roadside figures or his articulated carvings made to attract and delight their audience (cat. 11 and cat. 180).

All these qualities imply a one-on-one physical relationship between the maker and the object. But Edgar Tolson's pithy remark, "You make it with your mind," reminds us that ideas lie behind the manipulation and invention of self-taught artists.[158] Few things in this collection exist simply for the sake of making.

Perhaps as an antidote to his own shyness, Hemphill has favored objects that reflect the underlying passions of their makers. The works of Martin Ramírez, who was mute and institutionalized for more than thirty years, attempt to reconstruct a contorted world into sinuous drawings marked on resourcefully handmade paper. When Calvin and Ruby Black devoted their adult lives to the complex *Possum Trot and Fantasy Doll Show*, they too invested themselves in an effort to come to grips with personal and environmental desolation (fig. 65). Although perceived as less compulsive, powerful emotional undercurrents run through a retired sailor's efforts to relive a career's adventures in a carefully outfitted diorama (cat. 146).

While not personally political or religious, Hemphill has collected objects that incorporate social commentary or express a sense of spirituality. These strong expressions of conviction connect the objects to their own time and place yet often lend them universality. Many are intended to be read, whether elements of language appear or not. Harold Garrison, like most of his fellow Americans, did not escape the media barrage of Watergate during the early 1970s; his *Government Machine (Watergate Pistol)* is a nonviolent but pungent political statement (cat. 91). So too is Edward Kay's *see no evil, hear no evil, speak no evil* totem pole, a midwesterner's variation on Lord Acton's maxim on the corruption of power (fig. 66). Less evident to contemporary eyes is the idealistic pride in the American

Fig. 66 Edward Kay with *Gerald Ford Totem Pole* and its background panel, Mt. Clemens, Michigan, ca. 1974. Courtesy the artist and Herbert Waide Hemphill, Jr.

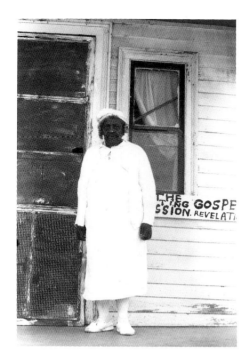

Fig. 67 Sister Gertrude Morgan at her home, St. Bernard's Parish, New Orleans, 1977. Photograph by Kenneth A. Fadeley, Ortonville, Michigan.

dream and belief in progress represented by R. M. Chalmers' sketch for a building at the Philadelphia Centennial Exposition of 1876 (cat. 83). The spirituality of Joseph Koenig's carefully crafted shrine provided his family and friends with a focus for worship during an unsettling migration in the last century (cat. 96). Through her painted word, fundamentalist missionary Sister Gertrude Morgan (fig. 67) informed anyone interested in salvation that the events and promises of Revelation would shortly come to pass (cat. 108). From these efforts we receive an artist's enlightening impressions rather than literal models of reality. That Hemphill and some of the artists sometimes focus on a dark interpretation of life emerges as subtheme that is best represented by Louis Monza's socially caustic *Orcastra at War* and an apocalyptic missionary map (cat. 87 and cat. 95).

Closely tied to the interpretation of the world around us is an interest in time, and many works in the Hemphill collection bear potent witness to its effects. Hemphill's own perception of folk art as a continuum has definitely colored his choices. The brevity of life is best evoked by the sentiments of mourning pictures that gently cope with mortality. Memory vessels, covered with small everyday treasures, are as commemorative as the anonymous bravura collage of Washington's headquarters made in honor of the nation's centennial (cat. 84). "Peter Charlie" Boshegan left no clues about the significance the years 1953 and 1962 held for him, while Fred Campbell's caricature of Hitler and G. W. Rich's cane with its Civil War references immediately revive the past (cat. 88, cat. 86, and cat. 50).

One final thread in the Hemphill collection merits special attention since it is not commonly associated with the collector's interests. Many of the objects were created to serve a particular audience. As such, these objects bear witness to the concept of community in their use or origin. To the decoys, trade signs, ceramics, and textiles should be added those categories that seem to be filled with quaint oddities—fraternal, tattoo, and carnival paraphernalia, tramp art, sailors' home projects, and Native American tourist trade beadwork. All were created to serve particular constituencies, and often reflect the conventions, and sometimes the innovations, of the people making them.[159]

Together, the collection's patterns delineate broad relevance for Hemphill's endeavor and the objects he has embraced. Rather than an act of insular simplification, folk art, the collection reveals, is just the opposite—an elaboration, a metamorphosis of social and personal expression, from decorating a functional object to reinterpreting popular idioms, contemporary mores, or discarded objects. Itself a creative act of sorting and recycling, Hemphill's collection offers the themes of elaboration and metamorphosis as a key to valuing the different. It is, as critic Suzi Gablik reminds us, "not just a matter of seeing things differently, but of seeing different things."[160] Hemphill's willingness to re-form his perception of art has exerted a subversive influence, asking as it has that we consider re-forming ours.

Lynda Roscoe Hartigan

NOTES

INTRODUCTION

1. The essay's title is a variation of the phrase, "The Man Who Preserves the Lone and Forgotten," that appears in Howard Finster's 1978 portrait of Hemphill (cat. 75). Oppenheimer's quote appears in Ida Ely Rubin, ed., *The Guennol Collection*, Vol. 2 (New York: The Metropolitan Museum of Art, 1982), title page. The quote's original source is unknown.

2. See Henry Glassie's *The Spirit of Folk Art: The Girard Collection at the Museum of International Folk Art* (New York: Harry N. Abrams, Inc., 1989) as a model for the ramifications of defining folk art. Glassie cites the key publications that deal with the field's definition in his extended note on page 260.

3. The phrases, a "Hemphill thing" or a "Bert thing," came into vogue in the folk art world during the 1970s as the collection gained public notoriety.

FROM ATLANTIC CITY TO NEW YORK CITY, 1929–49

4. Most of the biographical information and quotations from Hemphill that appear in this essay were obtained during interviews with Herbert Waide Hemphill, Jr., and the author between September 1988 and July 1989, unless otherwise indicated. Family members Marshall and Sara Hemphill also contributed information. The clippings morgue of the *Atlantic City Press* provided some of the information about Hemphill's parents.

5. Genealogist John Lassiter of the W. C. Bradley Memorial Library, Columbus, Georgia, graciously unearthed information about the Bradley family, which migrated in 1650 from London to Connecticut. Around 1828 descendants settled in newly established Columbus, Georgia, where the family became landowners, businessmen, and patrons of the arts. The career of W. C. Bradley exemplifies the distinguished position the Bradleys occupied in Columbus.

6. Genealogical research has not confirmed a relationship to William Jennings Bryan, who was frequently cited in the family's oral history, according to Hemphill.

7. An icon of Atlantic City's popular culture, the rolling chair was invented by Harry Shill as an attractive wheelchair for visitors to Philadelphia's Centennial Exposition in 1876. Shill later recognized its commercial potential.

8. During the late 1970s Louis C. Jones helped develop a catalogue card file system for Hemphill's collection. Information about his childhood acquisitions was obtained from these cards and confirms that Hemphill was collecting Americana during the late 1930s. The collector retained the duck decoy as a reminder of his early activities until donating it to the National Museum of American Art in 1988.

9. See Charles E. Funnell's illuminating social history of the resort, *By the Beautiful Sea: The Rise and High Times of That Great American Resort, Atlantic City* (New Brunswick, N. J.: Rutgers University Press, 1983). The phrase, "Newport of the Nouveau Bourgeois," is Funnell's.

10. The registrars and alumni relations staff of the Lawrenceville and Solebury schools were very helpful in reconstructing Hemphill's education.

11. Like other members of New Hope's small community, Hemphill knew about the local, self-taught painter Joseph Pickett who produced a very small body of work before his death in 1918. Pickett was included in Sidney Janis's 1942 book, *They Taught Themselves,* which Hemphill read as a teenager.

12. Hemphill does not recall the names of the Swiss collections he saw. Swiss art dealer Heinz Berggruen had begun collecting the works of Paul Klee during the late 1930s but was active in the United States rather than Europe during the late 1940s. It is difficult to suggest which private collection of Klee's works Hemphill would have seen at that time.

13. Mrs. Annys Wilson, registrar of Bard College, kindly provided information about the school's history and educational philosophy, some of which is available in brochure form.

14. Hemphill and Hirsch were not close but Hirsch apparently talked about folk art and shared his collection with his students. Hemphill recalls looking at works in Hirsch's apartment only in passing. He also remembers being aware of Victor Joseph Gatto's paintings while at Bard, perhaps through Hirsch or after reading Janis's book.

15. Titus C. Geesey was secretary to Henry du Pont and lived in Delaware.

THE COLLECTOR EMERGES, 1950–61

16. All information on the collection before 1961 is derived from Hemphill's catalogue file card system, done in the late 1970s, and from an appraisal of the collection made by W. C. Graham Co., Inc., New York, in 1961. A similar appraisal was done by Art and Antique Properties, New York, in 1964. Both appraisals can be found in the Herbert Waide Hemphill, Jr., Papers, Archives of American Art, Smithsonian Institution, Washington, D.C. Hemphill now believes that financial constraints prevented him from having the entire collection appraised during the 1960s, so its parameters can only be accurately described as being more than the 205 works listed in the appraisals.

17. LeRoy Davis, now of Davis and Langdale, New York, interview with the author, 21 September 1989. Other art dealers with whom Hemphill did business at this time included Eugene V. Thaw and Peter Dietch as well as the staff at Knoedler's.

18. Carlebach's gallery was so well known for this material that it was used as the setting for the 1956 film, *Bell, Book and Candle*, starring Kim Novak as a benevolent witch who deals in exotic materials in New York.

19. This characterization of Hirshhorn is derived from Aline B. Saarinen's title for her chapter on Hirshhorn in her book, *The Proud Possessors: The Lives, Times, and Tastes of Some Adventuresome American Art Collectors* (New York: Vintage Books, 1968), 268–86.

20. Stieglitz's exhibition "Negro Art" emphasized the aesthetic qualities of African tribal pieces.

21. Neal Prince, interview with the author, 2 October 1989.

22. My characterizations of this district and its shops have been gleaned from discussions with Hemphill, the longstanding Manhattan antique dealer Bernard Levy, LeRoy Davis, Michael Hall, and Neal Prince, as well as printed sources provided by the Museum of the City of New York and by Neil Printz, who poured through the holdings of the New York Public Library's Local History Room on my behalf. The most useful resources were guidebooks such as Katherine Simon's *New York's Places and Pleasures* (New York: Meridian Books, 1959); and Elizabeth Squire's *The New York Shopping Guide* (New York: M. Barrows and Co., 1961).

23. Penrose was a crucial figure frequently overlooked in discussions of folk art dealers. See Adele Earnest's recollections of Penrose in her book, *Folk Art in America: A Personal View* (Exton, Pa.: Schiffer Publishing Limited, 1984). According to Robert Bishop, another key dealer during the late 1950s was Juliet Kotner, who sold Americana, especially folk paintings and weathervanes, in her shop on Second Avenue.

24. Hemphill notes that Lipman's "early books on folk painting and sculpture were the first of which I was conscious as a young artist and collector of Americana" in his acknowledgments in the catalogue *Folk Art USA Since 1900: From the Collection of Herbert Waide Hemphill, Jr.,* for the exhibition organized by the Abby Aldrich Rockefeller Folk Art Center, Williamsburg, in 1980. Based on the dates of publication of Lipman's books, Hemphill believes that he read them during the 1940s.

25. The Haffenreffer Collection of Cigar Store Indians and Other Trade Signs was sold by order of the Narragansett Brewing Company Foundation, Providence, Rhode Island, at Parke-Bernet, New York, in two sales. The *Indian Trapper* was in the 11 April 1956 sale as item #69 *Warrior with Spear,* was illustrated on page 31, and appears to have been sold for $350.00. The *Indian Squaw* was included in the 10 October 1956 sale as item #17, was not illustrated, and appears to have been sold for $420.00. Although Haffenreffer acquired many of his figures from the collection of A. W. Pendergast, there is no evidence thus far that Hemphill's two figures share that provenance.

26. Diane Tepfer kindly pointed out the letter and its accompanying photograph. The two figures appear to have been available for $250.00, based on the photograph's inscription, although the letter states that they could be sold for $125.00. See Downtown Gallery Papers, Archives of American Art, Smithsonian Institution, Washington, D. C.

27. Caroline Weekley and Beatrix Rumford, interview with the author, 20 September 1988, and Mary Black, interview with the author, 7 August 1989.

28. After Hemphill acquired the figure, an unidentified restorer thoroughly cleaned it and cut off the rotting ends of its legs, once used presumably to stake it into the ground. A 1989 wood analysis by Regis Miller and Donna Christensen of the United States Department of Agriculture Forest Service confirms the figure's North American origins since it is made of sequoia, which grows only in the American Northwest. In February 1989 FBI forensic experts, Robert Spalding and Douglas Deedrick, found no traces of blood but located a remnant of a chicken feather.

29. In Hemphill's acknowledgments in the catalogue of his collection's exhibition at the Abby Aldrich Rockefeller Folk Art Center in 1980, he notes that he read Janis's book as a teenager and that it "had a strong influence on my folk art future."

30. The concept of the "common man" was introduced by Cahill, after which it became the early twentieth century's perception of folk artists.

31. Information derived from the collection's 1961 appraisal, which lists them as "grotesque jugs." Hemphill acquired the face jugs from Adele Earnest, whose inventory seldom included material from the South, so these examples may have been northern variations on the tradition.

32. Robert Bishop, interview with the author, 27 January 1989.

33. Ibid.

34. A good history of the influence of antique shows has yet to be written.

35. Robert Bishop, interview with the author, 27 January 1989.

36. Hemphill, however, bought an Erastus Salisbury Field painting, *The Plague of Darkness,* from Halpert's estate some time during the 1970s. The painting was offered, though did not sell, in Parke-Bernet's auction, "The Edith Gregor Halpert Folk Art Collection Property of Terry Dintenfass," November 1973. At the auction he definitely acquired a small paper-maché and plaster of Paris figure of *St. George and the Dragon* attributed to H. W. Hammond of Massachusetts.

37. See Louis C. Jones and Agnes Halsey Jones, "Folk Art at Fenimore House: A Historical Note," in Paul S. D'Ambrosio and Charlotte M. Emans, *Folk Art's Many*

Faces: Portraits in the New York State Historical Association (Cooperstown, N. Y.: New York State Historical Association, 1987), for a discussion of Mary Allis's contributions.

38. Mary Black, interview with the author, 7 August 1989.

39. See Earnest's autobiographical *Folk Art in America: A Personal View.*

40. See David Park Curry's time line in the National Gallery of Art's exhibition catalogue, *An American Sampler: Folk Art from the Shelburne Museum* (Washington, D.C.: National Gallery of Art, 1988), for useful entries on early folk art collecting in the United States. Often, Electra Havemeyer Webb's purchase of a cigar store Indian in 1907 is cited as the beginning of folk art collecting as the art world knows it, but Webb did not actively pursue the material until the 1930s. Figures such as Radeke, who was also collecting American "peasant" ceramics by 1907 in Rhode Island, and Henry Mercer, the anthropologist who began collecting Pennsylvania's tools and crafts in Doylestown in 1897, are frequently overlooked.

41. Alice Winchester, the magazine's editor, regularly featured folk art material. Hemphill did not begin reading the magazine until the late 1950s, so his initial collecting proceeded without knowing about recent attempts to define folk art, such as the now historic forum "What Is American Folk Art?" that Winchester published in the magazine in 1950. The forum included comments of a key group of the period's collectors, dealers, and art historians: John I. Baur, Holger Cahill, Erwin O. Christensen, Carl W. Drepperd, James Thomas Flexner, Edith Gregor Halpert, John A. Kouwenhoven, Jean Lipman, Nina Fletcher Little, Janet R. McFarlane, Louis C. Jones, E. P. Richardson, and Frank O. Spinney.

42. By this time Hemphill had also read Nina Fletcher Little's catalogue, *The Abby Aldrich Rockefeller Folk Art Collection* (Williamsburg, Va.: Colonial Williamsburg, 1957). The 1961 appraisal of Hemphill's collection bears his annotations for several works as being similar to examples in the Rockefeller collection. Not until some time during the 1960s did Hemphill visit the Shelburne Museum in Vermont.

43. The thumbnail sketch of Fried's career is based on Fried's interview with the author, 11 August 1989. The term "screwball" is Fried's own.

44. Ibid.

45. Walter Hopps, interview with the author, 13 August 1989. Warhol's friend Ted Carey notes in a 1978 interview that he sold Warhol his collection of Americana in 1957, before which Carey feels Warhol did not own any, only things that were "more of the sort of bizarre and of the unusual." Quoted in *The Andy Warhol Collection: Americana and European and American Paintings, Drawings and Prints* (New York: Sotheby's, 29–30 April 1988), n.p. with entry #3167.

46. Hopps, interview with the author, 13 August 1989. See also Sam Hunter, "Morton G. Neumann: A Profile," in the National Gallery of Art's catalogue, *The Morton G. Neumann Family Collection* (Washington, D. C.: National Gallery of Art, 1980), 8–10; and Russell Lynes, *The Tastemakers: The Shaping of American Popular Taste* (New York: Dover Publications, Inc., 1955 and 1980), 256–86.

47. The first influential mass media notice of avant-garde art was *Life* magazine's 1949 spread on Jackson Pollock, who became something of a cultural hero after its appearance.

NEW FORUMS FOR FOLK ART, 1961–74

48. Alice J. Hoffman's "Museum of American Folk Art History (1961–1988)" has provided much of the information that appears in this section. She graciously shared its unabridged, unpublished draft.

49. See Curry's timeline, which cites the founding of these fifteen public collections, beginning in 1924 with the opening of the first version of the Metropolitan Museum of Art's American wing and ending in 1959 with Strawberry Banke in Portsmouth, New Hampshire.

50. See catalogue for "Initial Loan Exhibition," Museum of Early American Folk Arts, 5 October–18 November 1962. "The Museum of American Folk Art History" cites Allis and Hemphill as the cocurators; Earnest's autobiography suggests that she and Burt Martinson marshalled the project.

51. Immediately recognizable as folk art collectors among the show's lenders are: Mary Allis, Mrs. Holger Cahill (Dorothy Miller), Adele Earnest, the Garbischs, Stewart Gregory, Martin Grossman, Edith Halpert, Cordelia Hamilton, Hemphill, Lincoln Kirstein, the Lipmans, Bertram and Nina Fletcher Little, and Burt Martinson.

52. Quoted in Hoffman's "Museum of American Folk Art History," 5.

53. Intermittently, Hemphill has given works to the Museum of American Folk Art and the Columbus Museum of Art, Georgia. Before his collection was acquired by the National Museum of American Art in 1986, he sold small but important groups of works to museums, most notably to the Museum of International Folk Art in 1978 and the Abby Aldrich Rockefeller Folk Art Center in 1980.

54. Hemphill curated shows at the museum until early 1974, but he probably left its staff the previous year, based on references to him as the former curator in press releases in 1974.

55. Exhibitions of the Garbisch collection, organized by the National Gallery of Art and the Metropolitan Museum of Art in 1954, 1957, and 1961 were the most notable examples at that time.

56. The cocurated shows were: "Promised Gifts" and "Folk Artists in the City/Painters and Carvers in Greater New York," 1967; "Art of the Decoy" and "Promised Gifts," 1968; "The Plenty of Pennsylvania," 1969; "The Tinker and His Dam," "Collectors' Choice Part II," and "Carvings for Commerce," 1970; "TATTOO," 1971; "OCCULT" and "Make a Joyful Noise," 1973. Hemphill curated: "Collectors' Choice Part I," 1969; "Twentieth-Century Folk Art and Artists," 1970; "MACRAMÉ," 1971; "Retrospective Look," "Fabric of the State," "Hail to the Chief," and "Spirit of Christmas," 1972; "Metal of the State," and "J. F. Huge Rediscovery," 1973; and "The Edith Barenholtz Folk Art Collection of Nineteenth-Century Weathervanes and Trade Signs," 1974.

57. The author is grateful to Harvey Kahn, Dorothy and Leo Rabkin, Michael and Julie Hall, Estelle Friedman, Phyllis Kind, Kenneth Fadeley, M. J. Gladstone, Mary Black, and Elias Getz for sharing their impressions of Hemphill's exhibitions.

58. See Willem Volkerz's "Mixed Baggage: A Decade of State Folk Art Surveys," *Folk Art Finder* (January–March 1989): 4–13, 19.

59. Pennsylvania's designation as the "keystone state" among the thirteen original states also came to apply to its position in the history of American folk art production. The state's German immigrants created some of the country's first folk art objects, including earthenware, which stimulated important publications as early as 1893.

60. Quoted in Lisa Hammel, "To Collectors, Americana Is More Than Pine Chests," *New York Times*, 25 March 1966. Fragment of article found in Hemphill Papers, Archives of American Art, Smithsonian Institution, Washington, D.C.

61. Gene Metcalf shared Sheeler's and Laurent's attitude with the author.

62. Noted in Hoffman's history of the museum and recalled by Hemphill and M. J. Gladstone, director at that time, in an interview with the author, 8 August 1989.

63. The author is indebted to Julia Weissman for sharing the only draft of the exhibition checklist that appears to be extant. Most of the newspaper articles are based on the museum's press release.

64. The early twentieth-century artists included: Cleo Crawford, William Doriani, Victor Joseph Gatto, Morris Hirshfield, John Kane, Olaf Krans, Lawrence Lebduska, Abraham Levin, Israel Litwak, Grandma Moses, Joseph Pickett, Horace Pippin, Fannie Lou Spelce, and Patrick J. Sullivan.

65. For example, Lee Brooks, Rosa Brooks Beason, Margaret S. Crane, Edna Davis, William Fellini, Wood Gaylor, Harkins, Henry Jackson, Harold Osman Kelly, William A. L., Louis Millican, F. H. Sweet, Awa Tsireh, Ed Victory, Grandpa Wiener, Sophie Regensburg, Catherine Ross, Clara McDonald Williamson, and Harry Zolotow.

66. Michael Hall, interview with the author, 16 August 1989.

67. The Museum of Modern Art's exhibition included: Louis Basciano, Emile Branchard, Vestie Davis, Joseph Fracarossi, Victor Joseph Gatto, Theora Hamblett, Morris Hirshfield, Thorvald Hoyer, John Kane, Lawrence Lebduska, Israel Litwak, Justin McCarthy, Horace Pippin, John Roeder, Patrick J. Sullivan, Gregorio Valdez, and Clara McDonald Williamson.

68. The Zabriskie Gallery's exhibition included: Emile Branchard, Vincent Canade, Vestie Davis, William Doriani, Louis Eilshemius, Victor Joseph Gatto, Wood Gaylor, Adelaide Lawson Gaylor, Morris Hirshfield, John Kane, Lawrence Lebduska, Israel Litwak, Justin McCarthy, Sophie Regensburg, Jack Savitsky, Clarence Stringfield, Patrick J. Sullivan, and George Victory.

69. Blasdel's exhibition included: J. R. Adkins, Andrea Badami, Catherine S. Banks, Margaret Batson, Nounoufar Boghosian, Mary Borkowski, Henry Berger, James Castle, Peter Contis, Minnie Evans, France Folse, Sarah Frantz, Flora Fryer, Theora Hamblett, Milton Hepler, Clementine Hunter, Fay Jones, Frank Jones, Anna Katz, Sadie Kurtz, Harry Marsh, Sister Gertrude Morgan, Jennie Novick, Shigeo Okumura, Gertrude Rogers, Anna Fell Rothstein, Helen Rumbold, "St. Eom," and Virginia Tarnoski.

70. This series was the first at the museum to be funded by the National Endowment for the Arts. The term "grassroots" was very much in vogue at the time.

71. See Hoffman's history of the museum and Grace Glueck, "Ailing Folk Art Museum Is Under Inquiry by State," *New York Times,* 30 April 1974. The auction took place in 1972. Opposed to the sale, Hemphill joined with Mary Black and Frederick Fried as "The Friends of Folk Art" to persuade the museum to retain six major pieces and the Alastair Martin decoy collection.

72. Glueck, *New York Times,* 30 April 1974.

73. Ibid.

74. Descriptions of the three exhibitions are based on their checklists and press releases.

75. Hemphill, in an interview with the author, 13 December 1988.

76. Ibid. See also "Out of This World," *Newsweek,* 29 January 1973, and Rita Reiff, "Blessed by Witches, An Occult Show Is Unveiled," *New York Times,* 17 January 1973. A copy of Reif's article is in the Hemphill Papers, Archives of American Art, Smithsonian Institution, Washington, D. C.

77. Unless otherwise noted, information and all quotes and recollections by the Halls in this section are derived from interviews in November 1988 and in February and August 1989.

78. The first paragraph quoted is taken from Michael Hall's interview with Sara Faunce in the Brooklyn Museum's, *Folk Sculpture USA* (Brooklyn: Brooklyn Museum, 1976), 49.

79. Michael Hall, interview with the author, 17 August 1989.

80. See Allen H. Eaton, *Handicrafts of the Southern Highlands* (New York: Dover Publications revised edition, 1973) for a discussion of southern craft fairs.

81. The author is grateful to Richard Bellandro, the Berea craft fair's organizer in 1967, for explaining its history.

82. Ceramic artist John Tuska, teaching pottery at the University of Kentucky, and his wife Miriam had purchased works by Tolson already, but were reluctant to share their knowledge of Tolson's whereabouts with collectors.

83. Hall believes that he was presdisposed toward collecting since childhood, when he avidly collected things like comic books, but art objects did not figure into his peripatetic lifestyle until 1967.

84. During the early 1970s sculptor and designer Kenneth Fadeley began helping Hall with efforts to distribute Tolson's work, and by 1977 Kentucky dealer Larry Hackley assumed the principal responsibility for handling the carver's works.

85. Michael Hall, interview with the author, 17 August 1989.

86. Ibid.

87. Harvey Kahn, interview with the author, 26 January 1989.

88. Ibid.

89. Michael Hall, interview with the author, 17 August 1989.

90. See Michael Hall, "The Hemphill Perspective: A View From a Bridge," in *American Folk Art: The Herbert Waide Hemphill, Jr. Collection* (Milwaukee: Milwaukee Art Museum, 1981), 15.

91. Information on the Strausers is based largely on Sterling Strauser's interview with the author, 10 August 1989.

92. See Ben Apfelbaum, "Dorothy and Sterling Strauser: Friends of Folk Art," *The Clarion* (Spring/Summer 1987): 56.

93. The dates cited for Strauser's encounter vary from 1939 to 1945. Cross-checking suggests that 1942 is the correct date.

94. See Gene Epstein, "The Art and Times of Victor Joseph Gatto," *The Clarion* (Spring 1988): 61.

95. Strauser, interview with the author, 10 August 1989.

96. See Nancy Karlins, "Four From Coal Country: Friendships and the Contemporary Folk Artist," *The Clarion* (Spring/Summer 1987): 54–61.

97. Apfelbaum, "Dorothy and Sterling Strauser," 57.

98. The unfolding of Carpenter's early career reflects Michael Hall's, Jeffrey Camp's and Don Walters's interviews with the author in 1989.

99. See the Whitney Halstead Papers, The Art Institute of Chicago, and Archives of American Art, Smithsonian Institution, Washington, D. C., for an unpublished manuscript that details the development of Yoakum's discovery.

100. Phyllis Kind, interview with the author, 27 January 1989.

101. Elsa Weiner Longhauser describes the discovery of Martin Ramírez in her exhibition catalogue, *The Heart of Creation: The Art of Martin Ramírez* (Philadelphia: Goldie Paley Gallery of Art, The Moore College of Art, 1985), 4–5.

102. Blasdel first began publishing on the topic with his essay on Jesse "Outlaw" Howard in *Epoch* (Spring 1967), Cornell University's art and literary magazine.

103. Wooldridge's monument also involved other local stonemasons trained in funerary decoration, and the monument subsequently displays varying degrees of figurative interpretation.

104. Walter Hopps called this connection to the author's attention.

105. Jules Langsner, "Sam of Watts," *Arts and Architecture* (July 1951): 23–25, and Calvin Trillin, "I Know I Want to Do Something," the *New Yorker*, 29 May 1965, 72–120.

106. Hopps, interview with the author, 13 August 1989.

107. See Allan Kaprow, *Assemblage, Environments and Happenings* (New York: Harry N. Abrams, Inc., 1966), 170–72, for a discussion of how Clarence Schmidt's upstate Newyork environment influenced a group of artists in New York.

108. Robert Doty, *Human Concern/Personal Torment: The Grotesque in American Art* (New York: Whitney Museum of American Art, 1969), n.p. Worth noting is the fact that Doty became familiar with Hemphill's collection and began collecting folk art as he traveled around the country.

109. Interestingly, artists such as H. C. Westermann and Edward Kienholz had been included in the much better received effort of William Seitz, "The Art of Assemblage," in 1961.

110. See Meredith Trumble and John Turner, "Striding Out On Their Own," *The Clarion* (Summer 1988): 40–47, for a discussion of the impact of contemporary self-taught art on San Francisco Bay area artists.

111. The term "trash treasures" occurs frequently in discussions about the vernacular "things" collected by Chicago's artists. Don Baum appears to have introduced the term in his introduction to *Made in Chicago: Some Resources* (Chicago: Museum of Contemporary Art, 1975), 7. See also Michael Bonesteel, "Chicago Originals," *Art in America* (February 1985): 128–35, for a discussion of some of the self-taught artists who influenced Nutt and other artists in Chicago.

112. Trumble and Turner, "Striding Out on Their Own," 40.

113. Jesse Kornbluth, "A Road Less Traveled," *Architectural Digest* (June 1987): 198.

114. Julie Hall, interview with the author, 21 August 1989.

115. Ibid.

116. Strauser, interview with the author, 10 August 1989.

BABY, LOOK AT YOU NOW, 1974–86

117. By the late 1970s Hemphill had begun using this phrase in private discussions. Its first public reference appeared in Hall's interview with Hemphill published by the Milwaukee Art Museum in 1981.

118. Jean Lipman, *The Flowering of American Folk Art (1776–1876)* (New York: The Viking Press, 1974), 7. Hemphill was one of seven consultants to the exhibition, as he was for the Whitney's 1980 exhibition, "Three Hundred Years of American Folk Art."

119. Douglas Davis, "The People's Muse," *Newsweek*, 11 February 1974, 56.

120. Hilton Kramer, "A Reservoir of Visual Memory," *New York Times Magazine*, 3 February 1974, 60–61.

121. Robert Hughes, "Whittling at the Whitney," *Time*, 4 February 1974, 62.

122. Thomas B. Hess, "Muhammad Ali vs. The Whitney Museum," *New York Magazine*, 25 February 1974, 70–71.

123. Bishop, interview with the author, 27 January 1989.

124. Robert Bishop, *American Folk Sculpture* (New York: E. P. Dutton and Co., Inc., 1974), 259.

125. Julia Weissman, interview with the author, 27 January 1989.

126. Julia Weissman, letter to Gustave Klumpp, Brooklyn, 28 January 1972. Collection of Julia Weissman.

127. Julia Weissman, letter to Robert Tessmer, Red Hook Senior Center, Brooklyn, 28 January 1972. Collection of Julia Weissman.

128. Herbert Waide Hemphill, Jr., and Julia Weissman, *Twentieth-Century American Folk Art and Artists* (New York: E. P. Dutton and Co., Inc., 1974), n.p. prefatory note.

129. Ibid., 9–10.

130. Barry Newman, "Grandma Moses Didn't Do It All," *Wall Street Journal*, 16 December 1974.

131. Strauser, interview with the author, 10 August 1989.

132. Michael Hall, "The Hemphill Perspective," 15–16.

133. Kind included "Peter Charlie" Boshegan, Vestie Davis, Minnie Evans, Albina Felski, Gustav Klumpp, Justin McCarthy, B. J. Newton, Jack Savitsky, Pauline Simon, Samuel Sims, Edgar Tolson, and Joseph Yoakum.

134. Hemphill, interview with the author, 13 October 1988.

135. Both of Michael Hall's quotes are taken from his interviews with the author on 17 and 18 August 1989.

136. Hemphill, interview with the author, 13 October 1988.

137. Bishop, interview with the author, 27 January 1989.

138. Quotes in this and the following paragraph are taken from Liza Kirwin's interview with Jeffrey and Jane Camp, 15 January 1988, Archives of American Art, Smithsonian Institution, Washington, D. C., and the author's interviews with the Camps, 27 December 1988.

139. Barry Newman, "Folk Art Finders," *Wall Street Journal*, 30 July 1974.

140. Between 1973 and 1988, exhibitions based on the collection have appeared at the following: Cincinnati Contemporary Art Center, Ohio; Heritage Plantation of Sandwich, Massachusetts; Rich's Downtown Auditorium, Atlanta; Renaissance Society at the University of Chicago; John Michael Kohler Arts Center, Sheboygan, Wisconsin; Oshkosh Public Museum, Wisconsin; Columbus Museum of Arts and Crafts, Georgia; Hudson River Museum, Yonkers, New York; Children's Museum, Indianapolis; Sullivant Gallery, Ohio State University, Columbus; Abby Aldrich Rockefeller Folk Art Center, Williamsburg; Brainard Art Gallery, State University of New York, Potsdam, New York; Milwaukee Art Museum, Wisconsin; Everson Museum of Art, Syracuse, New York; Whitney Museum of American Art, Fairfield County, Connecticut; Santa Barbara Museum

of Art, California; Allentown Art Museum, Pennsylvania; Joslyn Art Museum, Omaha, Nebraska; Georgia Museum of Art, Athens; Akron Art Museum, Ohio; Contemporary Art Museum, Houston; Olympia and York, New York; and Noyes Museum, Oceanville, New Jersey.

141. Michael Hall, "The Hemphill Perspective," 12.

142. Rita Reif, "Antiques: Folk Art Show," *New York Times,* 29 June 1974.

143. Michael Hall, "The Hemphill Perspective," 13–14.

144. Information about Kronen's career is based on the author's interviews with Hall, Bishop, Roger Ricco, and Frank Maresca in 1989.

145. Michael Hall characterizes Tim Hill's earliest efforts as a folk art dealer in this fashion; Hall, interview with the author, 17 August 1989.

146. Strauser, interview with the author, 10 August 1989.

147. See annotated definitions of "picker" in the *Oxford English Dictionary,* 2nd ed., vol. 11, 1989, 771–72.

148. Roger Ricco, interview with the author, 11 August 1989.

149. Frank Maresca, interview with the author, 11 August 1989.

150. John Ollman, interview with the author, 10 August 1989.

151. The connections among Chicago's and Philadelphia's art communities reflect the presence of Dennis Adrian, Raphael Ferrer, Cynthia Carlson, Italo Scango, and Jim Nutt, according to Ollman.

152. Shari Cavin and Randall Morris, interview with the author, 26 January 1989.

153. "The folk art show" is the common description of this event, in part because of its subsequent association with the Museum of American Folk Art.

154. Alan Jabbour, "Introductory Remarks, Washington Meeting on Folk Art," 5 December 1983, p. 3, from the Herbert Waide Hemphill, Jr., Papers, Archives of American Art, Smithsonian Institution, Washington, D. C.

155. Michael Hall, "The Hemphill Perspective," 16.

EXCAVATING A COLLECTION: SOUP OR ART?

156. Tomlin's question may also be a contemporary reprise of a "schtick" performed by Harpo and Chico Marx in *A Night at the Opera,* in which a demonstration of "Rise Soup" "Soup Rise" is a verbal charade for the word, surprise. The author is grateful to Nadine Cohodas for pointing out this antecedent.

157. Kenneth Fadeley, interview with the author, 27 October 1989.

158. Michael Hall, *Six Naives* (Akron: Akron Art Institute, 1973), n.p.

159. The phrase, "I have never seen anything like this before," recurred more times than researchers on this project would care to count as information about objects in the collection was pursued. The phrase reflects an initial reaction that often settled out into discussions of derivations and connections to some form of a tradition that shed light on contextual issues for many of the objects. Traditionally, it has been assumed that most of the objects owned by Hemphill are not related to traditions but instead are solely eccentric statements; that, however, is not the case.

160. Suzi Gablik, *Has Modernism Failed?* (New York: Thames and Hudson Inc., 1984), 128.

Catalogue of the Exhibition

EXPLANATORY NOTE

Since 1986, the National Museum of American Art has acquired 427 works from the collection of Herbert Waide Hemphill, Jr. The 199 works selected for this exhibition and publication represent the genres, media, themes, concentrations, periods, and quality of the museum's holdings as well as the much larger private collection from which they were chosen. Four major sections and twenty-five subsections were devised to address the intent and context of the objects and their makers. Certain works could readily be included in more than one category or in a different grouping, depending on one's interpretation. "Individual Paths" is not intended to isolate the artists included, but instead to suggest that they have developed clearly recognizable styles that often favor particular media, techniques, attitudes, or ambitions. Works are arranged chronologically within each subsection.

Any titles and inscriptions designated on works retain an artist's exact spelling, capitalization, and punctuation. Attributions and descriptive titles for certain objects vary from those previously published, based on research and, in the case of titles, semantic considerations. When an approximate year could not be stated with confidence, a likely segment of a century or, in certain instances, the span of an entire century has been suggested. Every attempt has been made to identify and list the specific materials and techniques used by the artists. Trade and brand names have been retained when they were characteristic of an artist's working method. Measurements provide height by width by depth. The immediate provenance of an object has been cited to document and characterize the Hemphill collection's diverse resources and patterns of acquisition; the comprehensive provenance for many of the objects must still be determined.

Any works with a 1986 accession number were the gift of Herbert Waide Hemphill, Jr., and museum purchase made possible by Ralph Cross Johnson. Any works with an accession number for the years 1987–89 were solely the gift of Herbert Waide Hemphill, Jr.

Author's initials—for Andrew L. Connors, Lynda Roscoe Hartigan, Elizabeth Tisdel Holmstead, and Tonia L. Horton—appear at the end of each entry.

Exterior Accessories

Cat. 1

Cat. 2

Cat. 1
Attributed to HENRY LEACH
birthplace and date unknown; died 1872,
Boston, Massachusetts; active Boston
Black Hawk Horse Weathervane Pattern,
1871–72
carved and painted wood
22 × 34½ × 3⅝ in.
acquired from Adele Earnest, Stony Point,
New York, early 1960s
1868.65.358

Rare before the 1830s, the trotting horse
became one of the most frequent subjects
for weathervanes in the last half of the
nineteenth century. The sport of racing
trotters became popular in the 1840s, and
most horse weathervanes were modeled
after famous trotters. Almost every manu-
facturer of such weathervanes marketed a
model commemorating Black Hawk, a
well-known winner in the 1840s, and a
famous stud in Vermont after his racing
career ended. The different manufactured
versions of Black Hawk are almost identi-
cal, probably because an early lithographic
portrait was the source of the various de-
signs. This spirited, anatomically detailed
piece is a wooden model, or pattern, for
making the hollow iron molds that were
used to mass produce many copper vanes.
It was probably made by Henry Leach,
who carved original patterns for Cushing
and White, weathervane manufacturers,
based in Waltham, Massachusetts.[1] (ETH)

[1]Attribution and dating by Myrna Kaye, Lex-
ington, Mass., 1989.

Cat. 2
UNIDENTIFIED ARTIST
Gate, nineteenth century
painted, turned, and carved wood, and
wrought iron
44⅛ × 41¾ × 3½ in.
acquired from Gary Stass, Litchfield,
Connecticut, 1976
1986.65.72

Previously, this gate has been described as
the effort of a Pennsylvania German
farmer who used its color scheme and an
acorn motif to advertise the marriageabil-
ity of his daughter. The stalwart structure
emphasizes the interaction of vertical and
horizontal elements offset by curvilinear
acorns. Traces of red, yellow, and green
paint indicate that this gate was once
richly decorated. Its design, however, is
not readily identifiable with traditional ru-
ral architecture of the Pennsylvania Ger-
man community, nor does the gate's al-
leged use as an advertisement for suitors
relate to the community's customs. (LRH)

Cat. 3
JOSE DOLORES LOPEZ
1868–1937; born, active, and died Cór-
dova, New Mexico
Screen Door, ca. 1930–37
carved pine and aspen
73¼ × 35⅞ × 4½ in.
acquired from Pamela Pettis Mitchell,
Santa Fe, New Mexico, 1987
1989.30.3

Jose Dolores Lopez was a skilled carpen-
ter and furniture maker. Initially, he cre-
ated painted domestic furnishings based
on popular and imported Mexican furni-
ture styles for his neighbors and friends.
He was also skilled at creating delicate
filigree silver jewelry common at the end
of the nineteenth century. Encouraged by
"Anglo" (a term used in the region to
denote all persons of non-Hispanic, non-
Indian heritage) settlers and visitors to

New Mexico, López left his work un-
painted and began to construct objects
more in keeping with the "Anglo" way of
life. His *Screen Door* is typical of the
work he created for this market. Later,
newcomers to the area encouraged him to
create images of saints in this same un-
painted, chip-carved manner. The wide-
spread acclaim and successful sale of these
religious objects encouraged members of
his family and neighbors to begin carving
in the same style. Led by his descendants,
the Córdova carvers continue to create in-
novative objects, primarily in the manner
of José Dolores López (see cat. 126). (ALC)

Cat. 3

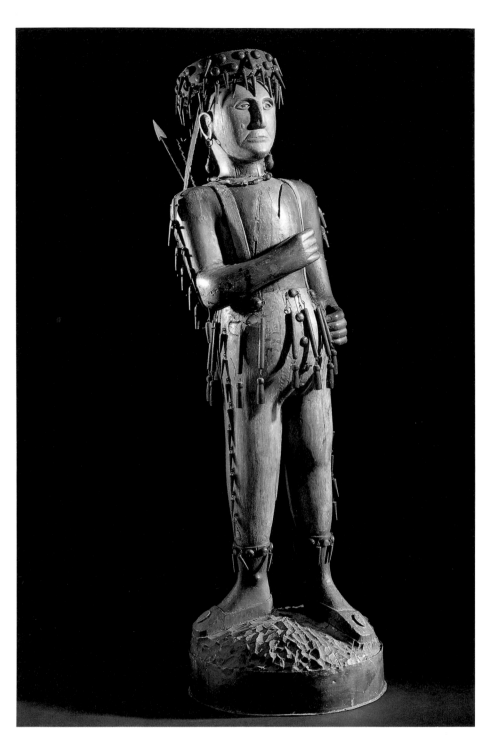

Cat. 4

Cat. 4

UNIDENTIFIED ARTIST

Indian Trapper and Indian Squaw, ca.
1850–1890
carved softwood with traces of paint and
stain, and metal
trapper: 60½ × 20 × 19 in.
squaw: 48¾ × 16¾ × 16¼ in.
acquired from the Haffenreffer Collection
of Cigar Store Indians and Other Ameri-
can Trade Signs, Parke-Bernet Galleries,
Inc., New York, April and October, 1956
1986.65.303 and 1986.65.384

The cigar store Indian was among the
trade signs that originated in Europe. Six-
teenth-century English explorers intro-
duced Europeans to the tobacco first cul-
tivated by Native Americans; in the early
seventeenth century, English tobacco
shops adapted the exotic "red man" as
their commercial symbol. Colonial arti-
sans continued the tradition, and by the
mid nineteenth century, the cigar store
Indian was the principal character carved
or cast in metal as "show" figures for
American businesses.

Within this genre, *Indian Trapper* and
Indian Squaw have been considered prim-
itive curiosities since 1933 when they first
entered the folk art market in Boston.
These figures depart considerably from the
highly decorative cigar store Indians usu-
ally made along the eastern seaboard by
shipcarvers who adapted their skills as the
country's call for wood ships declined.
The male figure does not conform to the
conventional depictions of Indian braves,
scouts, or chiefs—often bare-chested,
draped in tunics or blankets, and adorned
with feathered headdresses. His costume
suggests, instead, the buckskin pants (with
suspenders), shirt, and hat adapted by
white trappers and frontiersmen from
clothing worn by Eastern tribes. Seem-
ingly eccentric, the dangling, turned wood
cones are plugs for bottles and jugs, and

Cat. 4

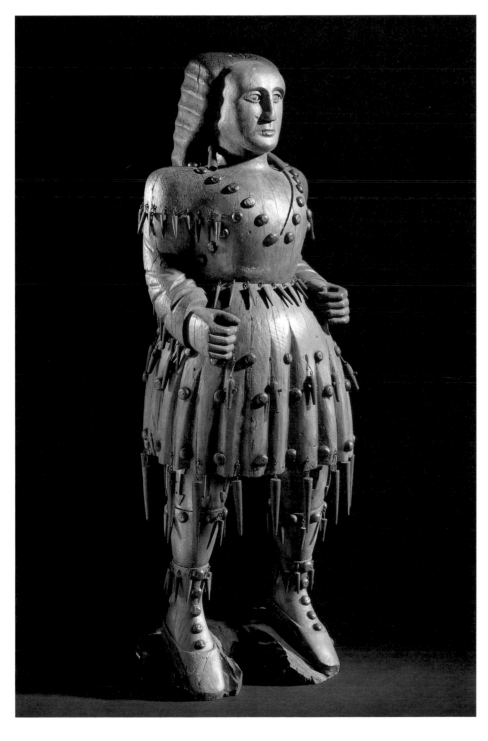

suggest fringed buckskin. A carpenter or wood turner, probably untrained in (but aware of) the figurative carving tradition, may have created the *Trapper* and *Squaw* for himself or a local merchant. This was not uncommon in small inland towns without access to professional carvers.

The pair represent less a departure than commonly thought. Like most nineteenth-century Americans, the carver romanticized Native Americans as noble and heroic, and imposed European traits, such as the *Squaw*'s high-buttoned footwear, waisted dress, and wavy hairstyle. True to the show figure tradition, the carver worked from a single, softwood log (probably pine), anchored the figures on bases, and hollowed their hands—no doubt to hold an object chosen by a shopkeeper. Early photographs indicate that the *Trapper*'s arms were attached with dowels, a conventional technique among show figure carvers (see fig. 18). In the photographs, both works have bare, cracked surfaces, and many of their dangling accessories are missing, signs, perhaps, of extensive outdoor use. Before 1956, the sculptures were repaired and repainted or restained—customary maintenance for trade figures. Two other Indian squaws appear to have been carved by the same hand. They are currently in private collections. (LRH)

Cat. 5

Cat. 6

UNIDENTIFIED ARTIST
*ORIENT DELIGHTS ORIENT'S
MOST FAMOUS SWEETS*, ca. 1920
36 × 72 in.
housepaint on plywood
acquired from Robert Bishop, New York,
before 1966
1986.65.151

This piece is thought to have been created
as a trade sign for a candy factory in
Hoboken, New Jersey. "Sweets" suggest
candy, and the representation of a mosque
may imply that the candy had some rela-
tion to the Middle East—or that the man-
ufacturer wanted the consumer to believe
that it did. Heightened interest in the
Middle East, beginning in the late nine-
teenth century and peaking in the 1920s,
presented American advertisers with many
logos for their products. Here, for exam-
ple, the building pictured resembles the
Blue Mosque in Istanbul. If this painting
is a trade sign, it has lost its original
meaning. Today, the product it was meant
to advertise can only be imagined. More-
over, Hoboken's city records for the early
twentieth century do not include evidence
of a factory producing Orient De-
lights. (ETH)

Cat. 5

UNIDENTIFIED ARTIST
Optician's Sign, twentieth century
braized and painted sheet brass, porcelain
and metal electrical sockets, electrical wir-
ing, and replacement incandescent bulbs
12 × 24⅜ × 2 in.
acquired from Tom Rumbaugh, New
York, early 1960s
1986.65.314

Pince-nez eyeglasses were introduced in
the 1840s and remained popular for dec-
ades. Opticians often used monumental
pince-nez, carved and painted, as trade
signs. This sign updates the tradition by
incorporating electric light bulbs. Perhaps
the maker wanted to suggest that a new
pair of glasses, like an electric light bulb,
would help one see better. (ETH)

Cat. 7

Attributed to ELMER A. HALLOCK
life dates and place of activity unknown
TOOLS SHARPENED, ca. 1920s
painted wood with painted metal saw
11½ × 47⅜ × 2 in.
acquired from Harris Diamant, New
York, 1975
1986.65.332

This trade sign was probably made by
Elmer A. Hallock, the proprietor of the
sharpening business. It may have hung
outside a hardware store or machine shop
or, if Hallock was a traveling tradesman,
it may have decorated the wagon or cart
that held his grinding wheels and stones.
The words "TOOLS SHARPENED" are
painted on the blade of a real saw which
has been attached to the wood board. (ALC)

Cat. 6

Cat. 7

Cat. 8
LOUIS SIMON
born 1884, Bessarabia (now Moldavia),
Russia–died 1970, Brooklyn, New York;
to USA 1905
Bicycle Shop Sign, early 1930s
carved and painted wood, gesso, metal
and rubber bicycle parts, marbles, and
metal hardware
34½ × 14 × 23½ in.
acquired from the artist's family, 1976
1986.65.265

Louis Simon, a champion motorcycle
racer, opened his motorcycle sales and re-
pair shop in 1912 on Manhattan Avenue
in Brooklyn. Inspired by his love of rac-
ing, Simon invented many solutions to cy-
cling problems for which he earned several
patents.

He carved his first figure of a boy rid-
ing a bicycle in 1922 when he began sell-
ing and repairing bicycles. As a public
announcement of his new inventory, Si-
mon attached the sign high on the exterior
wall of his shop. He added a motor to

Cat. 8

make the wheel revolve and the legs move up and down.

Simon made this second carving during the Great Depression while work was scarce. It hung inside the shop next to the bicycle racks. When viewed from the front, the boy appears to be riding a complete bicycle, so artfully has Simon arranged the parts. He constructed the figure's body from wood boards glued together to form a block which was then carved. The arms and legs are cut from single boards bolted together at the joints. When the wheel turns in this version, the pedals rotate, pushing the legs up and down to resemble a cyclist's pumping action. (ALC)

Cat. 9

UNIDENTIFIED ARTIST

Monkey Trade Sign, ca. 1930–50
argon and mercury, glass tubing, black paint, electrical tape, and transformer
32⅛ × 19⅝ × 1⅞ in.
acquired from Let There Be Neon, New York, 1974
1986.65.312

Neon lighting was introduced in Paris in 1910 and was widely used in America by the 1930s. Its use declined by the 1950s as new technology replaced it. In recent years, neon has regained popularity as an art form. This example, originally found in Philadelphia, is from the heyday of neon signs. The type of establishment that displayed it is unknown. While "neon" has become the generic term for this type of lighting, the blue/violet color of this monkey is actually produced by argon gas. Neon would have produced an orange/red color. In either case, electrodes are fused to the ends of glass tubes bent into a pattern. After air and other impurities are removed, gas is introduced, and the tube is sealed. A transformer feeds about fifteen thousand volts to the electrodes, which causes the gas to ionize and glow steadily. A well-made tube can last thirty years or more. (ETH)

Cat. 9

Cat. 10

GERALD McCARTHY

life dates unknown; active Ogdensburg,
New York
Galvanized Man, ca. 1950
cut, bent, assembled, and soldered galvan-
ized iron
78 × 37¼ × 20¾ in.
acquired from anonymous antiques dealer,
Saratoga Springs, New York, ca. 1979
1986.65.329

Gerald McCarthy placed the larger-than-
life *Galvanized Man* outside his small
shop in Ogdensburg, New York.
"Plumbing, Heating, Cooling," painted
across the figure's chest, was the sole indi-
cation that the building was the commer-
cial establishment of a "tin knocker," the
regional name for sheetmetal workers. The
message was clear and direct. The words
described his product; the figure demon-
strated his technique and materials.

As with Dominick's *Marla,* (cat. 13), all
of the figure's elements, except its shoes,
are standard metalworkers' ventilation
forms. The figure's right hand is a round
Y junction, his left hand, an exhaust duct
with attached flashing, and the head, a
roof ventilator, painted an eyecatching
bright red on the inside. The *Galvanized
Man* is a homemade version of the still-
popular human and animal colossi that
first appeared in large numbers along
America's rural roads in the 1920s and
1930s. Intended to attract the attention of
passing motorists, these figures depended
on unusual and arresting images to entice
customers. (ALC)

Cat. 10

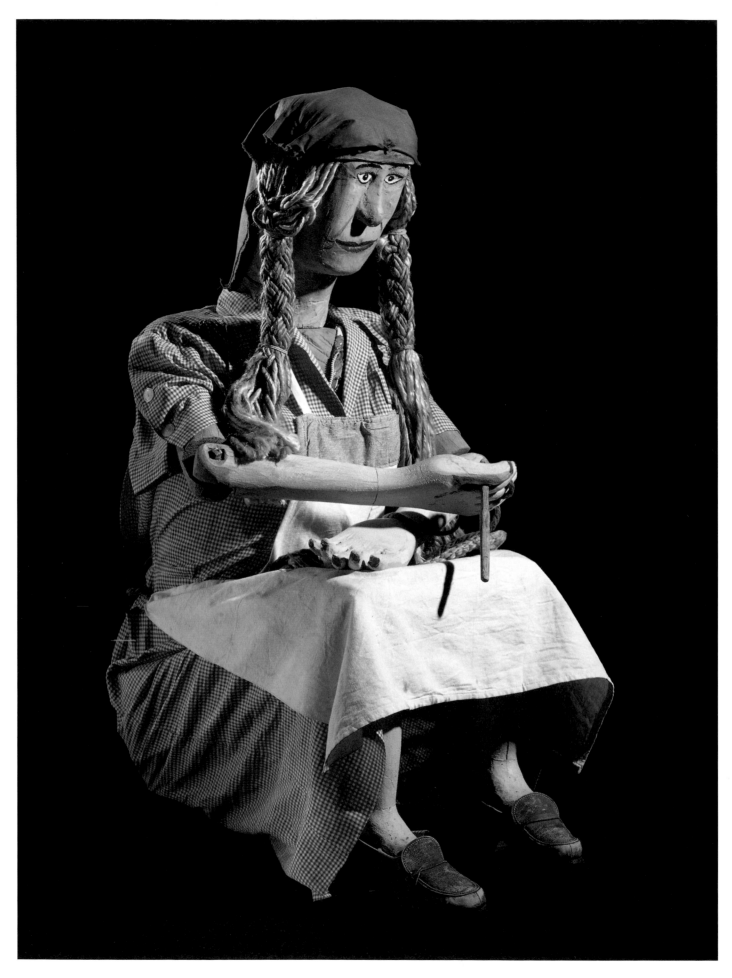

Cat. 11

Cat. 11

MILES BURKHOLDER
CARPENTER

born 1889, near
Brownstone, Pennsylvania–
died 1985, Waverly, Virginia;
active Waverly after 1941
Indian Woman, ca. 1970
carved and painted wood, cotton, syn-
thetic fibers, and leather
49½ × 20 × 30 in. (seated)
acquired from Michael and Julie Hall,
Bloomfield Hills, Michigan, ca. 1973
1986.65.235

Cat. 12

MILES BURKHOLDER
CARPENTER

Bull's Head, 1972
carved and painted wood, rubber, and
thread
21¼ × 12 × 15 in.
acquired from the artist, ca. 1973
1986.65.234

"You may know your business, but no
one else will, if you don't advertise."[1]
Miles Carpenter's successful lumber and
ice business, active after 1912, needed lit-
tle promotion, and his first small carvings
of animals and figures, made during the
early 1940s, were essentially pastimes. Af-
ter "retiring" in 1955, the industrious
Carpenter opened a roadside store offering
ice, soda pop, and vegetables. In 1960 he
began carving trade signs for the new
business. After his wife's death in 1966,
Carpenter devoted himself to a third ca-
reer—carving sculptures. Many he called
"advertisements"; others were benevolent
interpretations of contemporary history
and human nature. Still others were meant
to entertain children and adults alike, and
some were decorative pieces. All reflect
his astute grasp of an audience, his un-
erring ability to extract forms from wood,
and his delight in tinkering with materials
at hand.

After 1966 Carpenter carved figures and
animals that he displayed in the flatbed of
his pickup truck, which he strategically

parked next to his roadside stand or drove
through the community (see fig. 39). *In-
dian Woman* was one of the first "adver-
tisements." The articulated figure hooks a
small rug as she rests on her haunches.
Although her wardrobe changed over the
years, she has always worn the clothing of
Carpenter's late wife. A male Indian fig-
ure and a boy were among her compan-
ions in the truck and, locally, the trio was
considered a portrait of Carpenter's fam-
ily. *Bull's Head* was also part of the
truck's original ensemble before Carpenter
was discovered by the contemporary art
world in 1972. As carvings in the truck
sold, he substituted new works, often the
watermelon slices, "monkey dogs," "root
monsters," (see cat. 180), and small farm
animals that became the staple of Carpen-
ter's repertoire. (LRH)

[1]Jeffrey Camp quoted in Miles B. Carpenter,
Cutting the Mustard (Tappahannock, Va.:
American Folk Art Company, 1982), 5.

Cat. 12

Cat. 13

IRVING DOMINICK

born 1916, Bronx, New York; active
Spring Valley, New York; lives Delray
Beach, Florida
Marla, 1982
cut, bent, soldered, and riveted galvanized
iron
59 × 35¼ × 14¾ in.
acquired from Aarne Anton, American
Primitive Gallery, New York, 1987
1988.74.13

After a lifetime creating ductwork for
heating and air conditioning systems, roof-
ing, gutters, and "anything else that could
be made from metal," Irving Dominick
began to create the objects he calls his
"art." *Marla,* with her permanent wave
hairstyle, eye-catching lashes, and snappy
shoes, is the best surviving example of the
whimsy and care that inspired his metal
figures.

Dominick began working in the sheet
metal trade with his father after school
and on Saturdays when he was fourteen,
and soon thereafter entered into a formal
apprenticeship with a firm in Brooklyn.
As an advertising attraction, his father
crowned the roof of his shop in the Bronx
with a larger-than-life figure called "Tiny
Tin," a self-portrait by the shop foreman.
After his father's death, Dominick and his
brother moved the family business and its
mascot, "Tiny Tin," to Spring Valley, a
suburb of New York. Dominick, pleased
to have a reason to create nonfunctional,
imaginative forms, made two replacement
"Tiny Tin" figures after collectors bought
previous versions. A collector who owned
one figure asked Dominick to produce a
female companion for "Tiny Tin." Dom-
inick used his ten-year-old granddaughter,
Marla, as his model. (ALC)

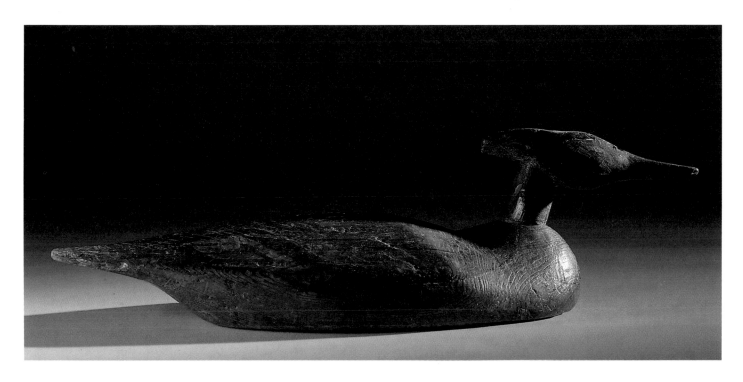

Cat. 14

Cat. 14
UNIDENTIFIED ARTIST
Merganser Duck Decoy, nineteenth century
carved and painted wood
4⅝ × 16¼ × 5 in.
acquired from Adele Earnest, Stony Point, New York, early 1960s
1986.65.66

First made by native Americans, decoys have been used by American hunters to attract migrating birds since the seventeenth century. By the mid nineteenth century, decoys were carved for commercial as well as private use. Regional styles began to develop, and some carvers became well known for their personal artistry. Although this merganser drake has previously been attributed to Roger Williams of Sheepshead Bay, Long Island, no definite attribution can be assigned. The head is made of a root and inserted into the body—a typical feature of Long Island decoys. Such roots often washed up on shore, and their natural shapes lend themselves easily for use as heads of decoys. (ETH)

Cat. 15
UNIDENTIFIED ARTIST
Owl Decoy, early twentieth century
carved and painted wood, leather, and glass
14½ × 5¼ × 5¼ in.
acquired from Adele Earnest, Stony Point, New York, early 1960s
1986.65.59

This owl decoy may have been constructed from what was once a hollow Brant goose decoy. The original head has

Cat. 15

been removed, and the owl's eyes have been inset in what was once the goose's tail section. Placed in trees or on posts, owl decoys were used to attract crows. Crows dislike owls and in their eagerness to harass one, they will ignore a hunter and fly into easy shooting range. (ETH)

Cat. 16
JOHN W. ("MICKEY") McLOUGHLIN, Jr.
born 1911, Bordentown City, New Jersey–died 1985, Tucson, Arizona; active Bordentown City
Black Duck Decoy, ca. 1930s
carved and painted pine with lead and glass
6⅝ × 16⅜ × 6¾ in.
acquired from 1807 House, New Jersey, early 1960s
1986.65.49

This black duck appears to have been made around 1940 as a hunting decoy for use on the Delaware River. It exhibits many of the regional characteristics of decoys from that area. McLoughlin's decoys are usually hollow and two-piece. His early works (before 1940) have flattened bottoms, little relief carving, and are generally carved in cedar. His later decoys, similar to this, have relief-carved wing tips and are made from sugar pine. The paint on this decoy may be original, an unusual feature, since decoys are subject to much wear and tear, and must often be re-painted and repaired. (ETH)

Cat. 17
WILBUR A. CORWIN AND SCHYLER ("BUD") CORWIN
born 1895, Bellport, New York–died 1965, Louisiana; active Bellport; born 1930, Bellport, New York; active Bellport
Cormorant Decoy, ca. 1951–53
painted plywood
33⅝ × 38¾ × 1¼ in.
acquired from Adele Earnest, Stony Point,

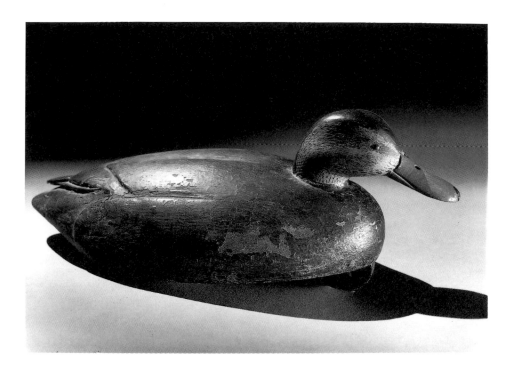

Cat. 16

Cat. 17

New York, early 1960s
1986.65.44

Wilbur A. Corwin owned and operated the Quanch Gunning Lodge in Bellport, Long Island, from 1914 to 1932, and was an active hunter and guide. Flat stick-up decoys were used to attract ducks and shore birds and were among the earliest decoys made. Hunters later began to use

floating decoys to attract ducks. Because the simpler profile decoys could easily be placed along the shore, they continued to be used in hunting shore birds. Since cormorant is rarely eaten, this piece may have been used as a "confidence decoy"—designed not to attract birds of the same species, but simply to make birds think an area is safe and undisturbed. (ETH)

Cat. 18

UNIDENTIFIED ARTIST

Perch Decoy, late nineteenth century
carved and painted wood with metal
1⅝ × 7½ × 2⅝ in.
acquired from Julia Militello, Westville,
New York, 1974
1986.65.48

Fish decoys, or simply "fish" as they are
called by ice fishermen and collectors, are
made and used most frequently in New
York, Michigan, Wisconsin, and Minne-
sota. During the winter months, fisher-
men cut holes through the thick lake ice
and suspend a fish decoy on a cord into
the water below. When larger game fish
pass by to investigate the decoy, the fish-
erman spear them.

This *Perch Decoy* was probably made in
the Lake Chautauqua region of western
New York where most of the state's fish
decoys have traditionally been carved. A
characteristic feature of New York "fish"

is the hole drilled in the back ridge
through which a tie line is passed. Most
carvers developed particular tricks to at-
tract live fish. In this decoy, the maker
attached a spinner behind the tail to imi-
tate a live fish's movement in the
water. (ALC)

Cat. 19

UNIDENTIFIED ARTIST

Brook Trout Decoy, late nineteenth cen-
tury
carved and painted wood with metal and
leather
3 × 8½ × 2 in.
provenance and date of acquisition un-
known
1986.65.43

Like the *Perch Decoy* (cat. 18), this work
was probably made in the Lake Chautau-
qua region of New York. Bill Alday,

probably a previous owner, identified this
"fish" with his name and added the date
1973. Although the carving is much older,
Alday may have also touched up and pol-
ished its painted surface, a common prac-
tice when old paint begins to show signs
of wear. The decoy's flexible leather tail
resembled the flicking tail of a live fish
when the fisherman manipulated this
Brook Trout Decoy in the currents of
water below the ice. Because leather disin-
tegrates easily, few old "fish" still wear
their original leather tails. (ALC)

Cat. 18

Cat. 19

Cat. 20

OSCAR "PELEE" PETERSON

1887–1951; born, active, and died
Cadillac, Michigan
Perch Decoy, ca. 1935–44
carved and painted wood and metal
1½ × 6½ × 1¾ in.
provenance and date of acquisition unknown
1986.65.45

Oscar "Pelee" Peterson is among the best known and most widely imitated "fish" carvers. He began carving around 1905 and may have made as many as ten thousand to fifteen thousand decoys. He sold many of them through bait stands and sporting goods shops during his productive career. Peterson also carved trade signs for fishing businesses and more decorative objects for interior use. His unique carving and painting style influenced other regional carvers to duplicate his "fish," creating what is now called the "Cadillac style." A reference to Peterson's home town, "Cadillac" also alludes to the quality of his craftsmanship, easily distinguished by careful, detailed painting and the characteristic gentle curve in each decoy's body. (ALC)

Cat. 21

UNIDENTIFIED ARTIST

Frog Decoy, ca. 1940s
carved and painted wood with glass beads and metal
2½ × 11 × 3⅞ in.
acquired from an unidentified Michigan dealer at an antiques show, New York, ca. 1984
1986.65.54

Like fish decoys, frog decoys are also intended to attract game fish during ice fishing. This carving was probably made and used in northern Minnesota where frog decoys are most common, and where regional carvers are known for creating out-

Cat. 20

Cat. 21

Cat. 22

landish decoys of all types. This spotted, red frog was made from a forked stick, and sports back flippers represented by metal fins at the ends of the legs.　(ALC)

Cat. 22
"BUTCH" IRVIN SCHRAMM
born 1900, New Baltimore, Michigan; active Michigan
Harlequin Fish Decoy, mid twentieth century
carved and painted wood with metal
1¼ × 4⅞ × 2 in.
provenance and date of acquisition unknown
1986.65.64

"Butch" Irvin Schramm is well known in Michigan for both his duck decoys and his simply painted "fish." His "Harlequin" decoys, so called because their patterning suggests the costume of the traditional theatrical character, are painted in bold black and white quadrants. Lacking identifying features, such as eyes and specific dorsal fins, Schramm's "Harlequins" do not represent a particular species, but are intended to catch the eye of any passing fish.　(ALC)

Cat. 23
UNIDENTIFIED ARTIST
Sturgeon Decoy, ca. 1950s
carved and painted wood with bottlecaps, galvanized iron, and plastic
6 × 26¼ × 6½ in.
provenance and date of acquisition unknown
1986.65.46

This sturgeon decoy, possibly from the Lake Winnebago region of Wisconsin, may have been carved from a standard milled board. Bottlecaps frequently have been used in decoys to replicate the sucker mouth of sturgeons, but attaching folded bottlecaps here to suggest the dorsal fin is unusual. Many of the "coaxers," as fish decoys are called in this region, serve as visual guides for determining the legal length of the fish under the ice before they are speared.　(ALC)

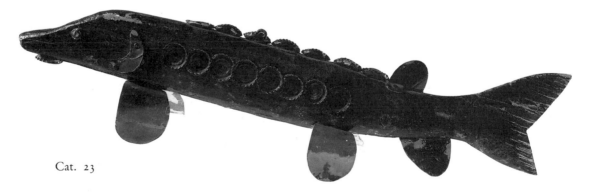

Cat. 23

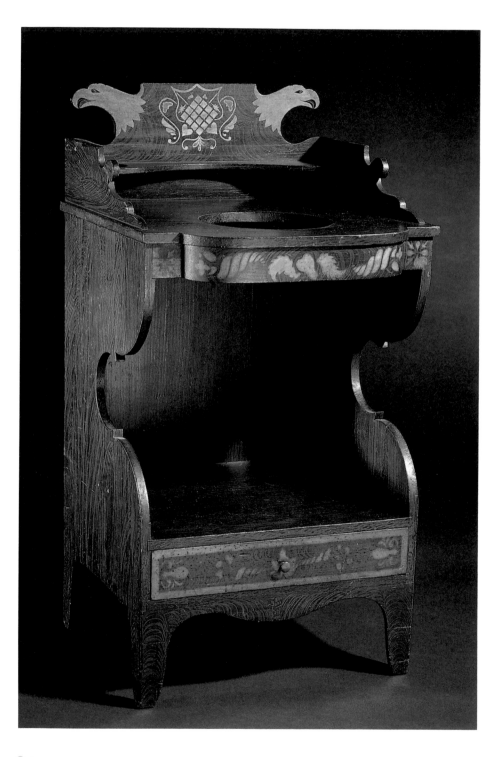

Cat. 24

Cat. 24

UNIDENTIFIED ARTIST
Washstand with Eagle Heads, 1830–45
grained, painted, and stenciled pine with
brass knob
35½ × 18¾ × 18¾ in.
acquired from Eric de Jong, Harrisburg,
Pennsylvania, 1967
1986.65.95

This American Empire-style washstand is
notable for its distinctive painted rose-
wood graining intended to make ordinary
pine look more like exotic and expensive
rosewood. A craftsman would first paint
the pine red and then cover it with a thin
coat of black paint. While that coat was
still wet, the wood was wiped with a
graining tool resembling an irregular
comb. The combs were made of stiff pa-
per, leather, or even tin. Stenciling was
often used to decorate pieces that had re-
ceived this graining treatment; in this case,
bronze-colored paint was applied. The ea-
gle heads and the shieldlike shape are pat-
terns not commonly seen on washstands.

Until the late nineteenth century almost
every home had a washstand or commode
for personal hygiene. Typically, wash-
stands had a flat top backed by a splash
board with space below to accommodate a
ceramic pitcher and basin. This particular
example, however, has a cut-out space on
the top in which to place the
basin. (ETH)

Cat. 25

UNIDENTIFIED ARTIST
Banjo Chair, ca. 1875
turned, inlaid, painted, stained, and var-
nished wood
41 × 15⅜ × 20⅝ in.
acquired from Susan Reed and James
Karen, New York, late 1950s
1986.65.73

Minstrel shows were immensely popular
in the last half of the nineteenth century,
and the banjo, the principal instrument
used in such shows, shared the same pop-
ularity. This unusual chair is an accurate

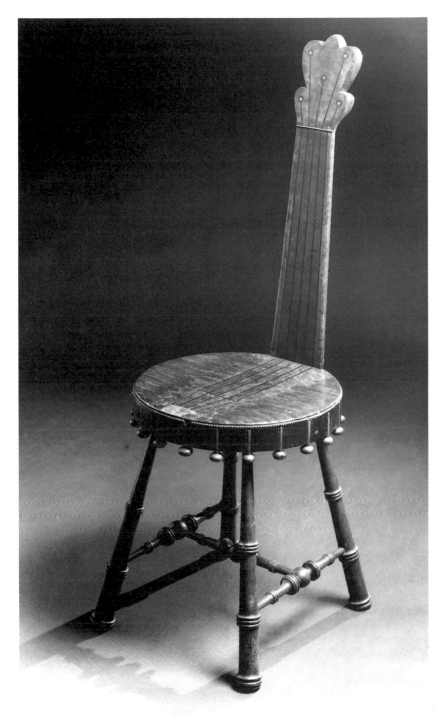

Cat. 25

Cat. 26

UNIDENTIFIED ARTIST

Carved Ornament, ca. 1900
carved, incised, painted, and varnished
root and wood
32 × 14¼ × 9½ in.
acquired from Jeffrey Camp, Richmond,
Virginia, ca. 1975
1986.65.87

This piece, made partially from a tree
root, was originally found in Georgia. Its
exact purpose or function is unknown. It
has been suggested that it may have sat on
a dresser and been used as a jewelry han-
ger. The box in the lower center portion
can hold small items. Such finely carved
details as the female bust on the lid sug-
gest that this domestic object was also
meant to provide a decorative
touch. (ETH)

rendering of a banjo. Notice, for example,
that its inlaid design suggests the five
strings of a typical banjo. Clearly not de-
signed for comfort, this chair may have
been inspired by minstrel shows, but the
banjo motif was a popular component of
many decorative objects such as clocks
and wall hangings made as late as the
1940s. (ETH)

Cat. 26

Cat. 27

Cat. 28

Cat. 27
UNIDENTIFIED ARTIST
Painted Box, ca. 1800–1850
painted wood and paper
6¼ × 14⅛ × 8⅝ in.
probably acquired from Martin Grossman,
New York, 1960
1986.65.77

Cat. 28
UNIDENTIFIED ARTIST
Dome-Top Box with Straw Marquetry, ca.
1800–1850
painted wood, straw, paper, and brass
7 × 15⅞ × 9¼ in.
acquired from unidentified dealer, near
Sandwich, Massachusetts, 1974
1986.65.70

Since their origin in ancient Egypt and
China, boxes have fulfilled functional and
decorative roles in the daily lives of both
men and women. Often, these indispensa-
ble containers also represent the social
customs of a time or place otherwise for-
gotten or undocumented. Embellishing
boxes and adapting their form to a specific
function are universal practices, and the
great variety of boxes made in this coun-
try since colonial times are no exception.

Between 1800 and 1850, painting, rather
than carving, was the principal means of
decorating American boxes. House, sign,
and "fancy" painters or the owners them-
selves all engaged in the practice. Deline-
ated in red, blue, and black on a white
background, a dramatic geometric pattern
emphasizes the rectangular form of this
Painted Box. An experienced ornamental
painter may have been responsible for its
sophisticated stylization and unerring exe-
cution. The image of a woman, excised
from a printed source, decorates the lid's
interior and suggests a feminine owner,
perhaps C. Sherwood, whose name is in-
scribed on the container. Its intimate scale
indicates that it may have been a sewing
or dressing box.

Even more painstaking is the elaborate
straw marquetry of this *Dome-Top Box*.
Its unsubstantiated provenance asserts that
it was made during the War of 1812 by a

prisoner-of-war, M. Swan, whose name is engraved on the lid's brass plate. Instead, the box may be English or French in origin or at least inspiration, since elegant straw marquetry was a popular form of decoration for boxes, pictures, and other accessories made by professional workshops and young women in both countries. English pattern books existed as early as 1750, and European straw-decorated dressing boxes appeared among New York's imported goods by 1864. This example's highly stylized motifs reflect the ambitions characteristic of its genre. (LRH)

Cat. 29
UNIDENTIFIED ARTIST
Box with Photographic Views, ca. 1900
carved, turned, and painted wood with photomechanical reproductions under glass
8½ × 13⅝ × 8⅜ in.
source and date of acquisition unknown; probably the early 1980s
1986.65.86

Cat. 30
UNIDENTIFIED ARTIST
Fish-Shaped Box, early twentieth century
painted wood, cardboard, and paper
13½ × 30 × 10¼ in.
source of acquisition unknown; by 1974
1986.65.79

Custom or need dictated the design of many boxes. Personal whimsy is also evident, perhaps in response to the factory-made containers increasingly available after 1825. The maker of *Box with Photographic Views*—perhaps a hobbyist—went to great lengths to transform a simple, dovetailed box into a quirky, evocative structure. The lid, moldings, and elements, reminiscent of pilasters or balustrades, were probably created just for the object. Turn-of-the-century photographs from newspapers or magazines picture a rocky shoreline, houses, and children fishing and on swings. One

photograph includes the caption, "big game always abundant." The images suggest a rustic environment, perhaps the setting of a vacation or an enterprise drawn from the maker's experience or imagination.

Similarly personalized is the *Fish-Shaped Box,* although animals have inspired the form of containers in many countries, including the United States.

This box suggests the maker's interest in fish or fishing, but its regional origin is unknown, and its previously attributed association with a fisherman or decoy carver is at best speculative. (LRH)

Cat. 29

Cat. 30

Textiles

Cat. 31

Cat. 31
UNIDENTIFIED ARTIST
Hooked Rug with Stars, Crescent, and Fret, after 1850
hooked wool on burlap
30½ × 48¼ in.
source and date of acquisition unknown
1986.65.351

The least puzzling feature of this hooked rug is its technique. An instrument resembling a crochet hook was used to pull unknotted loops of yarn, fabric scraps, or ribbon through a coarsely woven, stretched backing. A presketched design was followed. Although hooked rugs were made in the United States during the early nineteenth century, they became most popular after the 1850s when inexpensive burlap became widely available. During the 1860s, peddler Edward Sands Frost of Maine developed mass-produced stencils for patterns. They greatly contributed to the proliferation of American hooked rugs well into the early twentieth century.

This rug's design does not appear to be based on commercially available patterns, although the border's repeated fret is a common decorative motif not unlike other geometric or abstract patterns used in many hooked rugs. The red, white, blue, and gray colors suggest a patriotic impulse, and the rug has been described as an interpretation of the Confederacy. Although eleven white stars and a crescent moon appeared in some of the unofficial battle flags designed for the Confederacy or individual regiments, the rug does not resemble any known designs. The maplike silhouette does not conform to an outline of the Confederacy or any of its thirteen states. Since rug hookers took considerable license when creating original designs, this example may incorporate an idiosyncratic reference to an historical event. Its fetching design is otherwise of cryptic origin. (LRH)

Cat. 32

Cat. 32
UNIDENTIFIED ARTIST
Floral Runner, ca. 1880–1900
appliquéd and pieced wool, cotton, and rayon
19¼ × 43¾ in.
acquired from unidentified dealer, Pennsylvania, late 1960s
1986.65.346

This narrow, cloth cover was probably designed as a showpiece for a table, chest, or dresser top. Although not intended for use on the floor, textiles in this shape and size have also been called table rugs. This example incorporates many small pieces of fabrics; twenty-two pieces of heavy striped cotton compose the backing alone. The scraps, dyed by hand and machine, were probably salvaged from old clothing, a common practice in economical households where fabrics were recycled to make other textile accessories such as hooked rugs or crazy quilts. Careful feather stitching embellishes the runner's floral motifs, which are laid out in a format that suggests an awareness of floor runners or other rugs of the late Victorian era. The red, black, purple, and olive color scheme is also reminiscent of the period. (LRH)

Cat. 33

Cat. 33

RESIDENTS OF BOURBON
COUNTY, KENTUCKY
life dates unknown
Fan Quilt, Mt. Carmel, January 16, 1893
embroidered, appliquéd, and pieced cotton, wool, velvet, and silk, with ribbon, paint, and chromolithographic decals
85 × 72¼ in.
acquired from Boultinghouse and Hall of Lexington, Kentucky, at Armory Antiques Show, Washington, D.C., 1987
1987.80

Bearing one hundred and ten embroidered names, this fan quilt is a decorative registry of the small, rural community of Paris, Kentucky, in 1893. Although it is offcenter in the design, a painting of the Mount Carmel Christian Church is the focal point of the forty-two pieced squares. The building's depiction is accurate, even documenting the two doors through which men and women once entered the church to sit on opposite sides of the central aisle.

This quilt features the fan, a common pattern among Victorian quilters and other designers. The textile is, literally, a collage of handpainted, appliquéd, and embroidered scraps much more formally arranged than the randomly shaped pieces that comprise crazy quilts. Finishing details such as buildings, figures, names, decals, and elaborate embroidery are not uncommon in Victorian quilts, but it is unusual to find so many of these elements combined in one effort.

The abundance of names is particularly idiosyncratic. Many represent families historically associated with Bourbon County. Collectively, they probably represent the congregation of the Mount Carmel Christian Church. The quilt may reflect one of two traditions common among a community's quilters. This example may have been made by one or several members of the church, perhaps either as a presentation piece to honor someone or to commemorate an event. It could also have been made as a fundraising device, since people often paid to have their names on quilts that were subsequently sold or raffled to benefit a cause or group. Certain patterns, such as the fan, lent themselves to accommodating names. Incorporated into this design are the appliquéd figures of four women identified by embroidered inscriptions as officers of Mt. Carmel's Ladies Aid Society, perhaps the impetus of this ambitious quilt. (LRH)

Cat. 34

Attributed to EVELYN DERR or
MBK
life dates unknown; possibly active southeastern Pennsylvania
Sampler Block Quilt, July 1905
"fancy darning" in wool on pieced and quilted cotton huck toweling
79¾ × 79¾ in.
acquired from unidentified dealer at Armory Antiques Show, Washington, D.C., 1988
1989.30.4

Found in Lancaster County, Pennsylvania, this pieced quilt is a tour-de-force demonstration of a technique normally used to decorate much smaller accessories such as towels, dresses, and scarves. During the early twentieth century, English needlework magazines and manuals were available across the country. One of the techniques popularized by these magazines was "fancy darning," which emphasized contrasting colors, broad effects, and geometric patterns for decorating small areas such as borders. Generally, the backing was a coarse, loosely woven linen or cotton material; durable fabric used for toweling—known as huckaback or huck toweling—was especially recommended.

Needlework manuals also suggested "fancy darning" for making updated variations of early nineteenth-century samplers, demonstrations of exquisitely darned patterns on much more finely woven materials. Whoever made this quilt appears to have heeded this advice to create twenty-five darned squares, each of which reflects an adventuresome sense of patterning and color. No doubt the maker also enjoyed quilting, since the squares have been pieced, laid over a thin layer of stuffing, and stitched to a backing, itself stitched with stars and circles. Conceived as a quilt, this sampler has reached monumental proportions. As a resident of southeastern Pennsylvania, Evelyn Derr or someone with the initials MBK was probably aware of the pieced sampler block quilts often made in that area, especially in Pennsylvania German communities. Demonstrating the artistry of a single maker or a group of women, such quilts incorporated blocks of familiar quilted patterns as well as original designs. Derr is a common family name in the counties of southeastern Pennsylvania, especially those of Berks, Lehigh, and Chester. Thus far, information about Evelyn Derr has not been found in the region's genealogical and census records. Either Derr or MBK probably made the quilt, perhaps as a gift, one to the other. (LRH)

Cat. 34

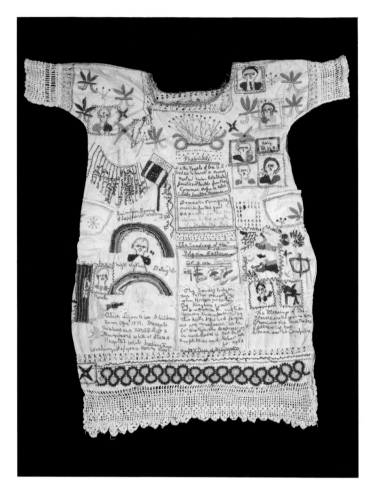

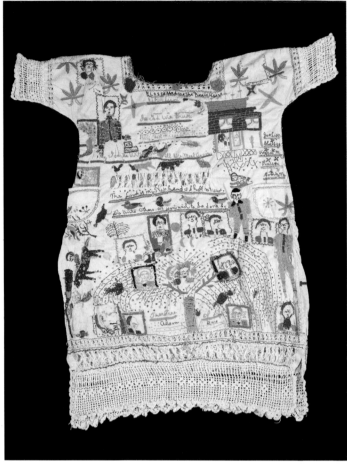

Cat. 35 front Cat. 35 back

Cat. 35
ALICE EUGENIA LIGON
born 1886, birthplace unknown–died
1959, Fulton, Missouri
Embroidered Garment, ca. 1949
embroidered muslin with crocheted cotton
and pencil
43¾ × 38½ in.
acquired from Aarne Anton, American
Primitive Gallery, New York, 1989
1989.78.2

Housewife Alice Ligon of Columbia,
Missouri, enjoyed sewing, crocheting, and
making historical quilts. This garment is
her only known surviving effort. Its cir-
cumstances are bittersweet, for embroi-
dered inscriptions indicate that Ligon cre-
ated this dress as a Christmas present for
her children while she was a patient at the
Fulton State Hospital in Fulton, Missouri.
(In 1851 the hospital became the first pub-

lic mental institution established west of
the Mississippi River.) Ligon was hospi-
talized for an unspecified condition in
1949 and 1953 and died at the facility
several years later. She displayed her love
of sewing primarily during her stay in
1949.[1]

Ligon's stenciled name and ward desig-
nation inside this baggy dress suggest that
it was first her hospital gown or uniform;
at one time, patients made their own
clothing. The garment is embroidered
overall with vignettes and inscriptions that
follow her penciled guidelines. Ligon
mingled patriotic, religious, seasonal, per-
sonal, and popular references in her free-
wheeling design, which was stitched by
hand and machine. Although often diffi-
cult to decipher, scenes include Noah's
Ark and Columbus's three ships on the
front; Adam and Eve in the Garden are
on the back. She also attempted portraits

of Truman, Eisenhower, and family mem-
bers, based on her stitched identifications.
Other inscriptions recount the Constitu-
tion's preamble and the Lord's Prayer, as
well as the theme of Ligon's gift to her
children, "May God be with you until we
meet again." She trimmed the garment's
sleeves and hemline with crocheted pat-
terns. (LRH)

[1] Ligon's death certificate and the Fulton State
Hospital provided some of this information.

Ceramics

Cat. 36
UNIDENTIFIED ARTIST
Alabama
Five-Gallon Home Brew Jar, ca. 1880
alkaline glaze stoneware with incised
tooled and wavy "sine" lines
16¾ × 14 × 12⅛ in. (diam.)
acquired from Jeffrey Camp, Tappahan-
nock, Virginia, from Howard Finster,
Summerville, Georgia, 1977
1986.65.40

Perhaps more than any other craft, South-
ern utilitarian stoneware illustrates the
self-sufficient agrarianism that character-
ized life in the region until the early twen-
tieth century. Potters found steady mar-
kets for their wares, particularly storage
vessels for homemade foodstuffs such as
butter, syrups, preserved fruits and vege-
tables, lard, and meat. Modified for the
fermentation of beer, wine, or cider, the
home brew jar was a variation of the tra-
ditional churn form for beer, wine, or
cider. The well-like construction around
the mouth of the jar was filled with water
and covered with a lid, providing both a
seal for the brew and a release for the
gases during the fermenting process. Cre-
ated by horizontal tooling with a wooden
comb while the pot was being turned on a
wheel, the combination of incised wavy
"sine" and straight lines was the preferred
form of decoration among potters in the
Deep South. Such patterning was rare,
however, as the more functional aspects of
the jars usually dominated their manufac-
ture.

Alkaline glazes were a distinctive re-
gional feature of stoneware from the Deep
South, appearing as early as the 1820s in
the Edgefield District potteries in South
Carolina. The erratic trade in salt meant
that rural potters often turned to alkaline
substances such as sand, clay, lime, or
wood ash to make their glazes. Migrating
Edgefield potters disseminated the practice

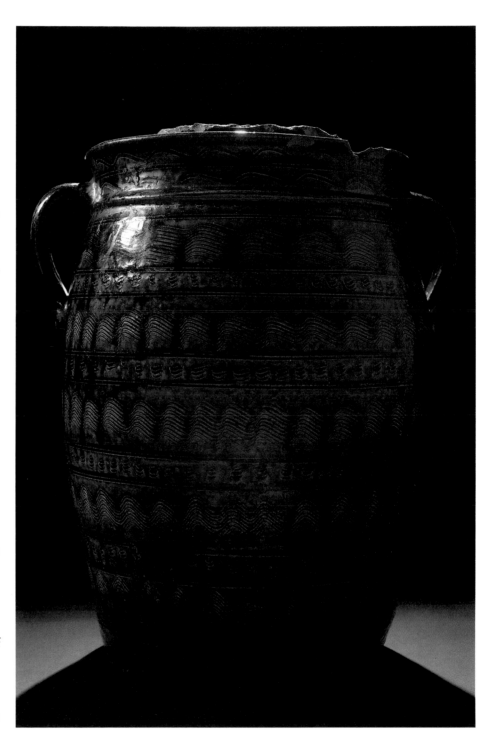

Cat. 36

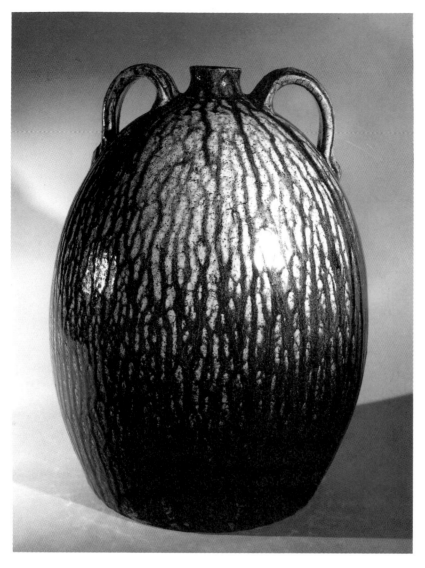

Cat. 37

Cat. 38

throughout the lower South, where it remained the standard until the latter part of the nineteenth century. (TLH)

Cat. 37
FRANKLIN LAFAYETTE ("FATE") BECHAM
born 1871, Crawford County, Georgia–
died 1958, Crawford County, Georgia
Double Handled Whiskey Jug, before 1918
alkaline glaze stoneware
17⅝ × 13⅛ in. (diam.)
provenance unknown; acquired ca. 1972
1986.65.29

Stamped on the upper left loop handle of this whiskey jug are the initials, "FLB," identifying marks of the Georgian potter, Fate Becham.[1] The 1850 census in Crawford County identified Fate's father, "Wash," and his four uncles as "Jug makers," a statistic that also applied to eighteen potteries operating in the same county before 1907. With the widespread destruction of livestock during the Civil War, the corn harvests shifted from feed to whiskey, which required enormous quantities of stoneware for its storage and sale. Potters of eastern Crawford County, such as the Bechams, specialized in liquor jugs, which were sold as fast as they could be made. Wash's sons, Fate and Jack, continued the family tradition until Prohibition curtailed the demand for jugs. Fate stopped working as a potter around 1918. This whiskey jug's beehive shape is characteristic of the family style that was inherited from Wash Becham. Its "tobacco spit" or "rock" glaze was an innovation of the alkaline glaze used by Southern potters; adding iron-bearing nodules (limonite and hematite) called "paint rocks" to the lime mixture achieved the dripping coloration. (TLH)

[1] See John Burrison, *Brothers in Clay: The Story of Georgia Folk Pottery* (Athens: University of Georgia Press, 1983).

Cat. 38
BROWN POTTERY
Arden, Buncombe County, North Carolina; active 1923–present
Face Jug, after 1923
albany slip glazed stoneware
6⅝ × 4⅞ × 5⅞ in.
acquired from Brown Pottery, 1974–75
1986.65.26

Cat. 39
ROBERT BROWN
born 1951, Arden, Buncombe County, North Carolina; active Arden
Devil Face Jug, 1960s–1970s
albany or clay slip glazed stoneware with kaolin eyes and horns, and painted lips and nostrils
13½ × 7⅜ × 9⅛ in.
gift of Michael and Julie Hall, Bloomfield Hills, Michigan, ca. 1981
1986.65.33

The family-based pottery operation is central to the Southern tradition of stoneware. Unlike the craft apprenticeships of the urban Northeast, the agrarian environment fostered strong familial styles, known for their technological and aesthetic longevity. Originally based in Atlanta, eight generations of prolific Brown potters have continued the trade established by Bowling Brown prior to the Civil War.[1] In 1923, two brothers, Davis and Evan Javan, moved part of the family business to Buncombe County, North Carolina, where their descendants continue to produce pottery.

Face jugs, believed to have originated with slaves in the South Carolinian Edgefield District, have been made by the Browns since the family's arrival in North Carolina. The older work represents the continuation of a late nineteenth-century Georgia style common among white potters—an albany slip glazed jug modified by clay and kaolin additions. As the demand for household stoneware declined after World War II, face jugs became the source of steady income as purely decorative novelties. Robert Brown's devil face

jug is a contemporary version of his uncle Javan's 1930 hardware store advertisement, placed on the porch to attract customers. (TLH)

[1]See Burrison, *Brothers in Clay,* and Charles Zug, *Turners and Burners: Folk Potters of North Carolina* (Chapel Hill: University of North Carolina Press, 1986) for accounts of the Brown family potters in Georgia and North Carolina.

Cat. 39

Cat. 40
QUILLAN LANIER MEADERS
born 1917, Mossy Creek, White County, Georgia; active Mossy Creek
Face Jug, ca. 1972
stoneware with albany slip mixed with whiting, feldspar, and local clay slip glaze
9¼ × 8½ × 8 in.
acquired from the artist, 1974
1986.65.28

This face jug represents Lanier Meaders's continuation of traditional ceramic craftsmanship in White County, Georgia, where stoneware was possibly in production as early as 1820. His grandfather, John Milton Meaders, opened the Meaders Pottery in 1893, employing his sons, Wiley, Caulder, Cleater, Cheever, and Casey, to assist hired local potters. Through these men the Meaders learned the basic techniques employed by Mossy Creek potters for over half a century—knowledge that passed to Lanier when his father, Cheever, took over the original family shop in 1920. By 1930, the Meaders were the last of the family potteries in Mossy Creek.

When a Doris Ullman photograph of Cheever and his family was published in Allen Eaton's *Handicrafts of the Southern*

Cat. 40

Highlands in the late 1930s, the demand for Meaders stoneware significantly changed from utilitarian wares to whimsies such as face jugs. Lanier became a full-time potter after his father's death in 1967, initially producing an order of face jugs for the Smithsonian Institution's first Festival of American Folklife. Although he continues to make household stoneware, these face jugs are now his specialty. (TLH)

Cat. 41
UNIDENTIFIED ARTIST
Brick Portrait Bust, late nineteenth to early twentieth century
fired clay
7⅜ × 4⅞ × 6⅛ in.
acquired from James Kronen, New York, 1977
1986.65.34

Cat. 42
UNIDENTIFIED ARTIST
Midwest, possibly Ohio
Sewer Pipe Vase with Applied Decoration, twentieth century
alkaline glaze stoneware
11½ × 7½ × 5¾ in.
acquired from American Antiques/Furniture, Suffield, Connecticut, 1979
1986.65.39

Stoneware objects, such as the sewer pipe vase and brick bust, were diversions from making large numbers of identical commercial items in factories. Whether whimsical or functional, these handcrafted works were expressive of the individual worker, who made them as gifts or for personal use. In this case, a molded sewer pipe has been transformed into a decoratively textured vase by applying clay protrusions. Salt added during the firing process created the glaze's color and rind-like surface. Hand-formed or press-molded bricks also served as raw material for portraits in much the same way that turned and glazed busts were fashioned by traditional potters. Similar stoneware objects included whistles, miniature pots and jugs, doorstops, and banks. (TLH)

Cat. 41

Cat. 42

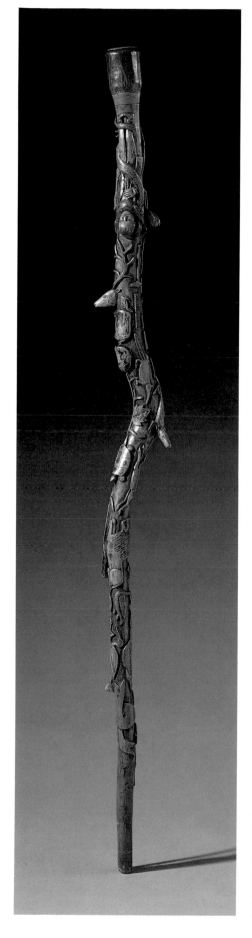

Canes

Cat. 43
UNIDENTIFIED ARTIST
Cane with Indian, Entwined Man, and Diverse Animals, ca. late nineteenth century
37 × 4 × 1½ in.
carved, painted, and varnished hickory and pecan with metal
acquired from unidentified dealer, Pennsylvania, 1970s
1985.65.25

Cat. 44
UNIDENTIFIED ARTIST
Cane Inscribed FÔRET DE LAIGUE, 1918
carved, pyro-engraved, and varnished wood with metal
37 × 2 in. (diam.)
source and date of acquisition unknown
1986.65.3

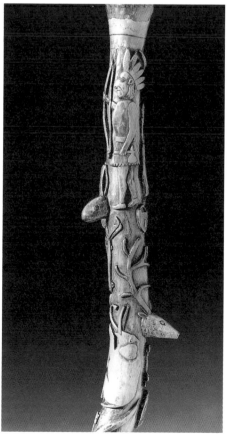

Cat. 45
UNIDENTIFIED ARTIST
Cane with Outstretched Hand, probably twentieth century
carved and stained birch with metal and rubber
35¼ × 4½ × 1¼ in.
source and date of acquisition unknown
1986.65.19

Cat. 46
UNIDENTIFIED ARTIST
Cane with Arched Nude Female, probably twentieth century
carved and painted wood
35¼ × 6 × ⅞ in.
source and date of acquisition unknown
1986.65.13

Cat. 47
UNIDENTIFIED ARTIST
Cane with Hand, Alligator, and Snake, probably twentieth century
carved wood
33¼ × 4⅛ × 1½ in.
source and date of acquisition unknown
1986.65.9

Cat. 48
UNIDENTIFIED ARTIST
Cane with Head and Geometric Inlay, probably twentieth century
carved, inlaid, painted, and stained walnut
36⅜ × 1⅜ in. (diam.)
source and date of acquisition unknown
1986.65.10

Cat. 49
BEN MILLER
born 1917, Breathitt County, Kentucky; active eastern Kentucky
Cane with Snake and Lizard, ca. 1968
carved, stained, and varnished dogwood or white ash with plastic and felt-tip pen
38 × 8¼ × 1¼ in.
acquired from the artist, ca. 1969
1986.65.1

Cat. 43

Cat. 43 detail

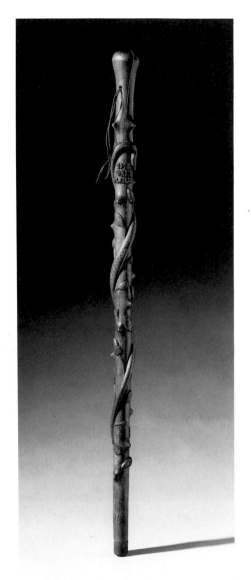

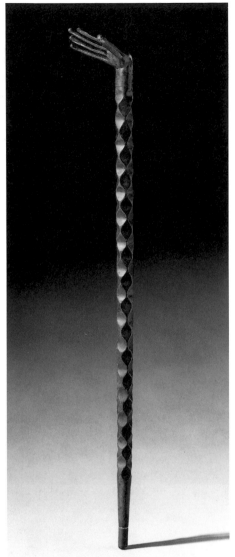

Cat. 44

Cat. 45

Cat. 46

Today, handmade canes are appreciated for their decorative features. Condensed along their slender shafts and handles have been a wide range of designs—stained, painted, and carved, intricately or broadly rendered—according to their maker's skill or inclination. For the carver, however, the object's purpose and execution have traditionally overshadowed its aesthetic dimension. Each walking stick has an obvious function to fulfill; its hard wood and design must sustain weight and wear, and its length must comfortably fit that of

its user's arm. Carving canes has usually been the domain of men, often with a familial or local history of carving, whittling, or woodworking. Fashioning handmade canes would help pass their maker's time productively and often define the maker's interaction with his family and communities.

Decorating the vertical surface of a walking stick and its horizontal handle is a challenge of integration and layout. One carver went to extraordinary lengths, turning natural protrusions into the heads

of animals and wrapping the entire surface in expertly sculpted vignettes (cat. 43). In one detail, a snake (a ubiquitous motif) encircles both the shaft and a man in a suit; other details feature an Indian with bow and arrow, farm implements, a rhinoceros, and a duck in flight. Another carver worked much more broadly as he incorporated the rough suggestions of a hand, snake, and alligator (cat. 47). The carved hand mimics the gesture of grasping the cane's vertical shaft. Some carvers concentrate on the handle rather than the

Cat. 47

Cat. 48

Cat. 49

shaft, as is the case with whoever carved this hand with elongated, outstretched fingers, complete with incised fingernails (cat. 45). The figure arching its back along the handle of one cane owes its graceful curve to the care taken in tying the wood into shape after it had been boiled or steamed (cat. 46).

Ben Miller of Kentucky takes obvious delight in finding dogwood roots that suggest evocative shapes. Here, in one of his earliest efforts to incorporate multiple reptilian forms, two entwined reptiles devour each other. Having discovered his shapes, Miller then uses pen and magic marker, sealed with glossy varnish, to create layers of obsessively patterned drawings that reinforce each cane's motif. (LRH)

Cat. 50
G. W. RICH
life dates and place of activity unknown
Cane Inscribed CHATTANOOGA,
CHICKAMAUGA, AND ATLANTA,
probably nineteenth century
carved, inlaid, and stained white ash with
metal
35¼ × ⅞ in. (diam.)
source and date of acquisition unknown
1986.65.2

Cat. 51
UNIDENTIFIED ARTIST
Cane Inscribed REMEMBER THE
MAINE & OUR HEROES DEWEY,
SCHLEY & HOBSON, after 1898
carved and painted wood
34⅝ × 1½ in. (diam.)
source and date of acquisition unknown
1986.65.4

Cat. 52
UNIDENTIFIED ARTIST
Cane Inscribed THY ROD AND THY
STAFF—THEY COMFORT ME, 1911
carved, incised, punched, and lacquered
birch
35⅞ × 1⅞ in. (diam.)
source and date of acquisition unknown
1986.65.8

Cat. 53
UNIDENTIFIED ARTIST
possibly New York
Cane Inscribed THE BLUE EAGLE IS
FLYING ALL OVER THE NATION,
SCARING THE HUNGER AWAY, WE
HAD ENOUGH OF THIS DEPRES-
SION, CHEER UP THE BLUE EAGLE
IS IN PARTNERSHIP WITH THE
N. R. A. NEW YORK CITY, 1933
carved and painted sumac
35⅞ × 1⅜ in. (diam.)
source and date of acquisition unknown
1986.65.5

Cat. 50

Cat. 50 detail

Cat. 54
UNIDENTIFIED ARTIST
possibly Virginia
Cane Inscribed THIS CANE WAS CUT
NEAR JEFFERSONS TOMB, probably
twentieth century
carved and lacquered hard maple with
metal
36⅛ × 1½ in. (diam.)
probably acquired from Jeffrey Camp,
Richmond, Virginia, after 1974
1986.65.7

Cat. 55
UNIDENTIFIED ARTIST
Cane with Eagle-Headed Handle and *Di-*
verse Emblems, probably twentieth cen-
tury
carved, stained, stamped, and varnished
birch with metal
34 × 5 × 1¼ in.
source and date of acquisition unknown
1986.65.16

Cat. 51 Cat. 51 detail Cat. 52 Cat. 53

Some cane carvers extend the sculptural imperative of their objects beyond the decorative. Carved, incised, and painted with inscriptions and symbols, canes can be hand-held (or waved) reflections of their times.

G. W. Rich, perhaps a veteran of the Civil War, commemorated three battles: the Confederate victory of Chickamauga, Georgia, in 1863; the Union victory at Chattanooga, Tennessee, in 1863 under Ulysses S. Grant; and another victory at Atlanta in 1864 under General William T. Sherman (cat. 50).

War themes also dominate an unidentified carver's effort to memorialize the American battleship, the *Maine*, sunk in Havana Harbor in 1898 (cat. 51). The event inspired the popular slogan, "Remember the *Maine*," and helped to spark the Spanish-American War that same year. The knob is a carved portrait of Admiral George Dewey, who defeated the Spanish at Manila Bay.

Another cane is wrapped with sinuous inscriptions that can only be read by turning its shaft again and again (cat. 54). Its wording celebrates Thomas Jefferson's

drafting of the Declaration of Independence, his presidency, and his founding role at the University of Virginia.

Capped with a fierce eagle for its handle, one cane is a compendium of symbols (cat. 55). Some are easily recognized, such as the Liberty shield, emblems for the U.S. Army and the Navy, and the Maltese Cross. Others are more obscure and appear to be regimental or fraternal in origin. Collectively, they suggest the maker's fascination with official designations that may reflect military service.

A religious theme characterizes the cane

Cat. 54

Cat. 55

Cat. 55 detail

inscribed, "THY ROD AND THY STAFF—THEY COMFORT ME," perhaps as an antidote to some tribulation, particularly since the presence of the devil is noted at the bottom of the shaft (cat. 52).

Social commentary was on the mind of the carver who hailed the "Blue Eagle" and the NRA as an antidote to the Depression on his cane of 1933 (cat. 53). President Roosevelt created the National Recovery Administration in 1933 to enforce codes of fair practice for business and industry. The Blue Eagle, the NRA's

official symbol, was displayed by businesses to show that they subscribed to the codes.

Whatever their messages, canes that incorporate lettering provide both text and texture, to be read as commentary and sculpture. (LRH)

Cat. 56

Cat. 57

Cat. 56

UNIDENTIFIED ARTIST

Whirligig with Two Figures on a Weather-vane, ca. 1900
carved and painted wood with iron
31¼ × 32 × 2½ in.
provenance unknown; acquired after 1978
1986.65.376

One of the earliest whirligig styles that originated in Europe during the Middle Ages featured single, standing figures with wind-driven spinning arms. Occasionally these figures held paddles, swords, or other wind-catching objects. They were mounted on poles so they would rotate to face the wind. In Washington Irving's *Legend of Sleepy Hollow*, Balthus Van Tassel sits on his porch "watching the achievements of a little wooden warrior, who, armed with a sword in each hand, was most valiantly fighting the wind on the pinnacle of the barn." It appears that this work originated as an arrow weather-vane, to which figures were subsequently added to create the whirligig. The larger figure's wind-catching arms are balanced with metal weights and rotate independently of each other on a metal axle. Clothing once decorated this figure. A smaller, presumably female form once had rotating arms as well, and is attached to the tail of the arrow as a rudder to keep its indicator pointing into the wind. (ALC)

Cat. 57

UNIDENTIFIED ARTIST

Whirligig with Fish and Pumping Figures, early twentieth century
painted metal and wood with leather
37½ × 56⅝ × 37½ in.
provenance unknown; acquired after 1978
1986.65.372

This whirligig illustrates the development of complex animated figures and combinations of disparate forms. The two figures turning the wheel, a common mechanical device, are combined with a tail in the

Cat. 58

shape of a fish. The painted patterns on the sheet-metal fish indicate that it probably first served as a weathervane and was later added to the wooden figures and propeller to complete the whirligig. Each of the articulated wooden figures bends at the waist as the wheel rotates. Fragments of their original leather clothing remain. Many whirligigs contain figures that move up and down, or back and forth, in imitation of such activities as washing clothes, hanging laundry, and chopping or sawing wood. (ALC)

Cat. 58
CHARLIE BURNHAM
life dates unknown; active Gouverneur, New York
Whirligig with Witch and Horse, 1918
painted metal and wood
25½ × 25 × 16¼ in.
acquired from Charles L. Flint Antiques, Inc., Lenox, Massachusetts, early 1970s
1986.65.377

An assortment of animated, seemingly unrelated, cut sheet-metal figures creates the complex action of this whirligig. The images include a witch with propeller arms flying on her broomstick, a bucking horse, two men in black union suits raising and lowering a propeller-topped water pump, the Stars and Stripes serving as a wind vane, and a row of dangling metal pendants that act as wind chimes. The water pump is made from a faucet, and the gears come from a gasoline engine. Burnham was a jack-of-all-trades. He created a large number of hooked rugs and other traditional craft objects for domestic use in addition to this object. (ALC)

Cat. 59
UNIDENTIFIED ARTIST
active upstate New York
American Flag Whirligig, mid twentieth century
painted iron and carved and painted wood
28¼ × 38½ × 28¼ in.
acquired from the unidentified artist, upstate New York, after 1978
1986.65.371

The evocative American icon of a working windmill driving a water pump, grain mill, or another machine is a common feature of the rural landscape. Wind-powered machines have been used by farmers and manufacturers in the Middle East and Europe for at least fifteen hundred years and became common throughout Europe during the Middle Ages. Hand-held children's toys, similar to today's pinwheel, can be seen in illustrated thirteenth-century manuscripts from northern Europe. Larger versions of these toys, which can be permanently mounted in fixed locations to catch the wind, are still produced in Europe and the United States and have become common features in yard and garden decoration. The tail, which provides a surface for ornamentation, is usually attached to keep the propeller blades spinning into the wind. This whirligig is simple, bold, and patriotic. As its painted

Cat. 59

Cat. 60

blades spin, they blend into concentric circles of red, white, and blue, echoing the colors of Old Glory painted on the tail. (ALC)

Cat. 60
JAMES LEONARD
born 1949, Orange, New Jersey; active New York City
Wind Machine with Gabriel, Eleanor Roosevelt, and Louis Armstrong, 1984
cut and soldered copper with liver of sulfate markings, and wood base
28 × 18½ × 10 in.
acquired from Michael McManus, New York, 1984
1986.65.368

Most whirligig makers place the propeller in front of the figures and add a tail at the rear to keep it pointed into the wind.

Leonard, a cabinetmaker and wood-worker, usually places the propeller behind the figures to increase the efficiency of the machine. The propeller maintains its own direction without a tail, freeing the artist to add more complex and articulated figures. In this tribute on the one-hundredth birthday of Eleanor Roosevelt (1884–1962), the former First Lady "is sitting down because it is her birthday, she is the lady of honor, and the other two guys are playing for her."[1] The other two guys, the Archangel Gabriel and Louis Armstrong (1900–1971), play their horns in Roosevelt's honor while she waves her arms between them. This finely crafted "wind machine" (as the artist calls his constructions) reflects an inventor's pride and a perfectionist's skill. Its working elements are meticulously engineered; the action is smooth and flawless as Gabriel flaps his wings, taps his foot, and moves

his arms, horn, and head, while Armstrong rocks back and forth with his trumpet reaching for his famous double high Gs. (ALC)

[1]James Leonard, interview with Andrew Connors, 5 September 1989.

Cat. 61
UNIDENTIFIED ARTIST
Model of The Virginia, ca. 1929
aluminum and other metals with plastic and painted cloth tape
10¼ × 34⅜ × 36⅞ in.
acquired from Earnest Quick, Palisades, New York, 1973
1986.65.369

The *Virginia,* a Fokker Super-Universal aircraft used for Antarctic reconnaissance by Admiral Richard E. Byrd, was destroyed in an Antarctic storm in March 1929. In the early twentieth century, aeronautical accomplishments so captured the nation's imagination that reports of these feats appeared regularly in newspapers and magazines. This model, complete with spinning propeller, was probably based on the many photographs of Byrd's plane published in the press. In this artist's interpretation of complex new technology, the propeller, tail flaps, passenger door, and tires (made from roller skate wheels) all move, and the detailing of the strut-work, engine block, and windows are all accurate representations of features from the airplane. (ALC)

Cat. 62

UNIDENTIFIED ARTIST

Airplane, ca. 1933–35
carved, painted, and varnished wood,
painted tinned iron, glass, and metal hard-
ware
22 × 43⅝ × 43½ in.
acquired from unidentified dealer, New
York, early 1960s
1986.65.71

This sculpture is a pastiche of elements
from a variety of aircraft used between
1933 and 1935. It most closely resembles
the military A–8 "Shrike," in general use
by 1933 and reproduced in widely pub-
lished accounts of the latest breakthroughs
in aviation technology. The artist took
pains to be accurate in his use of propor-
tions and certain details. This piece, how-
ever, is not a model or exact replica. Al-
though the cabin can be pivoted open or
removed completely to reveal a storage
space, the sculpture is primarily decora-
tive. (ETH and ALC)

Cat. 61

Cat. 62

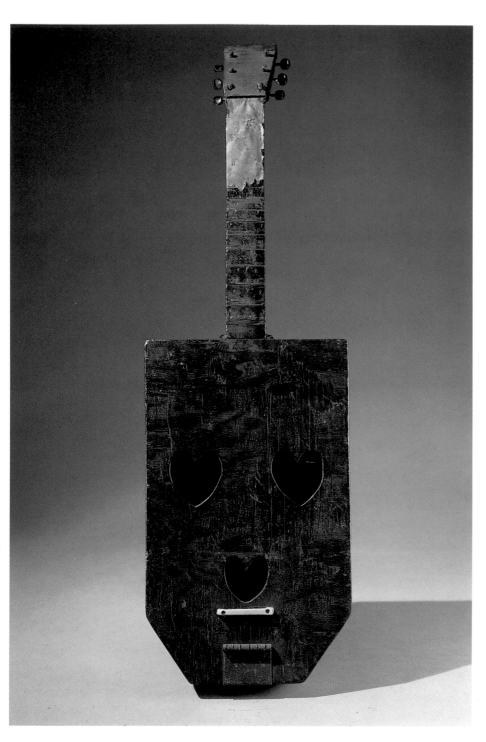

Cat. 63

Cat. 63
UNIDENTIFIED ARTIST
Guitar, ca. 1920s–1930s
painted wood and plywood, brass,
chrome, iron, lead, celluloid, metal wire,
and photograph
34¾ × 10⅞ × 4¼ in.
acquired from Frank Maresca, New York,
ca. 1985
1986.65.300

This boxy guitar is typical of many African-American homemade versions of more professionally or commercially produced instruments. The heart-shaped sound holes recall the decorative motifs on dulcimers unique to the southern mountains, and the usual single sound hole is increased to three. Attached to the guitar's back are decorative features including a brass relief plaque with a scene of a Chinese garden, and a small framed photograph of a black man standing in front of the George Washington Bridge in New York. At the lower edge of the instrument's back is a small hinged door that covers two compartments possibly intended to hold extra strings, picks, or other objects.

Although this guitar was a working instrument, the maker lacked certain basic knowledge about the construction of guitars. Its heavy structure would have significantly dulled the string sound. The fret marks on the neck, partly obscured by a protective and decorative brass covering, indicate a knowledge of sound based on trial-and-error. A metal coil, a spring, and other wire objects are mounted inside the sound chamber, producing a drone note, which would compound each note played on the strings. Such additions to stringed instruments have also been found in fiddles, where a rattlesnake's rattle is occasionally attached to the interior. (ALC)

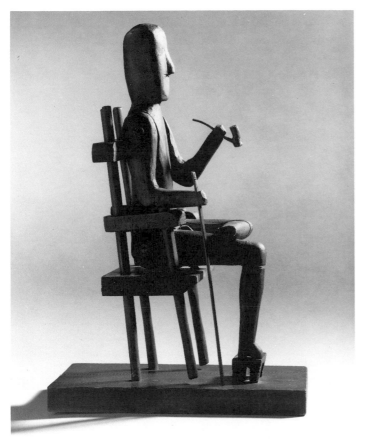

Cat. 64

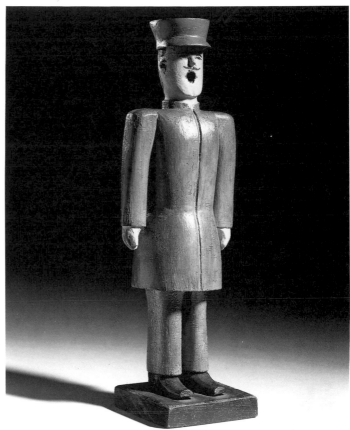

Cat. 65

Cat. 64
UNIDENTIFIED ARTIST
Seated Man with Pipe, ca. 1900
carved spruce with iron screws and traces
of paint and stain
12¾ × 4½ × 8⅜ in.
acquired from Timothy and Pamela Hill,
Novi, Michigan, ca. 1972–73
1986.65.324

"Part of you is in a carving, see; there's
something there that goes with it."[1] The
carver who fashioned this figure will
probably never be identified, but the sen-
timent expressed by another carver, Floyd
Bennington, captures the significance of
making things for those who have put
knife or chisel to wood. Carving has tra-
ditionally been the domain of men, young
and old, in many cultures, including our
own. Their reasons for carving have
ranged from meeting an occupation's or
environment's functional needs to fulfill-

ing creative impulses to please themselves
and others.

Here, a carver has created a figure short
on details of clothing and anatomy, but
rich in implied activity. A walking stick
and pipe suggest various diversions. The
figure appears to be articulated, since its
appendages and joints are either screwed
or notched. Only the left arm can be
moved to approximate the gesture of
smoking; the figure's crossed leg foils the
raising of the walking stick. Rather than
working from a single block of wood, the
maker assembled individually carved and
sawed parts with dowels and screws, per-
haps to resolve the challenge of depicting
a seated figure crossing its legs. (LRH)

[1]Floyd Bennington quoted in Simon J. Bron-
ner, *Chain Carvers: Old Men Crafting Mean-
ing* (Lexington: The University Press of Ken-
tucky, 1985), xiv.

Cat. 65
UNIDENTIFIED ARTIST
Policeman Smoking Toy, twentieth cen-
tury
carved and painted wood with iron
10⅞ × 3¾ × 3½ in.
provenance unknown; acquired after 1979
1986.65.318

This policeman is a hollow construction in
two pieces. Lifting the figure's torso re-
veals that a short pin has been inserted
into the leg section. The filter end of a
lighted cigarette can be mounted on the
pin. When the torso is replaced, the ciga-
rette's smoke rises and comes out of the
figure's open mouth. By tapping the po-
liceman's head, one can make the smoke
come out in puffs and occasionally, smoke
rings. During the heyday of smoking in
the twentieth century—circa 1900 to
1963—mass-produced versions of these
kinds of figures could be purchased in
dime stores. (ETH)

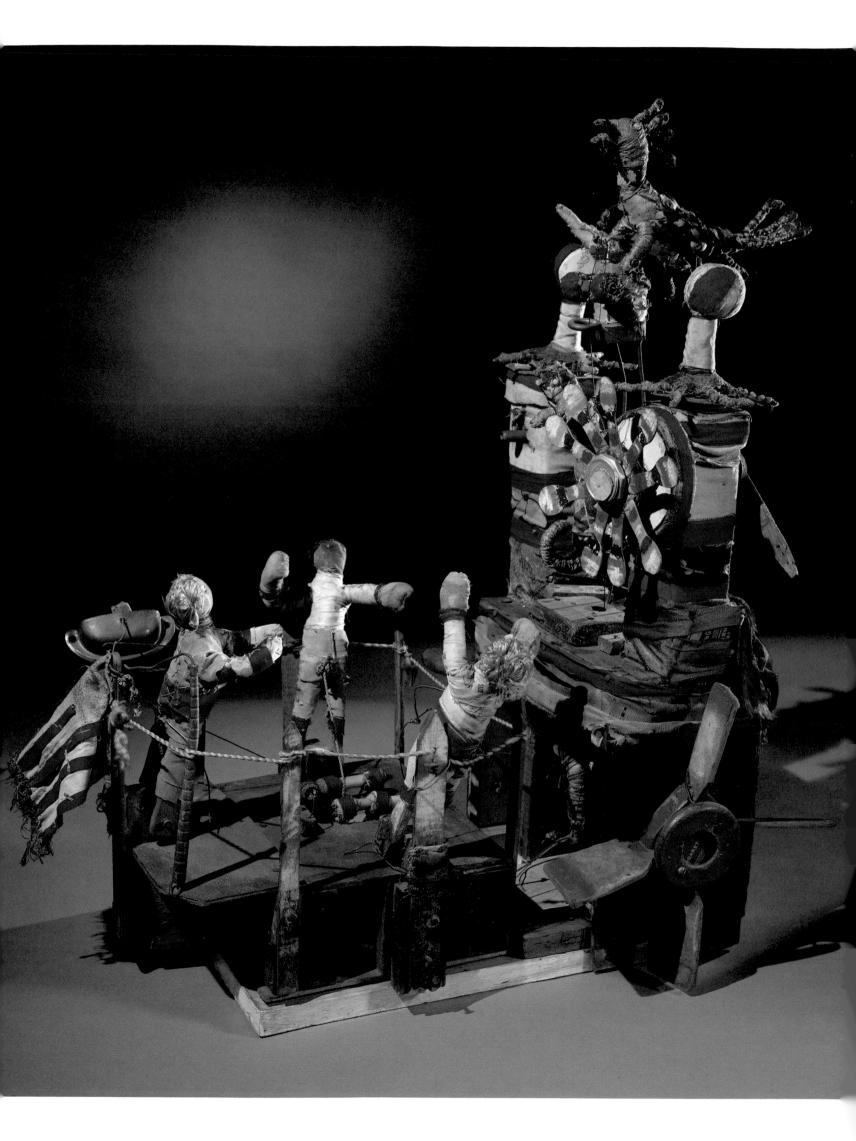

Cat. 66

UNIDENTIFIED ARTIST

Boxing Ring Crank Toy, twentieth century

painted wood, cardboard, masonite with metal, fabric, thread, twine, glass beads, and pencil

27¼ × 25½ × 15¾ in.

acquired from unidentified dealer, upstate New York, 1975

1986.65.284

Combining disparate elements in an odd setting has produced an unusual crank toy. When the crank is turned, myriad activities are set into motion. The pinwheels and propellers on the towers turn and the creatures between them move up and down; in the ring, the boxers and the referee go into action. The moving parts are enhanced by the colorful scraps of fabric wrapped around them. (ETH)

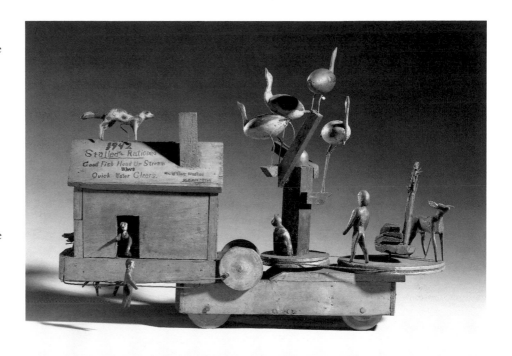

Cat. 67

"OLD MAN" TIRRELL

life dates and place of activity unknown

House Push Toy, 1942

carved, painted, and turned wood with metal and string

15¼ × 22⅞ × 7⅝ in.

provenance and date of acquisition unknown

1986.65.268

Cat. 67

Toys made to be pushed or pulled across the floor have been popular in America since the early nineteenth century. This example, however, is in much danger of falling over if it is pulled. The turning wheel moves the creatures in and on top of the house back and forth on a wire armature and rotates the disks and figures in front. The inscription on the roof reads: 1942/Stalled and Rationed/Good Fish Head up Stream/Where/Quick Water Clears/waste time wasted/OLD MAN TIRRELL. The inscription does not clearly relate to the toy or any of the figures on it, and seems out of place. Although a toy is an unusual vehicle for social commentary, the inscription may refer to conditions during World War II. "Old Man" Tirrell is assumed to be the artist, but nothing about him is known. (ETH)

Cat. 68

UNIDENTIFIED ARTIST

Bottlecap Lion, completed after 1966
carved and painted wood, bottlecaps,
flashcube, fiberboard, and plastic
29¼ × 49½ × 15 in.
acquired from Ronald and Norma Keno,
Mohawk, New York, ca. 1981
1988.74.17

The common bottlecap or "crown cap,"
as it is properly known, was perfected in
1891 and has remained essentially un-
changed. When bottles were sold from
iceboxes and the earliest mechanical coin-
operated dispensers, only the cap end was
visible to the purchaser. Most of the earli-
est bottles designed to be sold with
"crown caps" had no labels on the glass,
relying instead on the small area of the
cap to carry the logo and advertising mes-
sage of the product. As soon as glass bot-
tles appeared on the market with these
cork-lined, metal caps, artists began to
find uses for the nonreturnable, nonre-
fundable caps as raw material for craft and
art projects. Artists made solid but flexible
"ropes" from these caps by punching a
hole in the middle of each and stringing
them onto heavy wire. These ropes were
then wired together to form baskets, min-
iature furniture, and other domestic ob-
jects. The maker of this lion wrapped its
body with bottlecap ropes to give the ani-
mal a ribbed look. The printed surfaces of
the caps are used for decorative effect for
both the lion and the giraffe, where the
caps are individually nailed to the wood
form. Other found objects used on the
lion include "flashcubes" for eyes, and old
plastic wheels from a child's toy. As with
the giraffe (cat. 69), the lion's mouth is
rigged to open and close by pulling a
wire. (ALC)

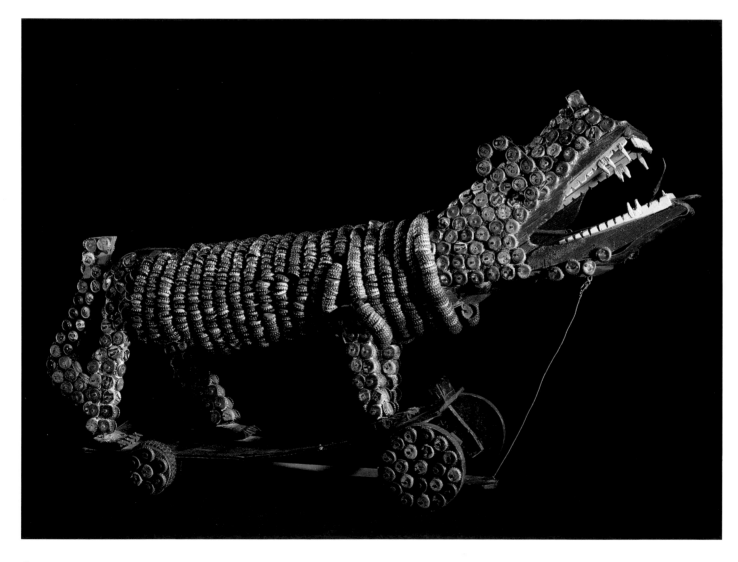

Cat. 68

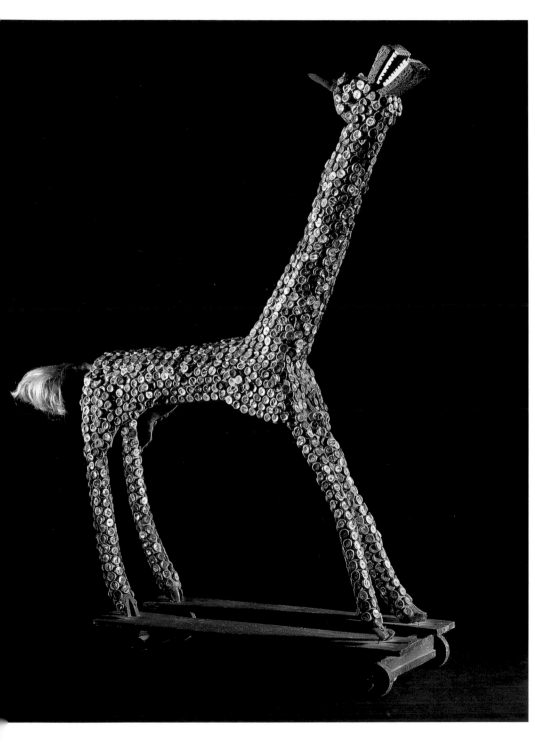

Cat. 69
UNIDENTIFIED ARTIST
Bottlecap Giraffe, completed after 1966
carved and painted wood, bottlecaps, rubber, glass, animal tail and fur, and sheet metal
72½ × 54 × 17½ in.
acquired from Ronald and Norma Keno, Mohawk, New York, ca. 1981
1986.65.283

This giraffe derives its decidedly cosmopolitan air from bottlecaps from more than thirty-four different beverages including the "Vichy Etat" water bottler in France, the Molson brewery in Canada, and the British soft drink manufacturers, Bryant's and Schweppes. Its creator, a true recycler, has gathered together a wide variety of other materials, including tree branches and a fur tail for his creation. The animal's backward-leaning stance opposes the potential forward motion of the wheels. The giraffe's mouth was originally rigged to open and close at the pull of a wire. (ALC)

Cat. 69

Portraiture

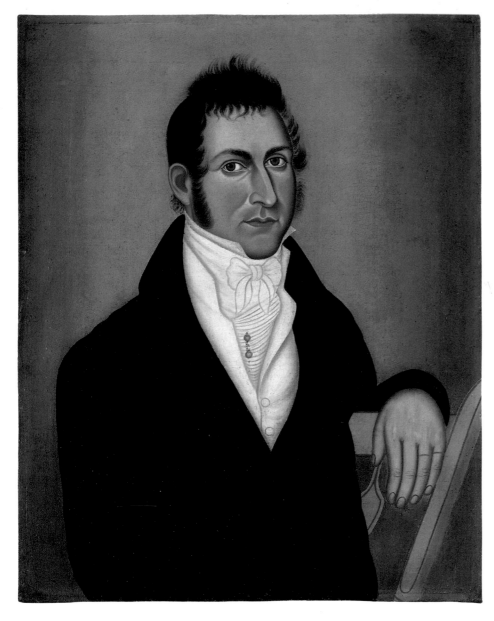

Cat. 70

Cat. 70
UNIDENTIFIED ARTIST
Man in Yellow Chair, ca. 1820
oil on canvas
30 x 24⅛ in.
acquired from Martin Grossman, New
York, 1958
1986.65.149

Neither the artist nor the subject of this
portrait has been identified, but sartorial
details, such as the number of notches in
the sitter's lapels, and the length of his
sideburns suggest the picture was painted
around 1820. It is evident, especially from
the sitter's hands, that the painter outlined
many of the forms, and only used model-
ing with lights and darks to a small degree
in the face. The subject's pose, with one
arm over the back of a painted chair, can
be seen in many other portraits of the
day. His strong features, however, distin-
guish the portrait, as does the lighting be-
hind him, which falls in a straight zone
rather than in a halo shape more typically
found in portraits of the same pe-
riod. (ETH)

Cat. 71
FREDERICK MAYHEW
born 1785, Chilmark, Martha's Vineyard,
Massachusetts–died 1854, Cambridge,
Ohio
Hulda Martin in her 55 year, 1826
oil on canvas
26¼ x 22¼ in.
acquired from Child's Gallery, Boston,
Massachusetts, 1967
1986.65.127

Frederick Mayhew painted in southeastern
Massachusetts and lived in Martha's Vine-
yard until the 1830s, when he went to
Ohio. The deed for his 1824 purchase of
twenty acres of farmland in Martha's
Vineyard cited his vocation as a "limner."
His advertisements placed in a local news-
paper, the *New Bedford Mercury,* identify
him also as a painter and a miniaturist.

Cat. 71

Cat. 72

Mrs. Hulda Martin, the sitter for this painting, was from the town of Rehobeth, Massachusetts. According to Rehobeth town records, she was born on September 8, 1771, was married to Jonathan Martin on November 13, 1788, and died May 26, 1831. Although many of Mayhew's documented portraits—such as those in the New Bedford Whaling Museum—are of area sea captains and their families, it is not known whether Mrs. Martin's family was associated with seafaring. (ETH)

Cat. 72
Possibly by MILTON WILLIAM HOPKINS
born 1789, Litchfield County, Connecticut–died 1844, Williamsburgh, Clermont County, Ohio
Woman in Black Dress, ca. 1835–40
oil on wood
26 x 21½ in.
acquired from Martin Grossman, New York, by 1961
1986.65.120

While nothing is known about the sitter, a great deal of information has recently been uncovered about the artist who may have painted this portrait.[1] Although M. W. Hopkins is known to have been trained as a decorative painter, he did not support himself solely as an artist. He was a farmer and a teacher, and had a brief career in business. He had a large family, owned property, and participated in church and civic affairs. Most of Hop-

kins's sitters were educated people of comfortable means who chose to have their portraits painted in a plain style, unlike the academic style of trained artists. Noah North (1808–1880), another well-known portraitist, is thought to have been Hopkins's apprentice, and the stylistic similarities between their works often make attribution difficult. (ETH)

[1]Attribution and dating by Jacquelyn Oak, registrar at the Museum of Our National Heritage, Lexington, Mass., 1989.

Cat. 73

JUSTIN McCARTHY

1891–1977; born, active, and died Weatherly, Pennsylvania
Linda Darnell, 1944
oil on canvas board
16 x 12 in.
acquired from Sterling Strauser, East Stroudsburg, Pennsylvania, 1972
1986.65.128

Justin McCarthy painted a wide range of popular imagery, with a preference for fashion models, movie stars, sports heroes, and other famous people, mostly found in newspapers and magazines. He began to paint after suffering a nervous breakdown when he failed to complete a law degree at the University of Pennsylvania. He supported himself by growing and selling vegetables and doing odd jobs. In the past, this work has been titled *Ava Gardner* or simply *Actress.* However, based on a partially legible inscription on the back of the painting, the woman pictured here may be Linda Darnell (1923–1965), a singer-actress popular in the 1930s and 1940s. Still, the subject's true identity may never be established since McCarthy would sometimes rename a

painting after anyone it closely resembled when he failed to capture the desired image. (ETH)

Cat. 74

W. G. WILLIAMS

life dates unknown; active Minnesota
President and Mrs. Eisenhower, May 12, 1955
oil on canvas and embossed paper with fabric and paper collage and plastic
30⅞ x 32⅞ in.
acquired from James Kronen, New York, 1974
1989.78.1

Known for creating this one painting, W. G. Williams may have been a member of the Minnesota Chippewa Tribe. He painted his portrait of Dwight David and Mamie Dowd Eisenhower several years after Eisenhower's election to the presidency in 1952. Although the artist was

attentive to such personal details as the small hat and pearl earrings often worn by Mrs. Eisenhower, his choice of a religious setting for the couple seems curious. Neither President nor Mrs. Eisenhower was known to be especially religious. When the "first couple" joined the National Presbyterian Church shortly after the inauguration in 1953, the church's pastor, against the President's expressed wishes, widely publicized the news. Williams may have been inspired by stories in the national press that mentioned the event. He surrounded his painting of the couple with collages of the Good Shepherd, the Holy Family, and Old Testament figures, suggesting a spiritual side of the peacetime president rather than his well-known military achievements. (ALC)

Cat. 73

Cat. 74

Cat. 75

HOWARD FINSTER

born 1916, Valley Head, Alabama; active
Summerville, Georgia
*THE HERBERT WADE HEMPHILL
J.R. COLLECTION FOUNDER OF
AMERICAN FOLK ART THE MAN
WHO PRESERVES THE LONE AND
FORGOTTEN. THE UNKNOWN
COLLECTION*, 1978
enamel on plywood with burnt cypress
wood frame
79½ x 50 in.
acquired from the artist through Jeffrey
Camp, 1978
1986.65.110

Around 1976, when Finster and Hemphill
first met, modestly scaled portraits of his-
torical, popular and biblical figures—cast
in concrete or painted on panels—were
scattered throughout Finster's *Paradise
Garden* (see cat. 112 and 113). There was
even a self-portrait. Most of the people
Finster has included in his pantheon cor-
respond to his perception of the inventor,
someone able to combine life's many fac-
ets in a creative process that Finster con-
siders to be the salvation of the world.

Hemphill commissioned this portrait
while visiting the artist in 1978. He asked
only that it fit on the back of a narrow
door. Jeffrey Camp posed Hemphill
dressed in T-shirt and white slacks in
front of the *Garden* and snapped several
polaroids. Finster worked from these pho-
tographs. Months later the bigger-than-a-
door portrait was ready, a tribute to "The
Herbert Waide Hemphill Jr. Collection,
Founder of American Folk Art, The Man
Who Preserves the Lone and Forgotten.
The Unknown Collection." Although
Finster did not know about Hemphill's
extensive library, he surrounded his sub-
ject with a potpourri of books, including
the Bible and imaginary publications such
as "Age of the UFOS." True to Finster's
evangelical intent, the painting is a visual
message about his perception of both the
collector and the world. (LRH)

Cat. 75

Cat. 76
UNIDENTIFIED ARTIST
Burnham's Hotel, ca. 1845
oil on canvas
25 x 30 in.
acquired from The Old Print Shop, New
York, 1962
1986.65.144

Burnham's Hotel was formerly the Van-
denheuvel mansion, built in the early
nineteenth century on a plot of land, then
north of New York City on Bloomingdale
Road, and now the block between Sev-
enty-eighth and Seventy-ninth streets on
Broadway. There were several large hotels
along the main roads north of the city,
and as fashions changed the relative popu-
larity of the hotels changed as well. Burn-
ham's Hotel remained a popular attraction
for upper middle-class families and court-
ing couples. "On each fine summer after-
noon the spacious grounds were filled
with ladies and children, who sauntered at
their leisure, having no fear of annoyance
and confident of perfect immunity from
affront."[1] A similarly active and optimistic
view of the Claremont Hotel, also on
Bloomingdale Road, is in the collection of
the Metropolitan Museum in New York.
It was probably painted by the same artist
who developed a lucrative market for por-
traits of the popular resorts of the time.
The figure groups and vehicles are almost
identical in both works. The compositions
of both paintings rely heavily on models
published in mid-nineteenth-century
painters' instruction books that gave ad-
vice on perspective, composition, and
shading. (ALC)

[1]Abram C. Dayton, *Last Days of Knicker-
bocker Life in New York* (New York: G. P.
Putnam's Sons, 1897), 361.

Cat. 76

Cat. 77

Cat. 77

UNIDENTIFIED ARTIST

Landscape (possibly of Staten Island, New York), ca. 1850
oil on canvas
27 x 34 in.
acquired from Virginia Sloan, Staten Island, 1970
1986.65.155

Discovered in the attic of an old house on Staten Island, this painting has previously been described as a portrait of Todt Hill, a well-known iron mining site on the island. However, this cannot be confirmed. The scene probably depicts a local farming settlement and its busy crossroads where heavy ore wagons and passenger stagecoaches gathered. At the store on the left, travelers could pause for refreshment while coaches made stops to exchange passengers. The Chinese laborers probably existed only in the imagination of the artist since no Asian residents or workmen are listed in the mid-nineteenth-century census or business listings for Staten Island. While the painting's original owner is unknown, most likely a resident of the area commissioned an itinerant artist who was interested in painting the local scene. (ALC)

fine and decorative art, much of which adorned his shops, as the paintings included in this drawing indicate. When he opened his second establishment in the late 1870s, his collection included jeweled caskets, tapestries, and a suit of armor. This illustration was probably commissioned by Cooper to hang in his new, uptown store as an advertisement for his original, downtown establishment. By 1882 his shops resembled gaudy museums, and Cooper's extravagant taste and business ventures eventually led his wife and brother to commit him to an insane asylum. The *New York Times* covered Cooper's insanity trial in nineteen articles from November 1882 through May 1883. The *Times* reported Cooper suffered from "'delusions of grandeur,' and that he was given to exaggerating his income, his prospects of income, his assets, and his capacities as a singer." The doctor who committed him charged that he had "ruinous business transactions, making large and extravagant purchases of real estate, works of art, and the like for which he has no means of paying."[1] (ALC)

[1] "H. P. Cooper's Alleged Insanity," *New York Times*, 2 November 1882.

Cat. 78

UNIDENTIFIED ARTIST

H. Prouse Cooper's Down Town Store, New York, ca. 1880
watercolor on paper
12¼ x 16½ in.
acquired from The Old Print Shop, New York, 1970
1986.65.208

Henry Prouse Cooper was a prominent tailor who had two shops in Manhattan, one at Fifty-four Broadway, illustrated here, and the second on Fifth Avenue. Arriving from London around 1865, he opened his Broadway shop, which quickly became profitable. He began to collect

Cat. 78

Cat. 79
F. J. HOWELL
life dates and place of activity unknown
The Ranch of Michael Caricof, 1882
pen and ink and ink wash on paper
9⅞ x 12⅛ in.
acquired from an unidentified dealer,
Lancaster, Pennsylvania, late 1970s
1986.65.172

F. J. Howell depicted the Caricof family
farm in Stockton, California, as an or-
derly, bountiful, and efficient establish-
ment. His drawing resembles illustrations
from county histories that were published
in the late nineteenth and early twentieth
centuries when private homes and farms

could be pictured in these volumes for a
subscription fee.

Behind Caricof's Italianate-style farm-
house and its formal garden stand the tank
house and windmill water pump, common
features of northern California farms. The
mechanical reaper and steam-powered
thresher indicate that his farm prospered
with the period's most up-to-date machin-
ery. An interesting omission is a gate for
the pasture where the cattle appear ready
to hit the road. (ALC)

Cat. 79

Cat. 80
UNIDENTIFIED ARTIST
SUN RIVER Montana US, ca. 1885
watercolor and gouache over pencil on pa-
per
6 x 9½ in.
acquired from M. Knoedler and Co.,
New York, 1958
1986.65.216

The town of Sun River Crossing is seen
from the south in this diminutive portrait
and includes many of the settlement's im-
portant buildings. They do not all appear
in their correct positions because the artist
moved or turned several of them and then
added large, identifying signs. Charles A.
Bull and John Largent moved to Sun
River, twenty miles west of Great Falls,
Montana, in 1867, and established a meat
market and a hotel, respectively. Here the
buildings face each other across Main
Street.

The community was established as a
major regional shipping center when
Largent built a toll bridge across Sun
River in the early 1870s to allow direct
passage from the important mining and
trapping districts in southwest Montana to
Fort Benton, the extreme point of naviga-
tion on the Missouri River. The two
freight teams were supply packers, prob-
ably driven by "bull-whackers" working
for the nearby ranches.

George Steele, who established a new
post for a fur company, built the general

Cat. 80

store and was named postmaster in the
mid 1870s. His brother, Dr. Steele, served
as Sun River's druggist. The house (lower
left) was built by Largent in 1883 or 1884
and is still owned by members of the fam-
ily. (ALC)

Cat. 81
UNIDENTIFIED ARTIST
Bandstand, ca. 1890
carved, turned, and painted wood with
metal
17½ x 10½ in. (diam.)
acquired from John Bihler and Henry
Coger, Ashley Falls, Massachusetts, 1960
1986.65.275

The roof of this miniature bandstand,
complete with a five-piece brass band and
conductor, lifts off to reveal a storage
compartment. The bandstand's shape
echoes simple styles built in small towns
throughout America from the 1870s until
the beginning of World War I. Most were
purely functional, but others were elabo-
rate constructions in outlandish and
whimsical styles. Brass bands, or "military
bands" as they were called, usually were
clad in styles similar to the army and navy
bands that served as models for later com-
munity, social, or ethnic-sponsored ama-
teur bands. These band members' tall,
plumed hats and gold epaulettes were typ-
ical of band uniforms of the pe-
riod. (ALC)

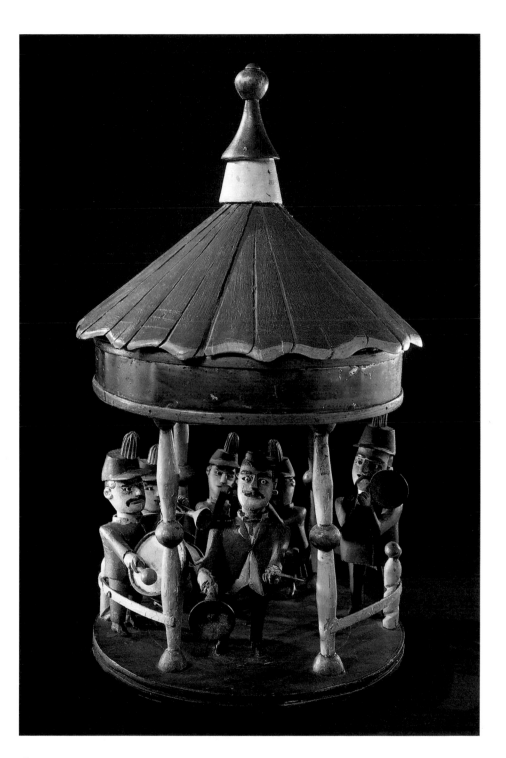

Cat. 81

Cat. 82
UNIDENTIFIED ARTIST
Mexican Eagle, after 1821
carved, painted, and gilded wood with
metal
53 x 36 x 21 in.
acquired from Sussel Sale, Parke-Bernet,
New York, 1958
1986.65.331

The Mexica, a fierce, nomadic people,
wandered in the valley of Mexico search-
ing for a spot that their gods would or-

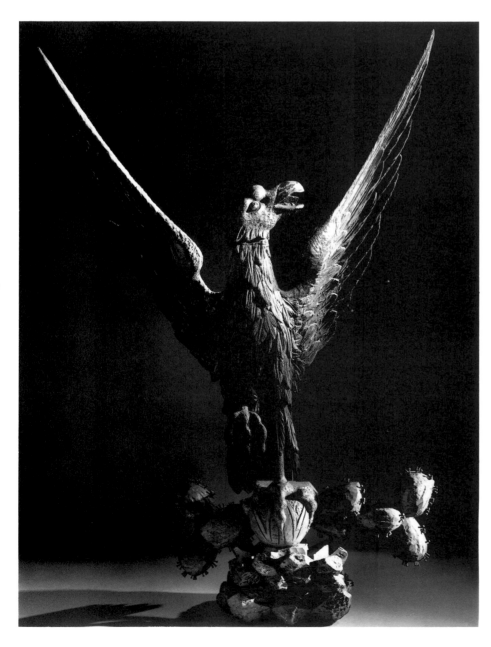

Cat. 82

dain their home. The location, they be-
lieved, would be indicated by an eagle
perched on a nopal cactus, devouring a
serpent. Such an eagle was found on a
small island in Lake Texcoco in June of
1325. There the Mexica (now known as
the Aztecs) founded their city of Tenoch-
titlan, which the Spaniards conquered and
renamed Mexico City. When Mexico
achieved independence from Spain in
1821, the new nation adopted the Mexica
eagle as its symbol, which serves as both a
political and cultural emblem.

This elegant carving is missing a snake
that probably wound from the eagle's ex-
tended claw to its beak. It also differs
from the broader and flatter figures typi-
cally reproduced for government use. The
construction of the base indicates that this
sculpture stood in a niche or against a
wall. Perhaps it served as a patriotic em-
blem displayed on a building. Many of the
carefully detailed feathers were carved
separately and nailed to the body, and the
spines of the cactus are nails driven into
the profile edges of the thick wooden
leaves. (ALC)

Cat. 83
R. M. CHALMERS
life dates and place of activity unknown
*PROPOSED————PERSPECTIVE ELE-
VATION. for an Art Exposition Building,
and Tower 600 feet in height, representing
New England in six divisions,* ca. 1876
pen and ink and watercolor on paper
28⅛ x 16 in.
acquired from Good and Hutchinson,
Tolland, Massachusetts, 1971
1986.65.166

This visionary proposal is based on the
American Gothic-revival style used for
buildings such as the main hall of the
Philadelphia Centennial Exposition and
the Smithsonian Arts and Industries
Building. Chalmers' complex design
called for brick construction, terra-cotta
decoration, and a slate roof. It is doubtful
that this proposal was developed with ac-

Cat. 83

tual completion in mind, nor can it be traced to a specific design competition. Based on construction techniques of the time, the six-hundred-foot central tower could not have included usable space. Chalmers was obviously fascinated with height and upward progression as he listed the six New England states at hundred-foot intervals. The inscription along the bottom describes the Tower of Babel, an interesting comment on the artist's understanding of a builder's conceit to reach toward heaven with his constructions. (ALC)

Cat. 84

UNIDENTIFIED ARTIST
WASHINGTON'S HEAD-QUARTERS
1780. At Newburgh, on the Hudson, after 1876
paper, straw, painted canvas, thread, mica, and metal
21¼ x 28 in.
acquired from The Old Print Shop, New York, 1967
1986.65.218

Cutouts from various Currier and Ives prints have been assembled to create the narrative portions of this ambitious collage, perhaps inspired by the patriotic flurry surrounding the centennial. The main image of George Washington on his horse is from the print *Washington, Crossing the Delaware: On the Evening of Dec. 25th. 1776, Previous to the Battle of Tren-*

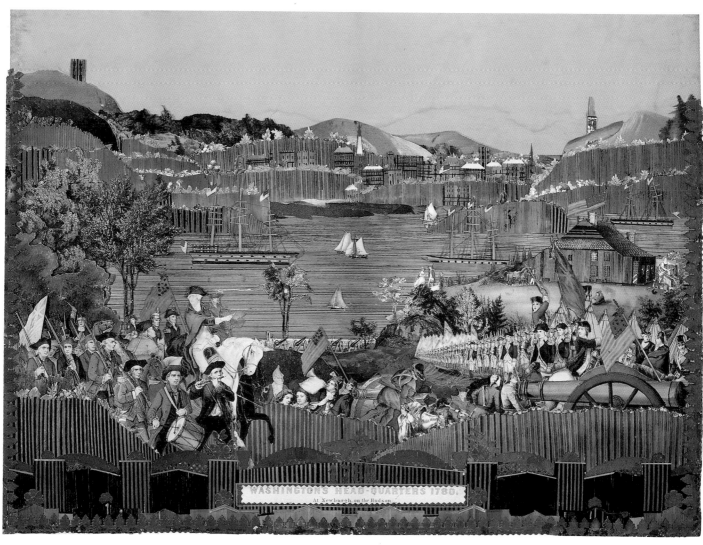

Cat. 84

ton, published in 1876. The men walking
downhill with a cannon are also found in
that print, but the line of soldiers receding
into the background is taken from *Wash-
ington Taking Command of the American
Army,* also printed in 1876. The printed
title at the bottom of the collage is that of
an undated Currier and Ives print. The
title appears to be the only element from
this source, however, as the print itself is
a historical view of New York State with
cows, a house, and a man tending a
horse. (ETH)

Cat. 85

Cat. 85
E. STEARNS
life dates and place of activity unknown
*King Capital forbits the rising tight [of the
poor],* 1931
oil on cardboard
17⅞ x 23⅞ in.
acquired from a junk store, New York,
late 1950s
1986.65.141

Painted during the Depression, a crowned
"King Capital" sits in a thronelike chair,
facing a cresting wave of heads and arms.
His ineffectual gesture cannot hold back
the rush of the anonymous masses impov-
erished by the Crash of 1929. The break
in the storm cloud suggests that the peo-
ple are falling from above, a detail that
may unwittingly recall traditional illustra-
tions of the damned expelled from heaven.
Behind "King Capital" huddle the men
and women of the establishment—the
wealthy, the clergy, and the military.
Their wide-eyed expressions and upturned
heads indicate that they fear the on-
slaught; two have turned, as if to flee. The
painting's title reinforces the concept of
the radicalized masses, then inherent in
the leftist messages painted by the coun-
try's Social Realist artists, many of whom
were supported by the federal art projects.
Currently, nothing is known about
Stearns or the impetus and context of his
timely social commentary. (LRH)

Cat. 86

Cat. 87

Cat. 86
FRED CAMPBELL
life dates unknown; active Philadelphia?
*Untitled (Hitler-Headed Serpent in Bom-
barded Landscape)*, after 1939
oil on canvas
26¼ x 28¾ in.
acquired from John Ollman, Janet
Fleisher Gallery, Philadelphia, ca. 1977
1986.65.148

Ambiguity dominates this scene of de-
struction, the only known example of
Campbell's work. The composition fea-
tures a serpent, a common wartime sym-
bol of Adolf Hitler. A briefly clad, male
figure appears to tread on the coiling crea-
ture and grasps a fine chain around the
serpent's neck. The painting, which at
first evokes the violence of Nazi Ger-
many, may instead be about Allied efforts
to end the war. The stylized bombers can-
not be identified with either side, but it is
possible that they are Allied planes bom-
barding the German countryside. The
painting's verso is inscribed with Camp-
bell's name and his address in "Fish-

town," one of Philadelphia's old working
class neighborhoods that was originally
settled by Irish and English immi-
grants. (LRH)

Cat. 87
LOUIS MONZA
born 1897, Turate, Italy–died 1984,
Redondo Beach, California; to the USA
1913
ORCASTRA AT WAR, 1943
oil on canvas
26 x 32 in.
acquired from Vanderwoude-Tannenbaum
Gallery, New York, 1985
1986.65.131

Louis Monza was a pacifist who also em-
braced radical socialist doctrines. His con-
cern for the human condition is evident in
his allegorical paintings executed during
World War II. Here, grim musicians per-
form against stark ruins and fiery skies in
the aftermath of bombing. The piano
player resembles Franklin D. Roosevelt.

The drummer represents Vyacheslav Mik-
hailovich Molotov, a key figure in the
Bolshevik Revolution, and the Soviet
Commissar of foreign affairs between 1939
and 1949 who later helped to draft the
Soviet Union's hostile policies toward the
West.[1] The drum's inscription—ORCAS-
TRA AT WAR—suggests that Monza
perceived the allies of World War II as an
ensemble brought together by necessity,
but soon to be at odds. The concept of an
orchestra may also recall the military tra-
dition of bolstering morale with music.
Characteristically, the painting's meaning
is cryptic, since Monza preferred that
viewers freely interpret his works.[2]

Monza was equally at ease when paint-
ing, drawing, sculpting, or making prints.
His youthful apprenticeship to a master
furniture carver and his exposure to
northern Italy's painting traditions influ-
enced the decorative detail, dramatic
color, and volumetric, exaggerated forms
of his later efforts. After emigrating to the
United States in 1913, Monza began ex-
perimenting with different media. He did
not devote himself to making art, how-
ever, until an accident in 1938 ended his
occupation as a house painter. Three years
later, his career as a regularly exhibited
artist began in New York. (LRH)

[1] These figures were identified in Josephine
Gibbs, "Louis Monza, Primitive," *Art Digest*
18 (15 November 1943):14.

[2] Heidi Monza, interview with Lynda Roscoe
Hartigan, 29 December 1989.

Cat. 88

Cat. 88

"PETER CHARLIE" BOSHEGAN

born Armenia, date unknown; died 1962,
Leechburg, Pennsylvania; to USA 1903
LADY LIBERTY OF 1953 TO 1962?, ca.
1962
house paint and metallic paint on paper-
board with pencil
22⅝ x 28½ in.
gift of George McGreery, New York,
1972
1986.65.100

Often called just "Peter Charlie," Boshe-
gan was a handyman and house painter in
Leechburg, Pennsylvania. He lived a soli-
tary life, and his activities as an artist re-
mained undiscovered until his death in
1962. At that time, sixty-nine paintings
were found in a garage he had rented be-
hind a hardware store. His work reflects
many themes—space, religion, Armenian
folk motifs, American history, and de-
mons, as well as other ideas from his sub-
conscious. Here a chained, peasant-
dressed version of Lady Liberty blasts

across a blue void. A headlamp guides her
on a mission that Boshegan's inscriptions
and images do not clarify. One can specu-
late, however, that he may have been in-
spired by events such as the death of Sta-
lin in 1953, the Cuban missile crisis, or
John Glenn's orbit of the earth in
1962. (ETH)

Cat. 89

JUSTIN McCARTHY

1891–1977; born, active, and died
Weatherly, Pennsylvania
*Washington Crossing the Delaware,
Variation on a Theme #3*, ca. 1963
oil on fiberboard
27½ x 48¼ in.
acquired from Sterling Strauser, East
Stroudsburg, Pennsylvania, before 1970
1988.74.12

McCarthy painted at least four versions of
this image, based on the famous 1851
painting of the same name by Emanuel

Leutze, which belongs to the Metropoli-
tan Museum of Art in New York. This
piece is the largest of the four. Often the
source for McCarthy's work is not so eas-
ily identifiable, as he took ideas from tele-
vision, movies, newspapers, magazines,
posters, and books. The painting's loose,
broadly rendered images are typical of
McCarthy's technique in his later years, in
contrast to the more decorative and de-
tailed style of his earlier works, such as
Linda Darnell of 1944 (cat. 73). (ETH)

Cat. 89

Cat. 90

MARSHALL B. FLEMING
born 1916, New Creek, West Virginia;
active New Creek
Kennedy Caisson, ca. 1964
carved and painted wood, leather, wire,
metal, printed paper, paperboard, cloth,
pen and pencil
20¾ x 43 x 10¼ in.
acquired from J. Roderick Moore, Fer-
rum, Virginia, early 1980s
1986.65.305

The assassination of President John Fitz-
gerald Kennedy on November 22, 1963, is
among the most emotionally powerful his-
torical events of recent times. Marshall
Fleming, like many other artists, was
deeply moved by the President's murder,
which inspired him to create a tribute to
Kennedy and the three other assassinated
American presidents, Lincoln, Garfield,
and McKinley. "I have always admired
President Kennedy. Upon seeing the fu-
neral procession [on television] I thought I
would like to make the caisson."[1] He
based his effort on one of the many com-
memorative postcards available after the
assassination. The carving is true to the
traditional features of a state funeral. It
also includes a signboard, added to place
Kennedy in the history of assassinated
American presidents. Fleming, who began
carving as a child, continues to construct
small horse-drawn wagons, carts, and
farming machinery that he houses in a
small museum he built near his
home. (ALC)

[1]Marshall B. Fleming, letter to Andrew
Connors, 1 October 1989.

Cat. 90

Cat. 91

HAROLD GARRISON
born 1923 near Weaverville, North
Carolina; active Buncombe County, near
Weaverville
*WATER GATE OR GOVERNMENT
MACHINE NO. 3*, December 1974
pen and ink on carved wood with leather,
metal, and coated wire
13¾ x 15 x 3½ in.
acquired from Jeffrey Camp, Richmond,
Virginia, 1975
1986.65.248

Garrison calls himself "one hundred per-
cent American" and speaks out strongly
against waste and corruption in the federal
government and the people's poor repre-
sentation by politicians who often provide
nothing more than "bunk."[1] Ironically,
the term bunkum, today bunk, comes
from the name of Garrison's home
county, Buncombe County. In the early
nineteenth century, when criticized for an
irrelevant speech, one of the county's con-
gressmen replied that he was "speaking to
Buncombe."

Garrison claims this machine does
everything the government does but in a
fraction of the time, and for much less
money.[2] When the trigger is pulled, the
Democratic donkey and the Republican
elephant rock back and forth on the "hee-
haw see-saw"; an arrow "shows where
Henry Kissinger goes, not what he prom-
ises"; Sam Ervin emerges from obscurity;
the White House tapes appear; Nixon re-
signs; Gerald Ford takes the oath of of-
fice; a street sign for Pennsylvania Avenue
unfolds; taxes rise; and a door marked
"Water Gate" opens to reveal spotted
bugs in the "Bug House." Garrison has
carved several of these complex govern-
ment machines—two with a Watergate
theme, and one concerning the Demo-
cratic Party at its 1972 Chicago conven-
tion. Most of Garrison's wood carvings,
however, are traditional Appalachian split
bark work or whittled forms of animals
and flowers shaved from sticks. (ALC)

[1]Harold Garrison, interview with Andrew
Connors, 24 November 1989.

[2]Ibid.

Cat. 91 closed (*top photograph*) and open (*bottom photograph*)

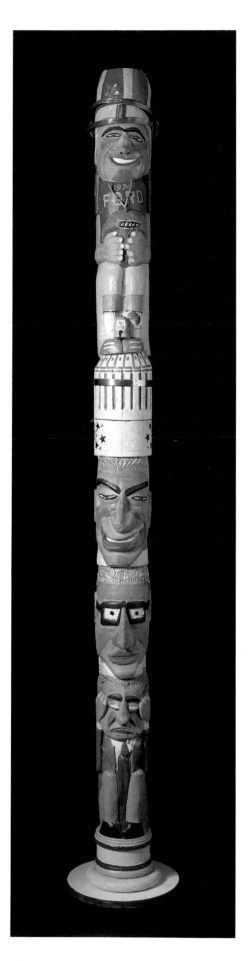

Cat. 92
EDWARD A. KAY
born 1900, Detroit, Michigan–died 1988,
Sun City, Arizona; active Mount
Clemens, Michigan
Gerald Ford Totem Pole, 1974
carved and painted and turned wood, with
metal, painted modeling compound,
printed papers and adhesive stickers,
wishbone, stamp, tacks, and safety pin
91 x 12½ in. (diam.)
acquired from the artist, 1975
1986.65.253

Edward Kay began to carve totem poles
and other complex figures during Prohibi-
tion when he traded a fifth of whiskey for
some wood-working tools. Until 1977,
when he moved into an apartment, many
of his more than 100 totems stood outside
his home in Michigan. Political parody
was a favorite subject for Kay. Here, from
top to bottom, he has depicted President
Ford in his University of Michigan foot-
ball uniform, the U.S. Capitol, Vice Pres-
ident Nelson Rockefeller, Secretary of
State Henry Kissinger, and President
Nixon, his lips sealed with a safety pin.
To provide background for his political
works, Kay frequently produced free-

Cat. 92

Cat. 93

MALCAH ZELDIS

born 1931, Detroit, Michigan; active New York City

Miss Liberty Celebration, 1987

oil on corrugated cardboard

54½ x 36½ in.

acquired from the artist, 1987

1988.74.14

A self-taught artist who began to paint in her late thirties, Malcah Zeldis is now a widely exhibited contemporary painter. Recovering from cancer in 1986, Zeldis was too weak to lift masonite, her usual painting surface. Using corrugated cardboard, found on the street, she celebrated her release from disease by painting a well-known symbol of freedom. Zeldis incorporated famous figures and people personally meaningful to her, all united by her characteristically explosive color. From left to right, the larger figures across the bottom are Ben Applebaum (a neighbor), Elvis Presley, Marilyn Monroe, Beethoven, and Bert Hemphill. (Zeldis always said that she would do a portrait of Hemphill, so she "stuck him in.") Next to Hemphill is the artist herself, and on the right is her boyfriend, Leonard Marcus. In the boat to the right of the statue are Miss America, Albert Einstein, Charlie Chaplin, and Abraham Lincoln. Her relatives occupy the sailboat further up to the right—her daughter Yona McDonough, son-in-law Paul McDonough, and son, David Zeldis. In the sailboat in the upper left are her boyfriend's three sons, Jason, Peter, and Ted Marcus. The rest of the people are "just ordinary mortals."[1] (ETH)

[1] Malcah Zeldis, interview with Marjorie Zapruder, 14 June 1989.

standing collages using photographs, clippings, and texts. This totem's panel of collage included a history of the impeachment proceedings against President Andrew Johnson in 1868 (see fig. 66). Perhaps Kay was alluding to public sentiment before Nixon's resignation in the aftermath of Watergate. The panel made for this totem, however, was lost in 1975. (ALC)

Religion

Cat. 94

Cat. 95

Cat. 94

UNIDENTIFIED ARTIST

Representation of the Different Ways Leading to Everlasting Life or Eternal Damnation, 1848–1860

pen and ink, watercolor, and pencil on paper

14 x 18 in.

acquired from John Gordon, New York, 1967

1986.65.207

This careful, yet untutored drawing, done by someone of Pennsylvania German origin, is a copy after a broadside printed by Gustav Sigismund Peters, who was active in Harrisburg, Pennsylvania, from 1827 to 1847.[1] The design is not original to Peters, but probably came from a European, perhaps medieval, source. The writing is in German school script and consists of pious admonitions and descriptions of the kinds of people who will go to either heaven or hell. The city at the top of the drawing is labeled "The New Jerusalem" and shows Christ in the center. The devil is in the lower right corner. (ETH)

[1] Title taken from original prints by Peters.

Cat. 95

UNIDENTIFIED ARTIST

MISSIONARY MAP, late nineteenth century

painted on muslin with pencil

50 x 69 in.

acquired from Allan Daniel, New York, 1974

1986.65.150

In America, the millennial anticipation of Christ's Second Coming gained wide currency among revivalists, and was continually reinterpreted in radical sectarian movements through the mid nineteenth century. In the late 1830s and early 1840s, William Miller led the Adventist movement, the most spectacular, outspoken,

and impassioned manifestation of American Millennialism. Relying on dates and figures mentioned in the biblical books of Daniel, Ezekiel, the Gospels of John and Matthew, and Revelation, Miller predicted that Christ would return to "cleanse the temple" in 1843 and 1844. The millennial movement splintered into a variety of sects when the prediction proved false. Some groups established themselves as independent churches, such as the Jehovah Witnesses and the Seventh Day Adventists.

This chart, or "Missionary Map," is very similar to those printed by William Miller and other early Adventists but it does not assign any date for the "cleansing of the temple," a prominent feature on these charts. However, the beasts, angels, figures, and map are all standard millennialist interpretations of passages from the books of Daniel and Revelation. Its label as a "Missionary Map" and the inclusion of the entire African continent suggests that it may have served as a recruiting and teaching tool for late nineteenth-century missionaries working in Africa. The band across the top of the painting, describing the five ages, or "dispensations," of the world, is a feature of the late nineteenth-century dispensationalist movement, which shared a prophetic belief with the Adventists, but avoided exact chronologies and the setting of precise dates for the second advent of Christ's kingdom. (ALC)

Cat. 96

Cat. 96
JOSEPH KOENIG
life dates unknown
Crucifixion Shrine, late nineteenth century
carved and painted wood with glass and metal
23¼ x 19½ x 6⅞ in.
acquired from James Karen and Susan Reed, New York, 1967
1986.65.254

Joseph Koenig is identified only by a slip of paper that was attached to this shrine when it was purchased. According to the same source, Koenig moved from Pennsylvania to Wisconsin with his family and made this shrine for his house where it was used for devotions until the community could erect a church. The composition and figures resemble northern European, baroque church carving of the type that was widely copied in churches in the United States. Koenig may have based his carving on such models, which could be found throughout Pennsylvania. The sides and back of the shrine are made of boards from shipping cases manufactured in New York between 1865 and 1892. (ALC)

Cat. 97
UNIDENTIFIED ARTIST
Standing Articulated Figure, ca. 1920
carved and painted sequoia and black ash, painted metal, wire, and metal hardware
32¾ x 13⅜ x 9 in.
acquired from Charles (Elmo) Avet, New York and New Orleans, late 1950s
1986.65.278

According to oral tradition, this carving was covered with blood and chicken feathers when found in a back room of an African-American barbershop in New Orleans. The object was subsequently cleaned; no traces of blood remain, al-

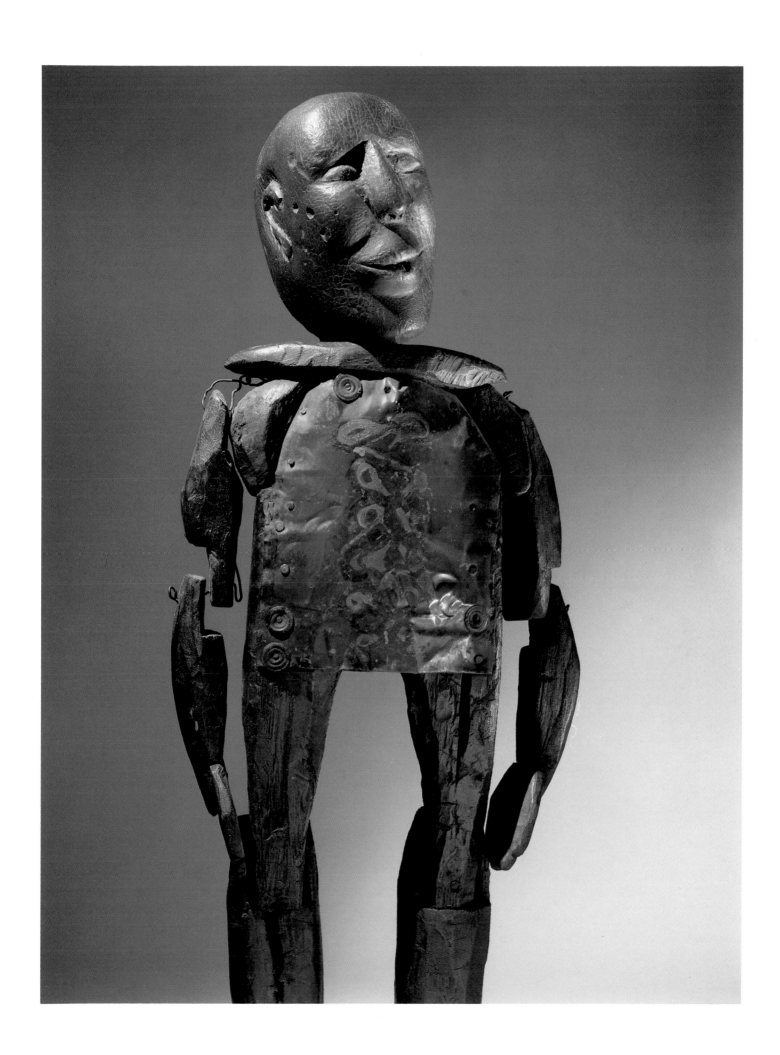

though forensic scientists recently found small bits of brown chicken feathers lodged in the figure's hollow interior. The legs originally ended in points. The slack, articulated arms show great wear at the wire joints, implying that the figure had been used or moved frequently.

Some experts have attributed this figure to the vodoun (or voodoo) religion, a New World hybrid of Roman Catholicism and African religions. If the carving is of vodoun origin, the painted shapes on the chest plate are probably adaptations from "veve," or spirit drawings, which are sewn or painted on banners and wall paintings as well as drawn in cornmeal on the earth. Recent attempts to ascertain the figure's authenticity as a ritualistic object have sparked contradictory opinions. It

has been characterized as both a benign and evil spirit, and of Haitian, African, and Afro-Cuban origin.[1] If vodoun-related, this figure is a personal or theologically aberrant interpretation. Except for commercially produced figures of saints, three-dimensional human figures or "dolls" are almost never used in the vodoun religion. The figure's head and much of the body is carved from sequoia, which grows only in California. (ALC)

[1]See information based on research by Faulkner Fox, Yale University, New Haven, Conn., and found in the curatorial files, National Museum of American Art, Smithsonian Institution, Washington, D.C.

Cat. 98
VICTOR JOSEPH GATTO
born 1893, New York–died 1965, Miami, Florida
Suffering Christ, late 1930s
oil on canvas
15⅜ x 13¼ in.
acquired from Epstein/Powell Gallery, New York, 1983
1986.65.114

"Joe" Gatto, an Italian Catholic, rarely went to church, but in his religious visionary images (many sparked by his memories of a near-fatal illness) Gatto tells a story of personal importance. Created early in his career, *Suffering Christ* is his most austere and solemn work. The image of Christ bears some resemblance to the artist's slight, athletic body. Most of Gatto's paintings—scenes of everyday life in New York, exotic cultures, historical events, and tropical episodes—are packed with endless detail built up with many layers of minute brushstrokes. Gatto, a bachelor and a former featherweight boxer, lived with his widowed stepmother in the section of New York known as "Little Italy." Painters Elaine and Willem De Kooning lived in the next apartment in the late 1930s, and Elaine De Kooning and other artists encouraged Gatto's painting. His work received critical acclaim through several exhibitions in New York galleries during the 1940s and 1950s, his most productive period. (ALC)

Cat. 98

Cat. 99
JOHN W. PERATES
born 1895, Amphiklia, Greece–died 1970,
Portland, Maine; to USA 1912
Icon of Saint Mark, ca. 1940
carved and painted wood
49¾ x 28 x 6 in.
acquired by trade from Michael Hall,
Bloomfield Hills, Michigan, 1976
1986.65.259

This carving of Saint Mark combines tra-
ditional Greek iconography and composi-
tion with Perates's very personal carving
style in low relief. Although the saint's
staring eyes and carefully stylized hair and
beard are highly abstracted, the figure's
bold physicality differs from the spiritual-
ized, transfigured representations in most
Greek Byzantine icons. Here Saint Mark
is identified by his symbol, the lion, and
verses from his Gospel.

After immigrating to Maine, Perates be-
came a furniture maker, the outgrowth of
his grandfather's woodworking lessons in
Greece. After 1930, he specialized in Eng-
lish and Colonial American reproduction
pieces in his own business. When his two
sons were called to serve in World War II,
he began carving religious icons and furni-
ture based on Byzantine painting and
sculpture and traditional Greek Orthodox
Church furnishings. At his death, Per-
ates's shop contained more than forty
large icons, including this Saint Mark, as
well as a sixteen and one-half foot-tall al-
tar in the Greek style, which he hoped
would be sold to a church for the benefit
of his grandchildren. He never sold his
dazzling array of saints, stating that he
made them for himself from his own in-
spiration and creativity. (ALC)

Cat. 99

Cat. 100

iar to him from his native Mexico. The towers, façade, central domes surmounted by crosses, and the roofed arcade are all common elements in Spanish Colonial and Mexican mission architecture. The dark, arched doorway recalls the tunnel imagery that Ramírez repeated in many of his approximately three hundred drawings.

Ramírez left Mexico as a young man to seek employment in the United States. He worked for a short time with railway construction crews, but was soon unable to cope with the pressures of his new life in California and was diagnosed as paranoid schizophrenic. Ramírez spent the remainder of his life in California mental hospitals. After 1940, while institutionalized at the DeWitt State Hospital near Sacramento, he assembled his memories on pieces of scrap paper, pasted together with improvised adhesives, and drew his precise, dense, and repetitive marks and shapes with scavenged pencils, crayons, and markers. (ALC)

Cat. 100
MARTIN RAMÍREZ
born 1885, Jalisco, Mexico–died 1960, Auburn, California; to USA early twentieth century
Untitled (Church), ca. 1950
crayon, pencil, and watercolor on joined papers
31⅞ x 37⅛ in. (irregular)
acquired from Phyllis Kind Gallery, Chicago, 1973
1986.65.192

The art of Martin Ramírez presents a world of patterns and repetitions based on cultural iconography and personal, idiosyncratic symbols. In this drawing, the symmetrical structures of a Baroque church recall buildings undoubtedly famil-

Cat. 101
MARTIN RAMÍREZ
born 1885, Jalisco, Mexico–died 1960, Auburn, California; to USA early twentieth century
Untitled (Our Lady of the Immaculate Conception), ca. 1953
crayon, pencil, and colored pencil on joined papers
71 x 24⅛ in.
acquired from Phyllis Kind Gallery, Chicago, 1973
1986.65.193

Ramírez drew many images of the Virgin Mary. This version represents the iconography he used most often, the Immaculate Conception of Mary, proclaimed as doctrine by the Roman Catholic Church in 1854 and subsequently depicted in mass-produced images. For Ramírez, the Virgin must have held particular significance as a pure, gentle protectress, and his drawings of her represent an exploration of holy

personality, a wish to know and understand by recreating the image. The crowned figure tramples a serpent, representing original sin and the fall of mankind. Ramírez floated the figure in empty space with the moon supported by his characteristic concentric arched shapes. (ALC)

Cat. 102
PERLEY MEYER ("P. M.")
WENTWORTH
life dates unknown; active San Francisco Bay Area and Southern California, ca. 1950s
MOUNT-CALVARY. JERUSALEM. EARTH PLANET, ca. 1955
crayon and gouache on wove paper
30¼ x 25¾ in.
acquired from Phyllis Kind Gallery, Chicago, 1975
1986.65.220

P. M. Wentworth expressed his interest in the stars, planets, and worlds beyond our

own in his drawings, many of which have an ethereal quality and allude to Christian theology. To confirm that his concerns were not of this world, Wentworth wrote the word "imagination" on many of his works. While based in the traditions of the Bible, his interpretations extend beyond traditional iconographic imagery. This ambiguous, complex landscape, which depicts Christ already dead and wrapped for burial, is an unusual departure from the iconography of Christ on the cross. (ALC)

Cat. 101

Cat. 102

Cat. 103

Cat. 103

EDGAR TOLSON

born 1904, Lee City, Kentucky–died
1984, Campton, Kentucky
Paradise, 1968
carved and painted white elm with pencil
12⅞ x 17 x 10 in.
acquired from Michael Hall, Bloomfield
Hills, Michigan, 1968
1986.65.271

Once a Baptist preacher, Tolson abandoned the ministry when he realized that he could not live according to God's word. Tolson viewed the first four chapters of the Bible as representations of every human condition, of "all the stories possible—all through the Bible. That's from the beginning to the end, from Genesis to Revelations [*sic*]."[1]

Tolson carved many representations of the Adam and Eve and Cain and Abel stories and claimed that "God made the first Adam and Eve and I made the second. But I lack a long shot of being God."[2] This carving of Adam and Eve represents man and woman in their pure state: "And the Lord God planted a garden eastward in Eden; and there he put the man whom he had formed. . . . And the rib, which the Lord God had taken from man, made he a woman, and brought her unto the man. . . . And they were both naked, the man and his wife, and were not ashamed" (Gen. 2:8–25).

Appalachian VISTA workers and volunteers, who organized craft cooperatives in the mid 1960s first documented Tolson's carvings while conducting a survey of Appalachian craftsmen and craftswomen. Tolson demonstrated his carving skills at the Smithsonian's Festival of American Folklife in 1968 and has since become one of the most celebrated Appalachian wood carvers. (ALC)

[1]Michael D. Hall, "You Make It with Your Mind," *The Clarion* 12 (Spring–Summer 1987): 41.

[2]Ibid., 38.

Cat. 104

Cat. 105

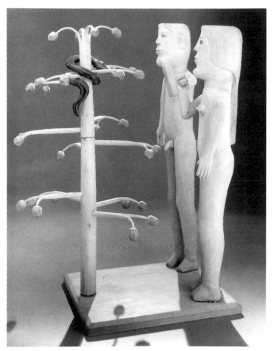

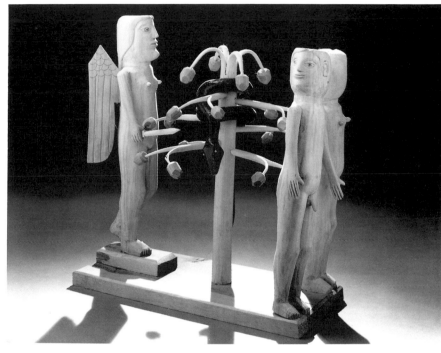

Cat. 104
EDGAR TOLSON
born 1904, Lee City, Kentucky–died
1984, Campton, Kentucky
Temptation, 1970
carved and painted white elm with pen
and pencil
21⅞ x 16½ x 12 in.
acquired from Michael Hall, Bloomfield
Hills, Michigan, 1970
1986.65.273

". . . she took of the fruit thereof, and
did eat, and gave also unto her husband
with her; and he did eat" (Gen. 3:1–6).
Tolson carved many variations of this
scene representing the crucial moment of
choice when mankind determines his des-
tiny. The fateful decisions and pressures in
our daily lives reenact the temptation of
Adam and Eve. Tolson's snake is black, a
traditional color used to denote evil, and
contrasts boldly with the light unpainted
wood of the graceful tree and pale figures.
The artist recalled the temptation as would

a preacher giving a sermon: "And the ser-
pent said, 'The Lord knows the day that
you take this fruit and eat it that your
eyes will be opened and you'll become as
one of God's, a-knowing good from evil.'
And Adam said it was pleasin' to his eye
and she took and eat it and gave it to
Adam. And he eat it and they was drove
out."[1] (ALC)

[1]Michael D. Hall, "You Make It with Your
Mind," *The Clarion* 12 (Spring–Summer
1987): 42.

Cat. 105
EDGAR TOLSON
born 1904, Lee City, Kentucky–died
1984, Campton, Kentucky
Expulsion, 1975
carved and painted white poplar with
pencil
14 x 13½ x 9⅛ in.
acquired from Michael Hall, Bloomfield
Hills, Michigan, 1975
1986.65.270

"Therefore the Lord God sent him forth
from the garden of Eden, to till the
ground from whence he was taken. So he
drove out the man; and he placed at the
east of the garden of Eden Cherubims,
and a flaming sword which turned every
way, to keep the way of the tree of life"
(Gen. 3:23–24).
 In most of his carvings of the Expul-
sion, Tolson placed the cherubim on a
pedestal, flying above and separate from
the earthly world of Adam and Eve. In
this carving, the cherubim walks toward

the man and woman, driving them out of Eden with a sword. Adam and Eve look to the right and to the left at their new world, while the black snake, still entwined in the tree, hangs its head, heading down to the earth and out of the garden. (ALC)

Cat. 106
EDGAR TOLSON
born 1904, Lee City, Kentucky–died 1984, Campton, Kentucky
Adam and Eve, 1979
carved and painted wood and pencil
10¼ x 10¾ x 7¼ in.
acquired from Kenneth Fadeley, Birmingham, Michigan, 1981
1986.65.269

"And Adam knew Eve his wife . . ." (Gen. 4:1). While most of Tolson's works can be linked to an exact passage of Scripture, this one can not. This *Adam and Eve* illustrates Tolson's sense of humor and his attraction to the profane. As Eve leans over the stump, the serpent bites her on the breast, an incident fully in keeping with God's condemnation of the creature: "And I will put enmity between thee and the woman, and between thy seed and her seed; it shall bruise thy head, and thou shalt bruise his heel" (Gen. 3:15). (ALC)

Cat. 107

Cat. 106

Cat. 107
FRANK JONES
born ca. 1900, in or near Clarksville, Texas–died 1969, Huntsville, Texas
Indian House, ca. 1968–69
colored pencil on paper
22⅝ x 22⅝ in.
acquired from Atelier Chapman Kelley, Dallas, Texas, 1972
1986.65.175

Frank Jones began to draw in 1964 while serving a life sentence for murder in the Texas State Penitentiary in Huntsville. (Jones maintained his innocence, but was incarcerated for most of his adult life.) His drawing materials were salvaged stubs of red and blue accountant's pencils and sheets of typing paper from the trash cans in the prison office where he worked. Later, as his drawings received favorable attention inside and outside the prison, he

was given better paper and new colored pencils. Jones experimented with other colors, but preferred red and blue, which he said represented fire and smoke.[1]

Jones, an African-American, was born with a portion of fetal membrane over his left eye. In the African-American tradition, as well as the traditions of other cultures as ancient as those of Greece and Rome, such a "veil," allows people to see spirits and devils. Jones first saw his "haints" (haunts or ghosts) and "devils" when he was nine and continued to see them throughout his life. He created several hundred complex drawings of houses that reveal these "haints" in cell-like rooms. His horned "haints" characteristically assume physical attributes of animals and inanimate objects. The double-thick walled house is based on the architecture of "the Walls," the section of the Huntsville prison where Jones lived. The

clock recalls the large exterior clocks in prison yards and is common to Jones's drawings, although its two sets of hour numerals are curious. Jones signed many of his works with his prison number until someone taught him to write his name, which he usually misspelled. (ALC)

[1]See Lynne Adele, *Black History/Black Vision: The Visionary Image in Texas* (Austin, Tex.: Archer M. Huntington Art Gallery, University of Texas at Austin, 1989), 41–51.

Cat. 108
"SISTER" GERTRUDE MORGAN
born 1900, Lafayette, Alabama–died 1980, New Orleans, Louisiana
Come in my Room, come on in the Prayer Room, ca. 1970
tempera, acrylic, ballpoint pen, and pencil on paper
12⅛ x 23 in. (irregular)
acquired from E. Lorenz Bornstein, New Orleans, 1970
1986.65.186

Gertrude Morgan was raised as an active member of the Southern Baptist church. "My heavenly father called me in 1934. . . . Go ye into yonder's world and sing with a loud voice you . . . are a chosen vessel to call men women Girls and boys."[1] After moving to New Orleans in 1939, she began her missionary work as a singing street preacher and soon joined a "sanctified" fundamentalist church where the services emphasized singing, music, and dancing. With two other street missionaries in the early 1940s, "Sister" Morgan built and operated a small chapel and center for orphans, runaways, and other children who required food and attention.

In 1956, Morgan began wearing only white clothing, anticipating that she would be the bride of Christ. She also prepared an all-white room in her house as the "prayer room." In 1966, Morgan claimed God instructed her to draw pictures of the world to come—the New Jerusalem. Her sermons on paper illustrate aspects of her life and visions, as well as her interpretation of the Book of Revelation. Her

drawings, she believed, were composed by God, "Through his Blessed hands as he take my hand and write . . . I just do the Blessed work."[2] *Come in my Room* derives its title from one of Morgan's original songs and includes a vignette of Morgan in her prayer room in the lower section. Several of her visionary paintings hang on the wall. (ALC)

[1]Gertrude Morgan, "Poem of my Calling," undated, handwritten manuscript to Regenia Perry. Papers of Dr. Kurt Gitter, New Orleans, Louisiana.

[2]Morgan, letter to Regenia Perry, 23 December 1972; Gitter papers.

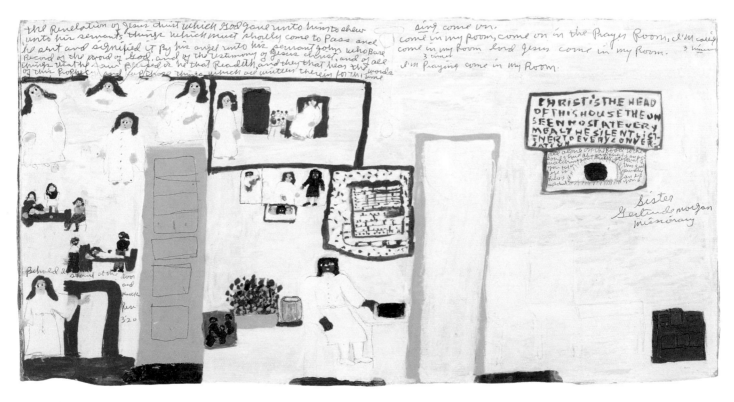

Cat. 108

Cat. 109

JIM COLCLOUGH

born 1900, Fort Smith, Arkansas–died
1986, Westport, California
The Crucifixion, ca. 1970
carved and oiled redwood with glue and
sawdust
52⅞ x 39 x 10 in.
acquired from David Davies, New York,
1975
1988.74.4

Jim Colclough learned to use traditional
Ozark Mountain woodworking tools as a
child in his father's blacksmith shop.
When he was sixty-two (after his wife had
died, and he had retired), Colclough be-
gan to carve seriously, creating hundreds
of figures from redwood logs he found
washed up on the beach near his home in
northern California. Before World War II,
Colclough worked with carnival compa-
nies building and operating rides and at-
tractions. Although he is best known for
carvings that reflect the humor and clever
kinetic movement of these animated scenes
and figures, several of his works, such as
this *Crucifixion,* depict serious religious
subjects. Colclough characterized his
shifts between humorous and religious
subjects as unconscious. He stubbornly
refused to carve anything suggested by
others and his methods were sometimes
unorthodox. "To get the proper position
of Christ hanging limp on the cross," he
told a neighbor, "I drove two big spikes
in the wall and I backed up to the wall—
grasped a spike in each hand and then I'd
go limp to get the correct pose. . . . I
didn't have anything to go by for the
face—so I carved the face according to my
own interpretation."[1] (ALC)

[1]Typed notes taken by a neighbor, based on the
artist's statements. Papers of Mary Colclough
Ruth, Freemont, California.

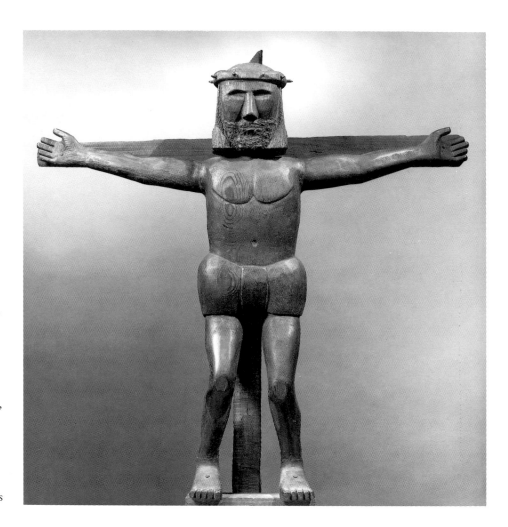

Cat. 109

Cat. 110

156 TOKENS OF MEANING

Cat. 111

Cat. 110
PETER J. MINCHELL
born 1889, Treves (now Trier), Germany–
died 1982, West Palm Beach, Florida; to
USA 1906
FALL OF JERUSALEM 70 A.D., ca. 1972
watercolor and pencil on paper
18 x 25¾ in.
acquired from Michael and Julie Hall,
Bloomfield Hills, Michigan, 1972
1986.65.184

For devout Roman Catholic Peter
Minchell, creating religious and visionary
drawings was much more of a spiritual
than physical process: "You have to have
a considerable imagination to carry out
these ideas on paper. . . . Before I start
any painting at all I always lie down. I
wake up and I can't sleep. And I begin to
think 'Well, what shall be the next thing
on paper?' And I form an idea of what it's
going to be, and I work out the details
before I even draw a line."[1]

Inspired in part by visits to museums,
Minchell began painting after moving to
Florida soon after the end of World War
II. After his retirement in the late 1960s,

Minchell created this complex, cataclysmic
painting based on his dreams about de-
struction of religious beliefs and moral
standards. He was only able to devote
much time to his painting after he moved
to Florida. Between his retirement and his
death at the age of ninety-two, Minchell
created three major series of paintings that
depict the trials of mankind after earth has
been burned by the passing tail of "Comet
X," life without sin and fault on "Planet
Perfection," and the primitive purity of
life in the Amazon jungle. (ALC)

[1]Peter J. Minchell, interview with Lewis
Alquist, 1978. Papers of Lewis Alquist, Tempe,
Arizona.

Cat. 111
JOHN WILLIAM ("UNCLE
JACK") DEY
born 1912, Phoebus (now Hampton), Vir-
ginia–died 1978, Richmond, Virginia
ADAM & EVE LEAVE EDEN, 1973
model-airplane enamel on fiberboard
23⅛ x 47 in.
acquired from Jeffrey Camp, Richmond,
Virginia, 1973
1986.65.107

Even in his most serious religious paint-
ings, Dey added a dash of his dry humor.
In this garden paradise where all four sea-
sons coexist, the angel of the Lord hands
down an "eviction notice" to Adam and
Eve. Dey summarized their future life on
a note pinned to the ground, "Gravy train
gone. Adam settled down. Work hard in
the barren land. Raise a family. Passed
years befor [*sic*] Eve." The figures of
Adam and Eve are based on Michelange-
lo's Sistine Chapel version of the story,
which Dey may have seen in a reproduc-
tion.

After retiring from the Richmond police
force in 1955, Dey began painting illustra-

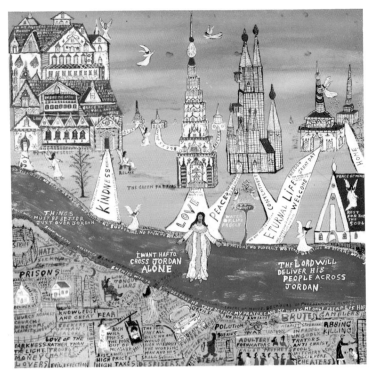 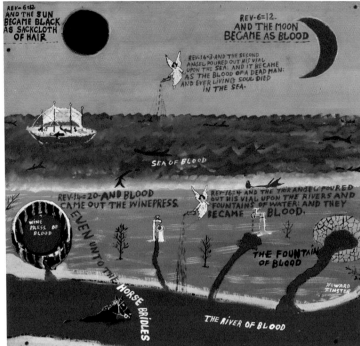

Cat. 112

tions of stories and scenes from his life.
Neighborhood children nicknamed him
"Uncle Jack," which he used to sign all
his artwork. Preferring bright colors, he
painted with unmixed Testor's model-air-
plane enamel. (ALC)

Cat. 112
HOWARD FINSTER
born 1916, Valley Head, Alabama; active
Summerville, Georgia
*THE LORD WILL DELIVER HIS
PEOPLE ACROSS JORDAN;
AND THE MOON BECAME AS
BLOOD;
THER SHALL BE EARTH qUAKES,*
1976
enamel on fiberboard
30⅛ x 29⅝ in.; 29⅝ x 30⅛ in.; 30 x 29½
in.
acquired from the artist, 1976
1988.74.6, 7, and 8

The Reverend Howard Finster is perhaps
the most famous religious artist alive to-
day. Because Finster realized that his con-
gregation did not remember his sermons
even minutes after he had finished, he
published religious songs and poetry in
local newspapers in the 1930s and hosted a
radio prayer show in the late 1930s and
early 1940s. He claims God charged him
to illustrate his religious visions in 1976
when "A warm feeling came over me to
paint sacred art."

These three panels are some of the
artist's earliest paintings explicating bibli-
cal revelations and the theme of salvation.
"I began to paint these pictures thinking
nobody wouldn't want them, and I nailed
them with cement nails to cement walls on
the side of my business place."[1] As a re-
sult, these three panels have been per-
ceived as a triptych because Finster hung
them side by side. As his sense of artistic
personality developed, Finster incorpo-
rated characteristic passages into his paint-
ings that explained his identity as a "Man
of Visions." Such self-conscious presenta-
tions are absent from these early works,
which lack the promotional flair charac-
teristic of his later work. (ALC)

[1]Howard Finster, interview with Jeffrey Camp,
29 November 1977. Jeffrey and Jane Camp
Papers, Archives of American Art, Smithsonian
Institution, Washington, D.C.

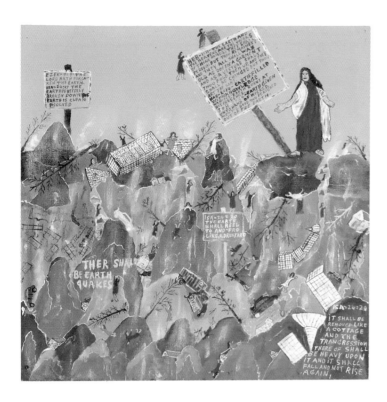

Cat. 113
HOWARD FINSTER
born 1916, Valley Head, Alabama; active
Summerville, Georgia
*THE MODEL OF SUPER POWER
PLAINT (FOLK ART MADE FROM
OLD T.V. PARTS)*, 1979
painted plastic and metal electronic tele-
vision parts, glitter, mirror, wood, and
metal
20 x 6⅝ x 7⅝ in.
acquired from Jeffrey Camp,
Tappahannock, Virginia, 1979
1986.65.245

Finster began building his everchanging
environmental sculpture, *Paradise Garden*,
on swampy land behind his house in the
early 1960s. Composed of walkways and
constructions made from cast off pieces of
technology, the *Garden* assembles individ-
ual monuments to human inventors into
an all-encompassing "Memorial to God."
Much of the building material in the gar-
den was accumulated from Finster's tele-
vision and bicycle repair businesses and
his twenty-one other trades.

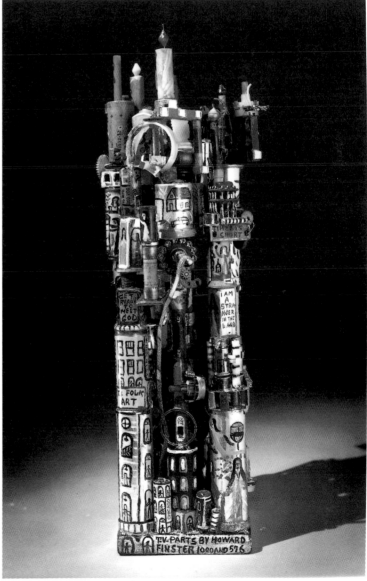

Cat. 113

Cat. 114

Cat. 114
JOSEPHUS FARMER
born 1894, Gibson County, Tennessee;
lives Joliet, Illinois
Samson, 1982
carved and painted redwood relief with
rhinestones
27⅜ x 27¾ x 1½ in.
acquired from Richard B. Flagg,
Milwaukee, Wisconsin, 1983
1986.65.242

Josephus Farmer began his public mission
as an itinerant evangelical minister in St.
Louis, where he received his "calling from
God" in 1922. After his retirement in the
late 1960s from jobs as varied as hog
farmer and hotel porter, Farmer spent
much time carving religious images that he
sold to help finance his proselytizing jour-
neys. Reverend Farmer painted several
banners with images drawn from theologi-
cal charts commonly used in the nine-
teenth century (see cat. 95), which he used
as preaching tools during his revival meet-
ings. His relief carvings, usually executed
in redwood painted with enamel, contain
either images of American history or
scenes from the Bible and often combine
seemingly unrelated stories into one panel.
Farmer selects biblical stories extempora-
neously as he carves. This carving illus-
trates the stories of Samson slaying the
lion at Timnath and revealing the secret of
his strength to Delilah. Farmer has also
included vignettes of Adam and Eve, the
sacrificial lamb, Jeremiah in chains, and
the Lamb of God. (ALC)

Eager to deliver sermons, Finster hopes
that objects in his *Paradise Garden* will
inspire visitors to ask questions. This
model of a super power plant, an assem-
blage of discarded parts from television
sets, echoes the large constructions in the
Garden. Finster employs parts that for-
merly delivered the message of one mass
medium to deliver his own, and states that
"I am my own TV. Picking up visions all
through the night hours of darkness from
thin air."[1] Finster establishes a grand scale
in a tiny world with his painted windows
and figures on all the surfaces of the cy-
lindrical television tubes. Even on this
seemingly secular work, he establishes his
"vision of the times" with standard reli-
gious slogans such as "Time is Short,"
"God is Love," and "Jesus Saves."
Finster's self-conscious labeling of this
construction as "T.V. Folk Art" demon-
strates his awareness of his role as an art-
ist, as well as his appropriation of both
pop culture and the business of art, in the
service of his mission. (ALC)

[1]"Thought card," ca. 1978. Howard Finster
Papers, Archives of American Art, Smithsonian
Institution, Washington, D.C.

Cat. 115
UNIDENTIFIED ARTIST
Memory Bottle with Harmonica and Razor, early twentieth century
glass bottle with composition dough embedded with metal, plastic, glass, and wood objects, gilded with bronze paint
12⅜ x 6⅜ in. (diam.)
source and date of acquisition unknown; probably the 1970s
1986.65.306

Cat. 116
UNIDENTIFIED ARTIST
Memory Jug with Finial, early twentieth century
ceramic jug with composition dough embedded with metal, plastic, glass, and wood objects, gilded with bronze paint
11¾ x 7½ x 7¼ in.
source and date of acquisition unknown; probably the 1970s
1986.65.310

Cat. 117
UNIDENTIFIED ARTIST
Memory High-Buttoned Shoe, early twentieth century
masonite with composition dough embedded with metal, plastic, glass, and wood objects, gilded with gold paint
15½ x 12⅜ x 2⅜ in.
source and date of acquisition unknown; probably the 1970s
1986.65.279

Currently, "memory vessels" are discussed as a variation on the African-American tradition of decorating gravesites with everyday objects, ostensibly for use in their previous owner's afterlife. Embellishing surfaces with embedded objects and saving mementos of loved ones, however, are universal practices. Memory vessels have, in fact, been made by men and women of diverse ethnic backgrounds across the country. The gilded versions now popular among collectors were made

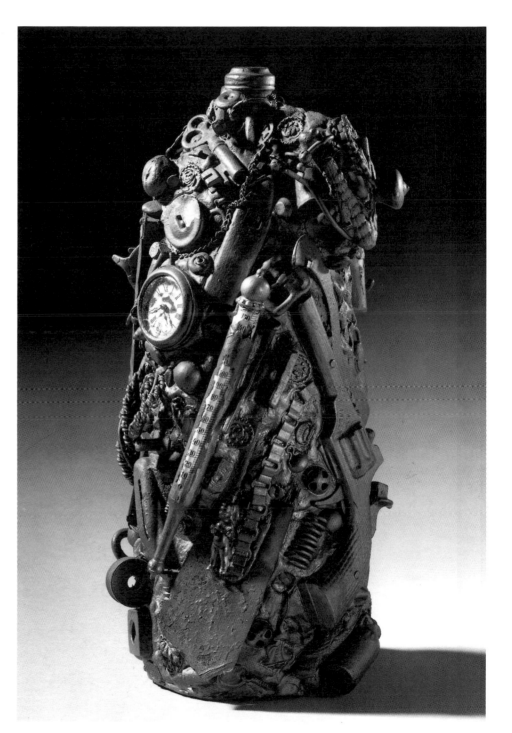

Cat. 115

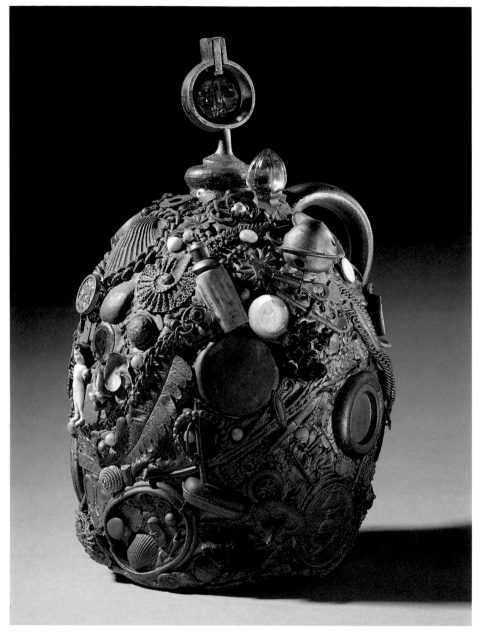

The domestic environment provided most of the materials for creating memory vessels. Bottles, vases, and jugs were common armatures, although forms, such as this silhouette of a lady's high-buttoned shoe, were sometimes especially designed for a project. Frequently, the encyclopaedic array of objects crowding the surfaces reflects the times and interests of the maker or the person for whom the vessel was conceived. This *Memory Jug* includes a campaign button for William Jennings Bryan, a Democratic presidential candidate between 1896 and 1908. The bullet casings, straight-edged razor, pocket watch, and belt buckle on this *Memory Bottle* suggest a masculine reference. Baroque in their sensibility, these vessels are three-dimensional memory pictures, capturing the decorative, documentary, and often spiritual inclinations of their makers. (LRH)

Cat. 116

primarily around the turn of the twentieth century, although more contemporary, often polychromed, examples also exist. The late Victorian era's scrapbook mentality, and its period taste for decorating frames, bell jars, boxes, and entire interiors with an eclectic array of objects, may have influenced the style and sentiment of memory vessels as a popular art.

Cat. 117

Native America

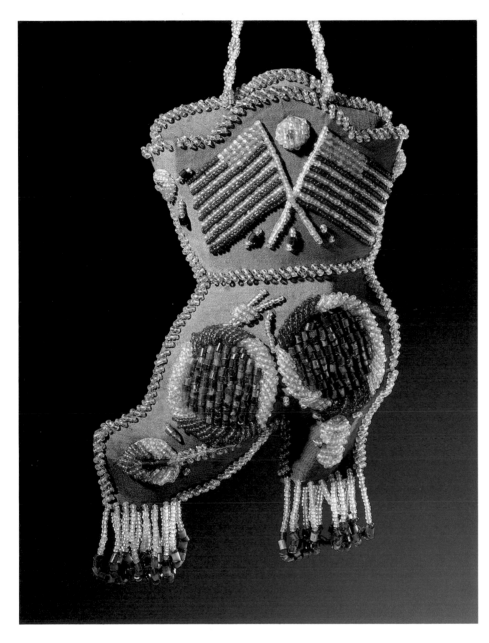

Cat. 118

Cat. 118

UNIDENTIFIED ARTIST

Tuscarora (Iroquois)
Beaded Whimsy, Niagara Falls style, ca.
1900
glass beads on cardboard-reinforced cotton with wool and sawdust
15⅞ x 7 x 2⅜ in.
acquired from George Juergen's Antiques,
New York, 1957
1986.65.356

The Victorian zeal for ornamental beadwork inspired designs for costumes as well as utilitarian objects including jewel cases, mats, hanging picture frames, lamp stands, and pin cushions. Fashion magazines such as *Peterson's, Godey's Lady's Book,* and *Harper's Bazaar* featured "bead painting" designs that could be applied to household furnishings. This hanging whisk-broom holder in the shape of a lady's boot is an example.

Although beadwork was a traditional craft among the Tuscarora tribe in upstate New York, the commercial appeal of a cottage industry aimed at the local Niagara Falls tourist market stimulated a change in the tribe's decorative forms. Aware of the popular trade designs for domestic items, the Tuscarora developed a distinctive "Niagara Falls" style—larger glass beads tatted onto substantial backings of velvet, felt, or cardboard-reinforced cotton. Beads had been trade commodities for Native Americans since the earliest contact with French and Dutch explorers in the seventeenth century. In *Beaded Whimsy,* the large areas of iridescent cut beads resemble wampum, the strung polished shells that once served as currency among tribes. The American flag was a common beadwork motif decorating pin cushions and other accessories sold as "whimsies" or "fancies" in local resort areas. (TLH)

Cat. 119

Cat. 119

UNIDENTIFIED ARTIST
Attributed to Great Lakes (Menominee/
Winnebago/Eastern Sioux) tribes
Wolf Riding Turtle, after 1930
carved, varnished, and painted walnut
15½ x 9⅝ x 14 in.
acquired from Dr. William Greenspon,
New York, mid 1970s
1986.65.339

Woodworking among the Native American tribes of the Great Lakes area was largely reserved for the manufacture of utilitarian or ceremonial objects until the twentieth century when circumstances forced functional changes in craftsmanship. President Roosevelt's concern for impoverished tribal conditions led to the creation of the Indian Arts and Crafts Board, established in 1935 by WPA legislation that sought to expand the market for Indian arts and crafts in order to foster economic development. With a new economic emphasis on art, government-supported Indian programs at schools such as Hampton Institute in Virginia, and the Institute of American Indian Arts in Santa Fe, encouraged artistic expression in both traditional and nontraditional styles, paving the way for an expanded art market.

Wolf Riding Turtle is an unusual example of the impulses stemming from this period. While virtually nothing is known about the work, its subject matter reflects aspects of traditional myths associated with the Great Lakes Midewiwin or Grand Medicine Society. Among the Menominee and Winnebago, the "Turtle" is one of the original culture heroes; the "Wolf" is the tragic little brother of another culture hero, the "Hare." *Wolf Riding Turtle* may also represent a form of cross-cultural exchange with the neighboring Eastern Plains tribes, who often combined animal figures in effigy carving, particularly on their pipes. (TLH)

Cat. 120

PUEBLO; Attributed to HOPI
New Mexico pueblos; possibly Hopi
mesas, Arizona
Mickey Mouse Kachina, after 1930
carved and painted cottonwood, feathers,
and string
11¾ x 5⅜ x 4¾ in.
acquired from Delacourt Gallery,
New York, 1950s
1986.65.311

The primary actors in the rich ceremonial life of the Southwestern pueblos are the dancers and clowns who reenact the stories of the kachinas, spiritual ancestor guardians of their native way of life. Traditional dolls, carved from cottonwood and hung on the adobe walls of the kivas (subterranean ceremonial rooms) or in family dwellings, are often used by the kachina dancers. Throughout the twentieth century, the value of the dolls as collectibles greatly influenced styles of representation while innovations in carving reflected an increasing response to American culture as portrayed through the mass media.

Mickey Mouse kachina dolls appeared in the pueblos after Walt Disney's 1929 cartoon character captured America's attention in the early 1930s. Perhaps inspired by Mickey's comical antics, this particular doll has been made to resemble one of the "Mudheads," the ritual clowns important to kachina ceremonies. (TLH)

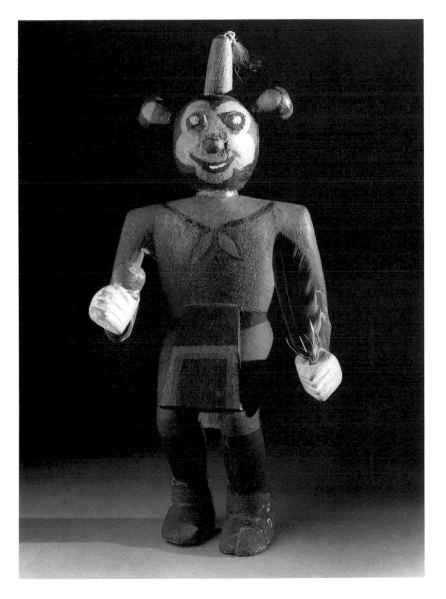

Cat. 120

Cat. 121
CHARLIE WILLETO
born ca. 1900–1905, New Mexico, Navajo
reservation (Dinetah)–died 1965, Nageezi,
New Mexico, Navajo reservation (Dine-
tah); active Blanco Canyon, New Mexico,
Navajo reservation (Dinetah)
Male and Female Navajo Figures, ca.
1962–64
carved and painted wood
male: 66¼ x 16½ x 10¼ in.
female: 66½ x 16¼ x 14¼ in.
acquired from Skip Holbrook, Santa Fe,
New Mexico, 1977
1986.65.342 and 1986.65.385

A traditional Navajo sheepherder, Charlie
Willeto began carving in the early 1960s,
only a few years before his death. He
used his works as barter—a standard form
of trade on the reservation—for groceries
at the Mauzy Trading Post near Ly-
brook.[1] Jim Mauzy accepted Willeto's
carvings, although they differed from the
more conventional Navajo crafts of weav-
ing and silverwork. Only one other life-
sized carving exists; most of Willeto's four
hundred figures range in size from twelve
to thirty inches. Originally brightly
painted, these male and female figures,
their hair bound in Navajo style, stood
outside the front of Mauzy's trading post,
an ironic twist on the "cigar store Indian"
advertising tradition.

Willeto's figures came from a heritage
of carving that had little to do with com-
mercial signs. A Navajo curing rite, *'a-
wééshíín 'análnééh,* prominently featured
the carving of human figurines. These
were usually between four and eight
inches long, and were used only in a reli-
gious context specific to that ceremony.
After the rite's completion, the doll-like
carvings were usually taken to sacred sites
and left with paired male and female
prayer sticks. Willeto's statuesque figures
are almost identical in form to many of
these small, stylized carvings found in re-
gions of the reservation where *'awééshíín
'análnééh* was performed. The painted
markings may be decorative reminders of

the jeweled inlay and painted bands found
on many surviving examples of the
figures. (TLH)

[1]Jim Mauzy, interview with Tonia L. Horton,
20 September 1989.

Cat. 122
MARY ADAMS
born 1920s, St. Regis Reservation,
Quebec; active St. Regis Reservation
Wedding Cake Basket, 1986
woven sweet grass and ash splints
25½ x 15¾ in. (diam.)
acquired from the artist, 1986
1989.30.1

The works of basket maker Mary Adams
represent the ingenious marriage of tradi-
tional Mohawk crafts with contemporary
popular forms. Adams, who is in her six-
ties, teaches basketry at the local reserva-
tion museum twice a week. Half a dozen
traditional basket makers work near Ad-
ams on the St. Regis Reservation, includ-
ing her sister, Margaret. The *Wedding
Cake Basket* is a personal invention that
layers storage compartments in the shape
of exquisitely crafted tiers.

After coming into contact with Europe-
ans in the late eighteenth century, the
Algonkian and Iroquoian peoples replaced
their indigenous style of basketry—
stitched wood and bark, twining, and
plaited matting—with the plaited wood-
splint technique common to Germanic and
Swedish colonists. The sharp points of
woodsplint in the *Wedding Cake Basket*
are a variation of the "porcupine twist" or
"curlicue" manipulation of the splints,
recognized as "thistle weave" in the dis-
tinctive Mohawk style. Adams skillfully
contrasts protruding design elements with
the smooth texture of surface splints,
which are interwoven with sweet grass.
Since 1968 Adams has made several bas-
kets in this style—each differing in the
number of layers, but all typically requir-
ing six weeks to complete. (TLH)

Cat. 122

Cat. 123

Cat. 124

Cat. 124
PEDRO ANTONIO FRESQUÍS
born 1749–died 1831; active Truchas,
New Mexico
Our Lady of Guadalupe, ca. 1780–1830
water-based paint on wood
18⅝ x 10¾ in.
acquired from Martin Grossman, New
York, early 1960s
1986.65.113

Ring dating of the pine panels on which Fresquís painted his *retablos* (paintings of saints) reveals that he may have been working as early as 1780; if so, he is probably the first native-born New Mexican *santero* (creator of saint images). The image of Our Lady of Guadalupe, the patroness of Mexico, is one of the most popular of all religious subjects for Mexican-Americans. A miracle was said to have occurred in 1531 when the Virgin Mary reportedly visited a converted Indian, Juan Diego, as he was walking to mass outside Mexico City. The image of the Virgin, it was claimed, was miraculously imprinted upon Diego's cloak after her fourth appearance and was widely copied in prints and paintings. This representation, painted on a hand-adzed board, follows strict conventions including the Virgin's stance upon a dark, crescent-shaped moon supported by an angel within a scalloped halo. The decorative borders of the painting, scratched through the wet paint, are characteristic of Fresquís's work. (ALC)

Cat. 125
JOSÉ BENITO ORTEGA
born 1858, La Cueva, New Mexico–died
1941, Raton, New Mexico
Our Father Jesus of Nazareth, ca. 1885
carved and painted wood, painted cloth,
and leather with metal
30 x 9¾ x 9⅜ in.
acquired from unidentified source, New
York, late 1970s
1986.65.258

Ortega is known for the flattened, simplified figures he frequently carved from

Cat. 123
EIGHTEENTH-CENTURY
NOVICE
active late eighteenth century, New
Mexico
St. Anthony of Padua, late eighteenth
century
oil on pine panel
13¾ x 9¼ in.
provenance and date of acquisition
unknown
1986.65.96

After the Pueblo Revolt of 1680, the Spanish did not return to the North American Southwest until 1693. It was only after the Spaniards returned that the first non-Indian paintings appeared in the region. Called *santos,* these religious images were painted in the Spanish Renaissance and baroque styles and were brought from Mexico (then called New Spain) by Franciscan monks who estab-

lished missions for the conversion of the natives. Early *santos* were usually painted on hide or canvas so they could be rolled for convenience on the long journey. Later the Franciscans and converted Indians began painting and carving *santos.* Occasionally artists were brought from New Spain to create images for the growing number of mission churches.

The artist's attention to flowing drapery and modeling of the robes reflects the influence of earlier baroque paintings. Saint Anthony of Padua, the finder of lost articles (especially animals) and worthy husbands, and the patron of the home, is depicted wearing the blue robe of the Franciscans in the New World. The unidentified painter, known as the Eighteenth-Century Novice, was the last artist to use expensive oil paints imported from New Spain until commercially manufactured paints became available with the arrival of the region's first rail line in 1879. (ALC)

Cat. 125

Cat. 126

boards discarded by lumbermills. These works were sold to private chapels, local churches, or families for use in their homes. The small size of this Christ figure and the supporting wood slats at his waist indicate that it, like many similar figures by Ortega, was carried in processions, probably by members of the Penitente brotherhood of the Roman Catholic church during Holy Week. Because of its moveable arms, this figure can be dressed and posed to represent several different stages of the Passion, such as the Scourging at the Pillar, the Presentation of Christ to the People, the Crucifixion, the Deposition from the Cross, and the Entombment. Frequently sensationalized in the press, the bloody reenactments of these events during Holy Week in the small towns of New Mexico and southern Colorado became popular tourist attractions for "Anglo" (a term used in the region to

denote all persons of non-Hispanic, non-Indian heritage) settlers and visitors to the region during the late nineteenth and early twentieth centuries. (ALC)

Cat. 126
GEORGE LÓPEZ
born 1900, Córdova, New Mexico; active Córdova
Saint Michael the Archangel and the Devil, ca. 1955–56
carved aspen and Palo Duro (mountain mahogany)
48 x 33 x 39½ in.
acquired from the artist, 1972
1986.65.256

Saint Michael the Archangel (San Miguel Arcangel) is the protector of the just, the opponent of Satan, the patron of soldiers, and the guardian of young children. Im-

ages of Saint Michael are found in all periods of Hispanic New Mexican carving and painting. This expressively animated carving owes its style and composition to similar figures developed by the artist's father, José Dolores López (cat. 3). George López's version is particularly imaginative in depicting the devil as half snake and half insect-dragon with pointed beard and sharp claws. López does not consider his carvings of saints holy unless a priest has blessed them. If they have not been blessed, carvings such as *Saint Michael* cannot properly be called *santos*. (ALC)

Cat. 127

UNIDENTIFIED ARTIST

In Memory of Margaret L Bates, after
1805
watercolor, pen and ink, and glitter on
paperboard
17 x 19⅝ in.
provenance unknown; acquired before
1974
1986.65.209

This picture exemplifies a genre known as
"memorial pictures"—romantic and sym-
bolic expressions of grief popular during
the first half of the nineteenth century.
Inspired by the death of George Washing-
ton in 1799, this genre is characterized by
a standardized set of features: an urn on a
tomb, a weeping willow, and mourning
relatives placed in a garden setting that
sometimes includes a church or the family
home in the background. This standard-
ization arose not only from the symbolism
of the objects themselves, but from the
fact that the pieces were often created by
young girls as part of a school curriculum,
or by amateurs, who studied art instruc-
tion books or received private drawing
lessons. The inscription on this piece ded-
icates the work to a child, and includes a
poem that reinforces the general theme of
death and resurrection. Its composition is
similar to other known memorials, so a
common source, as yet unidentified, is
likely. Since memorial pictures were often
created long after the subject's death, this
piece was probably painted sometime after
1805, the date included in the inscrip-
tion. (ETH)

Cat. 128
Attributed to HANSON FAMILY
MEMBER
*IN MEMORY OF BELOVED
PARENTS OLOFF AND BETSEY
HANSON,* after 1832
pen and ink and brush and ink, height-
ened with white, on paper
19½ x 27⅛ in. (irregular)
provenance unknown; acquired by 1961
1986.65.212

During the early nineteenth century most
memorial pictures were embroidered in
silk, but by the 1820s they were painted
on paper or velvet. Inexpensive printed
memorial pictures became available after
1835, and subsequent handmade memorial
pictures often reflected the influence of
mass-produced counterparts. The general
composition of this piece, especially the
pose of the young lady, is very similar to
that of a memorial lithograph published
by Nathaniel Currier. (ETH)

Cat. 127

Cat. 128

Cat. 129

Cat. 130

Cat. 129
Attributed to ELIZABETH W.
CAPRON
born 1803, Worchester, Massachusetts;
death date unknown; active Winchester,
Massachusetts
Still Life, ca. 1830–48
oil on velvet
18 x 19⅛ in.
acquired from Martin Grossman, New
York, 1962
1986.65.103

Painted on either paper or velvet, still lifes
created with the aid of stencils were
known as theorems and were most popu-
lar from 1820 to 1840. The stencils were
made of heavy paper coated with shellac
and oil to strengthen them for repeated
use. The stenciling technique, however,
was not simply mechanical, as a certain
amount of skill was required to shade the
edges. This particular composition, with
the bowl's round, footed base and care-
fully placed fruit, exists in several other
close variations, including one from
Boston in the Abby Aldrich Rockefeller
Folk Art Collection. Perhaps a kit or in-
struction book was the common source
for the design. Attached to the back of
this theorem is a religious poem, signed
and dated 1830 by Elizabeth Capron, who
is believed to be the artist. (ETH)

Cat. 130
UNIDENTIFIED ARTIST
Grisaille Theorem, nineteenth century
pencil and watercolor on wove paper
14⅛ x 10 in.
provenance and date of acquisition un-
known
1986.65.210

Theorems, still-life compositions created
with stencils, were a popular hobby
among young ladies in the early nine-
teenth century. This example, however, is
unusual since most such works were exe-
cuted in color. Images done in two or

Cat. 131

three tones of gray are known as grisaille theorems. The grisaille technique came to America with seventeenth-century Dutch settlers in the Hudson Valley who painted similar still lifes on furniture, a tradition also reflected in the frame chosen by the collector. The Museum of American Folk Art owns a close variation, suggesting a common source. (ETH)

Cat. 131
J. C. SATERLEE
life dates unknown; active Corry, Pennsylvania?
Why not learn to write?, June 11, 1866
pen and ink on joined sheets of wove paper
28 × 76¼ in.
acquired from unidentified dealer, Westville, New York, 1974
1986.65.195

Expert penmen used elaborate drawings such as this to demonstrate their skill or to advertise themselves as instructors of calligraphy, a method of drawing and lettering done in repeated cursive flourishes and strokes with a quill or steel pen. The drawing could be in any form, such as the shape of an animal, but the character of the line is the same one used to form letters. Major sources of inspiration for calligraphic works were the many instruction books available in the nineteenth century, such as those published by Platt Rodgers Spencer during the 1850s. The conventional subjects included birds, lions, horses, and running deer. Since a similar version of this lion and chariot design exists, an instruction book (as yet unknown) is a likely source for the design. The ambitious scale of this work, however, sets it apart from most other penmanship pieces, which are much smaller and confined to a single sheet of paper. (ETH)

Cat. 132

"PROFESSOR" JOHN H. COATES

life dates and place of activity unknown
Eve, and the Serpent, in the Garden, of Eden. REAL PEN WORK, 1916
pen and ink and colored pen and ink on
paperboard
28 x 21⅞ in.
Gift of Michael Hall, Bloomfield Hills,
Michigan, before 1981
1986.65.167

Using stippling and crosshatching, rather
than the usual calligraphic strokes, "Pro-
fessor" Coates has created a strong and
sinuous design, with an expressive rather
than accurate approach to anatomy. In-
corporated into the tree are the words
"Real Pen Work," which may refer to a
penmanship manual of the same title,
published in the 1880s by Knowles and
Maxim in Pittsfield, Massachusetts.
Coates' composition does not appear to be
taken from this manual, but images from
the book also include the words "Real
Pen Work." A twentieth-century variation
on a nineteenth-century tradition, Coates'
effort is more narrative and allegorical
than those by Knowles and Maxim or
other penmanship pieces in general. (ETH)

Cat. 132

Cat. 133

Cat. 133
UNIDENTIFIED ARTIST
Monochromatic Landscape, ca. 1875–99
crayon and pencil on coated paperboard
14⅝ x 20⅛ in.
provenance unknown; acquired 1972
1986.65.204

Sometimes referred to as "sandpaper" or
"marble dust painting," this type of
black-and-white imagery is best known as
monochromatic drawing because the com-
mercially prepared board used in the
process was called monochromatic board.
Dark forms were laid on the textured sur-
face with charcoal or black crayon, and
highlights were created by scraping the
black charcoal or crayon from the board.
The medium required little skill to create a
satisfactory picture, and perhaps for that
reason it was very popular with amateur

artists in the third quarter of the nine-
teenth century. Inspiration for subject
matter often came from printed sources.
This image appears to be based on one or
several unidentified English scenes from
Currier and Ives. (ETH)

Cat. 134
UNIDENTIFIED ARTIST
Masonic Regalia Box, ca. 1780
painted wood and iron
10 x 20¼ x 10½ in.
acquired from Shreve, Crump and Low,
New York, 1960s
1986.65.83

Freemasonry is an oath-bound fraternal
organization that originated in seven-
teenth-century England. The earliest fra-
ternal organization in America, its lodges
were established in Boston and Philadel-
phia by the 1730s. Members of the orga-
nization, known as Masons, promote
moral and social virtues among their
members through ceremonies, degrees,
and symbols. Most of their symbols are
based on stonemason's tools, classical ar-
chitecture, the Bible, and heraldry.

 One of the many different orders and
degrees of masonry is the Royal Arch De-
gree, represented here by its insignia on
the lid. The insignia's precise meaning is a
Masonic secret. The letters "T.N." in the
center of the circle are probably the ab-
breviation of a local chapter of the order,
or may be the initials of a specific person.
On the front of the box is the most com-
monly known Masonic symbol—the
square and the compass. Together they
symbolize faith and reason. This box was
probably used to store regalia related to
Masonic ceremonies. It may have be-
longed to a tiler, the officer responsible
for distributing Masonic regalia to mem-
bers before the ceremony. (ETH)

Cat. 134

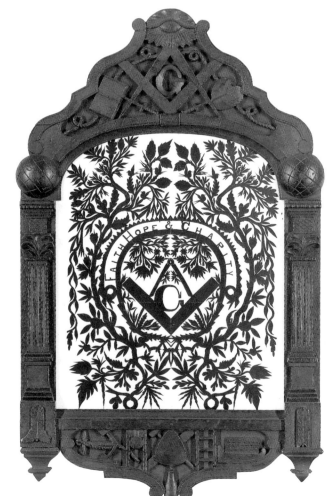

Cat. 135

Cat. 135
UNIDENTIFIED ARTIST
Frame and Cutout with Masonic Symbols,
ca. 1875
carved, stained, and varnished wood, and
cut paper
30⅞ x 19½ x 1⅜ in.
acquired from George Juergen's Antiques,
New York, early 1960s
1986.65.81 a and b

Although this carved frame and its paper
cutout employ many Masonic symbols,
they are not part of official Masonic re-
galia. They illustrate that fraternal sym-
bolism was often used to decorate per-
sonal possessions. The *G* between the
compass and the square stands for geome-
try or God; the eye at the top represents
watchfulness and the Supreme Being; the
sword and heart demonstrate that justice
will overtake us; and the globes are sym-
bolic of the universality of Freemasonry.

The frame's maker is unknown, but its
design is similar to those created by John
Haley Bellamy, a wood carver in Maine,
New Hampshire, and Massachusetts, dur-
ing the last half of the nineteenth century.
Although best known for his ship figure-
heads, carved eagles, and other decorative
pieces, Bellamy also obtained a patent for
his frames embellished with Masonic sym-
bols. The carving penetrates through the
surface of the wood on Bellamy's frames.
This frame, however, is carved in relief. It
is not known whether the paper cutout
was made for the frame or if it was added
later. (ETH)

Cat. 136
UNIDENTIFIED ARTIST
Skull, nineteenth or twentieth century
carved and painted wood
8⅞ x 5⅜ x 6½ in.
acquired from Aarne Anton, American
Primitive Art, New York, early 1980s
1986.65.326

Symbols of death and eternal life are com-
monly associated with Freemasonry and
other fraternal organizations. Starkly dra-
matic images, such as skulls and skeletons,
represent the symbolic rebirth of the new
member within the order and act as re-
minders of death and mortality. This
gape-featured skull may have hung in a
York Rite Masonic Temple. (ETH)

Cat. 136

Cat. 137

Cat. 138

Cat. 137
UNIDENTIFIED ARTIST
Portrait of an Odd Fellow, ca. 1850
watercolor and gouache on wove paper
11¼ x 7¾ in.
acquired from James Abbe, Oyster Bay,
New York, 1970
1986.65.214

The Independent Order of Odd Fellows,
a fraternal organization that originated in
England, established its first American
lodge in Baltimore, Maryland, in 1819. As
in Freemasonry, the Odd Fellows use rit-
uals and symbols to teach moral lessons to
their members. This portrait is a rare ex-
ample of an Odd Fellow wearing his re-
galia. The heart in the hand, which ap-
pears in the upper right of the sash, is a
standard Odd Fellow symbol, designed to
remind its members to act with mercy and
benevolence toward their fellow man, and

to do so cheerfully. The blue sash identi-
fies this man as a Vice Grand Station in
the lodge, an office second in command to
the Noble First, the officer in charge of
the lodge. By the late nineteenth century,
members of the Independent Order of
Odd Fellows no longer wore sashes or
aprons like those pictured here. (ETH)

Cat. 138
UNIDENTIFIED ARTIST
Odd Fellows Shelf and Mirror, ca. 1850–
1900
carved and repainted wood with mirrored
glass
35⅜ x 29⅞ x 7⅜ in.
acquired from unidentified dealer, location
and date unknown
1986.65.84

Freemasonry and Odd Fellowship, more
than any other orders, inspired the prac-
tice of decorating personal objects with
fraternal symbolism. Such objects pro-
vided reminders of the rights and respon-
sibilities associated with membership in
the order. This custom-made shelf is re-
plete with Odd Fellow symbols. The three
pillars and the chain of three links repre-
sent the motto of the Odd Fellows—
friendship, love, and truth. Other sym-

bols, such as the serpent, the horn, the staff, and the tent on the pillar, are secret symbols of the Odd Fellows.

With its mirror, drawer, and towel rack, the shelf suggests function rather than ritual, but its original context is unknown. The shelf may have hung in a member's home or in a lodge that commissioned custom-made furniture. Prior to Hemphill's acquisition, the shelf was repainted; its original color is unknown. (ETH)

Cat. 139 and Cat. 140
Manufactured by HENDERSON-AMES COMPANY, Kalamazoo, Michigan
Odd Fellows Initiation Banner, ca. 1908
Odd Fellows Third Degree Banner, ca. 1908
painted and embroidered satin with cotton backing and metallic fringe and tassles
31 x 25½ in. (each)
acquired from unidentified shop near Jamestown, New York, 1975
1986.65.353 and 354

By the mid nineteenth century, much of the standardized regalia used by various fraternal organizations could be obtained through large mail-order companies. These banners, manufactured by the Henderson-Ames Company of Kalamazoo, Michigan, were sold in its 1908 catalogue as part of a set of four for $18.30. The banners were used as visual aids in the third-degree ceremony of the Odd Fellow Order to remind members of the degrees that had come before.

The pink banner represents initiation (cat. 139); white, the first degree; blue, the second degree; and red, the third and highest order (cat. 140). The bundle of sticks on the pink initiation banner represents the strength of united effort over the actions of the individual. The bow and arrows symbolize the friendship between David, the king of Israel, and Jonathan, the son of Saul, and are to remind the Odd Fellow to help a brother in trouble. Depicted on the red banner are more Odd Fellow symbols: the Bible (the Order's textbook), a sword and scale representing the importance of justice, an hourglass denoting the brevity of life, and a coffin suggesting mortality. (ETH)

Cat. 141
UNIDENTIFIED ARTIST ("A. G.")
NATIONAL-MILITARY-HOME-OHIO,
ca. 1900
carved and painted wood, glass beads, and brass tacks
11¾ x 6½ x 6⅞ in.
acquired from Joel and Kate Kopp, American Hurrah, New York, before 1982
1986.65.336

This sculpture, once thought to be a fraternal object, cannot be readily associated with any known organization. Its references appear to be elsewhere. The Veterans Administration Domiciliary in Dayton, Ohio, is one of three original National Soldiers Homes authorized by Congress in 1867. The Home was first called the "National Military Asylum for the Relief of the Totally Disabled Officers and Men of the Volunteer Forces." The negative connotations of the term "asylum," soon brought a name change. Called the National Home for Disabled Soldiers in 1873, it thereafter became known as the National Military Home. This is probably the reference intended by the phrase incised on the base of the carving. Between 1880 and 1900, the facility housed anywhere from six to eight thousand residents, who were supplied with materials for a wide variety of activities, including painting and carving. (One resident even built a steam engine.) The home was also a tourist attraction, with a deer park, monkey house, alligator pond, and an amusement park across the street—an ambience that may be reflected in this enigmatic sculpture. (ETH)

Cat. 139

Cat. 140

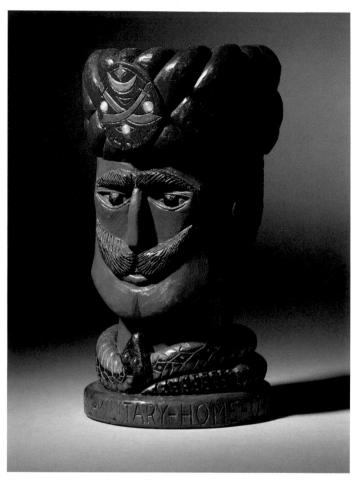

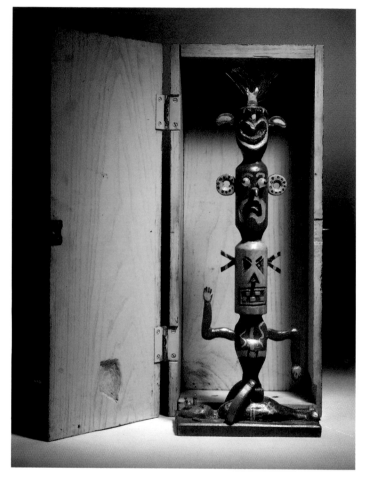

Cat. 141

Cat. 142

Cat. 142

UNIDENTIFIED ARTIST

Boxed Totem, twentieth century
carved and painted wood, glass, and bristle in painted wood box
21 x 8⅝ x 5⅝ in.
provenance unknown; acquired ca.
1980–86
1986.65.315

Most objects associated with or inspired by fraternal organizations follow a standard design or use recognizable symbols. Some, however, are completely whimsical and personal creations. This miniature totem has previously been attributed to the Improved Order of the Red Men. Established in 1834, the Order claims to be the oldest secret society of "pure" American origin. It bases its ceremonies on native American legends and terminology, but none of the organization's symbols are used in this quirky piece, which casts doubts on its origins as a fraternal object. (ETH)

Cat. 143

UNIDENTIFIED ARTIST
New England, possibly around New
Bedford, Massachusetts, or Staten Island,
New York
Mariner's Fancy, Celebra, late nineteenth
century
carved and painted wood, cloth, rope, and
metal in carved wood and glass case
32⅛ x 35¼ x 17⅝ in.
acquired from Allan Daniel, New York,
1972
1986.65.298

Known as a "grandfather model" or
"character piece," this composite work is
a miniature representation of an individu-
al's seafaring life over many decades rather
than a straightforward technical model.
Grandfather models were popular recrea-
tion at Snug Harbor, the turn-of-the-cen-
tury seaman's retirement home on Staten
Island. This particular vessel—a double
top-sailed bark similar to American whal-
ing ships after the Civil War—is of mid-
to late-nineteenth-century vintage. Histor-
ically, ship models were constructed as
votive offerings for successful voyages,
ceremonial processions, displays in profes-
sional guilds, and scale "builders' models"
for owners and shipwrights.

Mariner's Fancy, however, portrays
more of the seafarer's way of life in its
carved references to whaling, fishing, pir-
acy, and possibly military service. The
construction is a curious mixture of de-
tailed knowledge and incongruity. For ex-
ample, the *Celebra* is fully rigged, but the
sail reef points—details that would indi-
cate a knowledge of rigging—are incom-
plete. One of the small craft alongside the
bark carries harpooners, but the armament
of the larger vessel is appropriate to a
privateer or pirate ship; the figure bran-
dishing a sword at the stern is surely more
outlaw than commercial captain. The fan-
tastic sea creatures that lead the *Celebra*

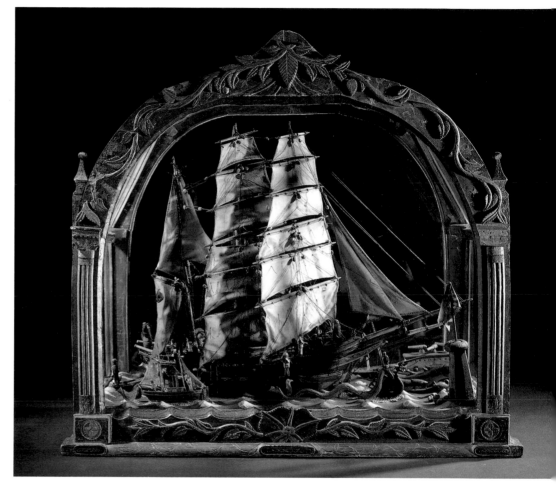

Cat. 143

are latter-day versions of the monsters
common to sixteenth-century European
cartography, depictions of whaling scenes,
and older biblical illustrations. (TLH)

Cat. 144
UNIDENTIFIED ARTIST
"A TOKEN OF LOVE" Puzzle Bottle,
ca. early twentieth century
carved and painted holly with metal foil in
glass bottle
8⅜ x 2 in. (diam.)
provenance and date of acquisition
unknown
pre-conservation photograph
1986.65.281

Cat. 145
CARL WARNER
life dates and place of activity unknown
*"FIND THE MISSING MAN
SALOON" Puzzle Bottle,* 1914
carved and painted wood and paper in
glass bottle
12¼ x 3⅝ in. (diam.)
acquired from unidentified dealer,
New York, mid 1960s
pre-conservation photograph
1986.65.343

Cat. 146
UNIDENTIFIED ARTIST
Puzzle Bottle, early twentieth century
carved wood in Rumford Baking Powder
glass bottle
3¼ x 1¾ in. (diam.)
provenance and date of acquisition un-
known
1986.65.280

Puzzle bottles—constructions meant to
demonstrate superior skill and clever-
ness—have been associated with seafarers
since the late eighteenth century. In many
cases, they may have been part of a local
shipboard economy or used as barter for
food and lodging in port towns in the
same manner as scrimshaw and other
nautical crafts. Striking combinations of
secular and religious motifs characterize
these puzzle bottles. Although puzzle
bottles were probably whimsical pieces,
the sculpted forms hint at a wide range of
experience and are symbolically more

complex than they first appear. For in-
stance, a bottle can juxtapose the romantic
sentiment of "A TOKEN OF LOVE"
and a pasted newsprint with the religious
inscription I.N.R.I. ("Jesus of Nazareth,
King of the Jews"—the traditional in-
scription on the Cross). In the Rumford
bottle, a popular carved combination of
woodworking tools (perhaps Masonic in
inspiration) is linked with one of the most
enigmatic of scrimshaw motifs, the disem-
bodied pointing hand. Carl Warner's im-
perative to "FIND THE MISSING
MAN" may in fact refer to the nefarious
crimping system—the cruel abduction of
unsuspecting deep-water seamen that often
was staged in portside towns. (TLH)

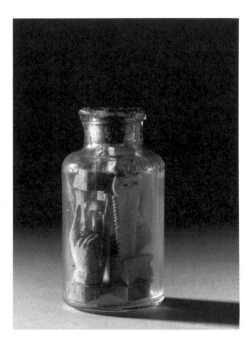

Cat. 146

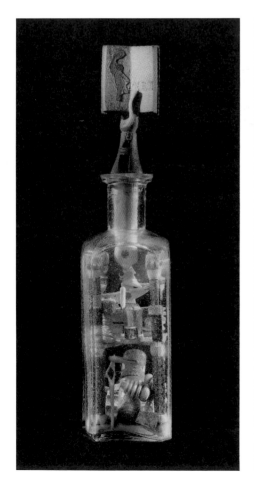

Cat. 144

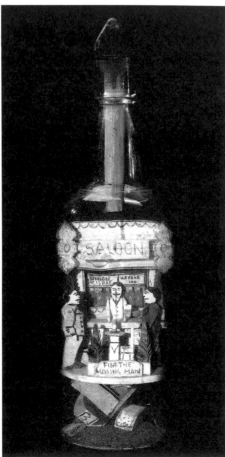

Cat. 145

Cat. 147

UNIDENTIFIED ARTIST

Sailor's Fancy Ropework, late nineteenth
to early twentieth century
cotton, wool, wood, and carved bone
42½ x 3¼ x 2 in.
provenance unknown; probably acquired
in the 1960s
1986.65.352

Sailors were famous for their ropework,
both utilitarian and fancy, since skills at
weaving, splicing, knotting, and rethread-
ing rope were a necessity at sea. The fancy
ropework shown here was knotted in the
same manner as a ditty bag lanyard, the
carrying strap for a sailor's gear bag. Ditty
bag lanyards were strictly personal items;
as individual decoration, the complicated
and elaborate knot-tying reflected the sta-
tus of its maker as a seaman. In this case,
the lanyard style appears to have been
adapted for ornamental purposes, possibly
for sale, since less delicate shipboard rope-

work was usually tarred or painted for
protection against the elements. Deep-
water mariners, especially whalemen, were
more likely to be accomplished at fancy
ropework since coastal crews rarely had
the time for such intricate handi-
work. (TLH)

Cat. 148

UNIDENTIFIED ARTIST

Portrait of the Thomas W. Lawson, after
1906
collage, sand, and oil on academy board
24 x 31⅞ in.
acquired from an unidentified junk store,
Staten Island, early 1960s
1986.65.154

The nostalgic and expressionistic painting
of the *Thomas W. Lawson* is heir to a
tradition of ship portraiture, particularly
the American zeal for illustrating clipper

ships at full sail. Despite the arrival of the
age of steam, in 1902 the *Lawson*'s Amer-
ican designers proposed a creative advance
in sailing ships—the experimental seventh
mast. Believing that bulk cargoes would
be cheaper to transport via sail than by
steam, the *Lawson* was designed with a
full suit of twenty-five sails to carry do-
mestic cargo along the coastline. The ves-
sel proved unmaneuverable in local ports,
and was converted to a trans-Atlantic
freighter. On a coal voyage to England in
1907, the Lawson was lost in back-to-
back hurricanes in the Scilly Isles. Despite
its short-lived career, this singular seven-
masted schooner generated tremendous
publicity in the American press, inspiring
countless popular prints and illustra-
tions. (TLH)

Cat. 148

Cat. 147

Cat. 149
UNIDENTIFIED ARTIST
New England
Painted Swordfish Bill, ca. 1920s
painted bone, carved and stained wood
inlaid with plastic
7⅛ x 43⅝ x 1½ in.
acquired from unidentified dealer, Chadds
Ford, Pennsylvania, early 1970s
1986.65.328

For a nineteenth-century mariner, the
long slender bones of swordfish bills were
ideal for the type of scrimshaw carving
typically seen on whalebone or ivory
tusks. The swordlike forms or "broad
bills," dating to the 1850s, differed little
in their subject matter or execution from
other narrative or picturesque scrimshaw.
Painted bills are a later adaptation; the
painted coastal scene with depictions of
small powerboats dates this work to the
1920s. Unlike the much simpler early
bills, the elaborate swords with curved
hilts were probably crafted for commercial
purposes such as trophies or tourist
souvenirs. (TLH)

Cat. 149

Cat. 150

UNIDENTIFIED ARTIST

"Cigar Box" Pin Cushion, ca. 1880–1920
carved, stained, and varnished wood with
glass beads and velvet
12⅛ x 10 x 10 in.
acquired from Jeffrey Camp, Richmond,
Virginia, ca. 1973
1986.65.92

Cat. 151

UNIDENTIFIED ARTIST

"Cigar Box" Crucifix, ca. 1880–1920
carved and varnished wood with ivory
figure and porcelain knobs
20½ x 10⅝ x 3¾ in.
acquired from unidentified dealer, upstate
New York, 1985
1986.65.91

Cat. 152

UNIDENTIFIED ARTIST

"Cigar Box" Chest (Comb Box?), ca.
1880–1920
carved, varnished, and painted wood
19 x 12⅞ x 6⅜ in.
provenance and date of acquisition un-
known
1986.65.90

Conventionally known as "tramp" art in
the folk art market, these wooden cigar
box objects illustrate a craft phenomenon
that flourished between 1870 and 1920.
The distinguishing feature of tramp ob-
jects is their chip-carved, layered-wood
construction with a stained or varnished
finish; the bright colors of this cigar box
pin cushion are unusual. Although chip or
"Frisian" carving appears in many cul-
tures, it has dominated centuries of Ger-
manic and Scandinavian woodworking
styles. "Tramp" works—combs or orna-
mental trinket chests, cabinets, hanging
shelves, sewing boxes and cushions, pic-
ture frames, home altars, crucifixes, match
holders, and doll furniture—may have

Cat. 150

Cat. 151

been produced for sale, but it is far more likely that they were produced for personal or family use.

The romantic notion of the hobo whittling to earn a meal is largely inaccurate; nevertheless, referring to these works as "tramp" art can shed some light on their makers. The idea of "trampen" signifies a stage in craft apprenticeship that dates to the Middle Ages: the itinerant years of journeymen perfecting their trade. In the late nineteenth century, this European practice extended to skilled American craftsmen: printers, carpenters, hatters, and cigar makers, who had the most immediate access to the raw materials used in tramp objects.

Records of the cigarmaking trade before the consolidation of labor into large factories reveal significant features coinciding with the golden age of tramp art, situating the anonymous carvers within a historic community of craft tradition. Germans and Bohemians dominated the cigarmaking craft guilds until the 1870s or so; even then, European immigrants commanded the largest share of the employment pool. More importantly, the mobility of cigarmakers across the United States was so great that they referred to themselves as the "traveling fraternity," and often had special rail travel privileges. (TLH)

Cat. 152

Cat. 153
Manufactured by C. F. DARE
COMPANY
Brooklyn, New York
Head from a Ball Toss Game, after 1878
carved and painted wood
11½ x 6⅞ x 8⅛ in.
acquired by trade from Frederick Fried,
New York, 1967
1986.65.301

In 1897, entrepreneur George Tilyou, in-
spired by the phenomenal financial success
of the sideshows, concessions, and amuse-
ment booths at the 1893 Columbian Ex-
position in Chicago, opened Coney Is-
land's Steeplechase Park. A grotesquely
grinning "Funny Face" became the logo
of Steeplechase Park, nicknamed by Til-
you as the "Funny Place." Ironically, the
Head from a Ball Toss Game mirrors this
image of irreverent hilarity even as it re-
veals contemporary racial and ethnic ten-
sions. As early as 1878, the C. F. Dare
Company of Brooklyn sold props for a
game of skill known as "African Dodger,"
"Hit the Coon," or "African Dip." Orig-
inally, players threw small balls at a black
man whose head protruded from a hole in
a hoisted canvas that depicted a planta-
tion, and won prizes for direct hits. The
game was altered somewhat when wooden
heads replaced the often scarce live tar-
gets. Clay pipes were inserted on either
side of the mouth of the wooden heads;
an operator behind the canvas manipulated
the heads from side to side. Other games
popular at this time ridiculed Irish and
Jewish immigrants. Legally prohibited in
some areas, *Head from a Ball Toss Game*
was used until the 1930s at Steeplechase
Park. (TLH)

Cat. 153

Cat. 154

Cat. 154

UNIDENTIFIED ARTIST
*HEREIN LIES WHAT THE MOUN-
TAIN-LIONS LEFT OF MUCHA-
BONGO. GONE TO THE HAPPY
HUNTING GROUNDS, WHERE
GAME IS EVER PLENTIFUL, AND
THE WHITE MAN NEVER IN-
TRUDES,* early twentieth century
carved and painted wood and plaster, syn-
thetic fiber and buttons, wool, cotton,
feathers, and shell
9¾ x 17¾ x 11¾ in.
acquired from Rebecca Hahn Antiques,
Mentor-On-The-Lake, Ohio, before 1981
1986.65.313

Consisting of skeletons, preserved body
parts, and waxworks executed with pain-
staking detail, European traveling anatomy
museums were a fixture of the mid to late
nineteenth century. Certain that the dis-
plays would be profitable, Samuel Gum-
pertz purchased P. T. Barnum's waxwork
holdings and introduced them to Coney
Island in his Eden Musée. A tableau of
pioneers burning at the stake in an Indian
raid was prominently featured. Native
Americans were also the victims of disas-
ter, as seen in the exhibit, *HEREIN LIES
WHAT THE MOUNTAIN-LIONS
LEFT OF MUCHABONGO.* Since wax-
work models were cheaper than live sub-
jects, and could be transported more
easily than other displays, they were often
the major constituents of carnivals and the
short-lived, often transient dime mu-
seums, common between 1890 and 1920.
The "remains" of the oddly named
Muchabongo—the encased Native Ameri-
can—represent both a fascination with
"exotic" populations and a macabre inter-
est in scenes of horror and disaster that
characterized the most popular (and typi-
cally fraudulent) attractions. (TLH)

Cat. 155

UNIDENTIFIED ARTIST
ELETRICAL TATTOOING, ca. 1920s
to 1930s
painted wood box with "Professor"
Charles Wagner tattoo needles; empty hy-
drogen peroxide bottle, and bottle of tat-
tooing ink
20⅞ x 14⅜ x 7 in.
acquired from unidentified dealer, New
Jersey shore, 1973
1986.65.379

Tattoo art was itinerant for most of its
early history in America. Artists often fol-
lowed the fleets from port to port along
the Eastern seaboard. Some tattooists even
worked on battlefields, accounting for the
early prevalence of military and patriotic
imagery such as the stenciled designs
painted on the *ELETRICAL TATTOO-
ING* box. With the 1891 patent of Samuel
Reilly's electric tattoo machine, shops be-
gan to proliferate in the Chatham Square
(now the Bowery) section of New York

City. Electrical tattooing was still a porta-
ble craft, as seen in this work, but it was
far less painful and time consuming than
earlier methods. This coincided with its
new-found appeal among the middle class
then emulating European aristocrats and
popular heroes who favored tattoos. In
1904 a Reilly apprentice, "Professor"
Charles Wagner, patented an improved
electric tattooing needle that became the
standard implement for tattoo artists of
the period. (TLH)

Cat. 155

Cat. 156
JOE CLINGAN
life dates and place of activity unknown;
possibly New York or the New Jersey
shore
*JOE CLINGAN. TATTOOING
ARTIST,* ca. 1920s to 1930s
pen and ink and ink wash on paperboard
14⅛ x 10⅝ in.
acquired from unidentified dealer, New
Jersey, before 1971
1986.65.68

Although nothing is known of tattoo art-
ist Joe Clingan, his "flash" is probably
contemporary with the work of the more
famous practitioners, Charles Wagner of
New York City, and his colleague, Louis
Alberts of New Jersey. Wagner, whose
legendary skill prompted the nickname,
"Professor," did not use stencils but
worked freehand. This innovation un-
doubtedly influenced Alberts, who pi-
oneered the use of the "flash," a sheet of
personal designs used for advertisement.
By the 1930s, the catalogue of designs of
"Lew-the-Jew," as he signed his work,
was the most widely used on the eastern
seaboard. Similar to carnival banners,
flashes such as *JOE CLINGAN. TAT-
TOOING ARTIST* were made to be hung
at sideshows, barbershops, or wherever
business could be found. (TLH)

Cat. 157
"TATTOO JACK" CRIPE (of Sigler and Sons Art Service)
life dates and birthplace unknown; active
Tampa, Florida
TATTOO ARTIST IN PERSON, ca. late
1940s to early 1950s
casein on sailcloth, leather, and iron rings
144 x 120 in.
acquired from unidentified dealer at
Renninger's Fleamarket, Adamstown,
Pennsylvania, 1971
1986.65.157

"Tattoo Jack" Cripe's canvas is typical of
several generations of banner paintings
that lined carnival midways to advertise,
or "hawk," sideshow acts and exhibitions.
Called "valentines" during their heyday at
Coney Island in the early 1900s, banner
paintings were graphic shorthand, vividly
executed to capture the attention of the
consuming public. With the proliferation
of traveling carnivals, banner paintings
were in great demand. When the shows
changed or moved, the banners were
taken down and rolled up for storage,
making them very practical advertise-
ments. Heir to the Coney Island banners
with their flashy colors, provocative illus-
tration, and plain script lines, the *TAT-
TOO ARTIST* was, in fact, a self-portrait
of Cripe, the tattooist "in person" behind
the large banner of the William Chalkas
Gold Medal Sideshow of Tampa, Florida.
Cripe worked with famous banner paint-
ers such as Bobby Wicks (also a tattoo
artist) and Snap Wyatt. Cripe went into
business with Sigler and Sons Art Service,
banner painters in Tampa, and was no
longer working the carnival circuit by the
early 1950s. (TLH)

Cat. 156

Cat. 157

INDIVIDUAL PATHS

Artists on Paper

Cat. 158
Attributed to LAWRENCE W.
LADD, or the UTICA MASTER
life dates and birthplace unknown; active
1865–1895 Utica, New York
Fire in an Opera House, 1865–95
pen and ink, watercolor, and gouache on
paper
17¾ x 28⅝ in.
provenance unknown; acquired before
1982
1986.65.177

This panel is taken from one of three pic-
torial panoramas thought to have been
done by Lawrence Ladd, also known as
the Utica Master. Panoramas were pic-
tures of exotic or exciting images, gener-
ally strung together as one long, continu-
ous scene, and were popular entertainment
during the nineteenth century. Ladd's
panorama is unusual in two respects.
First, it consists of individual scenes rather
than a continuous narrative. And sec-
ondly, the work is also in remarkably
good condition, suggesting that it was
rarely, if ever, exhibited. Most panoramas
have not survived, as they simply wore
out after being rolled and unrolled many
times. In his panoramas, Ladd drew upon
a wide range of sources for his diverse
images, including illustrated histories of
the United States, advertisements, Currier
and Ives prints, illustrated Bibles, periodi-
cals, and travel books. *Fire in an Opera
House* was part of the largest of the three
panoramas, thought to have been about
two hundred feet long. Two possible
sources of inspiration for this scene were

Cat. 158

the 1849 fire at the Astor Place Opera
House in New York, and that at the New
York Academy of Music in 1866.[1] (ETH)

[1]Paul D. Schweizer, *Panoramas for the People*
(Utica, N.Y.: Munson-William-Proctor
Institute, 1984), 54.

Cat. 159
J. C. HUNTINGTON
life dates and birthplace unknown; active
Sunbury, Pennsylvania?
Farm Scene, early twentieth century
lacquer or enamel paint (possibly model
paint) on wove paper
19⅝ x 42½ in.
acquired from Sterling Strauser, East
Stroudsburg, Pennsylvania, 1971
1986.65.173

Purportedly a retired railroad worker,
J. C. Huntington used his daughter as the
model for the children in his works. The

machine pictured here is not connected
with the railroads; it is a steam traction
engine used for many different purposes
on a farm. The name "frick" is written
just behind the machine's smokestack—an
apparent reference to the Frick steam
traction engines that were built in
Waynesboro, Pennsylvania, from 1880 to
1936. Though certainly recognizable, nei-
ther the machine nor the water pump is
precisely drawn. (ETH)

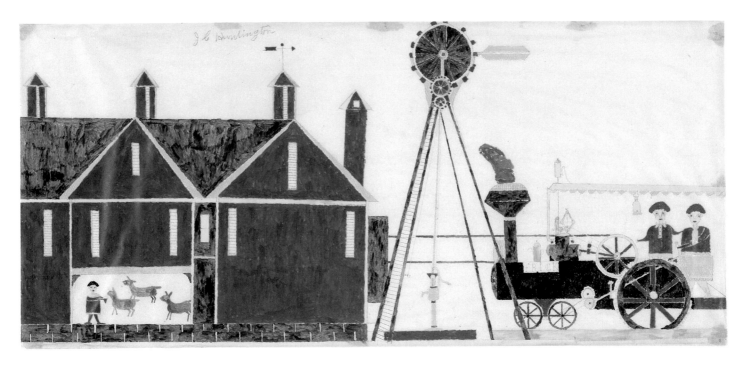

Cat. 159

Cat. 160
JOHN MOLL
life dates and place of activity unknown
Untitled (*Women and Birds at Waterfall*),
1931
pen and ink, colored pen and ink, and
pencil on wove paper
20½ x 25⅛ in.
acquired from Dr. William Greenspon,
New York, after 1979
1986.65.185

Intricate linear patterns cover the entire
surface of Moll's drawing, the only
known example of his work. His method
suggests premeditation rather than spon-
taneity, since he carefully drew his design
in pencil before reinforcing it with the
more permanent medium of ink. Incon-
gruities of scale, especially that of the cen-
tral, larger-than-life eagle and the feath-
ered pattern shared by the birds and robed
woman, heighten the scene's ambiguous,
if not imaginary, quality. The border's
wave motif echoes the watery element
while its deliberate symmetry encloses the
rocky landscape, making the setting—
grotto, island, or river bank—
unclear. (LRH)

Cat. 160

Cat. 161
BILL TRAYLOR
born 1855, near Benton, Alabama–died
1947, Montgomery, Alabama; active
Montgomery
Dancing Man, Woman, and Dog, ca.
1939–42
crayon and pencil on paperboard
22 x 14 in.
acquired from Luise Ross Gallery, New
York, 1982
1986.65.199

From 1939 to 1942, Bill Traylor recorded
the life around him with uncanny artistry.
A former slave and field hand, Traylor
came to work in Montgomery when he
was eighty-four, but circumstances soon
left him penniless. In 1939, Traylor began
to draw on discarded laundry cardboard,
aided by a measuring stick, while he sat in
front of the local pool hall observing
Montgomery's Monroe Street market.

Cast in powerful spatial arrangements,
Traylor's pictographic forms bear witness
to vestiges of the South's agrarian lifestyle.
Forceful, enigmatic, and fanciful, his im-
ages depict a former life as well as the new
characters in his daily environment. In
many cases, as with *Dancing Man,
Woman, and Dog,* an implicit intimacy
between people and animals characterizes
their pictorial relationship, reminiscent of
Traylor's years in the fields.

Traylor sold some of his drawings on
the street, attracting customers by hanging
the drawings behind his working space.
Most of his works, however, were saved
by Charles Shannon, a young painter who
had encouraged Traylor in his earliest ef-
forts. In 1940, Shannon arranged a one-
man show of Traylor's work at New
South, a local contemporary art center.
After an exhibition in New York in 1941,
Traylor's remarkable drawings were not
seen again until a show in 1979 at R. H.
Oosterom Gallery, also in New
York. (TLH)

Cat. 161

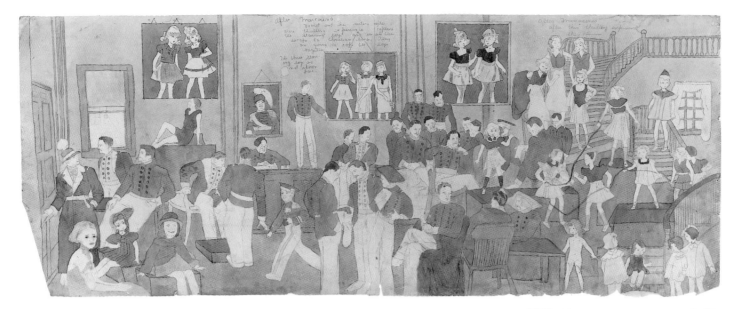

Cat. 162 front (*top photograph*) and back (*bottom photograph*)

Cat. 162
HENRY DARGER
born 1892, birthplace unknown–died
1973, Chicago; active Chicago after 1909
After Marcocino (front) and *At Jullio Cal-
leo* (back), after 1934
watercolor, carbon tracing, and pencil on
joined papers
19 x 47⅜ in.
acquired from Phyllis Kind Gallery, Chi-
cago, after 1973
1986.65.168 a and b

Henry Darger's visionary ambitions belie
the humble circumstances of his reclusive
life, spent primarily in a rented room.
Around 1909, he began writing an apoca-
lyptic epic, *The Story of the Vivian Girls,
in what is Known as the Realms of the
Unreal, of the Glandeco-Angelinian War
Storm, Caused by the Child Slave Rebel-
lion*. More than a decade later, Darger
completed nineteen thousand pages, orga-
nized in twelve volumes. Subsequently, he
executed approximately two hundred and
fifty large, horizontal drawings to illus-
trate events and characters in his complex
narrative. His elaborate, radiant drawings
appear to have occupied him until the late

1960s. Only after Darger's death was his
obsessive project discovered by his land-
lord, photographer Nathan Lerner.

Modeled after children's adventure sto-
ries and military accounts, *The Story of
the Vivian Girls . . .* chronicles the conflict
between two imaginary nations on an uni-
dentified planet. The heroines are the Vi-
vian girls, seven princesses, whose even-
tual victory symbolized the triumph of
good over evil to the devoutly Catholic
Darger. This double-sided drawing illus-
trates the aftermath of two battles from
which the protagonists have escaped. Typ-
ically, the incidents are not sequential
since economic necessity rather than nar-

rative intent dictated Darger's use of both sides of the paper. *After Marcocino* depicts a room where the Vivian girls prepare rope for their prisoners, the Starring Brothers, who are not shown here, according to Darger's annotation. Androgynous children are "desperately persued" in *At Jullio Calleo* because they have stolen the enemy's plans. Only the running formation of the figures suggests agitation in this deceptively calm landscape.

An uncomfortable draftsman, Darger traced his figures from children's books, newspapers, and magazines scavenged from the streets of Chicago. Near the center of the crowd in *After Marcocino,* for example, strides "Johnny," the bellboy featured in the advertisements of Philip Morris, Inc., between 1934 and the mid 1950s. (LRH)

Cat. 163

Cat. 163
JOSEPH E. YOAKUM
born 1886, Window Rock, Arizona–died 1972, Chicago; active Chicago
Imperial Valley in Imperial County Near Karboul Mounds California, 1966
colored pencil and ballpoint pen on wove paper
11⅞ x 17⅞ in.
acquired from Edward Sherbeyn Gallery, Chicago, 1970
1986.65.223

Yoakum began drawing in the early 1960s. Most of his work consists of radiantly colored landscapes with mountains, water, trees, and winding roads in abstract and complex configurations. *Imperial Valley* derives from his period of greatest activity—1965 to 1970—when he usually made one drawing a day.

Yoakum maintained he had seen all the places represented in his drawings, a statement that may not be true in some instances. He traveled a great deal, beginning in his early teens when he ran away from home and became a circus handyman. Yoakum's drawings can be considered memory images growing out of either

Cat. 164

actual or imagined experiences. All of his drawings have titles that grew longer and more specific over the years. He dated his works with a rubber stamp—an oddly impersonal, labor-saving device. (ETH)

Cat. 164
EDDIE ARNING
born 1898, Germania, Texas; active 1964–
1974, Austin County, Texas
Interior with Figures, 1969
crayon on wove paper
22 x 28⅛ in.
acquired from Alexander Sackton, Austin,
Texas, 1972
1986.65.164

Arning, like many self-taught artists, used
magazine advertisements and illustrations
as models or inspiration for his work.
Nonetheless his work is highly individual;
the link with the original source is often
difficult to discern. Although most of the
print sources for Arning's drawings have
been saved, the specific inspiration for
Interior with Figures is unknown.

Institutionalized for most of his adult
life, Arning was introduced to drawing in
1964 by a hospital worker who supplied
him with materials. Arning's medium
from 1964 to 1969 was Crayolas. In 1969,
he switched to oil pastels, or "Cray-pas."
Regardless of his media, Arning always
worked in the same manner, covering the
entire surface of the paper with dense
strokes of color. He stopped drawing in
1974, a year after leaving his nursing
home. (ETH)

Cat. 165
INEZ NATHANIEL-WALKER
born 1911, Sumter, South Carolina;
whereabouts unknown
Double Portrait, 1977
felt-tipped pen and ink, crayon, and pen-
cil on paperboard
28 x 22 in.
probably acquired from Webb-Parsons
Gallery, Bedford Village, New York, ca.
1977
1986.65.188

Inez Nathaniel went north to Philadelphia
during the "Great Migration" of the 1930s
to escape the harsh realities of farm work
in the rural South. Convicted of the man-

slaughter of an abusive male acquaintance,
she served time in the Bedford Hills, New
York, Correctional Facility from 1971 to
1972, where she began to draw to isolate
herself from the "bad girls" in the facility.
When she remarried in 1975, she took her
new husband's name, Walker. Walker's
drawings are almost exclusively single or
paired portraits of females. In most of her
works, the heads are drawn much larger
and more expressively than the rest of the
figures and dominate the composition.
Though Walker never felt she was able to
capture a likeness, and she relied on her
imagination to develop the faces, she cre-
ated clearly recognizable characters. Some,
like this red-faced woman and her drink-
ing companion, recur frequently. Ele-
ments of self-portraiture are also evident
in her figures, many of whom wear cloth-
ing, especially hats, based on the artist's
own. (ALC)

Cat. 165

Cat. 166

Attributed to THOMAS CHAMBERS
born 1807–08, England–died after 1865,
possibly New York City; active New
York 1834–40, Boston 1843–51, Albany
1851–57, New York City 1858–?
Landscape, mid nineteenth century
oil on canvas
14 x 18 in.
acquired from Martin Grossman,
New York, 1962
1986.65.106

Since the 1940s, Thomas Chambers has
been a publicly recognized artist, known
primarily for his marine paintings and
scenes of the Hudson River Valley. This
mountainous view, however, does not de-
pict that area and is perhaps taken from a
print of European origin. Although some
of his work is known to be based on
prints by W. H. Bartlett and others,
Chambers's compositions are not imita-
tions. His work is highly individual and
imaginative—characterized by areas of
bright, flat color, large generalized forms,
and sharp contrasts between light and
dark areas. (ETH)

Cat. 167

UNIDENTIFIED ARTIST
Stag at Echo Rock, late nineteenth century
oil on canvas
36 x 29 in.
acquired from Martin Grossman,
New York, early 1960s
1986.65.117

A carefully detailed, close-knit composi-
tion characterizes this scene of a stag en-
countered in a wintry landscape. At the
lower right, the heads of a pair of horses
are visible, suggesting someone's imminent
arrival. The stag's static yet powerful im-

Cat. 166

age measures the disparate scale of other
elements, such as the horses and trees.
Along the snowy road the landscape's ele-
ments are stacked in zones, while the
fence and tufts of grass marking the bend
literally turn sideways, hints of the artist's
attempts to deal with spatial relationships.
Stylistic comparisons do not substantiate
previous attributions to M. A. Hall.
Found in New Jersey, the painting is in-
scribed "Echo Rock," which suggests a
specific site. However, no town or geo-
logical formation bearing that name in
New Jersey has been located. Nor does
evidence support earlier descriptions of
the painting as a "puzzle picture," a de-
sign incorporating hidden elements. Al-
though some details are too small and
others are too difficult to read, such in-
congruities reflect an honest attempt to

project an idea onto canvas, rather than a
deliberate effort to encode the work with
concealed elements. (LRH)

Cat. 167

Cat. 168

EDMUND YOUNGBAUER

life dates and place of activity unknown
DIE JAGD NACH DEM GLÜCK
(Chasing After Happiness), late nineteenth
century
oil on canvas, mounted on fiberboard
20¼ x 28⅜ in.
acquired from unidentified source,
New York, ca. 1985
1986.65.158

A military man with a skeleton by his side
chases after an elusive nude woman carry-
ing a crown; she entices him forward by
trailing gold coins behind her. He seems
not to notice the figure lying beneath the
feet of his horse. It is not known whether
the source for this image is a print, a
legend, or simply the artist's imagination.
And, although the picture is signed, noth-
ing is known about the artist, who may
have been European. The message of the
work, however, is clear: the rider is will-
ing to trample anything that obstructs his
quest for wealth, carnal pleasure, fame,
and power—unaware that death follows
him closely. (ETH)

Cat. 169

PETER OLIVER FOSS

born 1865, Norway–died 1932, Randolph,
Massachusetts; active Randolph,
Massachusetts
Woman with Cockatoo, ca. 1895–1917
oil on canvas
28 x 24¼ in.
acquired from Sotheby Parke-Bernet,
New York, 1984
1986.65.112

According to his family history, Peter
Oliver Foss was a talented songwriter, in-
ventor, and painter.[1] Foss sought his early
fortune in the California gold mines after
immigrating from Norway in the 1880s.
Disappointed in this endeavor, he settled
in Massachusetts to work as a house
painter. *Woman with Cockatoo* is one of
approximately a dozen completed canvases
that were found in the family attic in
1982. Foss never sold his works and rarely
signed them.

Woman with Cockatoo may refer to a
religious narrative, since the majority of
Foss's extant paintings are of biblical sub-
jects such as Samson and Delilah and the

Beheading of John the Baptist. He may
have been inspired by old biblical illustra-
tions, particularly those continuing in the
style of fifteenth-century northern Euro-
pean altarpieces, which feature static com-
positions of monumental figures, richly
ornamented interiors, and, above all, a
blend of secular and religious elements
portrayed in the context of everyday
life. (TLH)

[1]See Foss research file at the Abby Aldrich
Rockefeller Folk Art Center, Williamsburg,
Virginia, for information compiled by William
T. Currier.

Cat. 168

Cat. 169

Cat. 170

Cat. 170

DANA SMITH

life dates unknown; active possibly in
Franklin, New Hampshire
Woman in Interior, ca. 1900
oil and lithographed paper on canvas
18⅛ x 26¼ in.
acquired from Robert Bishop, New York,
1962
1986.65.139

Very little is known about Dana Smith,
whose paintings were discovered by
Robert Bishop in a Germantown,
Pennsylvania, shop and in Franklin,
New Hampshire, during the early 1960s.
Based on his dozen or so extant works,
Smith favored a dramatic use of color and
mostly painted landscapes of small New
England towns in which railroads and
bridges are prominent features.[1] An excep-
tion, this figurative composition indicates
that Smith also experimented with collage,
since the work incorporates found mate-
rials. The woman's image consists of cut-
outs from printed sources, embellished
with paint, while background elements,
such as the chair, piano, and picture on
the wall, are all painted. Smith also at-
tached a thermometer to the canvas at the
lower left, and a knob, perhaps to facili-
tate lifting the picture in a hinged con-
struction. Now missing, these objects sug-
gest a complex but elusive scenario for the
provocatively dressed woman in a stage-
like interior. Although Smith usually did
not sign his works, tiny typeset letters
form his first name, DANA, in the lower
right corner. (LRH)

[1]Robert Bishop, interview with Lynda Roscoe
Hartigan, 27 January 1989.

Cat. 171

Cat. 171
MAX REYHER
born 1862, Germany–died, possibly 1945,
Belmar, New Jersey
NIRWANA, 1928
oil on wood
15⅜ x 19¾ in.
acquired from the artist's nephew, Ernst
Halberstadt, Cape Cod, Massachusetts,
1973
1986.65.136

An optician and naturalist in Philadelphia,
Max Reyher began to paint after he retired
to the New Jersey shore in 1919. Stories,
poetry, and legends usually inspired his
paintings. About his source for this work
he wrote: " . . . a Poem by Ernst Eck-
stein in the German language. The poem
is beautiful and deep. I received inspira-
tion from it to paint *Nirwana*. . . . The
Nirwana picture is freedom from all con-
dition of existence. Nirwana is the shore
of salvation for those who are in danger of
being drowned in life's confusion."[1] A
well-educated man, Reyher invented his
own process for mixing paint that he
called "life-everlasting paint." He painted
on wood only, and, once applied, the
paint took on an enamel-like quality. *Nir-
wana* was Reyher's first easel picture and
one of the smallest of his twenty or so
works. He made the frame for this piece,
as he did for all his works. (ETH)

[1]Sidney Janis, *They Taught Themselves:
American Painters of the Twentieth Century*
(New York: Dial Press, 1942), 152.

Cat. 172
JON SERL
born 1894, Oleans, New York; active
Lake Elsinore, California
2 Dogs—3 BANDSMEN: and camera,
June 1963
oil on fiberboard
69½ x 22 in.
acquired from Ethnographic Arts, Inc.,
New York, 1983–84
1986.65.138

According to Jon Serl, this painting began
one afternoon with the drawing of a
neighborhood boy who interrupted Serl's
painting.[1] Serl told the boy to retrieve a
piece of scrap board and work on his own
creation, instructing him to "put the head
all the way at the top and put the feet at
the bottom." When he saw the initial
drawing, Serl was inspired to work on it
himself, to "make it live." The result is a
composition characteristic of Serl's art that
interweaves daily realities with his pro-
foundly subjective view of contemporary
life.

 As a child, Serl performed in his fami-
ly's traveling vaudeville show, and this ex-
perience provided an essential element of
his mature painting style. When Serl be-
gan painting in earnest after World War
II, his earliest compositions were land-
scapes. By the mid to late 1950s, Serl's
vision had turned toward expressionistic
figurative studies that continue to com-
mand his attention. His portrayals of hu-
man interaction are usually stagelike,
achieving their mysterious qualities by a
masterful use of color. "You don't see my
paintings," Serl insists, "you feel
them." (TLH)

[1]Jon Serl, interview with Tonia L. Horton, 21
September 1989.

Cat. 172

Cat. 173

JACK SAVITSKY

born 1910, Silver Creek (now New Phila-
delphia), Pennsylvania; active Lansford,
Pennsylvania
Train in Coal Town, 1968
oil on masonite
31¼ x 47¾ in.
acquired from Sterling Strauser, East
Stroudsburg, Pennsylvania, 1972
1986.65.137

Jack Savitsky worked in Pennsylvania's
coal mines for almost forty years before
an accident forced him to retire in 1959.
His earliest paintings, other than some
sign painting and other commercial work,
were murals commissioned by a speak-
easy during the late 1920s and early 1930s.
When Savitsky could no longer work in
the mines, he returned to painting as a
hobby.

This painting depicts a coal-fired pas-
senger train bringing miners from Potts-
ville to the mines of Silver Creek. The
gray building housing the coal breaker and
a row of company-built employee houses
in the distance represent Silver Creek,
Savitsky's "Coal Town," where the artist
grew up and first worked the mines. The
lively border pattern is based on the
bright red Philadelphia and Reading Coal
and Iron Company-owned houses. Savit-
sky's father reared his family in a similar
house, where, Savitsky recalls, "We paid
seven dollars per month for a six-room
house . . . every one of them was the
same, all in rows, and you couldn't tell
them apart."[1] (ALC)

[1]Jack Savitsky, interview with Andrew Con-
nors, 15 November 1989.

Cat. 173

Cat. 174

Cat. 174

ALEXANDER ARAMBURO MALDONADO

born 1901, Mazatlan, Sinaloa, Mexico–died 1989, San Francisco, California; active San Francisco
SAN FRANCISCO TO NEW YORK IN ONE HOUR, May 22, 1969
oil on canvas and wood
21½ x 27½ in. (includes frame)
acquired from the artist, 1976
1986.65.126

In 1979, the artist's sister, Carmen, jokingly remarked in a letter to Herbert Waide Hemphill, Jr., that "I think we are ready to put Alex in a capsule and send him out of space."[1] The paintings of Alexander Maldonado—Mexican immigrant, former boxer, and retired shipyard worker—were first exhibited in 1973 at a gallery auction for KQED, the public television station in San Francisco. Beginning with his earliest paintings in 1961, Maldonado expressed his fantastic visions of a utopian future in his compositions of planets, space travel, and pollution-free cities. Although he referred to most of his visionary works as "21st Century Paintings," *SAN FRANCISCO TO NEW YORK IN ONE HOUR* was conceived as a "20th Century Painting"—a more contemporary possibility of a one-hour flight from coast to coast. The painted frame, which was decorated especially for Hemphill, seems to extend the artist's view, reaffirming Maldonado's desire to explore beyond the present. In fact, by the time this painting was complete he had already begun painting its sequel: the one-half hour flight for the next century. (TLH)

[1] Carmen Maldonado, letter to Herbert Waide Hemphill, Jr., 9 January 1979. Carmen frequently wrote to Hemphill, describing her brother's new works. The correspondence can be found in the Herbert Waide Hemphill, Jr., Papers, Archives of American Art, Smithsonian Institution, Washington, D.C.

Cat. 175

ANDREA BADAMI

born 1913, Omaha, Nebraska; active, 1966–1978, Omaha; 1979–present, Tucson, Arizona
St. Rosalia and the Hunter, 1970–73
oil on canvas
38⅞ x 58⅝ in.
acquired from Elias Getz, New York, 1973
1986.65.98

Although his talent was evident in childhood drawings, circumstances prevented Andrea Badami from pursuing his artistic inclinations until later in life.[1] When he was a child, Badami and his parents returned to their native Corleone, Sicily; as a young man, he was unwillingly conscripted into Mussolini's army despite his American citizenship and was taken prisoner by the British. Upon his release in 1947, Badami returned to the United States, and within two years was able to send for his wife and young daughter in Sicily. His need to support a growing family postponed an artistic career until the 1960s.

By the early 1970s, Badami's work had been recognized in shows at Creighton University in Omaha, and in an exhibition of contemporary primitive painters circulated by the American Federation of Arts. *St. Rosalia and the Hunter*, painted about this time, is a personal interpretation of the legendary twelfth-century hermit who lived in a cave on Monte Pellegrino. Rosalia later became known as the patron saint of Palermo, and her remains were enshrined in a small church on the mountain after she appeared to a plague victim during an epidemic in 1624. Religious shrines are common in Sicily's many grottoes; in this case, a hunter dressed in military garb has come upon Saint Rosalia at her devotion. A brilliantly colored work, Badami's narrative is a condensation of time and action, a contemporary vision of a medieval saint fusing the natural and spiritual worlds. (TLH)

[1] Gina Badami Parks, interview with Tonia L. Horton, July 1989.

Cat. 175

Cat. 176

Cat. 176

ALBINA KOSIEC FELSKI

born 1916, Fernie, British Columbia,
Canada; active Chicago
The Circus, 1971
acrylic on canvas
48 x 48¼ in.
acquired by trade from Clune Walsh, Jr.,
Detroit, Michigan, 1981
1986.65.108

Felski, who began painting in 1960,
wrote: "Im very busey [sic] around the
house and I work in a factory I paint in
fall, winter & spring time I enjoy sum-
mers the most."[1] In 1945 she came to
Chicago from Canada and worked for
twenty-seven years in an electronics fac-
tory, doing machine and assembly work.
Like *The Circus*, her paintings are usually
on four-by-four-foot canvases, and are
brightly colored and extremely detailed.
Though she has an easel, Felski prefers to
paint with her canvas spread flat on a
table. In this work, she includes virtually
every conceivable circus act, particularly
those involving animals. She was often in-
spired to paint animals—bears, deer,
mountain goats, etc.—from photographs
taken by her brothers in their native
British Columbia. (ETH)

[1]Albina Kosiec Felski, letter to Julia Weissman,
17 September 1972. Papers of Julia Weissman,
Jamaica, New York.

Cat. 177

GUSTAVE KLUMPP

born 1902, Black Forest Mountains,
Germany–died 1974, Brooklyn, New
York; to USA 1923
Wedding Dream in Nudist Colony, 1971
oil on canvas
24 x 30 in.
acquired from the artist, 1974
1986.65.122

In 1966, two years after his retirement as
a compositor and Linotype operator,
Klumpp visited Brooklyn's Red Hook

Senior Center seeking activities and com-
panionship to fill his days. The director
suggested that he join the art group and
try his hand at painting. His first work
was a portrait of Abraham Lincoln. His
next works were landscapes. Soon he be-
gan to develop his fantasies into paintings.
In 1972, bachelor Klumpp wrote, "My
philosophy of art painting which is ex-
pressed in the visualization of painting
beautiful girls in the nude or semi-nude
and in fictitious surroundings including
some other paintings of dream like na-
ture."[1] *Wedding Dream* expresses the ri-
baldry and humor Klumpp relied on for
inspiration. In the lower right, a woman,
perhaps Klumpp's alter ego, spreads her
brushes and palette on the grass and paints
a nude portrait. (ALC)

[1]"Abbreviated History of My Life," typed
manuscript written for Herbert Waide Hem-
phill, Jr., and Julia Weissman, February 1972.
Papers of Julia Weissman, Jamaica, New York.

Cat. 177

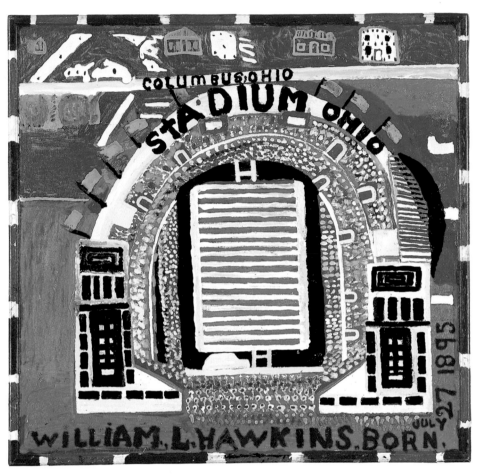

Cat. 178

Cat. 178
WILLIAM HAWKINS
born 1895, Madison County, Kentucky–
died 1990, Dayton, Ohio; active
Columbus, Ohio
Ohio State University Stadium, 1984
enamel housepaint on paneling with
painted wood frame
46½ x 48 in.
acquired from Ricco/Johnson Gallery,
New York, ca. 1984
1986.65.118

William Hawkins was raised on a farm in
Kentucky and learned to draw by copying
illustrations from horse-auction announce-
ments and calendar pictures. When he was
twenty-one, he moved to Columbus,
Ohio, where he painted the cityscapes and
fantastic animals for which he is best
known.

This image of the stadium at Ohio State
University is based on an aerial photo-
graph that Hawkins found in a history of
the city of Columbus. It is typical of his
use of photographs and illustrations for
inspiration. His buildings and other urban
views focus primarily on the city's local
structures, a sort of personal history book
of Columbus.

Hawkins painted his earliest large works
on scavenged board, such as this piece of
interior paneling, which he found on con-
struction sites near his home. The frames
are constructed of cast off pieces of wood
molding nailed directly to the painted
panel. In spite of his age, Hawkins re-
tained the vitality and enthusiasm of
youthful discovery, and said he drew "for
all the young people in the United
States."[1] As an affirmation of his spirit for
life, he signed many paintings with his
birthdate—July 27, 1895. (ALC)

[1]Gary J. Schwindler, "William L. Hawkins:
Myth in the Making?," *Dialogue* (July–August
1988): 13.

Cat. 179
BENNIAH G. LAYDEN
1875–1968; born, active, and died, York,
Pennsylvania
Accordion Player, ca. 1910
carved and painted wood and peach pits
30⅛ x 12 x 8 in.
acquired from unidentified dealer,
Baltimore, ca. 1971
1986.65.255

The whimsical *Accordion Player* is an
early example of Layden's skill as a wood-
carver. A lifelong Pennsylvania Railroad
employee, Layden began carving in 1905
after seeing a piece of wood inlay pro-
duced at a penitentiary. He relied heavily
on images seen in popular illustrations and
the Bible as the basis for his carved figures
and furniture. Layden was primarily
known for his masterful inlay work, once
fashioning a checkerboard game with al-
most twenty-two thousand pieces of
wood. Written in crayon on the base of
Accordion Player is the number "1190,"
denoting Layden's habit of recording the
number of wood pieces used to construct
his objects. The eccentric design of the
Accordion Player reflects a knowledge of
traditional chain carving, interlocking
wooden chains with caged balls whittled
from a single piece of wood. Although
Layden's many works were popular in his
community and at the York Interstate
Fairs, only one other work, now in the
collection of the Abby Aldrich Rockefeller
Folk Art Center, has been attributed to
him.[1] (TLH)

[1]Information on Layden courtesy of Abby
Aldrich Rockefeller Folk Art Center,
Williamsburg, Virginia.

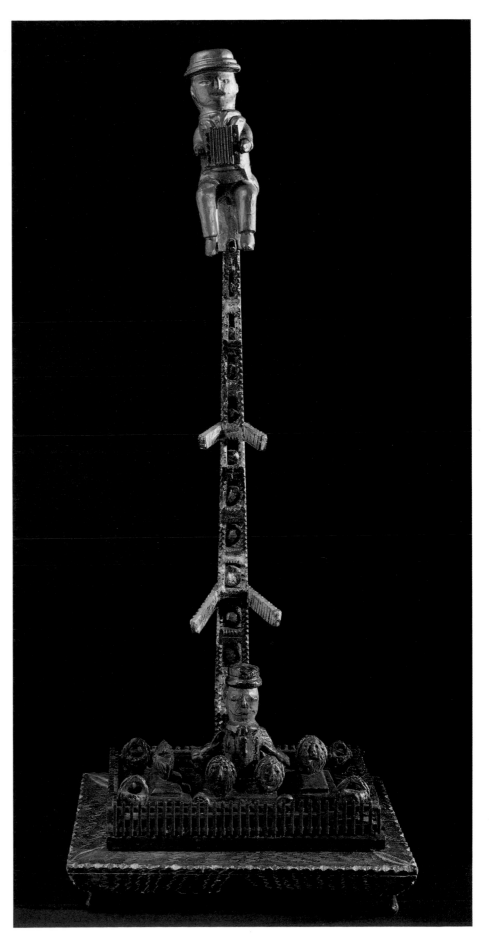

Cat. 179

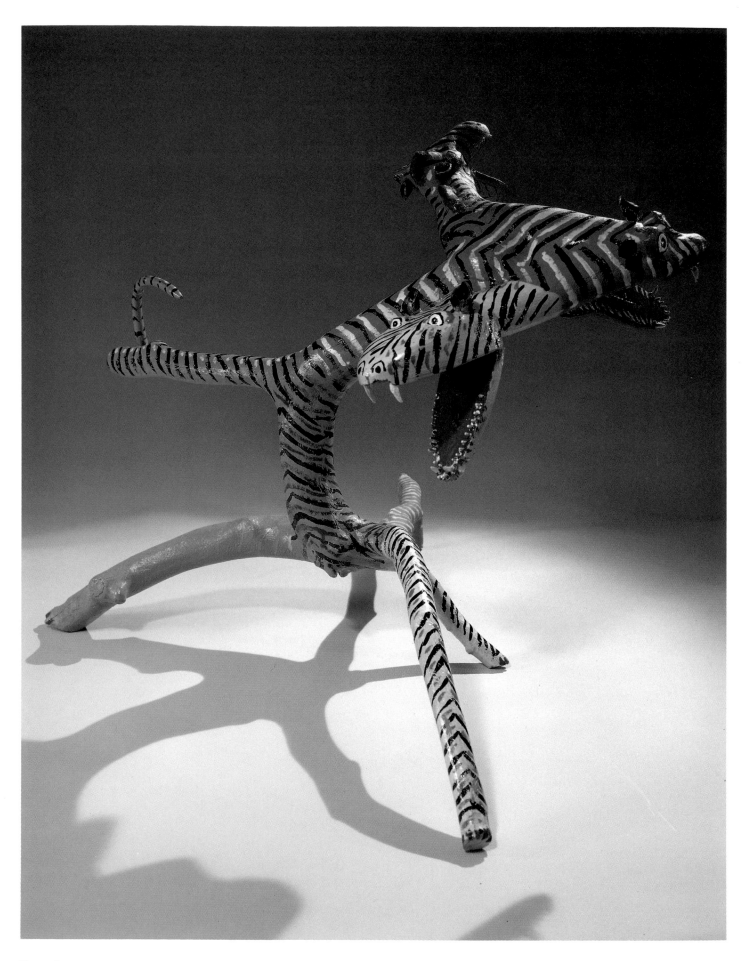

Cat. 180

Cat. 180

MILES BURKHOLDER CARPENTER

born 1889, near Brownstone,
Pennsylvania–died 1985, Waverly,
Virginia; active Waverly after 1941
Root Monster, 1968
carved and painted tree roots, rubber,
metal, and string
22⅝ x 28⅝ x 28¼ in.
acquired from Michael and Julie Hall,
Bloomfield Hills, Michigan, 1972
1986.65.238

"There's something in there, under the
surface of every piece of wood. You don't
need no design 'cause it's right there, you
just take the bark off and if you do it
good you can find something."[1] An expe-
rienced lumberman, Carpenter was accus-
tomed to dealing with wood's potential.
In the countryside around Waverly, Vir-
ginia, he collected fallen branches and ex-
posed roots and also cut trees into thick
planks as the raw materials for his carv-
ings (made primarily after 1966). Poplar is
indigenous to the area, and like many
carvers and furniture makers, Carpenter
found the wood's soft yet solid, rather
grainless qualities easy to work with. He
detected a dynamic creature in this strad-
dle-legged root, complete with its hint of
a tail. Snappily painted stripes, pert rub-
ber ears, and separately carved jaws and
teeth define Carpenter's insight. His sense
of humor animates many of his sculptures,
at times, literally. "Clackety-clack" go the
articulated jaws of this *Root Monster*
when someone manipulates the lengths of
string and rubber bands attached to its
three heads. Entertainment is humor's
companion, and Carpenter's carvings re-
veal his underlying urge to engage an au-
dience—sometimes directly, sometimes
metaphorically. (LRH)

[1]Carpenter quoted in "Fame Came Late in Life
for Waverly Folk Artist," *Richmond Times-
Dispatch*, 10 May 1982.

Cat. 181

SHIELDS LANDON ("S. L.") JONES

born 1901, Franklin County, Virginia;
active Hinton, West Virginia
*Country Band with Fiddler, Dobro Player,
and Banjoist*, 1975–76
carved, rouletted and painted hardwood,
pencil, felt-tipped pen, string, and metal
fiddler: 23¼ x 7⅞ x 7⅝ in.
dobro player: 25 x 7⅞ x 7⅜ in.
banjoist: 25¼ x 8½ x 8⅞ in.
acquired from the artist, 1975–76
1986.65.250, 1986.65.382, and
1986.65.383

"A person has to have some work to do,
so I carve some and play the fiddle."[1]
That's been S. L. Jones's philosophy since
1967 when he turned to his youthful
hobby of whittling after his first wife's
death and his retirement from forty-five
years with the Chesapeake and Ohio Rail-
road. Using his Bowie knife, Jones first
carved miniature figures and animals from
the local yellow poplar, walnut, and ma-
ple he gathered in the woods. Wood chis-
els proved more practical when he began
to carve life-size busts of people and heads
of animals from hardwood logs. Table-top
freestanding figures, singly or in groups,
began to appear in the mid 1970s. A simi-
lar evolution marks his surfaces—from
unpainted early carvings in the late 1960s
to the introduction of paint, stain, and
penciling around 1972. By the mid 1970s,
Jones used opaque paint to embellish his
sculptures.

Hemphill commissioned this country
band. It was an altogether fitting subject
for Jones, who has played the banjo and
fiddle since childhood. In fact, these stoic
musicians hold the instruments featured in
the prize-winning country band that Jones
organized as a young man. The contrast
between the untreated wood and the

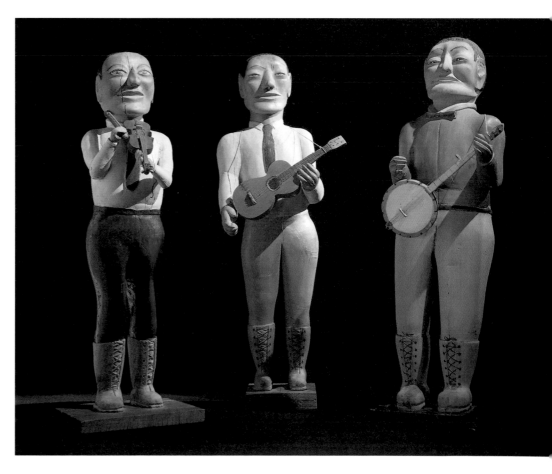

Cat. 181

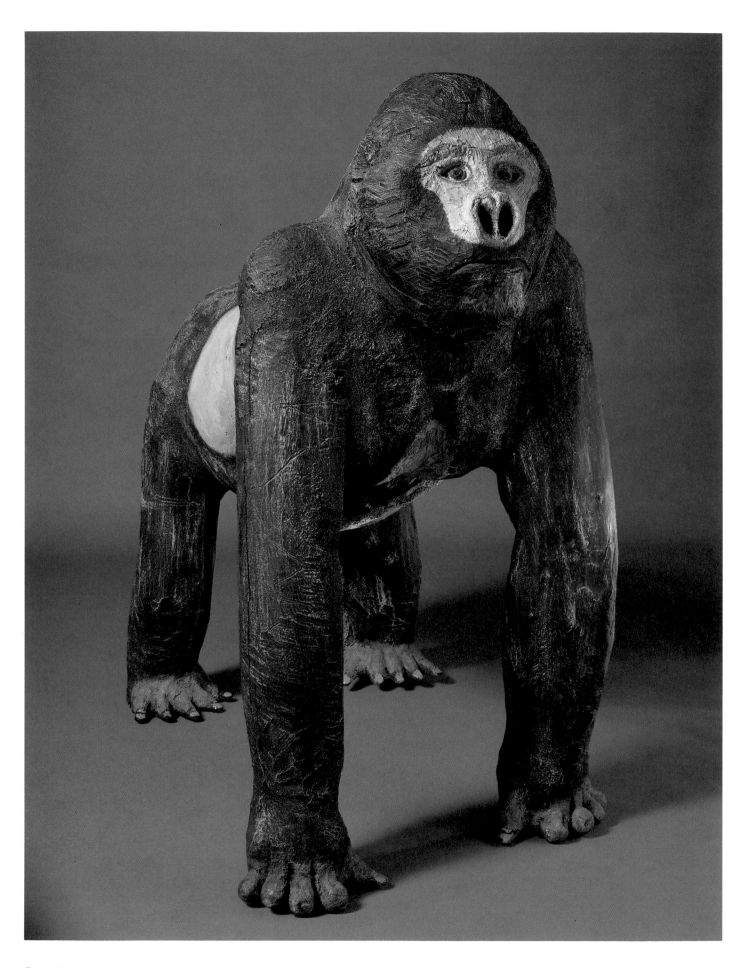

Cat. 182

painted or penciled surfaces accentuates the stark immediacy of his staring, stalwart figures, the hallmark of his mature carving style. (LRH)

[1]Charles B. Rosenak, "A Person Has to Have Some Work to Do: S. L. Jones, Wood Carver," *Goldenseal* 8 (Spring 1982): 52.

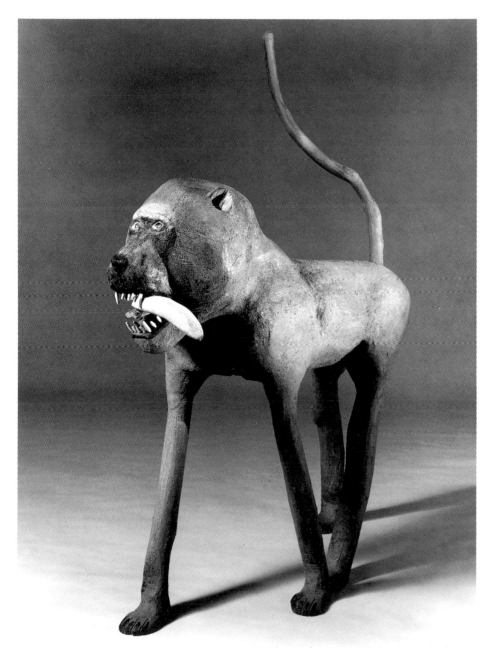

Cat. 183

Cat. 182
FELIPE BENITO ARCHULETA
born 1910, Santa Cruz, New Mexico; active Tesuque, New Mexico
Gorilla, August 27, 1976
carved and painted cottonwood with glue and sawdust
40 x 27¼ x 42 in.
acquired from the artist, 1976
1986.65.228

Cat. 183
FELIPE BENITO ARCHULETA
Baboon, June 2, 1978
carved and painted cottonwood and pine with glue and sawdust
41¾ x 69¼ x 16 in.
acquired from the artist, 1978
1986.65.227

Archuleta spent most of his adult life working as a carpenter and as an odd-jobs man until he prayed to God for something that he could make that was his own. Around 1967, he began to whittle and construct small toys and figures that he sold, with the help of his son, at local galleries and gift shops. With encouragement from gallery owners and customers, he gradually increased the size of his animal carvings until they were life-sized.

Hemphill commissioned the *Gorilla* after a visit to Archuleta when he noticed the artist's granddaughter playing with a smaller version. When carving animals not found locally, Archuleta looks at pictures in children's books and popular magazines. He based this carving on photographs from a *National Geographic* article about mountain gorillas of Africa. The shift in size from a small toy into this monumental work is typical of the artist's experimentation.

Archuleta rarely duplicates a figure, and when he does, there is usually a shift in scale, expression, or stance from one version to another. Hemphill later asked the artist to carve a monkey with a baby on its back. Archuleta, a man of stubborn independence, responded with this fierce *Baboon*. (ALC)

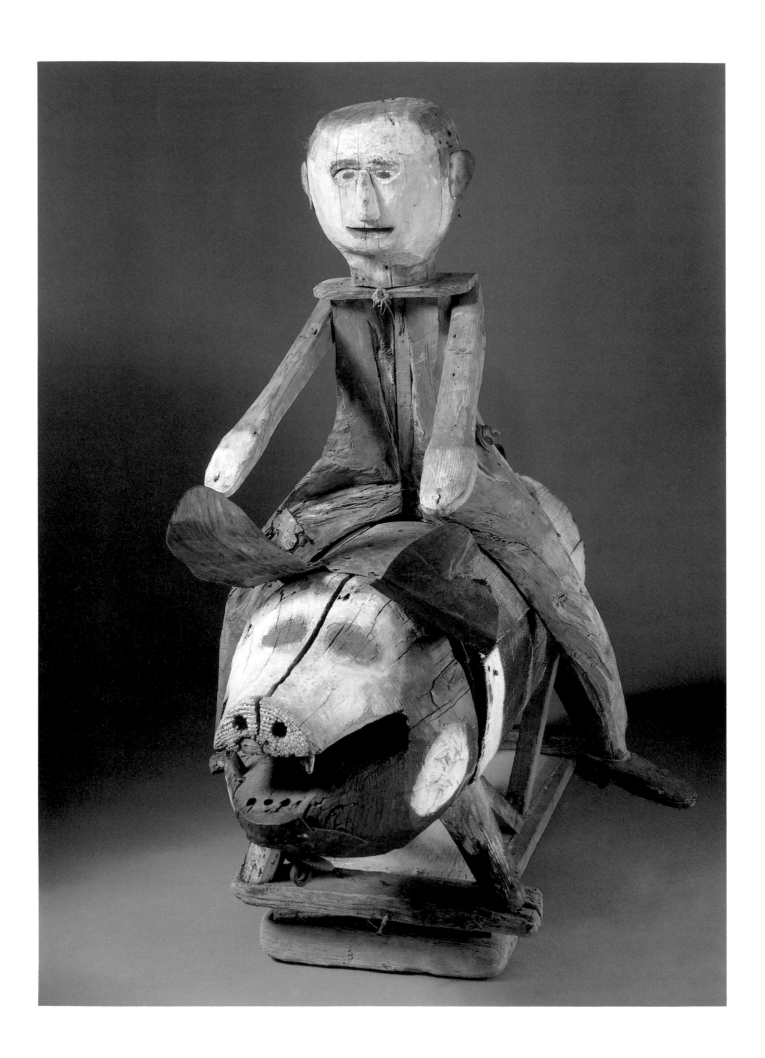

Environment Makers

Cat. 184
CLARK COE
born 1847, Madison, Connecticut–died
1919, Killingworth, Connecticut
Killingworth Image, Man on a Hog,
ca. 1890
carved, assembled, and painted wood,
tinned iron, and textile remnants
37 x 38 x 21⅜ in.
acquired from Adele Earnest, Stony Point,
New York, ca. 1964
1986.65.239

For his own delight and that of two
young grandsons, farmer and woodworker
Clark Coe constructed a larger-than-life
mechanical tableau in a streamside clearing
on his property in Killingworth,
Connecticut. Applying personal ingenuity
to vocational skills, Coe built approxi-
mately forty figures, a dam, a sluiceway,
and a small water wheel. He fashioned
each figure from scraps of baskets, barrels,
and planks, or from tree limbs and trunks.
He then added paint, makeshift hair, and
old clothes.

Among Coe's water-driven figures were
a fiddler playing; a mother cradling a
child; and a wife browbeating a flirtatious
husband—identified by an accusatory
sign. Their movements produced a ca-
cophony of creaks, groans, and scrapes,
which only drought or ice stilled. This
Man on a Hog simply rotated or moved
back and forth. Photographs taken around
1900 indicate that this figure wore a large
brimmed hat, jacket, and pants.

Locally, Coe's playful ensemble was
dubbed the "Killingworth Images." It at-
tracted a regional audience until 1926
when the deteriorating site was dismantled
and many of the figures were stored by
the local historical society, where Robert
Bishop found them during the early
1960s. A small group, including *Man on a
Hog,* was subsequently acquired by a
dealer who removed their tattered clothing
before exhibiting them in New York in
1964. (LRH)

Cat. 185
JOHN ORNE JOHNSON
("J. O. J.") FROST
1852–1928; born, active, and died Marble-
head, Massachusetts
"Blue Dog" Shark, ca. 1922–28
carved and painted wood with iron hooks
12½ x 71¼ x 1⅜ in.
acquired from Sotheby Parke-Bernet,
New York, 1974
1986.65.247

J. O. J. Frost grew up surrounded by the
maritime lore of his native Marblehead,
Massachusetts. He went to sea at age six-
teen for two years, but gave up being a
fisherman in 1870 to run a seafood restau-
rant for most of his life. After his wife's
suicide in 1919, Frost began to paint and
sculpt in an effort to educate the citizens
of Marblehead about the history of their
town. By 1925, he had built a small mu-
seum behind his house in which to exhibit
his work. Although the people of Marble-
head displayed little interest in the mu-
seum, it did become a minor tourist at-
traction. Frost labeled this carved fish
"Blue Dog"—a nickname for the blue
shark that swims near Marblehead in the
summer. The sculpture was probably dis-
played in the museum to remind visitors
of the town's important connection with
the sea. (ETH)

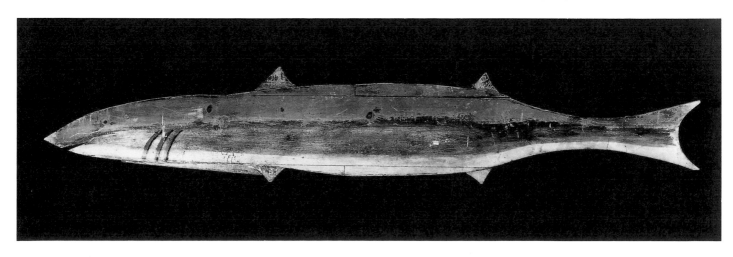

Cat. 185

Cat. 184

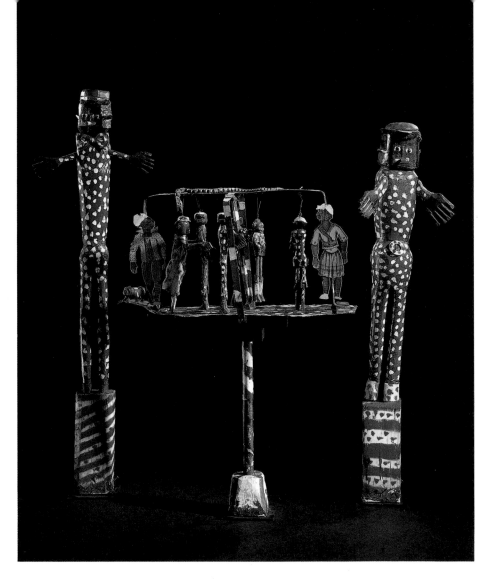

Cat. 186

Cat. 186
CHARLIE ("CEDAR CREEK CHARLIE") FIELDS
1883–1966; born, active, and died, Cedar Creek, Virginia
Set-up with Musicians and Dancers, ca. 1930–60
carved and painted wood, metal, fabric, printed paper dolls, paper-mâché snake, plastic bulldog, hair, and wire
standing figure: 48¾ x 14¾ x 5⅜ in.
standing figure: 44¾ x 12 x 10 in.
frame with hanging figures: 37½ x 27 x 12¼ in.
acquired from private dealer, late 1970s
1986.65.244, 1986.65.243, and 1986.65.381

Charlie Fields, better known locally as "Cedar Creek Charlie" or "Creek Charlie," was an eccentric bachelor who lived with his mother on the family's tobacco farm. After his mother's death in the 1930s, he began the decorating and building projects that occupied his spare moments for the remainder of his life.

Cat. 187

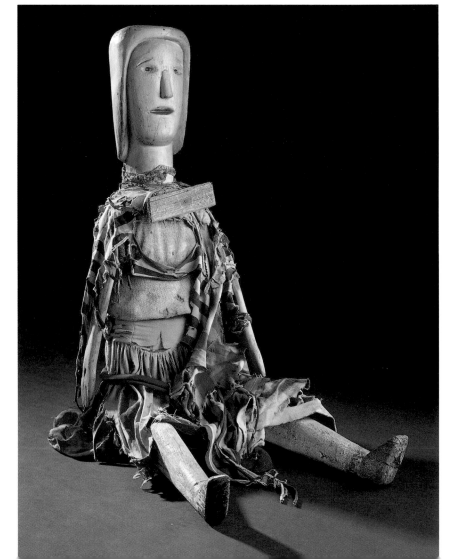

Fields completely repainted his house several times in various patterns including checker board, wavy lines, and stripes. His favorite pattern was polka dots, which covered all furnishings, including the coal stoves, bed, walls, and floors inside. His preferred color scheme—red, white, and blue—reflected his patriotic nature. Outside, whirligigs, model planes with doll passengers, a suspension bridge over a creek, and a ferris wheel were similarly decorated. The interior decoration also included collages made with cutouts from mass-produced imagery, and the exterior was illuminated year round by Christmas lights. On Sunday afternoons, Fields welcomed visitors, especially children, into his home and amusement park-like yard while dressed in his suit, shoes, and hat—all painted with polka dots.

The environment included his only known carving, *Set-up with Musicians and Dancers*, incorporating sterotypical African-American paper dolls. The taller standing figure originally held a banjo. The articulated dancing figures on the miniature platform resemble traditional "Dancing Jacks" whittled in the Southern Highlands. (ALC)

structing outbuildings, large whirligigs, tableaux, and other amusements to attract customers. They called this spot "Possum Trot," after a building type from their native South, and populated it indoors and out with home-made, life-sized dolls (see fig. 65). Calvin carved and painted the dolls, some based on real people, and gave each a name, which was painted on a wooden tag. Ruby used discarded clothing to dress the dolls. *SYLVIA* originally wore a hat and sat on a table attached to a large wind-driven, outdoor merry-go-around, one of several in "Possum Trot." Ruby replaced the figure's clothing at least once after it was torn and tattered by the wind.

Inside one building, the couple arranged the "Fantasy Doll Show" or "Bird Cage Theater" with scenes created with animated, "talking" dolls. Calvin attached speakers to the backs of several of the figures, and recorded dialogue, altering his voice to suit each figure. He also recorded songs and guitar accompaniment that he wrote for the scenarios. (ALC)

Cat. 188
STEVE ASHBY
1904–1980; born, active, and died, Delaplane, Virginia
Nodding Woman, ca. late 1960s
painted and unpainted wood, cotton, nylon, steel saw blade, and paper
48¼ x 24 x 17¾ in.
acquired from Kenneth Fadeley, Bloomfield Hills, Michigan, 1976
1986.65.232

"I wake up with an idea that won't let me get back to sleep. So I get up and make that idea."[1] Steve Ashby converted most of his ideas into objects in the early 1960s after his wife had died and he retired from his years of work as a farm hand and gardener. Ashby's favorite subjects were figures and animals, often inspired by the agrarian activities of Fauquier County, Virginia, where his ancestors had been slaves.

To create *Nodding Woman*, Ashby used tree branches, pieces of plywood cut on a

Cat. 187
CALVIN AND RUBY BLACK
born 1903, Tennessee–died 1972, Yermo, California; born ca. 1915, Georgia–died 1980, Yermo, California
SYLVIA, ca. 1953–72
carved and painted redwood with fabric, cord, and nails
30⅞ x 16⅜ × 21¾ in. (seated)
acquired from Roger Ricco and Frank Maresca, New York, ca. 1982
1986.65.233

Calvin and Ruby Black moved from Redding, California, to Yermo, located directly south of Death Valley in the heart of the Mojave Desert, in 1953. They opened a small rock shop and refreshment stand along the highway, and began con-

Cat. 188

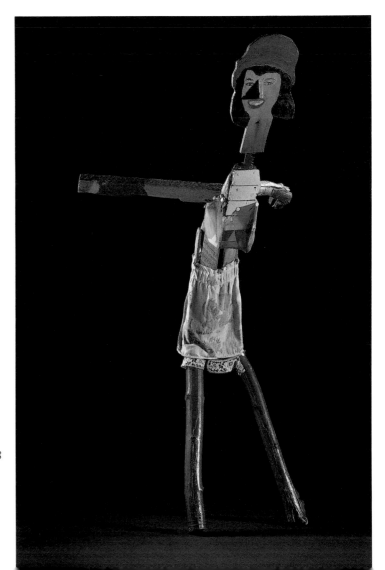

jigsaw, selections from his late wife's clothing, paint, and pasted paper cutouts, all typical features of his construction techniques. Now missing some of her clothing, this jaunty female once sat on a makeshift bench in Ashby's yard, where he frequently placed his sculptures in different settings and costumes.[2] Ashby took pride in endowing his figures with anatomically correct details, sometimes evident, as in this woman's thinly veiled chest, but often concealed under clothing. Some of his figures were wind-activated to perform various activities that ranged from the domestic to the pornographic. Others include parts that move when handled. This figure's flexible neck—a saw blade—allows her head to nod. (LRH)

[1]Ashby, in an interview with Michael Hall, quoted in *Six Naives* (Akron, Ohio: Akron Art Institute, 1973), n.p.

[2]This information is based on Kenneth Fadeley's photograph of the sculpture on Ashby's property around 1970. Papers of Kenneth Fadeley, Bloomfield Hills, Michigan.

Cat. 189
LESLIE J. PAYNE
born ca. 1907, Fairport, Virginia–
died 1981, Kilmarnock, Virginia;
active Lillian, Virginia, after 1947
G. H. McNEAL THIS IS FISH BOAT
BACK IN YEAR 1929 RUN BY StEAM,
ca. 1970–74
carved and painted wood, corrugated and painted metal, fishnet, plastic reflectors, and paper
32⅝ x 52⅛ x 12½ in.
acquired from the artist, ca. 1974
1988.74.15

Leslie J. Payne described himself as an "old airplane builder homemade," and called his constructions "imitations."[1] Although he began making objects around 1947, his few surviving works date from the 1970s. Collectively, they reveal his three principal sources of inspiration—airplanes modeled after those he saw as a child in an airshow, twentieth-century world events, and the Chesapeake Bay's

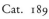
Cat. 189

fishing industry, for which he worked as a young man. His sculptures also reflect his careful, yet improvisational, building techniques, no doubt the outgrowth of his occupation as a handyman after 1947.

G. H. McNEAL . . . is one of several sculptures Payne made as accurate models of a fishing boat owned by the McNeal-Dodson Company of Fleeton, Virginia. During the 1920s, Payne worked on the company's large boats, fishing for menhaden, a local fish processed for animal feed, fertilizer, and oil. Here, pieces of fishnet stored in readiness on deck suggest Payne's attention to detail, while the thimble that caps one of the boat's spars demonstrates his inventive adaptation of found materials. The *G. H. McNEAL* steams through waves of corrugated roofing metal, although Payne's labels—citing the Atlantic Ocean and the lighthouse on Cape Hatteras, North Carolina—indicate that the boat has embarked on an imaginary voyage well beyond its usual territory of the Chesapeake Bay. (LRH)

[1]Payne quoted in *'Old Airplane Builder Homemade': The Art of Leslie J. Payne* (Richmond: Anderson Gallery School of the Arts, Virginia Commonwealth University, 1987), n.p.

Cat. 190
ROD ROSEBROOK
born 1900, Masonville, Colorado; active Redmond, Oregon
Gate, ca. 1975
welded and painted steel and iron
45½ x 39⅞ x 3 in.
acquired from Ricco/Johnson Gallery, New York, 1983
1986.65.69

In 1910, Rosebrook's family moved to the John Day Valley in eastern Oregon where he attended high school, "Long enough to play football and then I quit to go a'buckarooin'."[1] On cattle drives, Rosebrook learned enough blacksmithing to shoe horses and other metal, carpentry, and leather-working skills. He settled into a job shoeing horses at a lumbermill after marrying in 1931.

During the 1950s, Rosebrook began to collect "good stuff"—branding irons, lanterns, glass insulators, tools, and barbed wire—which he assembled in his barn. As his collection grew in his "Old Time Museum" of ranching and pioneer life, he hung some of the equipment on the outside of the barn. He welded a few tools into the steel frame of a garden gate, and eventually produced hundreds of these framed constructions. Many of these hang on his barn wall and make up a fence along the road. *Gate* is assembled from sheep shears, gun barrels, auger bits, wrenches, a jack, and a wagon wheel hub. The different steels and iron are joined together by a local welder because Rosebrook does not own the equipment required for this technical procedure. (ALC)

[1]Rod Rosebrook, interview with Andrew Connors, 18 July 1989.

Cat. 190

Cat. 191
QUENTIN J. ("Q. J.")
STEPHENSON
born 1920, Garysburg, North Carolina;
active Garysburg
Prehistoric Totem, early 1980s
painted concrete with varnished cypress
knees, beads, shells, stones, teeth, metal,
plastic flowers, poison ivy vine, feathers,
glass, and pine cone scales
54½ x 18¼ x 16¼ in.
acquired from Cavin/Morris Gallery, New
York, 1984
1986.65.267

Q. J. Stephenson is a trapper, explorer,
naturalist, and fossil hunter in northeast-
ern North Carolina. Concerned that
younger generations were not learning tra-
ditional trapping methods, he began con-
structing his roadside "Trapper's Lodge
Museum" during the early 1950s. The
building is covered inside and out with
concrete animals, imaginary beasts, slo-
gans, and patterns modeled in low relief
and inset with petrified wood, fossils,
shells, stones, and other found objects.
Each object and imprint in the walls and
floors is carefully identified and labeled.

While trapping, Stephenson has discov-
ered many fossils in the swamps near his
house, sparking his great interest in the
prehistoric world. He began to make his
"Prehistoric Art" in the late 1970s, relying
on his imagination to create terrifying and
often amusing creatures to populate his
Trapper's Museum. Totems such as this
one are set into the concrete floor and
encrusted exterior of the museum and re-
semble stalagmites in ancient caves. (ALC)

Cat. 191

Bibliography

ARCHIVAL RESOURCES

Abby Aldrich Rockefeller Papers, Rockefeller Archives Center, Pocantico Hills, North Tarrytown, New York.

Archives of American Art, Smithsonian Institution, Washington, D.C. Includes papers, interviews, and photographic documentation pertaining to collectors, museum professionals, dealers, and trained artists involved in the history of American folk art, and similar primary resources for twentieth-century, self-taught artists. Includes collectors J. Stuart Halliday, Herbert Waide Hemphill, Jr., Edward Lamson Henry, Jean Lipman, and Herrel G. Thomas; arts administrator Holger Cahill; dealers Edith Gregor Halpert, Jeffrey and Jane Camp, Robert Carlen, and Phyllis Kind; trained artists Michael Hall, Whitney Halstead, Nathan Lerner, Judy McWillie, Andy Nassise, Charles Sheeler, and Willem Volkerz. Coverage of self-taught artists includes Eddie Arning, David Butler, Miles Carpenter, Henry Darger, Uncle Jack Dey, Sam Doyle, William Edmondson, Howard Finster, Harold Garrison, Russell Gillespie, James Hampton, Perkins Harnly, Bessie Harvey, Jesse Howard, Clementine Hunter, S. L. Jones, Gustave Klumpp, Sister Gertrude Morgan, Grandma Moses, J. B. Murray, Leslie Payne, Elijah Pierce, Horace Pippin, Nellie Mae Rowe, Fred Smith, and Joseph Yoakum.

Corn, Wanda M. "The Return of the Native: The Development of Interest in American Primitive Painting." Masters thesis, New York University, Department of Fine Arts, 1965.

Dubuffet, Jean. "Anticultural Positions." Paper delivered at Art Institute of Chicago, 20 December 1951. Copy in Hemphill Papers, Archives of American Art.

Hoffman, Alice J. "Museum of American Folk Art History (1961–1988)." Prepared for the Museum of American Folk Art, New York.

Kansas Grassroots Art Association, Lawrence, Kansas. Slide collection and national index of environmental sites.

SPACES, Inc., Los Angeles, California. Library and archives include information on environmental sites, artists, and preservation efforts, oral histories, and maps.

Tatham, David. "Museums and the Art of the 'Common Man': The Birth, Growth, and Troubled Life of the Concept of American Folk Art." Paper presented at "Collections and Culture:

Museums and the Development of American Life and Thought." The Woodrow Wilson International Center for Scholars, Smithsonian Institution, Washington, D.C., 16 October 1987.

GENERAL

Abernathy, Francis Edward, ed., *Folk Art in Texas*. Dallas: Southern Methodist University Press, 1985.

Ames, Kenneth. *Beyond Necessity: Art in the Folk Tradition*. Winterthur, Del.: Henry Francis du Pont Winterthur Museum, 1977.

Antiques Magazine 132 (September 1987). Issue devoted to folk art.

Armstrong, Tom, et al. *Two Hundred Years of American Sculpture*. New York: David R. Godine Publisher in association with Whitney Museum of American Art, 1976.

Arts Council of Great Britain. *Outsiders: An Art without Precedent or Tradition*. London: Arts Council of Great Britain, 1979. Consult essays by Victor Musgrave and Roger Cardinal.

Barrett, Didi. "Folk Art of the Twentieth Century." *The Clarion* 12 (Spring/Summer 1987): 32–35. Issue devoted to the topic.

———. *Muffled Voices: Folk Artists in Contemporary America*. New York: Museum of American Folk Art, 1986.

Beardsley, John, and Jane Livingston. *Hispanic Art in the United States: Thirty Contemporary Painters and Sculptors*. New York: Abbeville Press, 1987.

Becker, Jane, and Barbara Franco, eds. *Folk Roots, New Roots: Folklore in American Life*. Lexington, Mass.: Museum of Our National Heritage, 1988.

Benedetti, Joan. "Who Are the Folk in Folk Art? Inside and Outside the Cultural Context." *Art Documentation* (Spring 1987): 3–8.

Berger, John. *Ways of Seeing*. London: Penguin Books, Ltd., 1972.

Bihalji-Merin, Otto and Nebojša-Bato Tomašević, eds. *World Encyclopedia of Naive Art*. Scranton, Pa.: Harper and Row, 1985.

Bishop, Robert. *American Folk Sculpture*. New York: E. P. Dutton and Co., Inc., 1974.

Black, Mary, and Jean Lipman. *American Folk Painting*. New York: Bramhall House, 1966.

Blasdel, Gregg N. "The Grass-Roots Artist." *Art in America* 56 (September–October 1968): 24–41.

———. *Symbols and Images: Contemporary Primitive Artists*. New York: The American Federation of the Arts, 1970.

Bronner, Simon, ed. *American Material Culture and Folklife: A Prologue and Dialogue*. Ann Arbor: UMI Research Press, 1985.

———. *Chain Carvers: Old Men Crafting Meaning*. Lexington: The University Press of Kentucky, 1985.

———. *Grasping Things: Folk Material Culture and Mass Society in America*. Lexington: The University Press of Kentucky, 1986.

Cahill, Holger. *American Primitives*. Newark, N.J.: Newark Museum, 1930.

———. *American Folk Sculpture*. Newark, N.J.: Newark Museum, 1931.

———. *American Folk Art: The Art of the Common Man in America 1750–1900*. New York: The Museum of Modern Art, 1932.

———. "Early Folk Art in America." *Creative Art* 11 (December 1932): 254–271.

Cardinal, Roger. *Outsider Art*. New York: Praeger Publishers, Inc., 1972.

Carraher, Ronald G. *Artists in Spite of Art: A Compendium of Naive, Primitive, Vernacular, Anonymous, Spontaneous, Popular, Grassroots, Folk, Serv-Ur-Self Art*. New York: Van Nostrand Reinhold Co., 1970.

Cerny, Charlene. "Everyday Masterpieces." Review of *Young America: A Folk-Art History* by Jean Lipman, Elizabeth V. Warren, and Robert Bishop. *The New York Times Book Review* (22 February 1987): 15–16.

Chalmers, F. Graeme. "The Study of Art in a Cultural Context." *Journal of Aesthetics and Art Criticism* 32 (Winter 1973): 249–55.

Christensen, Erwin O. *The Index of American Design*. Washington, D.C.: National Gallery of Art, 1950.

Clifford, James. *The Predicament of Culture: Twentieth-Century Ethnography, Literature, and Art*. Cambridge, Mass.: Harvard University Press, 1988.

Corn, Wanda M. "Coming of Age: Historical Scholarship in American Art." *The Art Bulletin* 70 (June 1988): 188–207.

Cranbrook Academy of Art Galleries. *American Folk Sculpture: The Personal and the Eccentric*. Bloomfield Hills, Mich.: Cranbrook Academy of Art, 1972. Consult essay by Michael Hall.

Crow, Thomas. "Modernism and Mass Culture in the Visual Arts." in *Modernism and Modernity*, ed. by Buchloh, Benjamin H. D., Serge Guilbaut, and David Solkin, 215–64. Halifax: The Press of the Nova Scotia College of Art and Design, 1983.

Curry, David Park. "Slouching Toward Abstraction." *Smithsonian Studies in American Art* 3 (Winter 1989): 49–72.

Danto, Arthur, et al. *Art/Artifact*. New York: The Center for African Art, 1988.

Dewhurst, C. Kurt, Marsha MacDowell, and Betty MacDowell. *Artists in Aprons: Folk Art by American Women*. New York: E. P. Dutton and Co., Inc. in association with Museum of American Folk Art, 1979.

Drepperd, Carl W. *American Pioneer Arts and Artists*. Springfield, Mass.: Pond-Ekberg Co., 1942.

Eaton, Allen H. *Immigrant Gifts to American Life: Some Experiments in Appreciation of the Contributions of Our Foreign-Born Citizens to American Culture*. New York: Russell Sage Foundation, 1932.

———. *Handicrafts of the Southern Highlands*. New York: Dover Publications, Inc., 1973 edition. Originally published by Russell Sage Foundation in 1937.

Ebert, John, and Katherine Ebert. *American Folk Painters*. New York: Charles Scribner's Sons, 1975.

Erikson, Jack T., ed. *Folk Art in America: Painting and Sculpture*. New York: Mayflower Books, Inc., for *Antiques Magazine Library*, 1979.

"Ethnic and Folk Art: Tradition and Transition." *Artspace: Southwestern Contemporary Arts Quarterly* 11 (Spring 1987): Issue devoted to the topic.

Ferris, William. *Local Color: A Sense of Place in Folk Art*. New York: McGraw Hill, 1982.

———. *Afro-American Folk Art and Crafts*. Jackson: University Press of Mississippi, 1983.

Folk Art Finder. Quarterly newsletter published by Gallery Press, Essex, Conn., March 1980–1989.

Folk Art Messenger. Quarterly newsletter published by Folk Art Society of America, Richmond, Va., 1987–1989.

"Folk Art: Mid-America and Beyond." *Forum* 12 (January–February 1987): Issue devoted to midwestern folk art.

Glassie, Henry. *Pattern in the Material Folk Culture of the Eastern United States*. Philadelphia: University of Pennsylvania Press, 1968.

———. "Meaningful Things and Appropriate Myths: The Artifact's Place in American Studies." *Prospects* 3 (1977): 1–49.

———. *The Spirit of Folk Art: The Girard Collection at the Museum of International Folk Art*. New York: Harry N. Abrams, Inc., Publishers in association with Museum of New Mexico, Santa Fe.

Goldin, Amy. "Problems in Folk Art." *Artforum* 14 (June 1976): 48–52.

Graburn, Nelson H. H., ed. *Ethnic and Tourist Arts: Cultural Expressions from the Fourth World*. Berkeley: University of California Press, 1976.

Greenberg, Clement. "Avant-Garde and Kitsch." In O'Brian, John, ed., *Clement Greenberg: The Collected Essays and Criticism, Vol. 1 Perceptions and Judgments 1939–1944*. Chicago: The University of Chicago Press, 1986.

Greenfield, Verni. *Making Do or Making Art: A Study of American Recycling*. Ann Arbor, Mich.: UMI Research Press, 1986.

Hall, Michael D., and Eugene Metcalf. *The Ties That Bind: Folk Art in Contemporary American Culture*. Cincinnati, Ohio: The Contemporary Arts Center, 1986.

Hall, Michael D. *Six Naives: Ashby, Borkowsky, Fasanella, Nathaniel, Palladino, Tolson*. Akron, Ohio: Akron Art Institute, 1973.

———. *Stereoscopic Perspective: Reflections on American Fine and Folk Art*. Ann Arbor, Mich.: UMI Research Press, 1988.

Hemphill, Herbert Waide, Jr., and Julia Weissman. *Twentieth-Century Folk Art and Artists*. New York: E. P. Dutton and Co., Inc., 1974.

Hemphill, Herbert Waide, Jr., ed. *Folk Sculpture USA*. New York: The Brooklyn Museum, 1976. Consult essays by Michael Kan and Daniel Robbins, and interview between Sarah Faunce and Michael D. Hall.

Hess, Thomas B. "Mohammed Ali vs. Whitney Museum." *New York Magazine* (25 February 1973): 70–71.

Hirschl and Adler Folk. *Source and Inspiration: A Continuing Tradition*. New York: Hirschl and Adler Folk, 1988.

Horwitz, Elinor Lander. *Contemporary American Folk Artists*. Philadelphia: J. B. Lippincott Co., 1975.

Hufford, Mary, Marjorie Hunt, and Steven Zeitlin. *The Grand Generation: Memory, Mastery, Legacy*. Washington, D.C.: Smithsonian Institution Traveling Exhibition Service and Office of Folklife Programs in association with University of Washington Press, Seattle, 1987.

INTAR Latin American Gallery. *Another Face of the Diamond: Pathways Through the Black Atlantic South*. New York: INTAR Latin American Gallery, 1989. Consult essays by John Mason, Judith McWillie, and Robert Farris Thompson.

Janis, Sidney. *They Taught Themselves: American Primitive Painters of the Twentieth Century*. New York: The Dial Press, 1942.

The Jargon Society. *Southern Visionary Folk Artists*. Winston-Salem, N.C.: R. J. Reynolds Gallery, 1985.

John Michael Kohler Arts Center. *From Hardanger to Harleys: A Survey of Wisconsin Folk Art*. Sheboygan, Wis.: John Michael Kohler Arts Center, 1987. Consult essays by Robert T. Teske, James P. Leary, and Janet C. Gilmore.

Johnson, Jay, and William C. Ketchum, Jr. *American Folk Art of the Twentieth Century*. New York: Rizzoli Press, 1983.

Jones, Michael Owen. *The Hand Made Object and Its Maker*. Berkeley: University of California Press, 1975.

———. *Exploring Folk Art: Twenty Years of Thought on Craft, Work, and Aesthetics*. Ann Arbor, Mich.: UMI Research Press, 1987.

Kaprow, Allan. *Assemblage, Environments and Happenings*. New York: Harry N. Abrams, Inc., 1966.

Kaufman, Barbara Wahl, and Didi Barrett. *A Time to Reap: Late Blooming Folk Artists*. South Orange, N.J.: Seton Hall University and Museum of American Folk Art, 1985.

KGAA News. Quarterly newsletter published by Kansas Grassroots Art Association, Lawrence, Kans., Spring 1981–1989.

Kind, Phyllis. "Some Thoughts About Contemporary Folk Art." *American Antiques* (June 1976): 28–44.

Kirwin, Liza. "Documenting Contemporary Southern Self-Taught Artists." *The Southern Quarterly* 26 (Fall 1987): 57–75.

Kouwenhoven, John A. *Made in America: The Arts in Modern Civilization*. New York: Doubleday and Co., Inc., 1948. Reprint. New York: Octagon Books, 1975.

Krannert Art Museum. *The Prinzhorn Collection: Selected Work from the Prinzhorn Collection of the Art of the*

Mentally Ill. Champaign: The University of Illinois, 1984.

Kroll, Jack. "The Outsiders Are In." *Newsweek* (25 December 1989): 72–73.

Kuspit, Donald B. "American Folk Art: The Practical Vision." *Art in America* 68 (September 1980): 94–98.

Larsen-Martin, Susan, and Lauri Robert Martin. *Pioneers in Paradise: Folk and Outsider Artists of the West Coast*. Long Beach, Calif.: The Long Beach Museum of Art, 1984.

Lipman, Jean. *American Primitive Painting*. New York: Oxford University Press, 1942. Reprint. New York: Dover Publications, 1972.

———. *American Folk Art in Wood, Metal and Stone*. New York: Pantheon Books, 1948. Reprint. New York: Dover Publications, 1972.

———. *Provocative Parallels: Naive Early Americans/International Sophisticates*. New York: E. P. Dutton and Co., Inc., 1975.

Lipman, Jean, and Alice Winchester. *The Flowering of American Folk Art (1776–1876)*. New York: The Viking Press in cooperation with Whitney Museum of American Art, 1976.

Lipman, Jean, and Tom Armstrong, eds. *American Folk Painters of Three Centuries*. New York: Hudson Hills Press, 1980.

Lipman, Jean, Elizabeth V. Warren, and Robert Bishop. *Young America: A Folk-Art History*. New York: Hudson Hills Press in association with Museum of American Folk Art, 1986.

Livingston, Jane, and John Beardsley. *Black Folk Art in America, 1930–1980*. Jackson: University of Mississippi Press and Center for the Study of Southern Culture for the Corcoran Gallery of Art, Washington, D.C., 1980. Consult essay by Regenia Perry.

MacGregor, John M. *The Discovery of the Art of the Insane*. Princeton, N.J.: Princeton University Press, 1989.

Manley, Roger. *Signs and Wonders: Outsider Art Inside North Carolina*. Raleigh: North Carolina Museum of Art, 1989.

Maquet, Jacques. *The Aesthetic Experience: An Anthropologist Looks at the Visual Arts*. New Haven, Conn.: Yale University Press, 1986.

McCormick, John. "In Praise of Grass-Roots Art." *Newsweek* (14 May 1984): 13.

Metcalf, Eugene. "Black Art, Folk Art and Social Control." *Winterthur Portfolio* 18 (Winter 1983): 271–89.

Meyer, George H., ed. *Folk Artist Biographical Index*. Detroit: Sandringham Press in association with Museum of American Folk Art, 1987.

Miele, Frank J., moderator. "Folk, or Art? A Symposium." *The Magazine Antiques* 135 (January 1989): 272–87.

Mitchells, K. "The Work of Art in Its Social Setting and Its Aesthetic Isolation." *Journal of Aesthetics and Art Criticism* 25 (Summer 1967): 369–74.

Museum of Early American Folk Arts. *Initial Loan Exhibition*. New York: Museum of Early American Folk Arts, 1962.

Museum of Modern Art. *Masters of Popular Painting: Modern Primitives of Europe and America*. New York: The Museum of Modern Art, in collaboration with the Grenoble Museum, France, 1938. Consult texts by Holger Cahill and Maximilien Gauthier.

Narvaez, Peter, and Martin Laba, eds. *Media Sense: The Folklore-Popular Culture Continuum*. Bowling Green, Ohio: Bowling Green State University Popular Press, 1986.

Newman, Barry. "Folk Art Finders: Uncovering the Works of Untrained Artists Takes Lots of Looking." *The Wall Street Journal*, 30 July 1974.

Oakland Museum Art Department. *Cat and a Ball on a Waterfall: Two Hundred Years of California Folk Painting and Sculpture*. Oakland, Calif.: Oakland Museum, 1986. Consult essays by Harvey Jones, Susan C. Larsen, Donna Reid, Seymour Rosen, and Louise Jackson.

Parsons, Pat. "Outsider Art: Patient Art Enters the Art World." *The Journal of Art Therapy* 25 (August 1986): 3–11.

Philadelphia College of Art. *Transmitters: The Isolate Artist in America*. Philadelphia: Philadelphia College of Art, 1981. Consult essays by Richard Flood, Julie and Michael Hall, and Marcia Tucker.

Posen, I. Sheldon, and Daniel Franklin Ward. "Watts Towers and the *Giglio* Tradition." *Folklife Annual 1985* (1985): 142–57.

Price, Matlack. "American Folk Art Defined: Its Discovery, Its Scope, Its Meaning—with Particular Reference to Early Portraits." *American Collector* 4 (14 November 1935): 4–6, 17.

Prown, Jules. "Mind in Matter: An Introduction to Material Culture Theory and Method." *Winterthur Portfolio* 17 (Spring 1982): 1–19.

———. "Style as Evidence." *Winterthur Portfolio* 15 (Autumn 1980): 197–210.

Quimby, Ian M. G., and Scott T. Swank, eds. *Perspectives on American Folk Art*. New York: W.W. Norton and Co., 1980.

Raw Vision: The New International Journal of Outsider Art. London, Spring–Winter 1989.

Rhodes, Lynette I. *American Folk Art: From the Traditional to the Naive*. Cleveland, Ohio: The Cleveland Museum of Art, 1978.

Rhodes, Richard C. *The Inland Ground: An Evocation of the American Middle West*. New York: Atheneum, 1970.

Ricco, Roger, and Frank Maresca, with Julia Weissman. *American Primitive: Discoveries in Folk Sculpture*. New York: Alfred A. Knopf, 1988.

Roberts, Warren E. *Viewpoints on Folklife: Looking at the Overlooked*. Ann Arbor, Mich.: UMI Research Press, 1988.

Rosen, Seymour. *In Celebration of Ourselves*. San Francisco: California Living Books in association with San Francisco Museum of Modern Art, 1979.

Rubin, Cynthia Elyce, ed. *Southern Folk Art*. Birmingham, Ala.: Oxmoor House, 1985.

Schlereth, Thomas J., ed. *Material Culture Studies in America*. Nashville: American Association for State and Local History, 1982.

Schroder, Fred E. H. *Outlaw Aesthetics: Arts and the Public Mind.* Bowling Green, Ohio: Bowling Green State University Press, 1977.

Seitz, William. *The Art of Assemblage.* New York: The Museum of Modern Art, 1961.

South Bank Center. *In Another World: Outsider Art from Europe and America.* London: South Bank Centre, 1987. Consult essay by Victor Willing.

Spaces: Notes on America's Folk/Art Environments. Annual newsletter published by SPACES Inc., Los Angeles, 1982–1989.

Steinfeldt, Cecilia. *Texas Folk Art: One Hundred Fifty Years of the Southwestern Tradition.* Austin: Texas Monthly Press, 1981.

Taylor, Joshua C. *America as Art.* Washington, D.C.: Smithsonian Institution Press, 1976.

Thompson, Michael. *Rubbish Theory: The Creation and Destruction of Value.* Oxford: Oxford University Press, 1979.

Thompson, Robert Farris. *Flash of the Spirit: African and Afro-American Art and Philosophy.* New York: Random House, 1983.

Tinkham, Sandra Shaffer, ed. *The Consolidated Catalog to The Index of American Design.* Cambridge: Chadwyck Healey, 1980.

Trumble, Meredith, and John F. Turner. "Striding Out on Their Own." *The Clarion* 13 (Summer 1988): 40–47.

Vlach, John Michael. *The Afro-American Tradition in Decorative Arts.* Cleveland, Ohio: The Cleveland Museum of Art, 1978.

———. "American Folk Art: Questions and Quandaries." *Winterthur Portfolio* 15 (Winter 1980): 345–55.

———. *Plain Painters: Making Sense of American Folk Art.* Washington, D.C.: Smithsonian Institution Press, 1988.

Vlach, John Michael, and Simon Bronner, eds. *Folk Art and Art Worlds.* Ann Arbor, Mich.: UMI Research Press, 1986.

Wadsworth, Anna, et al. *Missing Pieces: Georgia Folk Art, 1770–1976.* Atlanta: Georgia Council for the Arts and Humanities, 1976.

Walker Art Center. *Naives and Visionaries.* New York: E. P. Dutton and Co., Inc., 1974.

Wampler, Jan. *All Their Own: People and the Places They Build.* Cambridge, Mass.: Schenkman Publishing Co., 1977.

Ward, Daniel Franklin, ed. *Personal Places: Perspectives on Informal Art Environments.* Bowling Green, Ohio: Bowling Green State University Popular Press, 1984.

Winchester, Alice, ed. "What Is American Folk Art? A Symposium." *Antiques* 57 (May 1950): 335–62.

Winchester, Alice. "Antiques for the Avant-Garde." *Art in America* 49 (April 1961): 64–73.

Wintman, Elaine. "Seymour Rosen and Spaces." *The Clarion* 13 (Winter 1988): 47–51. Issue devoted to environments.

COLLECTIONS AND COLLECTING

Adams, Nancy. "Folk Art May Be Naive But Its Collectors Aren't." *Chicago Tribune*, 12 June 1983.

Appadurai, Arjun. *The Social Life of Things: Commodities in Cultural Perspective.* Cambridge and New York: Cambridge University Press, 1986.

Art and Antiques. "The Top 100 Collectors in America." Published annually, 1984–1989.

Becker, Howard S. *Art Worlds.* Berkeley: University of California Press, 1982.

Black, Mary C. "At the Sign of Gabriel, Flag or Indian Chief." Reprinted by Museum of Early American Folk Arts, New York, 1966, from *Curator* 9 (1966): 134–45.

———. "Museum of American Folk Art: A Quinquennial Report." *Curator* 12 (1969): 96–109.

Blodgett, Richard. "Collectors Flock to Folk Art." *The New York Times*, 12 September 1976.

Brant, Sandra, and Elissa Cullman. *Andy Warhol's Folk and Funk.* New York: Museum of American Folk Art, 1977.

Calvin College Center Art Gallery. *American Folk Art from the Collection of Martin and Enid Packard.* Grand Rapids, Mich.: Calvin College Center Art Gallery, 1981.

Children's Museum. *America Expresses Herself. Eighteenth, Nineteenth and Twentieth-Century Folk Art from the Herbert W. Hemphill, Jr. Collection.* Indianapolis, Ind.: Children's Museum, 1976.

Davis, Felice. "American Folk Art in the Hemphill Collection." *Connoisseur* 176 (February 1971): 113–22.

Doty, Robert. *American Folk Art in Ohio Collections.* Akron: Akron Art Institute, and New York: Dodd Mead, 1976.

Du Bois, Peter C. "Who Needs Picasso? Some Alternatives to $36 Million Paintings." *Barron's*, 2 January 1989.

Dudar, Helen. "Mr. American Folk Art." *Connoisseur* 210 (June 1982): 70–78.

Earnest, Adele. *Folk Art in America: A Personal View.* Exton, Pa.: Schiffer Publishing Ltd., 1984.

Edison Institute. *Selected Treasures of Greenfield Village and Henry Ford Museum.* Dearborn, Mich.: The Edison Institute, 1969.

Fendelman, Helaine. "The Art of Collecting Art: Herbert Waide Hemphill, Jr." *Ohio Antique Review* 4 (July 1978): 15–17.

Graeber, Laurel. "Collecting." *The New York Times Magazine*, 15 October 1989, 48–50.

Gustafson, Eleanor H. "Museum Accessions." *Antiques* 132 (September 1987): 438–39, 462.

Halpert, Edith Gregor. "Folk Art of America Now Has a Gallery of Its Own." *Art Digest* 6 (October 1931): 3.

Hemphill, Herbert Waide, Jr. "This Is the Confession of a Folk Art Collector. . . ." *National Antiques Review* (January 1975): editorial page.

Heritage Plantation of Sandwich. *The Herbert Waide Hemphill, Jr., Collection of Eighteenth, Nineteenth and Twentieth Century American Folk Art.* Sandwich, Mass.: Heritage Plantation of Sandwich, 1974.

Hitt, Jack. "The Selling of Howard Finster." *Southern Magazine* (November 1987): 52–59, 91.

Jones, Agnes Halsey, and Louis C. Jones. *New-Found Folk Art of the New Republic.* Cooperstown: New York State Historical Association, 1960.

Klein, Susan, and Susan Rotenstreich. "The Acquisitor's Eye: 20th-Century American Folk Art in the Collection of Herbert Waide Hemphill, Jr." *Art and Auction* 9 (May 1987): 131–33.

Lannion, Linnea. "Just Plain Folk: Old or New, Costly or Not, It's Hot Art." *Detroit Free Press,* 13 March 1988.

Lipman, Jean, ed. "American Primitive Painting: Collection of Edgar William and Bernice Chrysler Garbisch." *Art in America* 42 (May 1954). Issue devoted to Garbisch collection.

Little, Nina Fletcher. *The Abby Aldrich Rockefeller Folk Art Collection.* Williamsburg: Colonial Williamsburg, 1957. Distributed by Little, Brown, and Co., Boston.

———. *Little by Little, Six Decades of Collecting American Decorative Arts.* New York: E. P. Dutton and Co., Inc., 1984.

Lynes, Russell. *The Tastemakers: The Shaping of American Popular Taste.* New York: Harper and Brothers, 1955. Reprint. New York: Dover Publications, 1980.

"Major Folk Art Collection Acquired by Smithsonian." *The New York Times,* 19 January 1987.

"Marketing Folk Art." *New York Folklore* 12 (Winter–Spring, 1986). Issue devoted to the topic.

Metcalf, Eugene. "From the Mundane to the Miraculous: The Meaning of Folk Art Collecting in America." *The Clarion* 12 (Winter 1987): 56–60.

———. "Artifacts and Cultural Meaning: The Ritual of Collecting American Folk Art." In Gerald Pocius, ed. *Living in a Material World: Canadian and American Approaches to Material Culture.* St. Johns, Canada: Institute for Social and Economic Research, 1990.

Milwaukee Art Museum. *American Folk Art: The Herbert Waide Hemphill, Jr., Collection.* Milwaukee: Milwaukee Art Museum, 1981. Consult dialogue between Hemphill and Michael Hall, and essays by Russell Bowman and Donald Kuspit.

Museum of American Folk Art. *An Eye on America: Folk Art from the Stewart E. Gregory Collection.* New York: Museum of American Folk Art, 1972.

Museum of Contemporary Art. *Made in Chicago: Some Resources.* Chicago: Museum of Contemporary Art, 1975. Essay by Don Baum.

———. *Selections from the Dennis Adrian Collection.* Chicago: Museum of Contemporary Art, 1982.

Museum of Fine Arts, Boston. *M. & M. Karolik Collection of American Water Colors & Drawings 1800–1875.* Boston: The Museum of Fine Arts, 1962.

Museum of International Folk Art. *Multiple Visions: A Common Bond, The Girard Foundation Collection.* Sante Fe: Museum of International Folk Art, 1982.

Nassau County Museum of Fine Art. *Americans at Work and Play: Folk Sculpture from the Collection of Dorothy and Leo Rabkin.* Roslyn Harbor, N.Y.: Nassau County Museum of Fine Art, 1983.

National Gallery of Art. *American Primitive Paintings from the Collection of Edgar William and Bernice Chrysler Garbisch.* Washington, D.C.: National Gallery of Art, 1954 (part 1); 1957 (part 2).

———. *American Primitive Watercolors and Pastels from the Collection of Edgar William and Bernice Chrysler Garbisch.* Washington, D.C.: National Gallery of Art, 1966.

———. *An American Sampler: Folk Art from the Shelburne Museum.* Washington, D.C.: National Gallery of Art, 1987. Essays by David Park Curry, Richard L. Kerschner and Valerie Reich, Benjamin L. Mason, and Jane C. Nylander.

Northern Illinois University Art Gallery. *Twentieth-Century American Folk Art from the Arient Family Collection.* Chicago: Northern Illinois University Art Gallery, 1987.

Noyes Museum. *American Folk Art from the Collection of Herbert Waide Hemphill, Jr.* Oceanville, N.J.: The Noyes Museum, 1988. Essay by Sid Sachs.

Patton, Phil. "Collecting: The Art of Innocence." *Metropolitan Home* 21 (September 1989): 107–11.

Publishing Center for Cultural Resources. *Folk Art USA Since 1900 from the Collection of Herbert Waide Hemphill, Jr.* New York: Publishing Center for Cultural Resources for Abby Aldrich Rockefeller Folk Art Center, 1980.

Reed, Rochelle. "Collecting: Folk Art Hits Its Prime." *Metropolitan Home* (May 1981): 85–98.

Reginato, James. "Folk Art's Old Guard: The Families Who Began the Collecting Craze." *Town and Country* 162 (January 1990): 161–71.

Reif, Rita. "Antiques: Folk Art Show." *The New York Times,* 29 June 1974.

Rense, Paige, ed. *The Collectors: The Worlds of Architectural Digest.* Los Angeles: Knapp Press, 1982.

Rumford, Beatrix T., and Caroline J. Weekley. *Treasures of American Folk Art from the Abby Aldrich Rockefeller Folk Art Collection.* Boston: Little, Brown and Co. Bullfinch Press in association with The Colonial Williamsburg Foundation, 1989.

Rumford, Beatrix T., ed. *American Folk Paintings: Paintings and Drawings Other than Portraits from the Abby Aldrich Rockefeller Folk Art Center.* New York: The New York Graphic Society; Little, Brown and Co. in association with The Colonial Williamsburg Foundation, 1988.

Saarinen, Aline B. *The Proud Possessors: The Lives, Times and Tastes of Some Adventuresome American Art Collectors.* New York: Vintage Books, 1968.

School of the Art Institute of Chicago. *Ray Yoshida's Adoptive Home for Mis-*

placed Muses. Chicago: School of the Art Institute of Chicago, 1985.

Seibels, Cynthia. "Collecting Contemporary Folk Art: Art or Nostalgic Americana," *Antique Review* 11 (August 1985): 6–7.

Solis-Cohen, Lita. "Smithsonian Buys Hemphill Collection: What Price Folk Art?" *Maine Antique Digest* 15 (March 1987): 22A.

Sotheby's. *The Andy Warhol Collection: Americana and European and American Paintings, Drawings and Prints.* New York: Sotheby's, 29–30 April 1988.

Stewart, Susan. *On Longing: Narratives of the Miniature, the Gigantic, the Souvenir, the Collection.* Baltimore: Johns Hopkins Press, 1984.

Stocking, George W., ed. *Objects and Others: Essays on Museums and Material Culture, History of Anthropology.* Vol. 3. Madison: University of Wisconsin Press, 1985.

University of Kentucky Art Gallery. *American Folk Sculpture from the Hall Collection.* Lexington: University of Kentucky Art Gallery, 1974.

University of Southwestern Louisiana. *Baking in the Sun: Visionary Images from the South, Selections from the Collection of Sylvia and Warren Lowe.* Lafayette: University Art Museum, University of Southwestern Louisiana, 1987. Consult essays by Andy Nassise and Maude Southwell Wahlman.

Warren, Elizabeth V., and Stacy C. Hollander. *Expressions of a New Spirit: Highlights from the Permanent Collection of the Museum of American Folk Art.* New York: Museum of American Folk Art, 1989.

Watts, Michael. "Acquiring the Questionable." *Dialogue* 11 (July–August 1988): 16–17.

Welsh, Peter C. *American Folk Art: The Art and Spirit of a People from the Eleanor and Mabel Van Alstyne Collection.* Washington, D.C.: Smithsonian Institution Press, 1965.

William Benton Museum of Art. *Nineteenth-Century Folk Painting: Our Spirited National Heritage, Works of*

Art from the Collection of Mr. and Mrs. Peter Tillou. Storrs: The University of Connecticut, William Benton Museum of Art, 1973.

Winchester, Alice. "Maxim Karolik and His Collections." *Art in America* 45 (Fall 1957): 34–42, 70.

————. "Living with Antiques: Cogswell's Grant, the Essex County Home of Mr. and Mrs. Bertram K. Little." *Antiques* 95 (February 1969): 242–51.

Woodward, Richard B. *American Folk Painting, Selections from the Collection of Mr. and Mrs. William E. Wiltshire III.* Richmond: The Virginia Museum, 1977.

FUNCTIONAL ENVIRONMENT

Barber, Joel. *Wild Fowl Decoys.* New York: Windware House, 1934. Reprint. New York: Dover Publications, 1954.

Boothroyd, A. E. *Fascinating Walking Sticks.* New York and London: White Lion Publishers, 1973.

Burrison, John. *Brothers in Clay: The Story of Georgia Folk Pottery.* Athens: University of Georgia Press, 1983.

Churchill, Edwin A. *Simple Form and Vivid Colors: An Exhibition of Maine Painted Furniture, 1800–1850.* Augusta: The Maine State Museum, 1983.

Constantine, Mildred, and Egbert Jacobson. *Sign Language.* New York: Reinhold Publishing Corp., 1961.

Cottle, James T. "How to Carve Fish Decoys." *Michigan Out-of-Doors* (January 1988): 33–35.

Cranbrook Academy of Art. *The Decoy as Folk Sculpture.* Bloomfield Hills, Mich.: Cranbrook Academy of Art, 1986.

Davis, Mildred J. *Early American Embroidery Designs.* New York: Crown Publishers, Inc., 1969.

Delph, Shirley, and John Delph. *New England Decoys.* Exton, Pa.: Schiffer Publishing Ltd., 1981.

Dike, Catherine. *Cane Curiosa.* Paris: Les Editions de l'Auteur, 1983.

Earnest, Adele. *The Art of the Decoy: American Bird Carvings.* New York: Bramhall House, 1965.

Fales, Dean A., Jr. *American Painted Furniture 1660–1880.* New York: E. P. Dutton and Co., Inc., 1972.

Ferraro, Pat, Elaine Hedges, and Julie Silber. *Hearts and Hands: The Influence of Women and Quilts on American Society.* San Francisco: The Quilt Digest Press, 1987.

Fitzgerald, Ken. *Weathervanes and Whirligigs.* New York: Brahmhill House, 1967.

Fleckenstein, Henry A., Jr. *Decoys of the Mid-Atlantic Region.* Exton, Pa.: Schiffer Publishing Ltd., 1979.

Fried, Frederick. *Artists in Wood: American Carvers of Cigar-Store Indians, Show Figures, and Circus Wagons.* New York: Clarkson N. Potter, Inc., Publisher, 1970.

Greer, Georgeanna H. *American Stonewares: The Art and Craft of Utilitarian Potters.* Exton, Pa.: Schiffer Publishing Ltd., 1981.

Hall, Michael D. "This Side of Oz: A Heart for the Tin Man." *Metalsmith Magazine* 8 (Spring 1988): 22–27.

Harbeson, Georgiana Brown. *American Needlework.* New York: Bonanza Books, 1938.

Herman, Lloyd E. *Paint on Wood.* Washington, D.C.: Smithsonian Institution Press for the Renwick Gallery, 1977.

Holstein, Jonathan. *The Pieced Quilt: An American Tradition.* Greenwich, Conn.: New York Graphic Society, 1973.

Jackson, John Brinckerhoff. *The Necessity for Ruins, and Other Topics.* Amherst: The University of Massachusetts Press, 1980.

Kangas, Gene, and Linda Kangas. *Decoys: A North American Survey.* Spanish Fork, Utah: Hillcrest Publications, Inc., 1983.

————. "Chautauqua Fish Decoys." *Decoy Magazine* (September–October 1988): 38–45.

Kaye, Myrna. *Yankee Weathervanes.* New York: E. P. Dutton and Co., Inc., 1975.

Kentucky Art and Craft Foundation. *Historical and Contemporary Kentucky Canes.* Louisville: Kentucky Art and

Craft Foundation and Larry Hackley, 1988.

Kimball, Art, Brad Kimball, and Scott Kimball. *The Fish Decoy.* Vol. 1 (1986), Vol. 2 (1987). Boulder Junction, Wis.: Aardvark Publications, Inc.

Kimball, Art, and Brad Kimball. *Fish Decoys of the Lac du Flambeau Ojibway.* Boulder Junction, Wis.: Aardvark Publications, Inc., 1988.

Kopp, Joel, and Kate Kopp. *American Hooked and Sewn Rugs: Folk Art Underfoot.* New York: E. P. Dutton and Co., Inc., 1975.

Lipsett, Linda Otto. *Remember Me: Women and Their Friendship Quilts.* San Francisco: The Quilt Digest Press, 1985.

Little, Nina Fletcher. *Neat and Tidy: Boxes and Their Contents Used in Early American Households.* New York: E. P. Dutton and Co., Inc., 1980.

Mackey, William. *American Bird Decoys.* New York: E. P. Dutton and Co., Inc., 1965.

Marling, Karal Ann. *The Colossus of Roads: Myth and Symbol along the American Highway.* Minneapolis: University of Minnesota Press, 1984.

Meadows, Cecil A. *Trade Signs and Their Origins.* London: Routledge and Kegan Paul, 1957.

Meinig, D. W., ed. *The Interpretation of Ordinary Landscapes: Geographical Essays.* Oxford: Oxford University Press, 1979.

Montgomery Museum of Fine Arts. *The Traditional Pottery of Alabama.* Montgomery, Ala.: Montgomery Museum of Fine Arts, 1983.

Orlofsky, Myron, and Patsy Orlofsky. *Quilts in America.* New York: McGraw-Hill Book Co., 1974.

Parke-Bernet Galleries, Inc. *Cigar Store Indians and Other American Trade Signs, The Haffenreffer Collection,* 11 April 1956 (Part 1), and 10 October 1956 (Part 2).

Riley, John J. *A History of the American Soft Drink Industry: Bottled Carbonated Beverages, 1807–1957.* Washing-ton, D.C.: American Bottlers of Carbonated Beverages, 1958.

Rinzler, Ralph, and Robert Sayers. *The Meaders Family: North Georgia Potters. Smithsonian Folklife Studies,* no. 1. Washington, D.C.: Smithsonian Institution Press, 1980.

Stein, Kurt. *Canes and Walking Sticks.* York, Pa.: Liberty Cap Books, 1974.

Sweezy, Nancy. *Raised in Clay: The Southern Pottery Tradition.* Washington, D.C.: Smithsonian Institution Press, 1984.

Townsend, Jane E. *Gunners Paradise: Wildfowling Decoys on Long Island.* New York: The Museum at Stony Brook, 1979.

Webb, Michael. *The Magic of Neon.* Layton, Utah: Gibbs M. Smith, Inc., 1983.

Zug, Charles. *Turners and Burners: The Folk Potters of North Carolina.* Chapel Hill: University of North Carolina Press, 1986.

TOKENS OF MEANING

Abby Aldrich Rockefeller Folk Art Center. *American Folk Portraits: Paintings and Drawings from the Abby Aldrich Rockefeller Folk Art Center.* Boston: New York Graphic Society, 1981.

Craven, Wayne. *Colonial American Portraiture, The Economic, Religious, Social, Cultural, Philosophical, Scientific, and Aesthetic Foundations.* New York: The Cambridge University Press, 1986.

Cross, Whitney R. *The Burned-Over District: The Social and Intellectual History of Enthusiastic Religion in Western New York, 1800–1850.* New York: Cornell University Press, 1950.

D'Ambrosio, Paul, and Charlotte M. Evans. *Folk Art's Many Faces: Portraits in the New York State Historical Association.* Cooperstown: New York State Historical Association, 1987.

Daniels, Ted. "Advertisements for American Selves: Nineteenth-Century Pennsylvania County Atlases." *Landscape* 29 (1987): 17–23.

Dewhurst, C. Kurt, Betty Macdowell, and Marsha Macdowell. *Religious Folk Art in America: Reflections of Faith.* New York: E. P. Dutton and Co., Inc., 1983.

Dillenberger, Jane. "Folk Art and the Bible." *Theology Today* 36 (January 1980): 564–68.

Dillenberger, John. *The Visual Arts and Christianity in America: From the Colonial Period to the Present.* New York: The Crossroad Publishing Company, 1989. New expanded edition.

Froom, LeRoy Edwin. *The Prophetic Faith of Our Fathers: The Historical Development of Prophetic Interpretation.* Vol. 4, *New World Recovery and Consummation of Prophetic Interpretation.* Washington, D.C.: Review and Herald Publishing Assoc., 1954.

Horwitz, Elinor Lander. *The Bird, the Banner, and Uncle Sam: Images of America in Folk and Popular Art.* Philadelphia: J. B. Lippincott Co., 1976.

Metraux, Alfred. *Voodoo in Haiti.* New York: Oxford University Press, 1959.

Persons, Stow. "The American Enlightenment." In *American Minds: A History of Ideas.* New York: Henry Holt and Co., 1958.

Pierce, James Smith. *God, Man and the Devil: Religion in Recent Kentucky Folk Art.* Lexington: Folk Art Society of Kentucky, 1984.

Reps, John W. *Views and Viewmakers of Urban America: 1825–1925.* Columbia: University of Missouri Press, 1984.

Saunders, Richard H., and Ellen G. Miles. *American Colonial Portraits 1700–1776.* Washington, D.C.: Smithsonian Institution Press for the National Portrait Gallery, 1987.

Sears, Clara Endicott. *Some American Primitives: A Study of New England Faces and Folk Portraits.* Port Washington, N.Y.: Kennikat Press, Inc., 1941.

Smith, Michael P. *Spirit World: Pattern in the Expressive Folk Culture of Afro-American New Orleans.* New Orleans: New Orleans Urban Folklife Society, 1984.

Starr, S. Frederick, ed. *The Oberlin Book of Bandstands.* Ohio: Oberlin College, 1987.

United Press International. *Four Days: The Historical Record of the Death of President Kennedy.* New York: American Heritage Publishing Co., Inc., 1964.

Webber, Everett. *Escape to Utopia: The Communal Movement in America.* New York: Hastings House Publishers, 1959.

COMMUNAL EXPRESSIONS

Ashley, Clifford W. *The Ashley Book of Knots.* New York: Doubleday, 1944.

Bogdan, Robert. *Freak Show: Presenting Human Oddities for Amusement and Profit.* Chicago: University of Chicago Press, 1988.

Boyd, E. *Popular Arts of Spanish New Mexico.* Santa Fe: Museum of New Mexico Press, 1974.

Briggs, Charles L. *The Wood Carvers of Cordova, New Mexico: Social Dimensions of an Artistic "Revival."* Knoxville: The University of Tennessee Press, 1980.

Coe, Ralph T. *Lost and Found Traditions: Native American Art, 1965–1985.* Seattle: University of Washington Press in association with The American Federation of Arts, 1986.

Cooper, Patricia. *Once a Cigarmaker: Men, Women, and Work Culture in American Cigar Factories, 1900–1919.* Urbana: University of Illinois Press, 1987.

Creighton, Margaret S. *Dogwatch and Liberty Days: Seafaring Life in the Nineteenth Century.* Salem, Mass.: Peabody Museum of Salem, 1982.

Ewers, John C. *Plains Indian Sculpture: A Traditional Art from America's Heartland.* Washington, D.C.: Smithsonian Institution Press, 1986.

Fendelman, Helaine. *Tramp Art: An Itinerant's Folk Art.* New York: E. P. Dutton and Co., Inc., 1975.

Flayderman, E. Norman. *Scrimshaw and Scrimshanders: Whales and Whalemen.* New Milford, Conn.: N. Flayderman and Company, Inc., 1972.

Flexner, James Thomas. "Monochromatic Drawing: A Forgotten Branch of American Art." *Magazine of Art* 48 (February 1945): 63–65.

Franco, Barbara. *Fraternally Yours.* Lexington, Mass.: Museum of Our National Heritage, 1986.

Fried, Frederick. *America's Forgotten Folk Arts.* New York: Pantheon, 1978.

Gresham, William. *Monster Midway.* New York: Rinehart, 1953.

Hansen, H. J., ed. *Art and the Seafarer.* New York: Viking Press, 1968.

Hobsbaum, Eric. *Laboring Men: Studies in the History of Labor.* New York: Basic Books, 1964.

Hyman, Tony. *Handbook of American Cigar Boxes.* Elmira, N.Y.: Arno Art Museum, 1979.

Kasson, John E. *Amusing the Million: Coney Island at the Turn of the Century.* New York: Hill and Wang, 1978.

Kelly, Roger, R. W. Lang, and Harry Walters. *Navaho Figurines Called Dolls.* Santa Fe: Wheelwright Museum of the American Indian, 1972.

Lichten, Frances. " 'Tramp Work': Penknife Plus Cigar Boxes." *Pennsylvania Folklife* 10 (Spring 1959): 2–7.

Malley, Richard C. *Graven by the Fishermen Themselves: Scrimshaw in Mystic Seaport Museum.* Mystic, Conn.: Mystic Seaport Museum, Inc., 1983.

Mangels, William F. *The Outdoor Amusement Industry.* New York: Vantage Press, 1952.

McCabe, Michael. "New York City Tattoo: Origins of a Style." *Tattoo* 5 (Summer 1986): 58–63.

McCullough, Edo. *World's Fair Midways.* New York: Exposition Press, 1966. Reprint. New York: Arno Press, 1976.

Miele, Frank J. "Calligraphic Drawings: The Art of Writing." *The Magazine Antiques* 134 (September 1988): 537–49.

Morse, Albert L. *The Tattooists.* San Francisco: privately printed, 1977.

Olmstead, Francis Allyn. *Incidents of a Whaling Voyage.* New York: D. Appleton and Co., 1841. Reprint. Rutland, Vt.: Charles E. Tuttle Co., 1969.

St. Clair, Leonard, and Alan B. Govenar. *Stoney Knows How: Life as a Tattoo Artist.* Lexington: University Press of Kentucky, 1981.

Schorsch, Anita. *Mourning Becomes America: Mourning Art in the New Nation.* Clinton, N.J.: Main Street Press, 1976.

Schrader, Robert Fay. *Indian Arts and Crafts Board: An Aspect of New Deal Social Policy.* Albuquerque: University of New Mexico, 1983.

Shepherd, Barnett. *Sailors' Snug Harbor, 1801–1976.* New York: Snug Harbor Cultural Center and the Staten Island Institute of Arts and Sciences, 1976.

Steele, Thomas J. *Santos and Saints: The Religious Folk Art of Hispanic New Mexico.* Albuquerque, N.M.: Calvin Horn Publisher, Inc., 1974.

Tangerman, E. J. *Whittling and Woodcarving.* New York: Whittlesly House, 1936.

Turnbaugh, Sarah P., and William A. Turnbaugh. *Indian Baskets.* West Chester, Pa.: Schiffer Publishing Ltd., 1986.

Urbino, Madame L. B. *Art Recreations.* Boston: J. E. Tilton and Co., 1863.

Wade, Edwin, ed. *The Arts of the North American Indian: Native Traditions in Evolution.* New York: Hudson Hills Press and Philbrook Art Center, Tulsa, 1986.

Weedon, Geoff, and Richard Ward. *Fairground Art: The Art Forms of Travelling Fairs, Carousels, and Carnival Midways.* New York: Abbeville Press, 1981.

Weigle, Marta, with Claudia and Samuel Larcombe. *Hispanic Arts and Ethnohistory in the Southwest: New Papers Inspired by the Work of E. Boyd.* Santa Fe: Ancient City Press, 1983.

Wheelwright Museum of the American Indian. *Anii Ánáádaalyaa'Ígíí: Continuity and Innovation in Recent Navajo Art.* Santa Fe: Wheelwright Museum of the American Indian, 1988.

Wilmerding, John. *American Marine Painting.* New York: Harry N. Abrams, Inc., 1987. Originally published as *A History of American Marine Painting* by Peabody Museum of Salem, 1968.

Wroth, William. *Christian Images in Hispanic New Mexico: The Taylor Museum Collection of Santos.* Colorado Springs: Colorado Springs Fine Art Center, 1982.

INDIVIDUAL ARTISTS

Adele, Lynne. "Frank Jones." In *Black History/Black Vision: The Visionary Image in Texas.* Austin: Archer M. Huntington Art Gallery, The University of Texas at Austin, 1989.

———. " 'Old Airplane Builder Homemade': The Art of Leslie J. Payne." Richmond: Anderson Gallery School of the Arts, Virginia Commonwealth University, 1987.

Anderson Gallery. "Miles Carpenter: The Woodcarver from Waverly." Richmond: Anderson Gallery School of the Arts, Virginia Commonwealth University, 1985. Consult artist's interview with Chris Gregson and essay by Marilyn A. Zeitlin.

Carpenter, Miles B. *Cutting the Mustard.* Tappahannock, Va.: American Folk Art Company, 1982. Consult statements by Jeffrey T. Camp, Herbert W. Hemphill, Jr., and Lester Van Winkle.

Centro Cultural/Arte Contemporaneo, A. C. *Martin Ramírez: Pintor Mexicano (1885–1960).* Mexico City: Centro Cultural/Arte Contemporaneo, A. C., 1989.

Chicago Office of Fine Arts. *Bill Traylor Drawings.* Chicago: Chicago Office of Fine Arts: Chicago Public Library Cultural Center, 1988. Consult essay by Michael Bonesteel.

Connors, Andrew. "Q. J. Stephenson: North Carolina Trapper, Naturalist, and Artist." *GW Folklife Newsletter* 7 (Fall 1988): 3–4.

Cubbs, Joanne. *The Gift of Josephus Farmer.* Milwaukee: The University of Wisconsin, Milwaukee Art History Gallery, 1982.

Dewhurst, C. Kurt, and Marsha Macdowell. "Ed Kay." In *Rainbows in the Sky: The Folk Art of Michigan in the Twentieth Century.* East Lansing: Michigan State University, 1978.

Earley, Lawrence S., and Ted Dossett. "Occoneechee Trapper." *Wildlife in North Carolina* (May 1987): 22–27 (Q. J. Stephenson).

Epstein, Gene. "The Art and Times of Victor Joseph Gatto." *The Clarion* 13 (Spring 1988): 56–63.

Esman, Rosa, Gallery, and Phyllis Kind Gallery. *Henry Darger.* New York: Rosa Esman Gallery, and Chicago: Phyllis Kind Gallery, 1987. Consult statements by Stephen Prokopoff and Nathan Lerner.

Fagaly, William A. "Sister Gertrude Morgan." In *Louisiana Folk Paintings.* New York: Museum of American Folk Art, 1973.

Fels, Catherine. *Graphic Work of Louis Monza.* Los Angeles: The Plantin Press, 1973.

Finster, Howard. *Howard Finster's Vision of 1982. Vision of 200 Light Years Away Space Born of Three Generations. From Earth to the Heaven of Heavens.* Summerville, Ga.: Privately printed, 1982.

———. *The Scrap Book of All Times.* Summerville, Ga.: Privately printed, 1988.

———. *Howard Finster: Man of Visions.* Atlanta, Ga.: Peachtree Publishers, Ltd., 1989.

Finster, Howard, as told to Tom Patterson. *Howard Finster: Stranger from Another World, Man of Visions Now on this Earth.* New York: Abbeville Press, 1989.

Fritz, Ronald J. *Michigan's Master Carver: Oscar W. Peterson, 1877–1951.* Boulder Junction, Wis.: Aardvark Publications, Inc., 1987.

Goldie Paley Gallery. *The Heart of Creation: The Art of Martin Ramirez.* Philadelphia: Goldie Paley Gallery, Moore College of Art, 1985.

Gregson, Chris. "Life and Legend: Folk Paintings of Uncle Jack Dey." *Calendar of Events* (June 1986): n.p.

Hall, Michael D. "The Problem of Martin Ramirez: Folk Art Criticism as Cosmologies of Coercion." *The Clarion* 11 (Winter 1986): 56–61.

———. "You Make it With Your Mind." *The Clarion* 12 (Spring–Summer 1987): 36–43 (Edgar Tolson).

Halstead, Whitney. "Joseph Yoakum." Collection of Department of Prints and Drawings, Art Institute of Chicago, n.d.

Hand Workshop. *Miles B. Carpenter: Centennial Exhibition.* Richmond: Hand Workshop, 1989.

Hartigan, Lynda Roscoe. *James Hampton: The Throne of the Third Heaven of the Nations Millenium General Assembly.* Montgomery, Ala.: Montgomery Museum of Fine Arts, 1977.

Hewett, David. "Wm. Miller and W. M. Prior: The Prophet and the Folk Artist." *Maine Antique Digest.* (April 1987): 16–46.

Hirschl and Adler Modern. *Bill Traylor.* New York: Hirschl and Adler Modern, 1985. Consult introduction by Charles Shannon.

Jones, Suzi, ed. *Webfoots and Bunchgrassers: Folk Art of the Oregon Country.* Salem: Oregon Arts Commission, 1980 (Rod Rosebrook).

Karlins, N. F. "Four From Coal Country." *The Clarion* 12 (Spring–Summer 1987): 54–61 (Justin McCarthy, Jack Savitsky).

Karlins-Thomon, Nancy. "Justin McCarthy." Ph.D. dissertation, New York University, 1986.

Katz, Martha B. "J. O. J. Frost: Marblehead Artist." Masters thesis, State University of New York College at Oneonta, 1971.

La Chappelle, Greg. *Alfred Walleto.* Santa Fe: The Wheelwright Museum of the American Indian, n.d.

Light, Allie, and Irving Saraf. *Possum Trot: The Life and Work of Calvin Black.* San Francisco: Light-Saraf Films, 1977.

Luck, Barbara R., and Alexander Sackton. *Eddie Arning.* Williamsburg, Va.: The Abby Aldrich Rockefeller Folk Art Center, 1985.

Mather, Christine, and Davis Mather. "Felipe Archuleta." In *Lions and Tigers*

and Bears, Oh My!: New Mexican Folk Carvings from the Collection of Christine and Davis Mather. Corpus Christi: Art Museum of South Texas, 1986.

Morris, Randall Seth. "Good Vs. Evil in the World of Henry Darger." *The Clarion* 11 (Fall 1986): 30–35.

Niemann, Henry. "Malcah Zeldis, Her Art." *The Clarion* 13 (Summer 1988): 49, 52–53.

Oak, Jacquelyn, et al. *Face to Face: M. W. Hopkins and Noah North.* Lexington, Mass.: Museum of Our National Heritage, 1988.

Parke-Bernet Galleries. *American Painting and Folk Art.* New York: Parke-Bernet Galleries, 8 April 1971 (J. O. J. Frost).

Paulsen, Barbara. "Eddie Arning: The Unsettling World of a Texas Folk Artist." *Texas Journal* 8 (Fall–Winter, 1985–1986).

Rankin, Allen. "He Lost 10,000 Years." *Collier's* (22 June 1946): 67 (Bill Traylor).

Rosenak, Charles B. "A Person Has to Have Some Work to Do." *Goldenseal* 8 (Spring 1982): 47–53 (S. L. Jones).

———. "Rediscovering Andrea Badami." *The Clarion* 12 (Spring–Summer 1987): 50–53.

Rosenberg, Willa S. "Malcah Zeldis, Her Life." *The Clarion* 13 (Summer 1988): 48, 50–51.

Schweizer, Paul D. *Panoramas for the People.* Utica, N.Y.: Munson-William-Proctor Institute, 1984 (Lawrence Ladd).

Schwindler, Gary J. *William L. Hawkins: Transformations.* Charleston, Ill.: Tarble Arts Center, Eastern Illinois University, 1989.

Shannon, Charles. "Bill Traylor's Triumph." *Art and Antiques* (February 1988): 61–64, 95.

Stebich, Ute. *Justin McCarthy.* Allentown, Pa.: Allentown Art Museum, 1984.

Stevens, Alfred. "The Images." *Yankee Magazine* (July 1969): 79, 104–109 (Clark Coe).

Turner, John. "Howard Finster: Man of Visions." *Folklife Annual 1985* (1985): 158–73.

———. *Howard Finster: Man of Visions.* New York: Alfred A. Knopf, 1989.

University of Kentucky Art Museum. *Edgar Tolson: Kentucky Gothic.* Lexington: University of Kentucky Art Museum, 1981.

Index

Note: An asterisk (*) preceding an entry indicates the name of a collector; a dagger (†) indicates dealer. Where both marks appear the first is the area of greater activity.

DATE DUE